Oil Paintings in Public Ownership in Suffolk

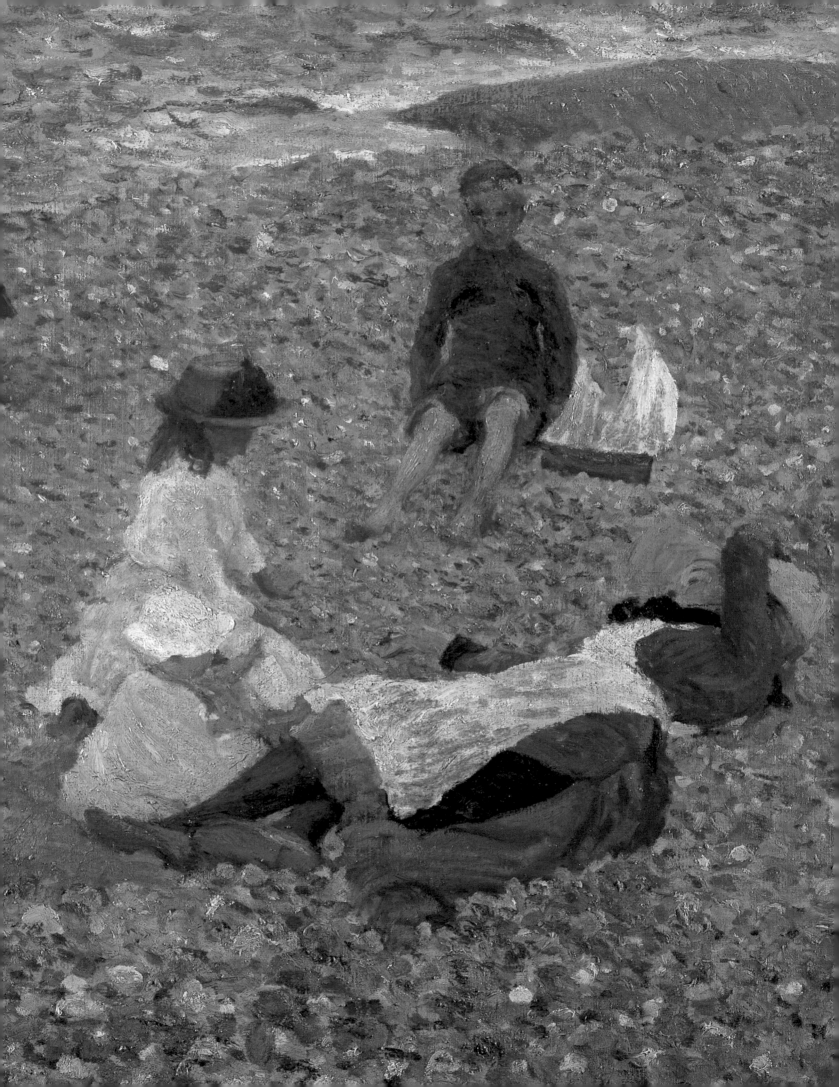

Oil Paintings in Public Ownership in Suffolk

The Public Catalogue Foundation

Andrew Ellis, Chief Executive
Sonia Roe, Editor
Alan Grundy, Suffolk Coordinator

First published in 2005 by the Public Catalogue
Foundation, St Vincent House, 30 Orange Street,
London, WC2H 7HH

**The responsibility for the accuracy of the
information presented in this catalogue lies solely
with the holding collections. Suggestions that
might improve the accuracy of the information
contained in this catalogue should be sent to the
relevant collection (addresses pp. 259–260) and
emailed to info@thepcf.org.uk.**

ISBN 1–904931–10–3 (hardback)
ISBN 1–904931–11–1 (paperback)

Suffolk photography: Douglas Atfield

Designed by Jeffery Design, London

Distributed by the Public Catalogue Foundation,
St Vincent House, 30 Orange Street,
London, WC2H 7HH
Telephone 020 7747 5936

**Printed and bound in the UK by Butler & Tanner
Ltd, Frome, Somerset**

Cover image:

Gainsborough, Thomas, 1727–1788
William Wollaston (1730–1797) (detail), c.1759,
Ipswich Borough Council Museums and Galleries
(see p. 90)

Image opposite title page:

Steer, Philip Wilson, 1860–1942
Knucklebones, Walberswick (detail), 1888,
Ipswich Borough Council Museums and Galleries
(see p. 140)

Back cover images (from top to bottom):

British (English) School
James I in His State Clothes 1610
St Edmundsbury Museums (see p. 11)

Lay, Cecil Howard 1885–1956
Forecasting a Loss No.2 1933
Ipswich Borough Council Museums and Galleries
(see p. 103)

Murfin, Michael b.1954
The Farrier 1985
Ipswich Borough Council Museums and Galleries
(see p. 121)

Contents

Woolpit

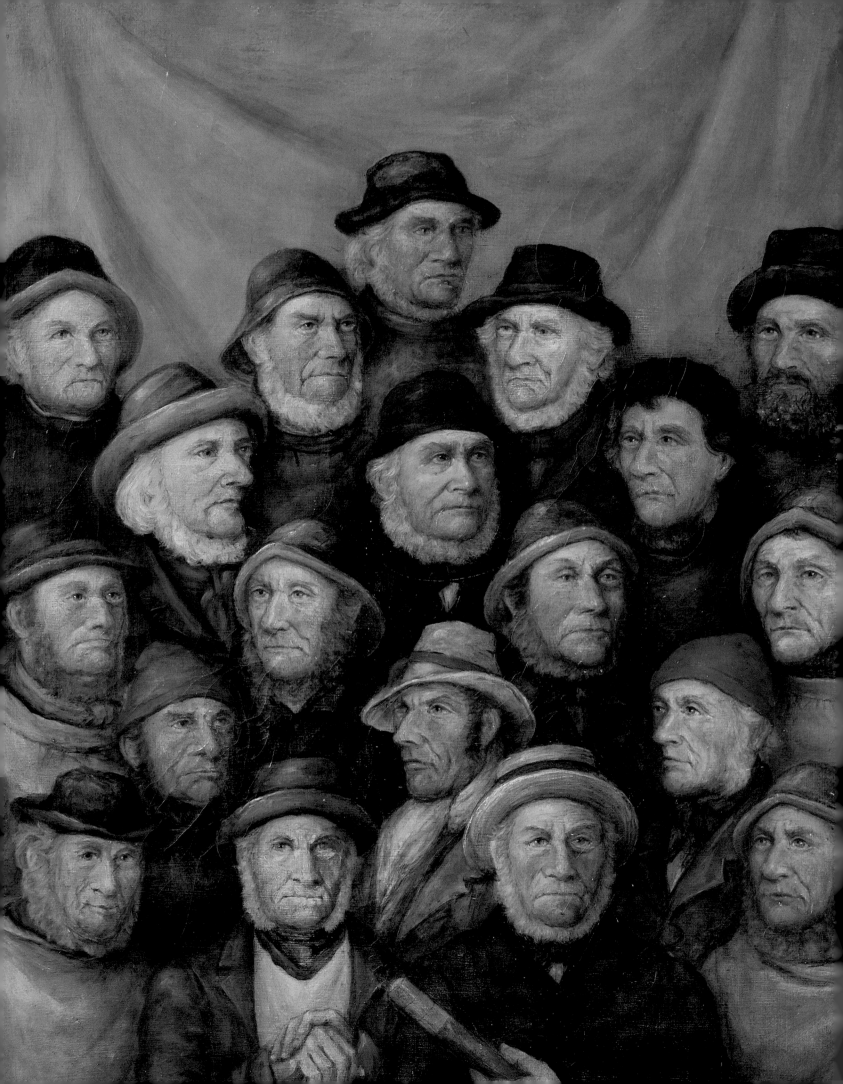

Foreword

As usual, credit and thanks are due – and fulsomely due – to those who have made this volume possible: the museum and gallery curators without whose cooperation and help none of this work would have been started; amongst those we are particularly grateful to are Sally Dummer and Hugh Belsey; Alan Grundy, our Suffolk Coordinator, who has diligently brought this volume together; the Public Catalogue Foundation 'home team' - in particular Sonia Roe and Nickie Murfitt whose painstaking checking and editing ensures the quality and editorial accuracy of each volume; Elspeth Foley and her team of NADFAS Heritage volunteers; and the funders.

Those whose financial generosity has made this volume possible – which, please note, still fails to include the Heritage Lottery Fund – are listed on page xi. It would be entirely ungracious, however, if it were not publicly recorded that robust support from Michael Spencer, Group Chief Executive of ICAP plc and Suffolk resident, and the staff of ICAP, has been essential in getting this volume to press. This support comes to us through a significant donation raised during the annual ICAP Charity Day. It is magnificent that individuals such as Michael and his staff remain willing to make good the failure of those one might logically assume were responsible for protecting our National Heritage.

In addition, I would like to express my great thanks to Suffolk County Council and the East of England Museums and Libraries Archive Council (EEMLAC) who, through the Association for Suffolk Museums and the enthusiastic support of Lyn Gash, have generously supported this catalogue. Finally, let me express our appreciation to Lord Marlesford for his help in raising money for this volume.

Suffolk is the sixth volume in our series and demonstrates the momentum that is now gathering behind our work. Our first volume, *West Yorkshire: Leeds*, proved that it was possible to produce a volume at all: *Suffolk* proves that we can produce a series.

At the start of this project, we were aware that the basic information on paintings in galleries would, broadly speaking, not be complete. Despite that, we have been consistently surprised by how much worse than expected much information has proved to be – and at times quite shocked. Local authority cutbacks have reduced the number of fine art curators, conservators and technicians to a degree that, in a number of regions, leaves the national collection seriously at risk.

The fact that, despite brutal staff shortages, galleries have been willing to stretch their resources even further to allow the PCF to catalogue their collection heavily underscores the deep loyalty and commitment of the remaining staff to their collections, for which we are enormously grateful. This also underscores the importance of the PCF's work and the necessity of getting the work completed with urgency.

Fred Hohler, Chairman

Facing page: Thurlow, Thomas, 1813–1899, The Town Worthies (detail), c.1885, The Aldeburgh Museum (see p. 4)

The Public Catalogue Foundation

The United Kingdom holds in its galleries and civic buildings arguably the greatest publicly owned collection of oil paintings in the world. However, an alarming four in five of these paintings are not on view. Whilst many galleries make strenuous efforts to display their collections, too many paintings across the country are held in storage, usually because there are insufficient funds and space to show them. Furthermore, very few galleries have created a complete photographic record of their paintings, let alone a comprehensive illustrated catalogue of their collections. In short, what is publicly owned is not publicly accessible.

The Public Catalogue Foundation, a registered charity, has three aims. First, it intends to create a complete record of the nation's collection of oil, tempera and acrylic paintings in public ownership. Second, it intends to make this accessible to the public through a series of affordable catalogues and, after a suitable delay, through a free Internet website. Finally, it aims to raise funds through the sale of catalogues in gallery shops for the conservation and restoration of oil paintings in these collections and for gallery education.

The initial focus of the project is on collections outside London. Highlighting the richness and diversity of collections outside the capital should bring major benefits to regional collections around the country. The benefits also include a revenue stream for conservation, restoration, gallery education and the digitisation of collections' paintings, thereby allowing them to put the images on the Internet if they so desire. These substantial benefits to galleries around the country come at no financial cost to the collections themselves.

The project should be of enormous benefit and inspiration to students of art and to members of the general public with an interest in art. It will also provide a major source of material for scholarly research into art history.

Financial Supporters

The Public Catalogue Foundation would like to express its profound appreciation to the following organisations and individuals who have made the publication of this catalogue possible.

Donations of £5000 or more

ICAP plc
The Monument Trust
Stavros S. Niarchos Foundation

Suffolk County Council through the Association for Suffolk Museums
Garfield Weston Foundation

Donations of £1000 or more

EEMLAC through the Association for Suffolk Museums

Caroline M. Southall

Other Donations

James Airy
Mr & Mrs Charles Brocklebank
Dr & Mrs T. H. Cocke
Kerseys Solicitors, Ipswich

Lord Marlesford
Michael More
Mid Suffolk District Council
Henry Strutt

National Supporters

The John S. Cohen Foundation
Hiscox plc
The Manifold Trust

The Monument Trust
Stavros S. Niarchos Foundation
Garfield Weston Foundation

National Sponsor

Christie's

Acknowledgements

The Public Catalogue Foundation would like to thank the individual artists and copyright holders for their permission to reproduce for free the paintings in this catalogue. Exhaustive efforts have been made to locate the copyright owners of all the images included within this catalogue and to meet their requirements. Copyright credit lines for copyright owners who have been traced, are listed in the Further Information section.

The Public Catalogue Foundation would like to express its great appreciation to the following organisations for their great assistance in the preparation of this catalogue:

Bridgeman Art Library
Flowers East
Marlborough Fine Art
National Association of Decorative and Fine Art Societies (NADFAS)
National Gallery, London
National Portrait Gallery, London
Royal Academy of Arts, London
Tate

The participating collections included in the catalogue would like to express their thanks to the following organisations which have so generously enabled them to acquire paintings featured in this catalogue:

Arts Council England
Friends of Ipswich Museums
Friends of Gainsborough's House
Friends of the National Horseracing Museum
Heritage Lottery Fund (HLF)
MLA/V&A Purchase Grant Fund
National Art Collections Fund (the Art Fund)
National Heritage Memorial Fund (NHMF)

Catalogue Scope and Organisation

Medium and Support

The principal focus of this series is oil paintings. However, tempera and acrylic are also included as well as mixed media, where oil is the predominant constituent. Paintings on all forms of support (e.g. canvas, panel etc) are included as long as the support is portable. The principal exclusions are miniatures, hatchments or other purely heraldic paintings and wall paintings *in situ*.

Public Ownership

Public ownership has been taken to mean any paintings that are directly owned by the public purse, made accessible to the public by means of public subsidy or generally perceived to be in public ownership. The term 'public' refers to both central government and local government. Paintings held by national museums, local authority museums, English Heritage and independent museums, where there is at least some form of public subsidy, are included. Paintings held in civic buildings such as local government offices, town halls, guildhalls, public libraries, universities, hospitals, crematoria, fire stations and police stations are also included. Paintings held in central government buildings as part of the Government Art Collection and MoD collections are not included in the county-by-county series but should be included later in the series on a national basis.

Geographical Boundaries of Catalogues

The geographical boundary of each county is the 'ceremonial county' boundary. This county definition includes all unitary authorities. Counties that have a particularly large number of paintings are divided between two or more catalogues on a geographical basis.

Criteria for Inclusion

As long as paintings meet the requirements above, all paintings are included irrespective of their condition and perceived quality. However, painting reproductions can only be included with the agreement of the participating collections and, where appropriate, the relevant copyright owner. It is rare that a collection forbids the inclusion of its paintings. Where this is the case and it is possible to obtain a list of paintings, this list is given in the Paintings Without Reproductions section. Where copyright consent is refused, the paintings are also listed in the Paintings Without Reproductions section. All paintings

in collections' stacks and stores are included, as well as those on display. Paintings which have been lent to other institutions, whether for short-term exhibition or long-term loan, are listed under the owner collection. In addition, paintings on long-term loan are also included under the borrowing institution when they are likely to remain there for at least another five years from the date of publication of this catalogue. Information relating to owners and borrowers is listed in the Further Information section.

Layout

Collections are grouped together under their home town. These locations are listed in alphabetical order. In some cases collections that are spread over a number of locations are included under a single owner collection. A number of collections, principally the larger ones, are preceded by curatorial forewords. Within each collection paintings are listed in order of artist surname. Where there is more than one painting by the same artist, the paintings are listed chronologically, according to their execution date.

The few paintings that are not accompanied by photographs are listed in the Paintings Without Reproductions section.

There is additional reference material in the Further Information section at the back of the catalogue. This gives the full names of artists, titles and media if it has not been possible to include these in full in the main section. It also provides acquisition credit lines and information about loans in and out, as well as copyright and photographic credits for each painting. Finally, there is an index of artists' surnames.

Key to Painting Information

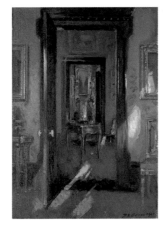

Almost all paintings are reproduced in the catalogue. Where this is not the case they are listed in the Paintings Without Reproductions section. Where paintings are missing or have been stolen, the best possible photograph on record has been reproduced. In some cases this may be black and white. Paintings that have been stolen are highlighted with a red border. Some paintings are shown with conservation tissue attached to parts of the painting surface.

Adam, Patrick William 1854–1929
Interior, Rutland Lodge: Vista through Open Doors 1920
oil on canvas 67.3 × 45.7
LEEAG.PA.1925.0671.LACF ✳

Artist name This is shown as surname first. Where the artist is listed on the Getty Union List of Artist Names (ULAN), ULAN's preferred presentation of the name is always given. In a number of cases the name may not be a firm attribution and this is made clear. Where the artist name is not known, a school may be given instead. Where the school is not known, the painter name is listed as *unknown artist*. If the artist name is too long for the space, as much of the name is given as possible followed by (…). This indicates the full name is given at the rear of the catalogue in the Further Information section.

Painting title A painting followed by *(?)* indicates that the title is in doubt. Where the alternative title to the painting is considered to be better known than the original, the alternative title is given in parentheses. Where the collection has not given a painting a title, the publisher does so instead and marks this with an asterisk. If the title is too long for the space, as much of the title is given as possible followed by *(…)* and the full title is given in the Further Information section.

Medium and support Where the precise material used in the support is known, this is given.

Artist dates Where known, the years of birth and death of the artist are given. In some cases one or both dates may not be known with certainty, and this is marked. No date indicates that even an approximate date is not known. Where only the period in which the artist was active is known, these dates are given and preceded with the word *active*.

Execution date In some cases the precise year of execution may not be known for certain. Instead an approximate date will be given or no date at all.

Dimensions All measurements refer to the unframed painting and are given in cm with up to one decimal point. In all cases the height is shown before the width. Where the painting has been measured in its frame, the dimensions are estimates and are marked with (E). If the painting is circular, the single dimension is the diameter. If the painting is oval, the dimensions are height and width.

Collection inventory number In the case of paintings owned by museums, this number will always be the accession number. In all other cases it will be a unique inventory number of the owner institution. (P) indicates that a painting is a private loan. Details can be found in the Further Information section. The ✳ symbol indicates that the reproduction is based on a Bridgeman Art Library transparency (go to www.bridgeman.co.uk) or that the Bridgeman administers the copyright for that artist.

Facing page: Becker, Harry, 1865–1928, *Man with Scythe Mowing* (detail), 1913–1928, Ipswich Borough Council Museums and Galleries (see p. 52)

The Aldeburgh Museum

Finch, H. H. active 1901–1922
James Cable, First Coxswain Lifeboat (1887–1917) 1922
oil on board 60 x 51
ALUMT.86

Moore, John of Ipswich 1820–1902
View of Thorpeness 1886
oil on canvas 31 x 70 (E)
ALUMT.81

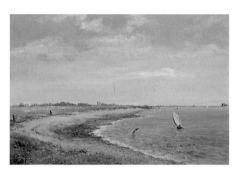

Moore, John of Ipswich 1820–1902
Slaughden Reach c.1895
oil on board 24 x 36 (E)
ALUMT.65

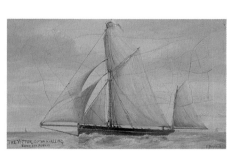

Pendred, S.
The Victor, Bound for Norway 1800s
oil on canvas 30 x 50 (E)
ALUMT.182

Thurlow, Thomas 1813–1899
An Aldeburgh Worthy c.1850–1888
oil on canvas 31 x 26
ALUMT.42B

Thurlow, Thomas 1813–1899
An Aldeburgh Worthy c.1850–1888
oil on canvas 31 x 26
ALUMT.42C

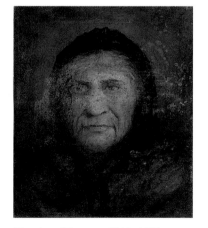

Thurlow, Thomas 1813–1899
An Aldeburgh Worthy c.1850–1888
oil on canvas 31 x 26
ALUMT.42D

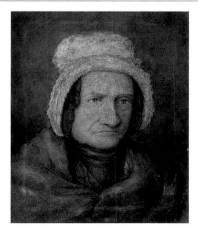

Thurlow, Thomas 1813–1899
An Aldeburgh Worthy c.1850–1888
oil on canvas 31 x 26
ALUMT.42E

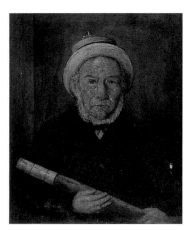

Thurlow, Thomas 1813–1899
*Robert Wilson of Lloyd's Signal
Section* c.1850–1888
oil on canvas 31 x 26
ALUMT.42A

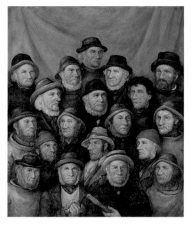

Thurlow, Thomas 1813–1899
The Town Worthies c.1885
oil on canvas 75 x 60 (E)
ALUMT.42

unknown artist
The Station Windmill, Aldeburgh late 1800s
oil on canvas 31 x 45 (E)
ALUMT.296

unknown artist
*St Peter's and St Paul's Church,
Aldeburgh* 1872
oil on canvas 26 x 38
ALUMT.307

unknown artist
View of Slaughden c.1900
oil on board 30 x 70 (E)
ALUMT.75

unknown artist
Battle of Sole Bay, 1672
oil on papier mâché 39
ALUMT.942

Beccles and
District Museum

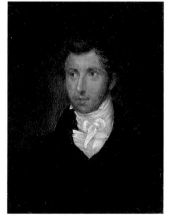

Arnold, Joseph 1782–1819
Joseph Arnold, MD of Beccles early 1800s
oil on board 10 x 8
BLS.BM1984.263

unknown artist
The Falcon Inn Yard, Beccles c.1940
oil on card 28 x 40
BLS.BM2005.40

Wilkinson, H.
Puddingmoor, Beccles 1913
oil on canvas 52 x 35
BLS.BM1996.196

Bungay Museum

unknown artist
Bungay Castle c.1800
oil on canvas 78 x 117
TP.01

unknown artist
The Thatched House, Flixton Road c.1800
oil on copper 34 x 38
1984.172

unknown artist
Holy Trinity Church, South Side,
Bungay c.1850
oil on canvas 30.5 x 35.8
1984.285

Bury St Edmunds Record Office

Cotman, Frederick George (attributed to)
1850–1920
Edward Greene, MP (1815–1891)
oil on canvas 125 x 100 (E)
03

unknown artist
Arthur Young of Bradfield Combust (1741–1820) late 1700s
oil on canvas 75 x 62 (E)
02

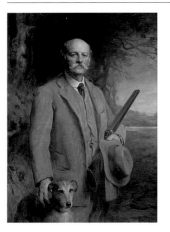

unknown artist
Sir Walter Greene, Bt 1916
oil on canvas 125 x 94 (E)
01

St Edmundsbury Museums

The Borough of St Edmundsbury holds a number of important collections of oil paintings. These, with relatively few exceptions, were acquired during the 20th century, generally in the form of bequests. It is only within the last 20 years that the Borough has actively sought to acquire paintings which reflect the historical and topographical interest of West Suffolk. The majority of the collections are displayed at the Manor House Museum; this was established in 1993 to provide a home for the Borough's fine and decorative art collections. The building dates from 1734 and provides an impressive setting for the historic portraits which constitute the greater part of the collections. It was built by John Hervey, the first Earl of Bristol, and appropriately houses a number of Hervey family portraits including an important portrait by Joshua Reynolds of the 3rd Earl, Augustus Hervey, depicted against the backdrop of his most successful naval action in the West Indies.

The largest and most important single collection is that which contains the Cullum family portraits, bequeathed to the Borough in 1921 by the last surviving member of the Cullum family. Rising to prominence in the 17th century for services to the Royalist cause, the Cullums settled at Hawstead and Hardwick Hall near Bury St Edmunds. Family portraits dating from the mid-17th century through to c.1900 form the core of the collection. These are of variable quality, but include fine works by Lely, Angelica Kauffmann, and Tissot. The latter, a portrait of Sydney Isabella Milner-Gibson, provides an excellent example of Tissot's work with female sitters. It was executed in 1872 during the artist's residence in London.

The Manor House also holds the largest and most significant collection of work by Britain's first professional woman artist. Mary Beale (1633–1699) was born and grew up at Barrow near Bury St Edmunds. Subsequently moving to London she received advice and support from Peter Lely, among others, and rapidly established herself as a professional portrait painter able to command a substantial income. Neglected for much of the last three centuries, her work has attracted increasing attention during the last 30 years. It is notable for its understated and sensitive treatment of subjects, best seen in portraits of the artist's own family and circle. These include three fine self portraits and five portraits of her husband Charles. The Museum's collection, founded on a bequest from Richard Jeffree to the National Art Collections Fund for display at the Manor House, also includes portraits acquired with support from the Heritage Lottery Fund and the V&A Purchase Fund.

The work of a more recent female artist, Rose Mead (1867–1946), is also extensively represented in the Borough's collections. Although trained in London and Paris she, unlike Mary Beale, never made the transition to a wider stage, preferring to remain in Bury St Edmunds where she produced numerous works based on the location and its inhabitants. Her work is variable in quality but seen at its best, as in the outstanding portrait of Barbara Stone, gives the sitter a forceful presence and immediacy. Her work in oils also includes several still life flower paintings though these are generally less successful than the portraits. As in the case of Mary Beale, the best qualities of the artist's work emerge in the portraits of her immediate circle, again including a couple of strong self portraits.

St Edmundsbury Museums' collections also include a number of local landscape and topographical paintings. Although less well represented than the category of historic portraits, there are nonetheless several striking pictures whose interest depends as much on their local and social historic significance as it does on their artistic merit. A group of four oil on panel paintings depicts aspects of Bury St Edmunds as it appeared c.1700, including notable representations of the old Cross and Beast Market. These are displayed at Moyse's Hall. There is also a naïve, unattributed, but exceptionally vivid painting showing the opening of the railway line from Ipswich to Bury in 1846 as well as a companion piece showing the mode of transport which it supplanted, *Bury Coach Arriving at the Great White Horse Inn, Ipswich*.

In addition to these collections a small group of 16th and early 17th century portraits is housed in the Guildhall. The most significant of these is a full length portrait of James I commissioned by the Guildhall feoffees.

Keith Cunliffe, Collections Care and Public Access Officer

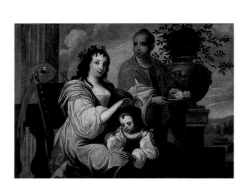

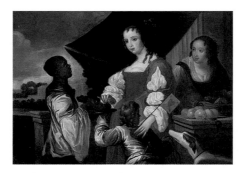

Anglo/Flemish School
Elizabeth Risby with Elizabeth c.1660
oil on canvas 81 x 115
1992.9.333

Anglo/Flemish School
Elizabeth Risby with John c.1660
oil on canvas 81 x 115
1992.9.332

Anglo/Flemish School
East Prospect of Bury St Edmunds c.1690
oil on panel 60 x 220 (E)
1992.9.296

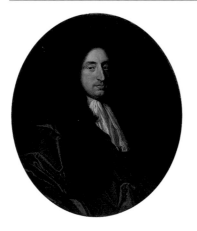

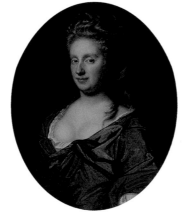

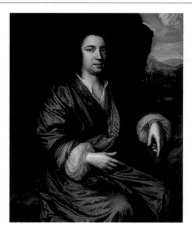

Beale, Charles 1660–c.1714
Bartholomew Beale 1693
oil on canvas 74 x 60
1993.38

Beale, Charles 1660–c.1714
Elizabeth Beale 1693
oil on canvas 74 x 60
1993.39

Beale, Mary 1633–1699
Charles Beale c.1666
oil on canvas 110 x 87
1992.13

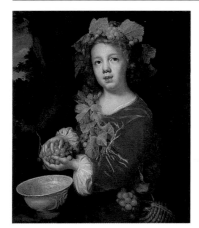

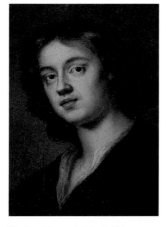

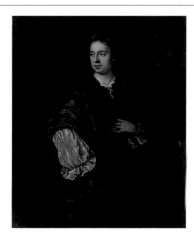

Beale, Mary 1633–1699
A Child as Bacchus c.1675
oil on canvas 65 x 56
1993.45

Beale, Mary 1633–1699
Charles Beale c.1675
oil on canvas 46 x 33
1993.34

Beale, Mary 1633–1699
Charles Beale c.1675
oil on canvas 45.7 x 38.1
1993.36

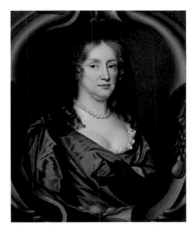

Beale, Mary 1633–1699
Gilbert Burnett, DD c.1675
oil on canvas 64 x 54 (E)
1993.37

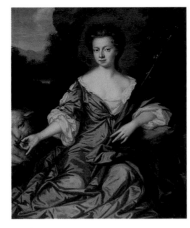

Beale, Mary 1633–1699
Jane Fox as a Shepherdess c.1675
oil on canvas 57 x 47
1993.33

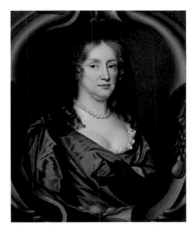

Beale, Mary 1633–1699
Jane, Lady Twisden c.1675
oil on canvas 72 x 60
1993.41

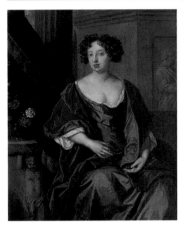

Beale, Mary 1633–1699
Lady Essex Finch c.1675
oil on canvas 45 x 37
1993.31

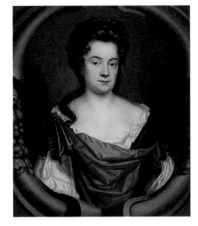

Beale, Mary 1633–1699
Lady Norwich c.1675
oil on canvas 74 x 61
1993.42

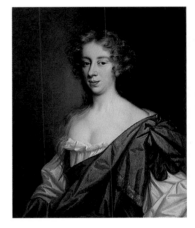

Beale, Mary 1633–1699
Margaret Twisden, Lady Style c.1675
oil on canvas 76 x 64
1993.44

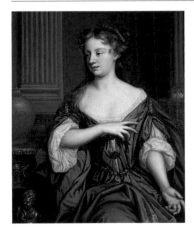

Beale, Mary 1633–1699
Self Portrait c.1675
oil on sacking 89 x 73
1992.9.624

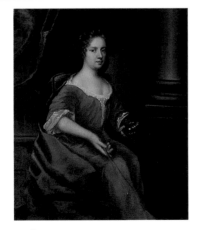

Beale, Mary 1633–1699
Self Portrait c.1675
oil on canvas 45.7 x 38.1
1993.35

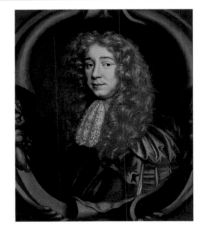

Beale, Mary 1633–1699
The Earl of Coventry c.1675
oil on canvas 74 x 61
1993.40

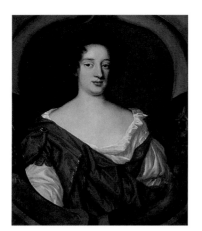

Beale, Mary 1633–1699
The Marchioness of Tweedale c.1675
oil on canvas 73 x 61
1993.46

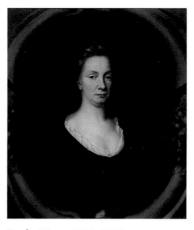

Beale, Mary 1633–1699
Unknown Widow c.1675
oil on canvas 75 x 63
1993.43

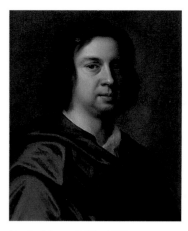

Beale, Mary 1633–1699
Charles Beale c.1680
oil on canvas 50 x 42 (E)
1993.32

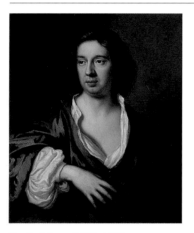

Beale, Mary 1633–1699
Charles Beale c.1680
oil on bed ticking 74 x 61 (E)
1997.40.1

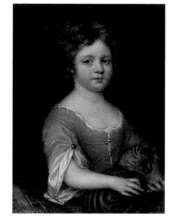

Beale, Mary 1633–1699
Girl with a Cat c.1680
oil on vellum 14 x 9
1997.40.4

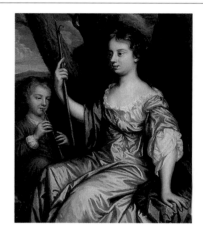

Beale, Mary 1633–1699
Self Portrait of the Artist as a Shepherdess
c.1680
oil on canvas 55 x 47 (E)
1997.40.3

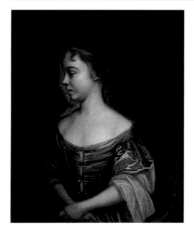

Beale, Mary 1633–1699
Young Girl in Profile c.1680
oil on canvas 73 x 62
1997.40.2

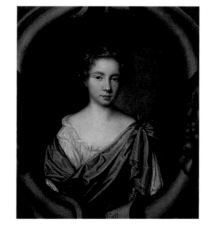

Beale, Mary 1633–1699
Lady Sarah Hall
oil on canvas 72 x 61 (E)
1992.9.389

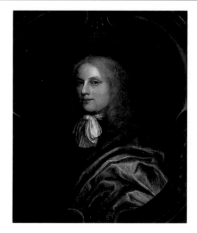

Beale, Mary (attributed to) 1633–1699
*Thomas Cullum, Younger Brother of Sir
Dudley Cullum, Bt*
oil on canvas 73 x 60 (E)
1992.9.345

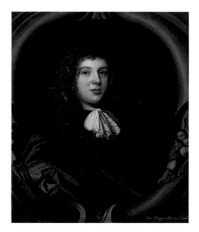

Beale, Mary (circle of) 1633–1699
Sir Roger Martin, Bt c.1650
oil on canvas 73 x 62
1992.9.388

Blundell, Alfred Richard 1883–1968
Snow Scene 1940
oil on canvas 59 x 44
1995.53.2

Blundell, Alfred Richard 1883–1968
River at Cavenham 1949
oil on canvas 49 x 60
1992.9.374

Bowring, G.
Eastgate Bridge, Bury St Edmunds, Suffolk
c.1800
oil on canvas 34 x 45
1992.9.368

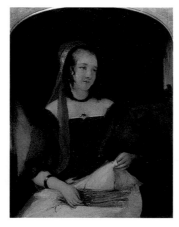

Boxall, William 1800–1879
Mrs Milner Gibson 1840
oil on canvas 45 x 35
1992.9.363

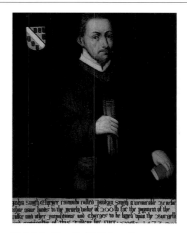

British (English) School
Jankyn Smith c.1550
oil on canvas 87 x 67 (E)
1992.9.482

British (English) School
Thomas Bright c.1550
oil on canvas 85 x 69 (E)
1992.9.484

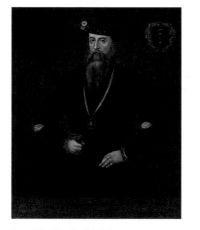

British (English) School
Edmund Jermyn of Rushbrooke c.1580
oil on canvas 122 x 100 (E)
1992.9.473

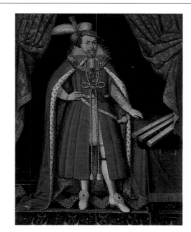

British (English) School
James I in His State Clothes 1610
oil on canvas 228 x 184 (E)
1992.9.472

British (English) School
Portrait of a Gentleman Wearing a Black Coat
c.1620
oil on canvas 74 x 64 (E)
1992.9.470

British (English) School
Portrait of a Man Holding a Staff c.1620
oil on canvas 111 x 84 (E)
1992.9.483

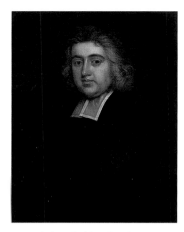

British (English) School
John Sutton c.1650
oil on canvas 74 x 61 (E)
1992.9.480

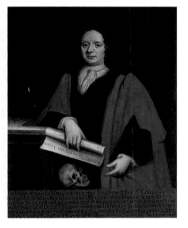

British (English) School
Jacob Johnson c.1670
oil on canvas 124 x 100 (E)
1992.9.471

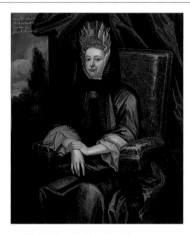

British (English) School
Anne Cullum, Wife of John Cullum, Draper
c.1690
oil on canvas 123 x 100
1992.9.343

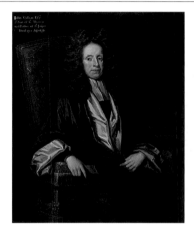

British (English) School
John Cullum c.1690
oil on canvas 127 x 99
1992.9.342

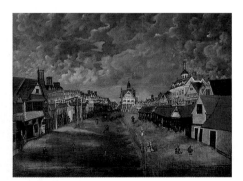

British (English) School
Market Square c.1700 c.1700
oil on panel 99 x 132
1992.9.298

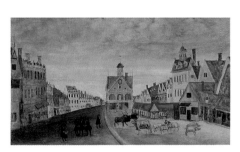

British (English) School
Market Square with Beasts, c.1700 c.1700
oil on panel 87 x 144
1992.9.299

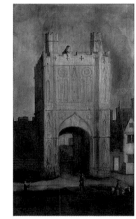

British (English) School
The Abbey Gate c.1700
oil on panel 124 x 73
1995.25

Facing page: Cufaude, Francis, active 1745–1749, *The Gosnall Twins* (detail), 1749, Ipswich Borough Council
Museums and Galleries, (p. 81)

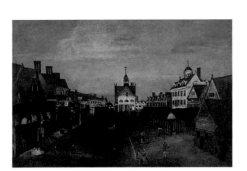

British (English) School
The Beast Market c.1700
oil on panel 103 x 156
1978.292

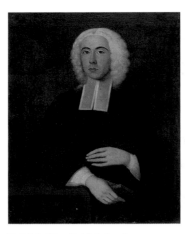

British (English) School
Reverend William Adamson 1735
oil on canvas 89 x 72
1993.70.6

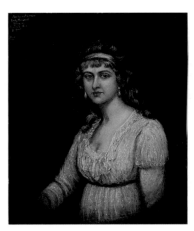

British (English) School
Arethusa, Lady Harland c.1790
oil on canvas 77 x 64
1992.9.361

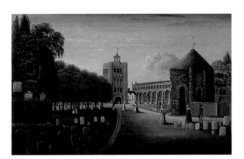

British (English) School
Churchyard Looking towards the Norman Tower 1820
oil on canvas 56 x 87
1992.9.410

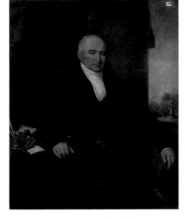

British (English) School
Orbell Ray Oakes c.1825
oil on canvas 126 x 101
1993.70.1

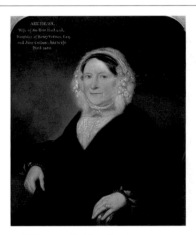

British (English) School
Arethusa, Lady Harland c.1830
oil on canvas 74 x 62
1992.9.360

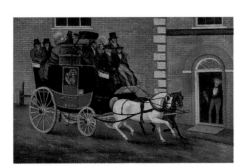

British (English) School
Bury Coach Arriving at the Great White Horse Inn, Ipswich c.1835
oil on canvas 60 x 90 (E)
1988.117

British (English) School
James Henry Oakes c.1840
oil on canvas 93 x 70
1993.70.3

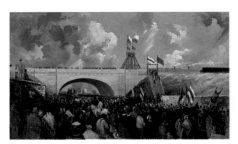

British (English) School
Opening of the Railway from Ipswich to Bury St Edmunds, 1846 1846
oil on canvas 54 x 96
1992.9.409

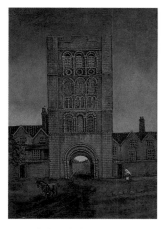

British (English) School
The Norman Tower c.1850
oil on canvas 35 x 24
1992.9.498

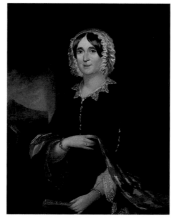

British (English) School
Mrs Henry James Oakes 1854
oil on canvas 89 x 68
1993.70.5

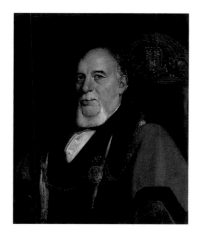

British (English) School
Thomas Ridley, Mayor of Bury St Edmunds,
1878 & 1882 c.1880
oil on canvas 75 x 62
1992.9.428

Campbell, Peter 1931–1989
Church in Suffolk c.1985
oil on canvas 78 x 65
1992.9.559

Campbell, Peter 1931–1989
The Way through the Woods c.1985
oil on canvas 54 x 39
1992.9.564

Cavalleri, Ferdinando 1794–1865
Sir Thomas Gery Cullum, 8th Bt 1824
oil on canvas 92 x 67
1992.9.357

Closterman, John 1660–1711
Portrait of a Gentleman Wearing Red
oil on canvas 71 x 60
1992.9.474

Dahl, Michael I 1656/1659–1743
Jane, Wife of Sir John Cullum 1729
oil on canvas 74 x 62
1992.9.347

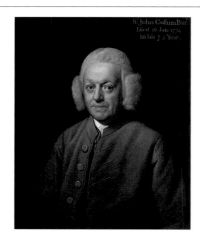

Dance-Holland, Nathaniel 1735–1811
Sir John Cullum, 5th Bt
oil on canvas 75 x 62
1992.9.346

De Suet, A.
Lackford Quarry 1981
oil on canvas 41 x 59
1992.9.369

Des Roches, Michel
Windmill 1970
oil on canvas 59 x 75
BRO.001

Durrant, Roy Turner 1925–1998
View of the River, Winter Morning 1944
oil on canvas 24 x 35 (E)
1999.80.17

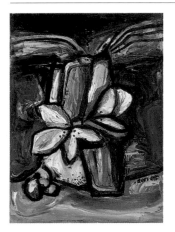

Durrant, Roy Turner 1925–1998
Blossoms in a Landscape 1950
oil on canvas 38 x 28
1999.80.19

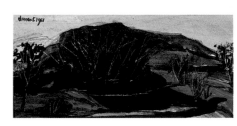

Durrant, Roy Turner 1925–1998
Red Landscape 1951
acrylic, oil & crayon on board 9.5 x 20.2
1999.80.152

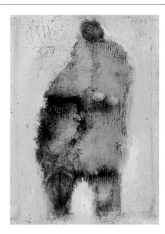

Durrant, Roy Turner 1925–1998
Female Nude in Grey 1957
acrylic, ink & oil on board 25 x 18
1999.80.34

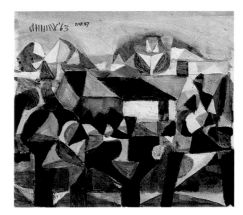

Durrant, Roy Turner 1925–1998
Geometric Landscape in Black, Brown, Blue and Pink 1963
acrylic on canvas 25 x 28
1999.80.36

Durrant, Roy Turner 1925–1998
Field Woman, Groton Wood 1982
acrylic on canvas 28 x 40
1999.80.7

Durrant, Roy Turner 1925–1998
Female Nude 1984
acrylic on cardboard 51 x 54
1999.80.16

Durrant, Roy Turner 1925–1998
Composition with Head of Woman (for Lo)
1995
acrylic & pencil on card 38 x 30
1999.80.1

Durrant, Roy Turner 1925–1998
Geometric Landscape in Black, Brown, Blue and Purple
acrylic on canvas 26 x 33
1999.80.44

Durrant, Roy Turner 1925–1998
Head, Black on Blue
acrylic & oil on card 46 x 35
1999.80.120

Durrant, Roy Turner 1925–1998
Snow Rhapsody
acrylic & oil on canvas 75 x 49
1999.80.SR

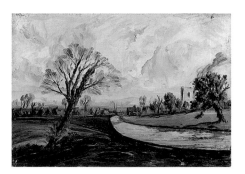

Durrant, Roy Turner 1925–1998
The Road
oil on canvas 26 x 36
1999.80.18

Durrant, Roy Turner 1925–1998
Urban Landscape and Moon
acrylic & oil on canvas 14 x 27
1999.80.42

Durrant, Roy Turner 1925–1998
Woman
mixed media on card 46 x 28
1999.80.4

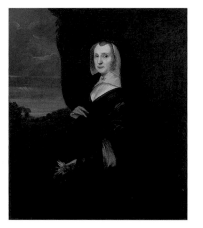

Dyck, Anthony van (follower of) 1599–1641
Lady Penelope Hervey c.1700
oil on canvas 127 x 101.5
1992.9.391

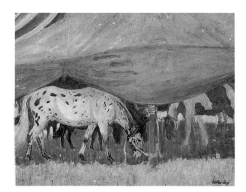

Farley, Charles William 1893–1982
Two Tethered Horses Grazing underneath a Tent c.1920
oil on canvas 30 x 39
1992.9.587

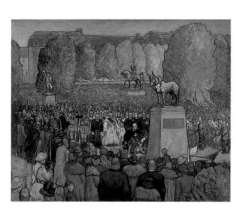

Farley, Charles William 1893–1982
Homage to the Unknown Mule c.1930
oil on canvas 62 x 75
1992.148

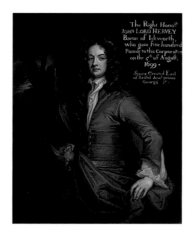

Fayram, John active 1713–1743
John, 1st Earl of Bristol (after Godfrey Kneller)
c.1715
oil on canvas 123 x 100
1992.9.476

Forbes, Charles Stuart 1860–1926
George Gery Milner-Gibson Cullum 1885
oil on canvas 72 x 49
1992.9.364

Fox, B.
Still Life with Fruit 1876
oil on canvas 30 x 35
1992.9.367.1

Fox, B.
Still Life with Fruit 1876
oil on canvas 30 x 35
1992.9.367.2

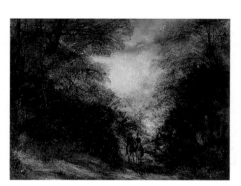

Fox, R. E.
Lord Arthur Hervey and His Daughter Mrs Sanford, Riding 1840
oil on canvas 45 x 61 (E)
1992.9.427

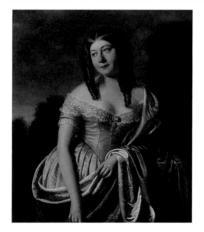

Gambardella, Spiridione c.1815–1886
Susanna Arethusa Cullum 1850
oil on canvas 29 x 24
1992.9.362

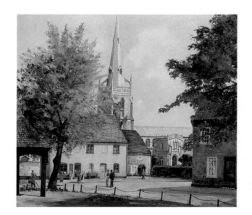

Graham, Kenneth
St Mary's, Woolpit c.1980
oil on canvas 39 x 44
1994.35

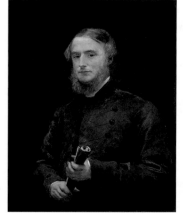

Graves, Henry Richard 1818–1882
Lord Arthur Hervey 1871
oil on canvas 89.5 x 69 (E)
1992.9.411

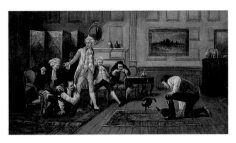

Harding, J.
A Cock Fight 1850?
oil on canvas 59 x 105
1992.9.408

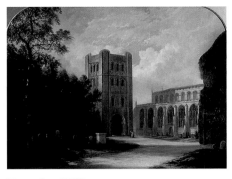

Harraden, William
Norman Tower from the Churchyard c.1840
oil on canvas 90 x 120
1992.9.399

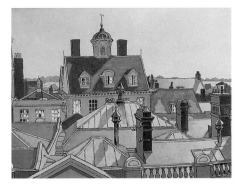

Harrap, Phyllis
Cupola House c.1946
oil on canvas 35 x 44
1994.31.1

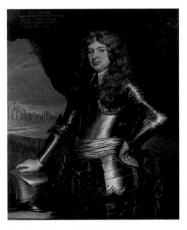

Hayls, John 1600–1679
Colonel John Strode c.1679
oil on canvas 124 x 100 (E)
1992.9.338

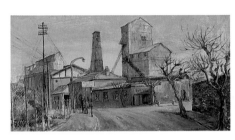

Heasman, Vera
Gasworks, Tayfen Road 1963
oil on canvas 45 x 84
1993.17

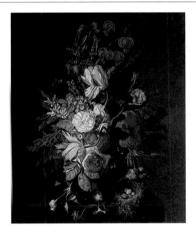

Huysum, Jan van (follower of) 1682–1749
Flowers and Nest with Eggs 1720
oil on canvas 74 x 62
1992.9.407

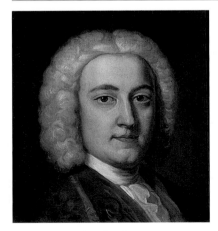

Hysing, Hans (circle of) 1678–1753
John Rix of Thrandeston c.1740
oil on canvas 36 x 32
1992.9.400

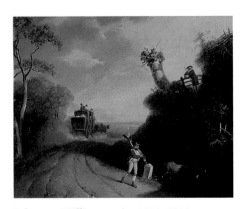

Johnson, William active 1780–1810
The Soldier Returning c.1810
oil on canvas 33 x 42
1992.9.293

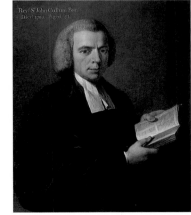

Kauffmann, Angelica 1741–1807
Reverend Sir John Cullum, 6th Bt 1778
oil on canvas 75 x 62
1992.9.349

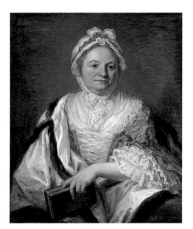

Kauffmann, Angelica 1741–1807
Susanna, Lady Cullum c.1780
oil on canvas 75 x 61
1992.9.348

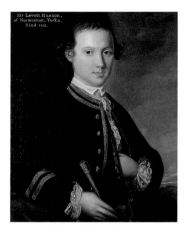

Kettle, Tilly (circle of) 1735–1786
Sir Levett Hanson 1770
oil on canvas 61 x 49
1992.9.353

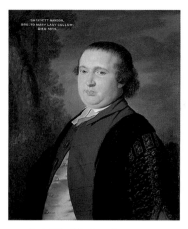

Kettle, Tilly (circle of) 1735–1786
Sir Levett Hanson, Kt
oil on canvas 74 x 61
1992.9.354

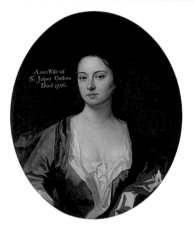

Kneller, Godfrey 1646–1723
Anne, Lady Cullum c.1700
oil on canvas 72 x 60
1992.9.344

Ladbrooke, Frederick 1812–1865
Frederick William, 1st Marquis of Bristol
c.1837
oil on canvas 137 x 109
1992.9.477

Ladbrooke, Frederick 1812–1865
Frederick William, 1st Marquis of Bristol (after Francis Grant) c.1837
oil on canvas 140 x 109
1994.90

Lawrence, Thomas (follower of) 1769–1830
Right Reverend C. J. Blomfield, DD
oil on canvas 140 x 110
1992.9.412

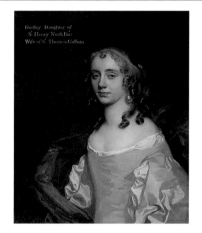

Lely, Peter 1618–1680
Dudley, Lady Cullum c.1670
oil on canvas 74 x 62
1992.9.337

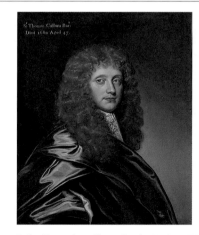

Lely, Peter (attributed to) 1618–1680
Sir Thomas Cullum, 2nd Bt c.1680
oil on canvas 75 x 62
1992.9.336

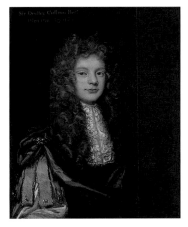

Lely, Peter (follower of) 1618–1680
Sir Dudley Cullum, 3rd Bt
oil on canvas 72 x 59
1992.9.339

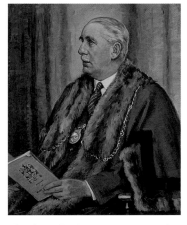

Lloyd, Katherine Constance active 1920–1974
Edward Lancelot Dewe Lake 1946
oil on canvas 89 x 74
1992.9.375

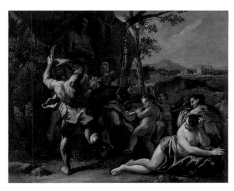

Matteis, Paolo de' (attributed to) 1662–1728
Nymphs and Satyrs c.1690
oil on canvas 44 x 59
1992.9.455

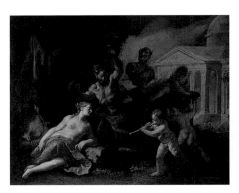

Matteis, Paolo de' (attributed to) 1662–1728
Pan and Nymphs c.1690
oil on canvas 44 x 58
1992.9.456

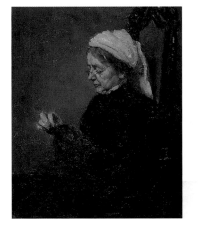

Mead, Rose 1867–1946
Archdeacon Hodges c.1907
oil on canvas 265 x 176 (E)
1995.57

Mead, Rose 1867–1946
Arthur Mead, Reading c.1910
oil on canvas 30 x 24
1992.9.618

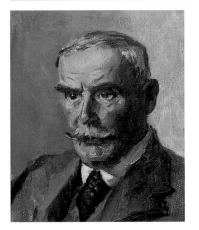

Mead, Rose 1867–1946
Frank Mead c.1910
oil on canvas 24 x 19
1992.9.619

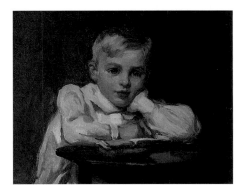

Mead, Rose 1867–1946
Mrs Mead Darning Socks c.1910
oil on canvas 29 x 23
1992.9.620

Mead, Rose 1867–1946
Reginald Mead c.1910
oil on canvas 45 x 53.7
1992.9.610

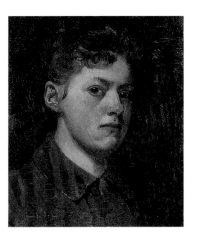

Mead, Rose 1867–1946
Self Portrait c.1910
oil on canvas 22 x 17
1992.9.617

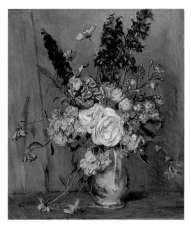

Mead, Rose 1867–1946
A Jug of Summer Flowers c.1920
oil on canvas 59 x 49
1992.9.609

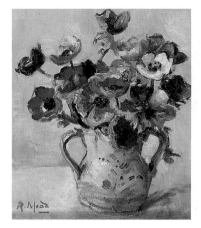

Mead, Rose 1867–1946
Anemones in a Flowered Vase c.1930
oil on board 31 x 26
1997.38.27

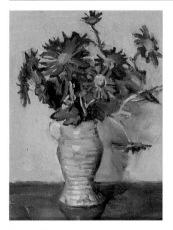

Mead, Rose 1867–1946
Asters in a Green Vase c.1930
oil on canvas 35 x 25
1997.38.32

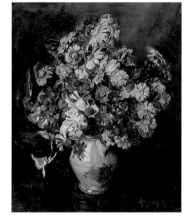

Mead, Rose 1867–1946
Autumn Flowers in Flowered China Jug
c.1930
oil on canvas 49 x 39
1992.9.580

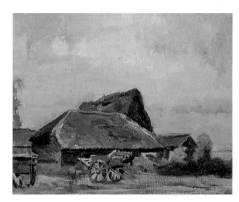

Mead, Rose 1867–1946
Cart with Barns c.1930
oil on board 23 x 28
1997.38.37

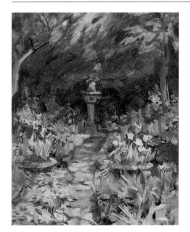

Mead, Rose 1867–1946
Garden Path with Urns and Statues c.1930
oil on wooden board 36 x 27
1997.38.35

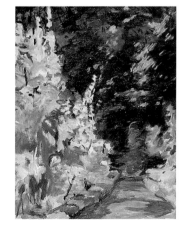

Mead, Rose 1867–1946
Garden with Hollyhocks c.1930
oil on board 36 x 26
1997.38.38

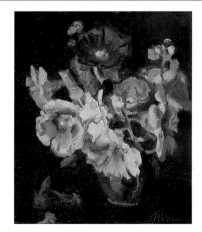

Mead, Rose 1867–1946
Hollyhocks in a Brown Jug c.1930
oil on canvas 29 x 24
1997.38.28

Facing page: Roe, Fred, 1864–1947, *4th Suffolks at Neuve Chapelle* (detail), 1918, Ipswich Borough Council
Museums and Galleries, (p. 130)

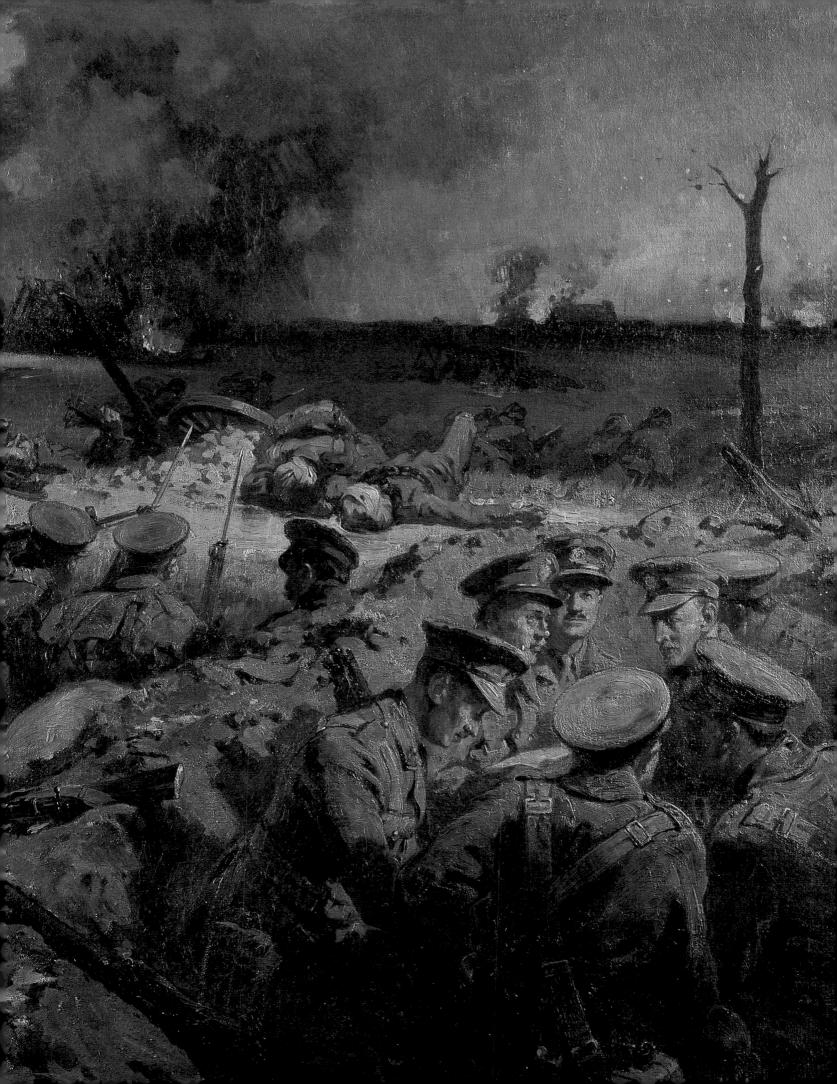

Mead, Rose 1867–1946
Mountainous Landscape and Stone Buildings
c.1930
oil on board 23 x 33
1997.38.39

Mead, Rose 1867–1946
Mrs John Greene, Mayor c.1930
oil on canvas 87 x 68
1992.9.450

Mead, Rose 1867–1946
Nasturtiums c.1930
oil on canvas 29 x 24
1992.9.573

Mead, Rose 1867–1946
Path and Trees c.1930
oil on wooden board 26 x 34
1997.38.31

Mead, Rose 1867–1946
Red Geraniums in a Pewter Mug c.1930
oil on wooden board 36 x 27
1997.38.34

Mead, Rose 1867–1946
River Scene with Trees c.1930
oil on canvas 24 x 30
1997.38.36

Mead, Rose 1867–1946
Sea View from a Hill, South of France c.1930
oil on canvas 48 x 48
1997.38.40.1

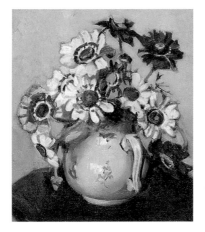

Mead, Rose 1867–1946
Summer Chrysanthemums in a Blue-Flowered Jug c.1930
oil on board 30 x 25
1997.38.30

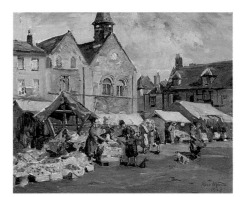

Mead, Rose 1867–1946
The Buttermarket, Bury St Edmunds c.1930
oil on canvas 37 x 46
1992.28

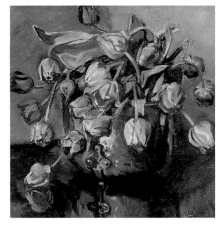

Mead, Rose 1867–1946
Tulips c.1930
oil on canvas 45 x 44.4
1997.38.40.2

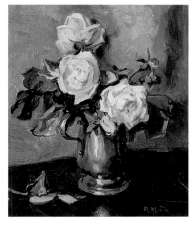

Mead, Rose 1867–1946
White Roses in a Pewter Mug c.1930
oil on board 30 x 25
1997.38.29

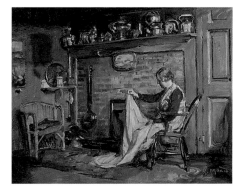

Mead, Rose 1867–1946
Interior of Athenaeum Kitchen 1933
oil on canvas 40 x 50
1995.71.1

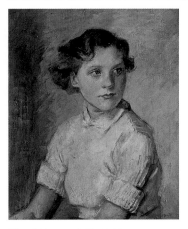

Mead, Rose 1867–1946
The Outdoor Girl c.1933
oil on canvas 60 x 50
1996.59

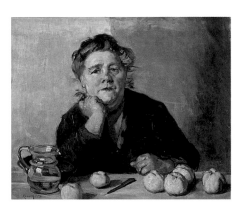

Mead, Rose 1867–1946
Barbara Stone c.1940
oil on canvas 64 x 76 (E)
1992.9.395

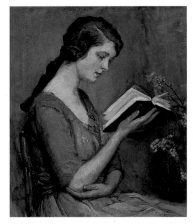

Mead, Rose 1867–1946
Molly Reading a Book c.1940
oil on canvas 74 x 62
1992.9.394

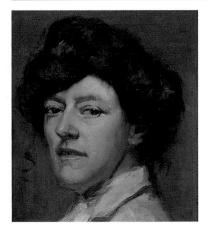

Mead, Rose 1867–1946
Self Portrait
oil on canvas 34 x 29
1992.9.616

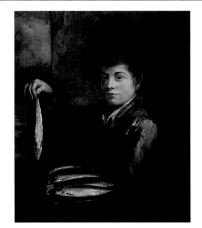

Mendham, Robert 1792–1875
Boy with Fish 1822
oil on canvas 74 x 62
1992.9.406

Moore, John of Ipswich 1820–1902
Sailing Boats at Sea
oil on canvas 26.5 x 34.5
1992.9.300

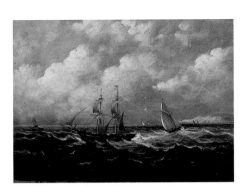

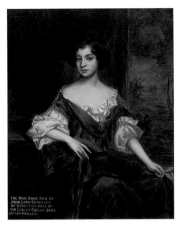

Moore, John of Ipswich 1820–1902
Sailing Boats at Sea
oil on canvas 26.5 x 34.6
1992.9.301

Munro, Olive
Anne, Lady Cullum (after Godfrey Kneller)
c.1690
oil on canvas 72 x 60
1992.9.340

Parker, William active 1730–1735
James Reynolds, Lord Chief Baron of the Exchequer c.1735
oil on canvas 240 x 144 (E)
1992.9.478

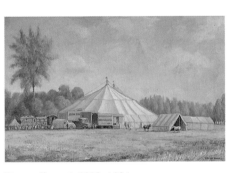

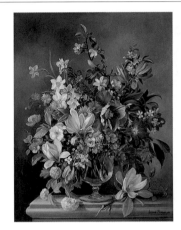

Patania, G.
Reverend Sir Thomas Gery Cullum 1839
oil on canvas 64 x 50
1992.9.358

Payne, Ernest 1903–1994
Lord John Sanger's Circus on Holywell Meadow
c.1930
oil on canvas 48 x 76
1992.43

Payne, Ernest 1903–1994
Vase of Spring Flowers 1963
oil on canvas 90 x 69
1992.147

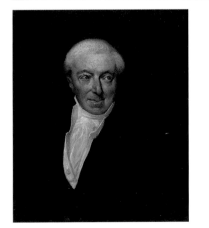

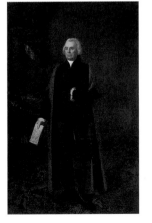

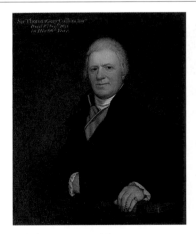

Pickersgill, Henry William 1782–1875
Portrait of a Gentleman 1850
oil on canvas 63 x 52
1992.9.403

Ralph, George Keith 1752–c.1811
Alderman John Spink c.1790
oil on canvas 234 x 147 (E)
1992.9.475

Ralph, George Keith 1752–c.1811
Sir Thomas Gery Cullum 1800
oil on canvas 75 x 62
1992.9.350

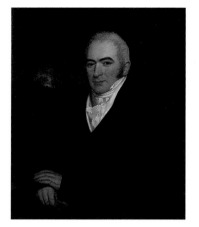

Ralph, George Keith 1752–c.1811
Orbell Ray Oakes 1807
oil on canvas 78 x 62
1993.70.2

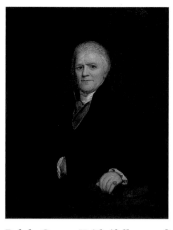

Ralph, George Keith (follower of)
1752–c.1811
Portrait of a Seated Gentleman c.1800
oil on canvas 90 x 70
1992.9.431

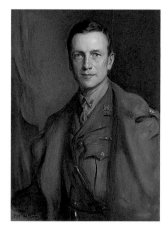

Ramos, Theodore b.1928
Lord Moyne (after Fülöp László) 1995
oil on canvas 82 x 64
1996.24 (P)

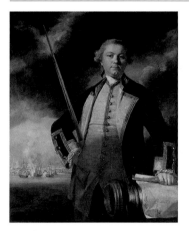

Reynolds, Joshua 1723–1792
Augustus John Hervey, 3rd Earl of Bristol
c.1770
oil on canvas 125 x 103 (E)
1992.9.390

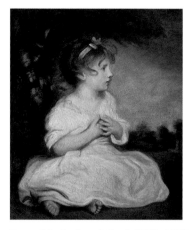

Reynolds, Joshua (after) 1723–1792
The Age of Innocence c.1850
oil on canvas 74 x 61
1992.9.404

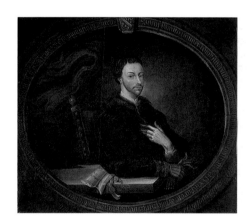

Rushbrooke, Barham active 1750
Jankyn Smith c.1750
oil on canvas 117 x 129.5 (E)
1992.9.481

H. M. S.
Portrait, Seated Gentleman 1898
oil on canvas 73 x 61
1992.9.430

Simington, Nicholas A. b.1930
Lighthouse I c.1985
oil on canvas 44 x 50
1992.9.566

Simington, Nicholas A. b.1930
Still Life with Flowers c.1985
oil on canvas 59 x 44
1992.9.560

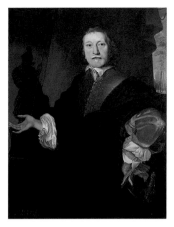

Smeyes, Jacobus
Connoisseur's Studio 1679
oil on canvas 58 x 87
1992.9.453

Smith, Charles b.1913
Stubble Burning c.1985
oil & impasto on canvas 106 x 50
1992.9.581

Smith, Herbert Luther
Sir Robert Rokewood of Coldham Hall 1660
oil on canvas 125 x 101
1992.9.405

Smythe, Edward Robert 1810–1899
Pastoral Scene with Cottage, Pond and Horse
1850
oil on canvas 46 x 64
1992.9.370

Smythe, Edward Robert 1810–1899
Pastoral Scene with Cottages and Windmill
1860
oil on canvas 49 x 67
1992.9.398

Smythe, Thomas 1825–1907
Pony and Dead Game 1860
oil on canvas 44 x 65
1992.9.457

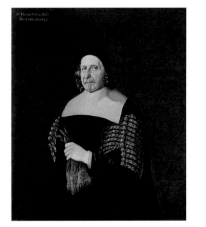

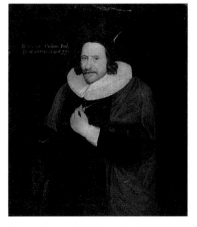

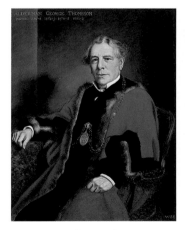

Soest, Gerard (attributed to) c.1600–1681
Sir Thomas Cullum, Bt c.1675
oil on canvas 113 x 94
1992.9.335

Soest, Gerard (circle of) c.1600–1681
Sir Thomas Cullum, 1st Bt c.1640
oil on canvas 111 x 94
1992.9.334

Spanton, William Silas 1845–1930
Alderman George Thompson 1883
oil on canvas 90 x 70 (E)
1992.9.401

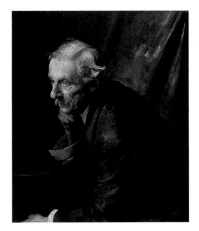

Spanton, William Silas 1845–1930
Self Portrait c.1890
oil on canvas 75 x 62
1992.9.429

Szego, Gilly
Tercentenary of Suffolk Regiment
oil on canvas 60 x 75
BO.1

Tingle, Michael b.1954
Thurlow Mill c.1980
oil on canvas 47 x 66
1994.36

Tingle, Michael b.1954 **with the assistance of
Emily and Louise Tingle, and Doris and Ted
Pearce, aged five to ten**
Bacchanal in Bury 1990
satinwood emulsion on plywood 120 x 196
1995.18

Tissot, James 1836–1902
Sydney Isabella Milner-Gibson 1872
oil on canvas 126 x 99
1992.9.366

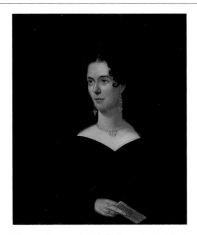

Tovey, Samuel Griffiths 1808–1873
Sarah Maddy 1832
oil on canvas 77 x 64
1992.9.402

unknown artist 16th C
The Cellarer's Window
oil on wood panel 190 x 104 (E)
1976.95

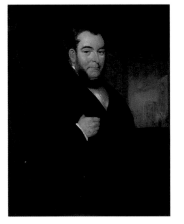

unknown artist
Henry James Oakes 1854
oil on canvas 89 x 68
1993.70.4

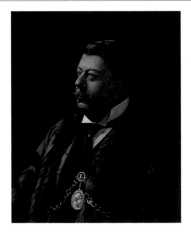

unknown artist
George Gery Milner-Gibson Cullum 1914
oil on canvas 50 x 39
1992.9.365

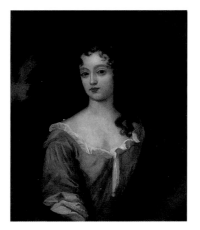

Verelst, Simon Pietersz. (follower of)
1644–probably 1721
Dionesse, Daughter of William Cullum c.1680
oil on canvas 74 x 62
1992.9.341

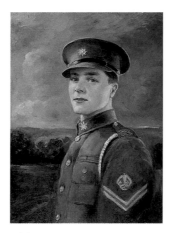

Vivian, H.
John Gershom-Parkington c.1940
oil on canvas 53 x 38
1992.9.392

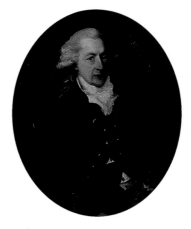

Walton, Henry 1746–1813
Rowland Holt c.1780
oil on canvas 37 x 29
1992.9.458

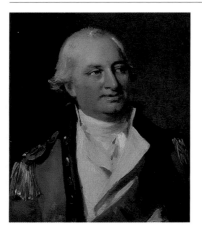

Walton, Henry 1746–1813
Charles, First Marquis Cornwallis c.1800
oil on canvas 24 x 19
1992.9.452

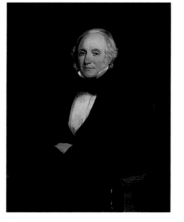

Walton, John Whitehead active 1830–1885
Reverend Sir Thomas Gery Cullum 1830
oil on canvas 95 x 74
1992.9.356

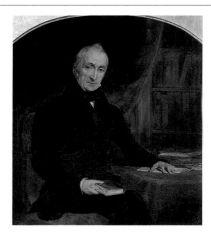

Walton, John Whitehead active 1830–1885
Frederick William Hervey 1850
oil on canvas 41 x 37
1992.9.372

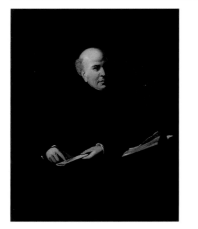

Walton, John Whitehead (attributed to)
active 1830–1885
Reverend Sir Thomas Gery Cullum c.1850
oil on canvas 126 x 102
1992.9.359

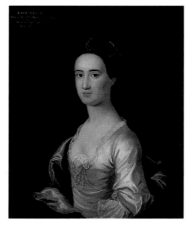

Webster, Joseph Samuel 1757–1796
Lady Cullum, Mary 1773
oil on canvas 75 x 62
1992.9.352

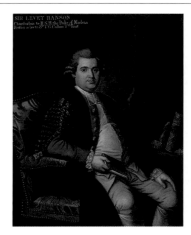

Webster, Joseph Samuel 1757–1796
Sir Levett Hanson, Kt
oil on canvas 126 x 100
1992.9.355

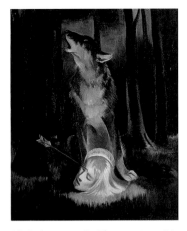

Zinkeisen, Doris Clare 1898–1991
Wolf Guarding the Head of St Edmund
oil on canvas 48 x 39
BO.2

Dunwich Museum

Blackman, E. (attributed to)
Lily Bird Lifeboat 1894
oil on board 23 x 29
DT.03

Lingwood, Edward J. active 1884–1919
All Saints' Church 1904
oil on board 30 x 40
SOWDM.1939.675A

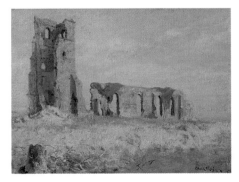

Lingwood, Edward J. active 1884–1919
All Saints' Church 1904
oil on board 30 x 40
SOWDM.1939.675B

Lingwood, Edward J. active 1884–1919
Dunwich Mount 1911
oil on board 11 x 16
DT.01

Lingwood, Edward J. active 1884–1919
Disappearance of All Saints'
oil on board 20 x 74
SOWDM.1977.674

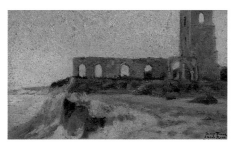

unknown artist
Dunwich 1908
oil on board 12 x 20
DT.02

Eye Town Council

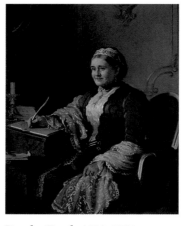

Brooks, Frank 1854–1937
Agnes Baroness Bateman (1831–1918) 1921
oil on canvas 125 x 100 (E)
TH.04

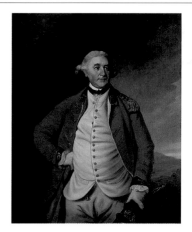

Dance-Holland, Nathaniel (attributed to)
1735–1811
Portrait of a Man in a Red Coat c.1770
oil on canvas 146 x 115 (E)
TH.03

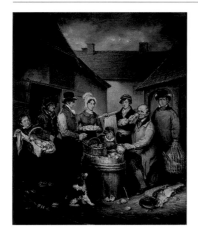

Mendham, Robert 1792–1875
Eye Worthies around the Market Cross 1827
oil on canvas 60 x 50 (E)
TH.01

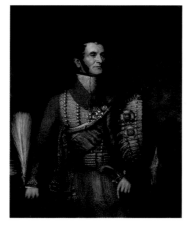

Mendham, Robert 1792–1875
*General Sir Edward Kerrison Bt, KCB, GCH
(1774–1853)*
oil on canvas 125 x 100 (E)
TH.07

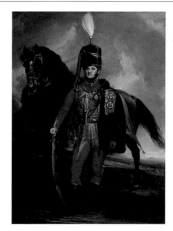

Shee, Martin Archer (attributed to)
1769–1850
*General Sir Edward Kerrison Bt, KCB, GCH
(1774–1853)*
oil on canvas 260 x 185 (E)
TH.02

Short, Mary active 1901–1940
Lady Catherine Elizabeth Tacon (1846–1927)
1901
oil on canvas 100 x 75 (E)
TH.05

Short, William 1827–1921
Charles Tacon (1833–1909), Mayor of Eye
oil on canvas 75 x 50 (E)
TH.06

Short, William 1827–1921
Samuel Peck (1812–1880), Mayor of Eye
oil on canvas 143 x 112 (E)
TH.08

Felixstowe Museum

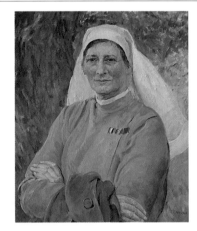

Colthorpe, Doreen
Landguard Fort, 1981 1981
oil on board 30 x 60 (E)
FX.03

Dugdale, Thomas Cantrell 1880–1952
*Caroline Amey Ruark, Matron of St Audry's
Hospital (1929–1947)*
oil on canvas 75 x 62 (E)
FX.05

Gaywood, P. 20th C
Billy Newson (1905–1988), Trinity House Pilot
oil on canvas 60 x 45 (E)
FX.02

Lewis, M.
Mary and Joseph
oil on canvas 117 x 88 (E)
FX.12

Nunn, A. L.
Walberswick, Suffolk 1880
oil on canvas 31 x 58
FX.01

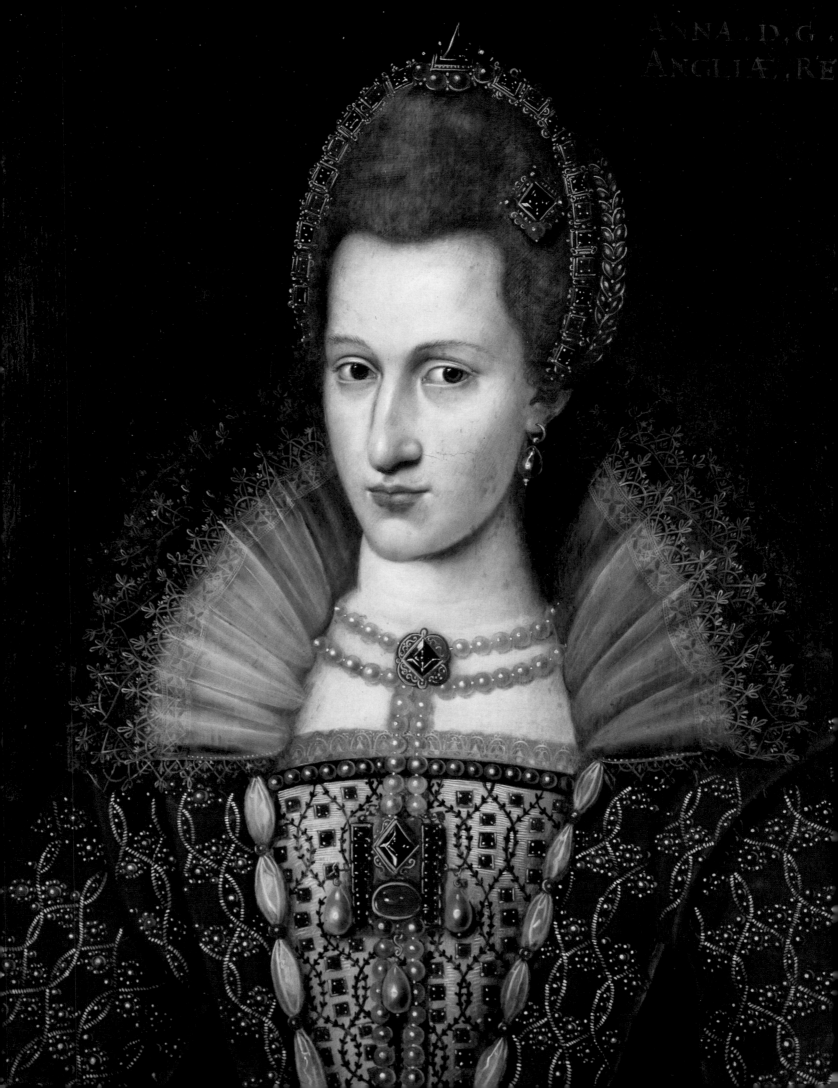

ANNA. D. G.
ANGLIÆ. RE

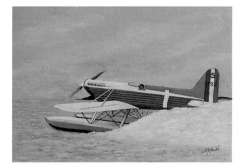

Reeve, John Constable b.1929
*Lancaster Bomber B1, LM258, HA-Q of 218
Squadron* 2000
oil on board 50 x 60
FXWFM.2001.20

Smith, Harry J. d.1983
Consolidated Catalina
oil & acrylic on board 25 x 33
FX.13

Smith, Harry J. d.1983
Supermarine Seaplane
oil & acrylic on board 25 x 33
FX.14

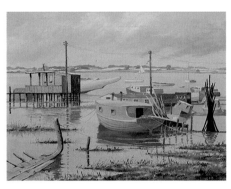

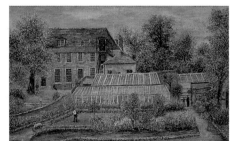

Twaite, H. E.
Felixstowe Ferry
oil on canvas 40 x 50 (E)
FX.06 (P)

unknown artist
St Audry's Hospital Chapel Entrance
oil on board 42 x 50 (E)
FX.10

unknown artist
St Audry's Hospital Garden
oil on board 77 x 116 (E)
FX.09

unknown artist
Town Scene
oil on board 39 x 51 (E)
FX.11

Watts, Alan
*Casemated Battery, Rear of Fortress,
Landguard Fort*
oil on board 53 x 65
FX.04

Facing page: Critz, John de the elder (attributed to), 1551/1552–1642, *Anne of Denmark (1574–1619)* (detail), c.1603,
Ipswich Borough Council Museums and Galleries, (p. 80)

Felixstowe Town Council

James, David 1834–1892
A North Cornish Breaker 1890
oil on canvas 61 x 127
FXWTC.2000.95

Meyer, Frederick W. active 1869–1922
Near Milford Haven, Evening 1882
oil on canvas 61 x 101.6
FXWTC.2000.96

Norfolk and Suffolk Aviation Museum

The idea for an aviation museum in the Bungay area was initially conceived by half a dozen local aviation enthusiasts, resulting in its establishment in 1972. Following coverage in the local press, the first public meeting of the Norfolk and Suffolk Aviation Society was held early the following year, attracting 25 attendees. It was not until four years later that their efforts were finally put on view to the general public. The current museum has grown considerably since its official opening in 1976 - their first premises were a Nissen hut behind the Flixton Post Office.

Besides its collection of aircraft and artefacts, the Museum houses a large collection of pictures including over 50 oil paintings. The oil paintings are mainly by amateur or semi-professional artists to illustrate an aircraft, an event or a particular set of markings.

The two largest paintings were painted for the 1968 Royal Air Force Stradishall Open Day. One is for the 50th Anniversary of the Royal Air Force (1918–1968) and features aircraft used during that period. The other painting celebrates the 30th Anniversary of Stradishall aerodrome and features aircraft based at the station.

In the hanger, a painting by John Constable Reeve shows a Super Sabre flying over Gorleston recalling when the aircraft crashed on the river bank there.

Two paintings by Geoffrey Parker, a professional artist and illustrator, show World War One dogfights.

The Norfolk and Suffolk Aviation Museum is now generally recognised as East Anglia's Aviation Heritage Centre and celebrated its 30th Anniversary in 2002. Constituting an impressive collection of aircraft and equipment, the Museum also houses the Royal Observer Corps Museum, the 446th (H) Bomb Group Museum, the RAF Bomber Command Museum and the Air Sea Rescue and Coastal Command Museum.

Huby J. Fairhead, Keeper

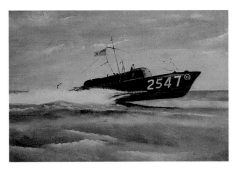

M. R. A.
The Whaleback 1977
oil on board 44 x 59
AVT.11

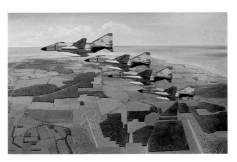

Anderson, S. G.
McDonnel F-4 Phantoms
oil on board 90 x 151
1986/230.23

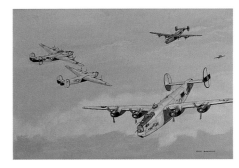

Barrington, Peter b.1928
Consolidated B-24 Liberator
oil on board 45 x 67
1986/351.3

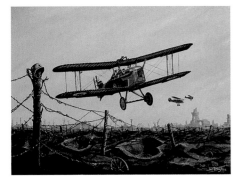

Brighton, R.
SE5 over the Front during the First World War
1975
oil on board 35 x 46
1999/18.1

Brighton, R.
Lancaster in the Far East during the Second World War 1977
oil on board 42 x 53
1999/18.2

Colson, Stan
RAF Red Arrows 1988
oil on board 40 x 49
1986/362.3

Fairhead, Huby J. b.1944
English Electric Lightning F1A
oil on board 25 x 35
1986/365.4

Fairhead, Huby J. b.1944
Gladiator
oil on board 23 x 40
AVT.04

Fairhead, Huby J. b.1944
Gloster Meteors in Formation
oil on board 25 x 35
1986/367.5

Fairhead, Huby J. b.1944
Junkers Ju87 Stuka
oil on board 22 x 30
AVT.08

Fairhead, Huby J. b.1944
Lightning Treble One
oil on board 25 x 34
AVT.07

Fairhead, Huby J. b.1944
Provost T1
oil on board 20 x 22 (E)
AVT.06

Fairhead, Huby J. b.1944
Swift, 56 Squadron
oil on board 20 x 22
AVT.05

Hammond, George
Anson Landing at RAF Rissington
oil on board 40 x 50
AVT.14

Lain, Arthur G.
Republic P-47 Thunderbolt 1975
oil on board 40 x 62
1986/351.1

Lee, Bert
Merlin, the Museum Cat
oil on card 35 x 25
AVT.01

Lee, Bert
Vulcan B2
oil on board 28 x 37
AVT.13

Parker, Geoffrey b.1930
Allied Bristol F2b Biplane, World War One
oil on board 40 x 75
1986/237.6

Parker, Geoffrey b.1930
Allied SE5 Biplanes, World War One
oil on board 47 x 79
1986/237.5

Reeve, John Constable b.1929
Handley Page HP42 1977
oil on board 40 x 50
2003/383.8

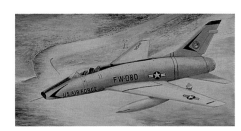

Reeve, John Constable b.1929
North American F-100 Super Sabre 2002
oil on board 122 x 244
1986/171.2

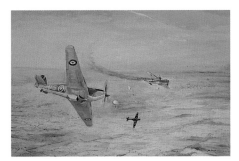

Reeve, John Constable b.1929
Air Battle over Ipswich
oil on board 75 x 122
1986/389.1

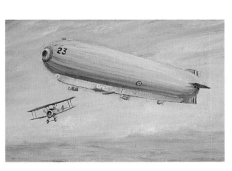

Reeve, John Constable b.1929
Airship R23 and Sopwith Camel at Pulham
oil on board 38 x 50
1986/417.3

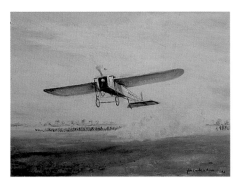

Reeve, John Constable b.1929
B. C. Hucks and His Bleriot at Gorleston
oil on board 40 x 50
1986/403.2

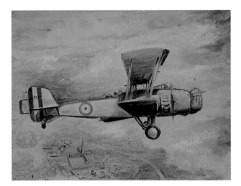

Reeve, John Constable b.1929
Boulton and Paul Overstrand
oil on board 42 x 54
1986/85.16

Reeve, John Constable b.1929
Bristol Blenheims, Take off at Wattisham
oil on board 40 x 50
1986/76.5

Reeve, John Constable b.1929
Bristol Bulldog IIA, 19 Squadron
oil on board 30 x 40
2003/16.8

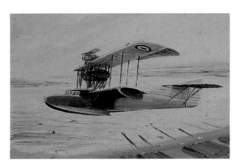

Reeve, John Constable b.1929
Bristol Scout on the Upper Wing of a Porte Baby
oil on board 41 x 45
1986/234.1

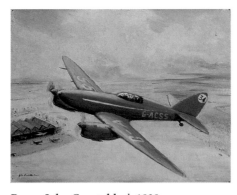

Reeve, John Constable b.1929
De Havilland Comet Racer over Mildenhall, 1935
oil on board 40 x 50
AVT.03

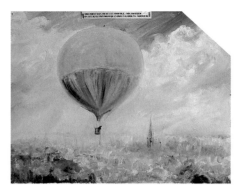

Reeve, John Constable b.1929
First Balloon Flight over Norfolk, 1785
oil on board 40 x 50
1986/403.1

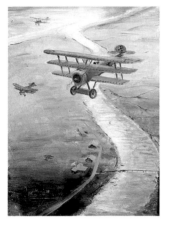

Reeve, John Constable b.1929
German Triplane over Orfordness
oil on board 43 x 32
1986/248.2

Reeve, John Constable b.1929
Handley Page V1500, Bircham Newton, 1918
oil on board 48 x 67
1986/403.8

Reeve, John Constable b.1929
Junkers Ju188
oil on board 41
1986/262.1

Reeve, John Constable b.1929
Mr Norman Spratt's Deperdussin, Southwold 1913
oil on board 40 x 50
1986/403.4

Reeve, John Constable b.1929
NE1 with Early Rockets, 1917
oil on board 40 x 50
1986/417.5

Reeve, John Constable b.1929
Norfolk and Norwich Aero Club, Mousehold Heath
oil on board 40 x 50
1986/403.7

Reeve, John Constable b.1929
Parachute Training at Martlesham
oil on board 41 x 30
1986/403.6

Reeve, John Constable b.1929
*Radio Direction Finding Station, Bawdsey
1938*
oil on board 40 x 50
1986/403.5

Reeve, John Constable b.1929
Sanders Biplane, Beccles 1909
oil on board 40 x 50
1986/403.3

Reeve, John Constable b.1929
Wing Commander Ken Wallis, MBE
oil on board 46 x 40
1986/343.1

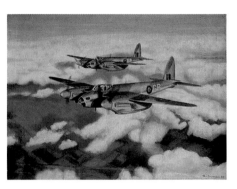

Seymour, A. J.
De Havilland Mosquitos, 105 Squadron 1943
oil on board 46 x 61
2004/331.1 (P)

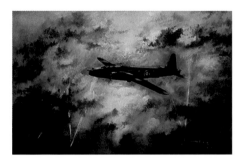

Spencer, Kenneth
Vickers Wellington 1a 1994
oil on board 52 x 75
1986/69.10

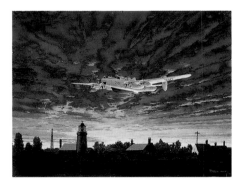

Tyson, Ken
Shackleton Mark 2 1976
oil on board 47 x 60
AVT.09

Tyson, Ken
Messerschmitt Me109
oil on board 70 x 100
1986/368.4

unknown artist
Boeing B-17 Flying Fortress
oil on board 122 x 267
1986/171.1

unknown artist
Fairchild Republic A-10 Thunderbolt II
oil on canvas 58 x 70
1986/230.8

unknown artist
RAF 1918–1968
oil on board 240 x 370
1986/168.3A

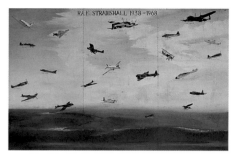

unknown artist
RAF Stradishall 1938–1968
oil on board 240 x 370
1986/168.3B

unknown artist
The Museum at Play
oil & pen on laminated board 24 x 30
AVT.12

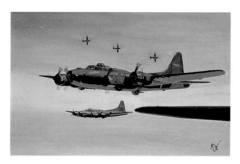

Warren, Ron
Boeing B-17 Flying Fortress Formation 1989
oil on board 35 x 54
1986/443.11

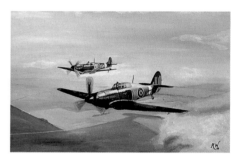

Warren, Ron
Hawker Hurricane and Supermarine Spitfire
1989
oil on board 36 x 53
1986/362.2

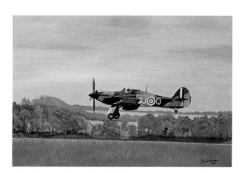

Warren, Ron
Hawker Hurricane 1990
oil on board 37 x 52
1986/362.4

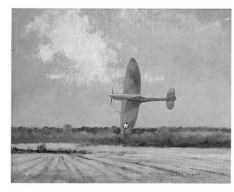

Whaley, Malcolm
Supermarine Spitfire, USAAF
oil on board 38 x 50
1986/433.10

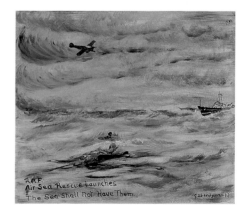

Wilyman, Geoffrey b.1917
'The Sea Shall Not Have Them'
oil on board 52 x 59
AVT.10

Lanman Museum

Scott, C.
Parham Old Hall
oil on canvas 39 x 54
1986.738

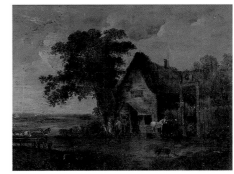

unknown artist
A Country Scene
oil on canvas 67 x 92
1986.736

unknown artist
A View up Castle Street, Framlingham
oil on canvas 29 x 52
1986.698

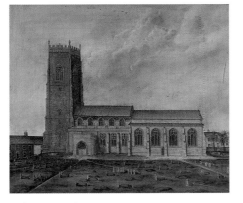

unknown artist
St Michael's Church, Framlingham
oil on canvas 52 x 60
1986.737

Halesworth and District Museum

Southgate, Anne active 1890s
Bramfield Village 1897
oil on canvas 23 x 14
HAHDM.252

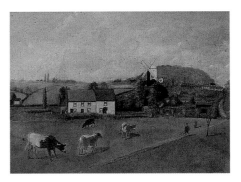

unknown artist
Rectory Street from Fenn Farm
oil on board 26 x 37
HAHDM.28

Haverhill and District Local History Centre

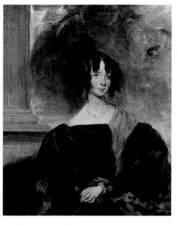

unknown artist
Celia Gurteen (1815–1838)
oil on wood panel 34 x 29
GT.02.LN (P)

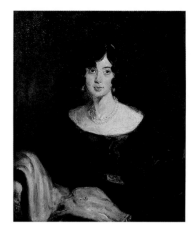

unknown artist
Clara Gurteen (b.1813)
oil on wood panel 36 x 30
GT.05.LN (P)

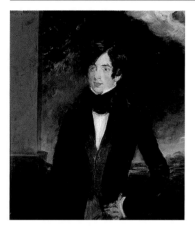

unknown artist
Daniel Gurteen (1809–1893)
oil on wood panel 34 x 29
GT.04.LN (P)

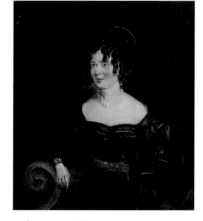

unknown artist
Sarah Gurteen (1806–1860)
oil on wood panel 34 x 29
GT.03.LN (P)

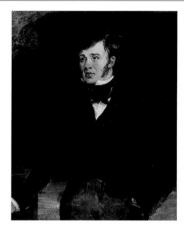

unknown artist
Stephen Gurteen (1808–1857)
oil on wood panel 34 x 29 (E)
GT.01.LN (P)

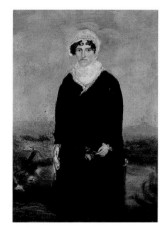

Webb, Conrade Manger 1797–1874
Alice Alfreed Webb (1777–1838)
oil on canvas 39 x 29
HC.02

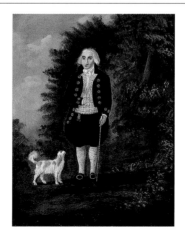

Webb, Conrade Manger 1797–1874
Barnabas Webb (1760–1846)
oil on canvas 42 x 34
HC.01

Facing page: Airy, Anna, 1882–1964, *The Kitchen's Queen* (detail), 1911, Ipswich Borough Council Museums and Galleries, (p. 49)

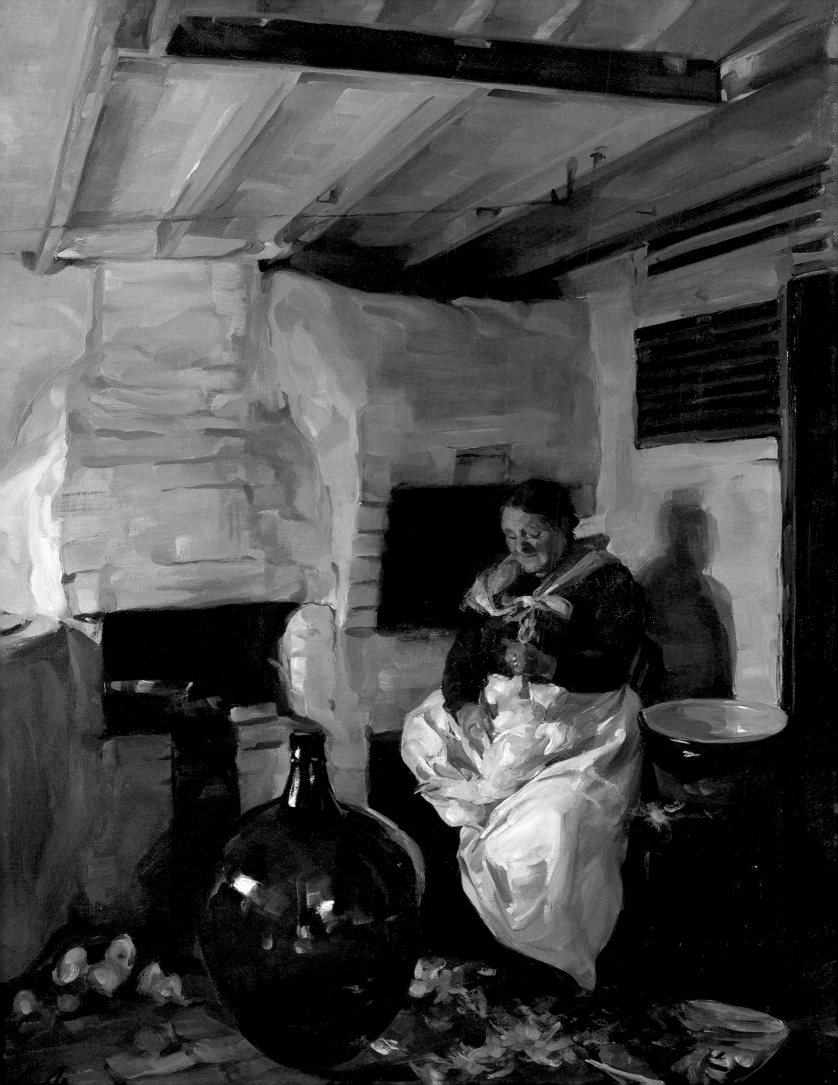

Ipswich Borough Council Museums and Galleries

The fine art collections held by Ipswich Borough Council Museums and Galleries comprise approximately 900 oil paintings, 7,025 watercolours and drawings as well as 7,000 prints and 60 sculptures representing over 2,000 artists dating from the 15th century to the present day. The collection's rich and varied contents include substantial holdings of the 'Suffolk School', Suffolk artists and groups, East Anglian artists, British, Dutch and Flemish Schools, topographical and modern and contemporary artists.

Ipswich Museum was opened as a Corporation Museum in 1881, transferring from its 1848 building in Museum Street to newly built premises in the High Street. At this time, the Museum housed predominantly a Natural History Museum and did not collect art. It was not until 1895, when Christchurch Mansion was given to the Borough of Ipswich by Felix Thornley Cobbold (a member of the local family of brewers, a banker and Mayor of Ipswich), that the town had a venue for displaying art and that pictures could be acquired. When the Mansion was presented to the town, it did not include any collections, and at its public opening in 1896 it was initially classified as an archaeological museum and picture gallery. It was not until 1931 that Ipswich Corporation built and opened the Wolsey Art Gallery, attached to the rear of Christchurch Mansion. This remains a premiere display space in East Anglia, and has been used repeatedly as a venue for temporary exhibitions. From 2006 it is planned that it will house major works from the fine art collections.

In 1906, Cobbold together with the then Mayor B. H. Burton, and Mr W. Paul, placed a sum of money at the disposal of the Museum for the purchase of paintings, watercolours and books at the sale of W. H. Booth's collection at Handford Hall. Booth had already given a number of paintings to the collection which represented pieces by local artists, as well as portraits of local notabilities.

Shortly after this, Cobbold bequeathed a trust fund to provide for the purchase of paintings, furniture and the applied arts to enable Christchurch Mansion to develop collections to create 'period' displays. It was due to his far-sighted generosity that the museum was able to buy pictures by Suffolk artists throughout the 20th century, before additional borough purchase funds were granted in 1966. Some of the earliest purchases through the bequest fund included, *Travellers* painted by a young Alfred Munnings, acquired in 1911; *A Glass of Wine with Caesar Borgia*, by John Collier and *Forging the Anchor* by Stanhope Forbes, both purchased in 1913.

Initially, no rigid policy was followed for the purchase of paintings, but the aim was the accumulation of pictures with local relevance. East Anglian country houses once held a wealth of Dutch paintings and numerous works have entered the collection as a result of country house sales. During the interwar years, a number of country houses passed out of private ownership and this enabled Ipswich Museum to acquire a wealth of artworks. In 1992 the Mussenden-Leathes family portraits from the late 17th century to the early 19th century, and numerous Dutch School artists, were acquired through donation.

The history of British landscape painting could not be written without reference to Suffolks' leading artists; Thomas Gainsborough (who lived in Ipswich from 1752 until 1759) and John Constable. Ipswich Collections'

particular strength is that the work of these two masters can be seen within the context of the English and Dutch portrait and landscape traditions that helped to form their unique visions. They can also be appreciated through the eyes of their followers and in hindsight, from later and contemporary artists portraying the East Anglian scene. There are now 15 Gainsborough and nine Constable oils in the collections.

The term 'Suffolk School' has come to mean the work of Gainsborough, Constable and later generations of landscape artists working in Suffolk who followed their example and shared similar landscape ideals. However, it was not a cohesive group of artists who worked and exhibited together. Their pictorial influences were the Dutch genre and landscape tradition, Gainsborough, Constable and John Crome of the Norwich School. The Collection has substantial holdings of works by Gainsborough, Constable, and George Frost, an enthusiastic collector and copyist of Gainsborough's pictures. Frost may also have influenced Constable with whom he went out sketching. The Ipswich group of artists who can be included in the 'Suffolk School' are; Thomas Churchyard, Edward Smythe, Thomas Smythe, Robert Burrows, Fred Brett Russel, John Moore, Henry Todd and John Duval. Duval's work *Suffolk Show in Christchurch Park* was donated in 1939.

The Ipswich Fine Art Club was founded in 1874 to 'encourage art and to excite interest in its study'. In 1887 the Club held a major exhibition, *Gainsborough, Constable and the Old Suffolk Artists*. This was the first time an attempt had been made to present Suffolk artists as a distinct group. The Cobbold Bequest Committee also purchased works exhibited by the Ipswich Art Club in their annual exhibition. Among the artists collected were Anna Airy, Bertram Priestman, Sydney Seymour Lucas, Arnesby Brown and Leonard Squirrell. In 2002 the Ipswich Art Society, as it is now known, donated its permanent collection of paintings (collected post-1981) to Ipswich Museums Service, including numerous works by local artists.

Bequests, gifts and long-term loans have formed the main source of the collections over the years. In 1947, F. J. Nettlefold gave the late Norwich School work, *The Travelling Tinker* by George Vincent. In the same year, Herbert E. West bequeathed four paintings and 19 watercolours by Philip Wilson Steer including the important English Impressionist work *Knucklebones, Walberswick*. In the 1880s an artists' colony formed at Walberswick which was lead by Steer and members of the New England Art Club. Other acquisitions such as *Whin Hill, the Common, Southwold*, by Frederick Brown were obtained with the assistance of the V&A Fund in 1976. Brown became Slade Professor in 1892. Some of the artists who studied at the Slade and who lived and worked in Suffolk represented in the collections include Anna Airy, Leonard Squirrell, Bertram Priestman, John Millar Watt, Allan Walton, Effie Spring-Smith, Claude Rogers, Elinor Bellingham-Smith and Rose Mead.

In 1859 the Ipswich School of Art was founded and trained local artists such as Frederick George Cotman, Walter Batley and William Symonds, Leonard Squirrell, Arthur Southgate and Elsie Haward among others. Colin Moss became Senior Lecturer in Painting in 1947.

Since its formation in 1903, the National Art Collections Fund have assisted Ipswich Museums Service to acquire artworks for the collection. They have helped us obtain paintings by Thomas Gainsborough, John Constable, Henry Bright, Cecil Collins, Philip Wilson Steer and Joshua Reynolds. The most notable donation was the Ernest E. Cook Bequest which added the two

important paintings to the collection by John Constable, *Golding Constable's Flower Garden* and *Golding Constable's Kitchen Garden*. Along with the Friends of Ipswich Museums, they are an important source of funding that the Service can access. Other grant bodies that have assisted with the acquisition of works are the Museums and Galleries Commission (via the Victoria & Albert Museum Grant-in-Aid Fund), the Pilgrim Trust, the Heritage Lottery Fund and the National Heritage Memorial Fund, who assisted with the acquisition of two of Gainsborough's 'fancy' landscape paintings in 1982.

In 1966 it was resolved to make an annual contribution from the general rates of Ipswich to a purchase fund for works of art. Until then the Felix Cobbold Bequest Fund had remained the only source of funding available for the purchase of artworks. The Annual Museum Service Purchase Fund, as it was called, enabled the collection to be brought up-to-date with works by contemporary artists such as *Champagne Laugh* by Maggi Hambling, which was purchased in 1996 with assistance from V&A/MGC Purchase Fund and Eastern Arts. Hambling was a student at the East Anglian School of Painting and Drawing which had been opened by Cedric Morris and Arthur Lett Haines at Dedham in 1937.

Paintings continue to be donated by local people and with the assistance of the grant aid bodies major historical and contemporary works are frequently added to the collections, such as *Holywells Park, Ipswich* by Thomas Gainsborough in 1991, a rare 'conversation piece' *Ladies of the Family of Mr Mason of Colchester* by John Constable in 2001, and *Shingle Laboratory No.3 with Lighthouse, Orford Ness* by John Wonnacott in 1997. The addition of new acquisitions continue to enable the collections to develop and expand.

Sally Dummer, Collections Manager

Adcock, Allan A. active 1915–1950
Waldringfield on the Deben c.1950
oil on canvas 35.5 x 45.5
R.1950-139

Adler, Jules 1865–1962
Boulogne 1904
oil on board 25 x 40
R.1948-124.X

Ager, F. W.
House and Winter Trees 1891
oil on panel 46.5 x 59.5
R.1988-53.32

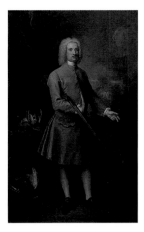

Aikman, William 1682–1731
Sir Charles Blois c.1725
oil on canvas 238 x 148
R.1939-176

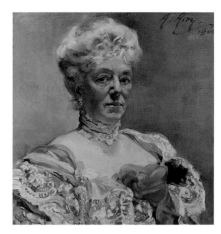

Airy, Anna 1882–1964
Mrs Telford Simpson 1906
oil on canvas 66 x 66
R.1974-50

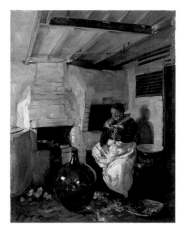

Airy, Anna 1882–1964
The Kitchen's Queen 1911
oil on canvas 111 x 85
R.1921-73

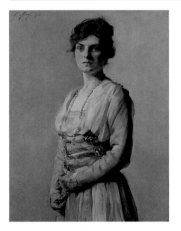

Airy, Anna 1882–1964
Mrs Monica Burnand 1916
oil on canvas 92 x 74
R.1974-51

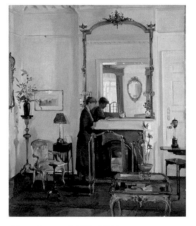

Airy, Anna 1882–1964
Interior with Mrs Charles Burnand 1919
oil on canvas 76.2 x 63.5
R.1974-52

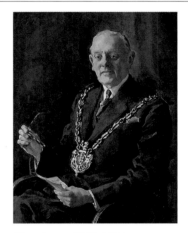

Airy, Anna 1882–1964
Alderman Cyril Catchpole 1950–1951
oil on canvas 77 x 64
R.1951-203

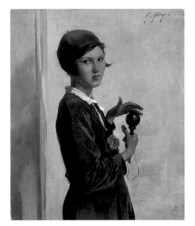

Airy, Anna 1882–1964
Greta
oil on canvas 76 x 64
R.1948-163

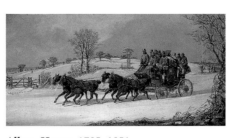

Alken, Henry 1785–1851
Ipswich to London Coach c.1840
oil on canvas 30 x 58
R.1948-135

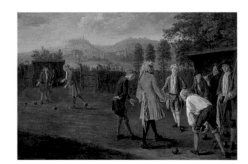

Angillis, Pieter 1685–1734
Figures on a Bowling Green 1700–1730
oil on panel 33 x 48.5
R.1992-8.19

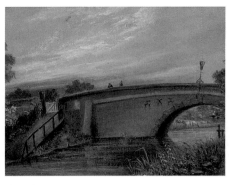

Arif, Saleem b.1949
Harbour of Intimacy (Diptych) 1986
acrylic & sand on paper & muslin 149 x 116;
149 x 116
R.1986-54

Ayrton, Michael 1921–1975
Broom Copse 1945
oil on board 29.5 x 39
R.1968-64

C. D. B.
Old Handford Bridge 1892
oil on canvas 25.5 x 34.5
R.1951-250.4

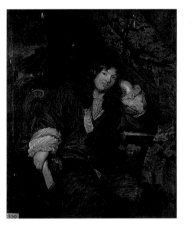

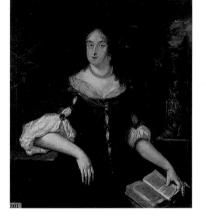

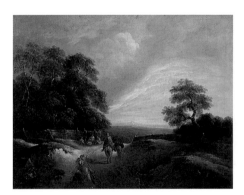

Bacon, T. (attributed to) active 18th C
Portrait of a Man
oil on canvas 53.5 x 44
R.1936-34.A

Bacon, T. (attributed to) active 18th C
Portrait of a Woman
oil on canvas 56 x 48
R.1936-34.B

Barker, Benjamin II 1776–1838
Landscape
oil on canvas 63 x 77
R.1990-58.33

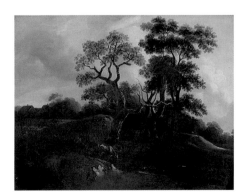

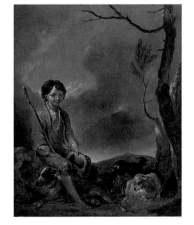

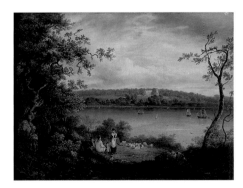

Barker, Thomas 1769–1847
Landscape and Cattle at Pool
oil on canvas 62 x 77.5
R.1931-71

Barker, Thomas (attributed to) 1769–1847
Shepherd Boy, Study
oil on canvas 68 x 53
R.1922-9

Barnicle, J. active 1821–1845
Orwell Park, Ipswich
oil on canvas 64 x 86
R.1934-140

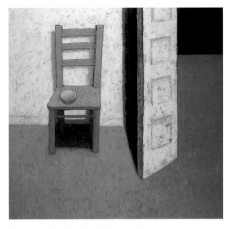

Barrett, Roderic 1920–2000
Chair in Its Place 1977–1980
oil on canvas 122 x 122
R.1987-134

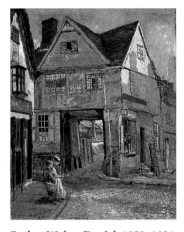

Batley, Walter Daniel 1850–1936
Angel Corner, Ipswich 1878
oil on canvas 59 x 46
R.1936-370

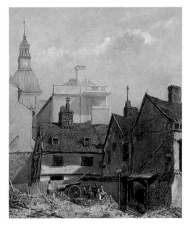

Batley, Walter Daniel 1850–1936
Demolition, Back of the Town Hall 1880
oil on canvas 61 x 51
R.1954-136

Batley, Walter Daniel 1850–1936
Old Provision Market, Ipswich 1882
oil on canvas 24 x 32
R.1946-176

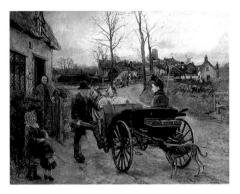

Batley, Walter Daniel 1850–1936
His First Vote 1887
oil on canvas 101 x 122 (E)
R.1946-175

Batley, Walter Daniel 1850–1936
Wharfedale 1888
oil on canvas 76 x 127.2
L.1943-114

Batley, Walter Daniel 1850–1936
Minsmere Cliff 1897
oil on canvas 60.8 x 122.5
R.1897-12

Batley, Walter Daniel 1850–1936
Now Comes Still Evening on 1913
oil on canvas 83 x 127 (E)
R.1935-137

Batley, Walter Daniel 1850–1936
Snow c.1915
oil on board 30 x 22
R.1915-15

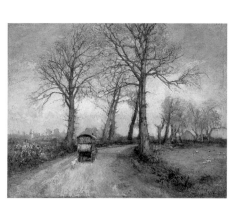

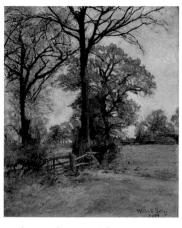

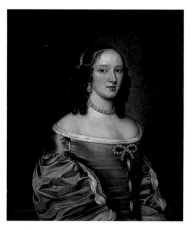

Batley, Walter Daniel 1850–1936
On the Road 1923
oil on canvas 96 x 121
R.1946-174

Batley, Walter Daniel 1850–1936
Trees and Gate
oil on slate 39 x 33
R.1991-37

Beale, Mary (attributed to) 1633–1699
Woman of Gage or Jermyn Families 1655–1660
oil on canvas 75.8 x 63.4
R.1952-208

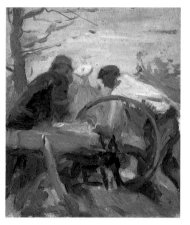

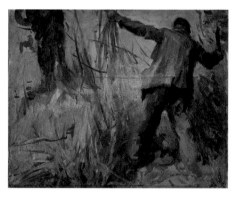

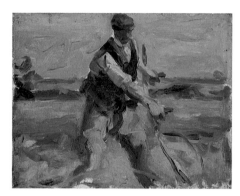

Becker, Harry 1865–1928
Cutting Chaff in the Open 1913–1928
oil on board 46 x 38
R.1954-126.8

Becker, Harry 1865–1928
Man Hedging 1913–1928
oil on canvas board 37.5 x 45.3
R.1954-126.5

Becker, Harry 1865–1928
Man with Scythe Mowing 1913–1928
oil on canvas board 21.5 x 26.6
R.1954-126.2

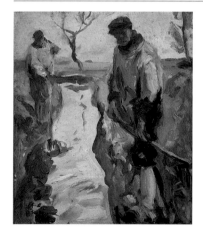

Becker, Harry 1865–1928
Two Men Clearing Banks 1913–1928
oil on canvas board 45.3 x 37.5
R.1954-126.4

Becker, Harry 1865–1928
Cattle by Dyke c.1913–c.1928
oil on board 38 x 45
R.1954-126.7

Becker, Harry 1865–1928
Farm Buildings in Landscape c.1913–c.1928
oil on canvas 55.5 x 61
R.1954-126.1

Becker, Harry 1865–1928
Landscape with Horses Ploughing c.1913–
c.1928
oil on canvas 21 x 26
R.1954-126.3

Becker, Harry 1865–1928
Reclining Man in Cap c.1913–c.1928
oil on unmounted paper/card 28.5 x 39.8
R.1954-126.6

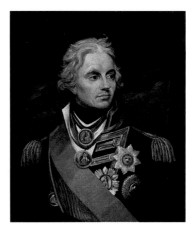

Beechey, William (attributed to) 1753–1839
*Admiral Horatio Nelson, 1st Viscount Nelson,
KB (1758–1805)* c.1800
oil on canvas 74 x 61
R.1983-143.6

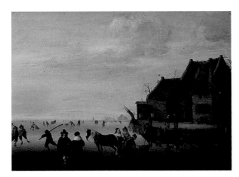

Beelt, Cornelis active 1661–c.1702
Skaters on Frozen River
oil on panel 54.6 x 73
R.1992-8.2

Belcher, George 1875–1947
The Musician c.1938
oil on canvas 93 x 67 (E)
R.1938-174

Bellingham-Smith, Elinor 1906–1988
Suffolk Landscape 1961
oil on canvas 100 x 150
R.1991-7

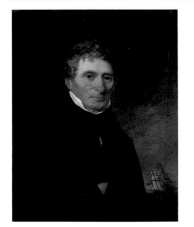

Bennett, William Mineard 1778–1858
Captain Richard Hall Gower (1768–1833)
c.1815–c.1820
oil on canvas 41 x 32 (E)
R.1966-7

Bennett, William Mineard (attributed to)
1778–1858
*William Batley, Town Recorder of Ipswich
(b.1758)* c.1800
oil on canvas 61 x 51
R.1990-58.17

Bentley, Alfred 1879–1923
The Silent River 1921
oil on canvas 46 x 61
R.1990-58.14

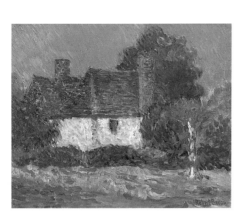

Bevan, Robert Polhill 1865–1925
A Small Southdown Farm 1906
oil on canvas 38 x 46
R.1974-130

Birley, Oswald Hornby Joseph 1880–1952
Sir Arthur Churchman, Lord Woodbridge
1929
oil on canvas 111 x 85 (E)
R.1949-209

Bischoff, Friedrich H. 1819–1873
Bishop Edward Stanley (1779–1849) c.1837–
c.1849
oil on canvas 140 x 109
R.1960-183

Bischoff, Friedrich H. 1819–1873
Reverend William Kirby (1759–1850),
President of the Ipswich Subscription Museum
1849
oil on canvas 142 x 111
R.1960-184

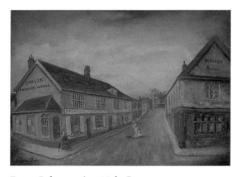

Boer, John active 19th C
St Nicholas' Street and Corner of Silent Street
oil on canvas 28 x 37
R.1953-106

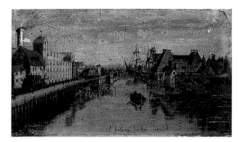

Boer, John active 19th C
St Peter's Bridge, Ipswich
oil on panel 17 x 28
R.1951-54

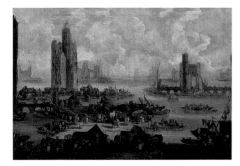

Bout, Peeter 1658–1719 **& Boudewyns,**
Adriaen Frans 1644–1711
Seaport Scene
oil on canvas 41 x 58.5
R.1992-8.20

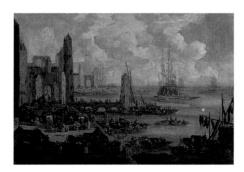

Bout, Peeter 1658–1719 **& Boudewyns,**
Adriaen Frans 1644–1711
Seaport Scene
oil on canvas 41 x 58.5
R.1992-8.21

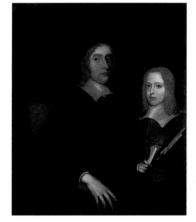

Bower, Edward (attributed to)
d.1666/1667
Anglican Divine with Boy
oil on canvas 96 x 79 (E)
R.1987-153

Boyd, Fionnuala b.1944 **& Evans, Leslie**
b.1945
Eclipse 1972
acrylic on canvas 122 x 122
R.2002-16.3

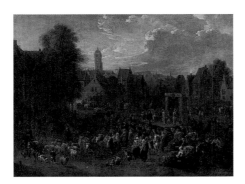

Bredael, Peeter van 1629–1719
Market Scene with Harlequin
oil on canvas 60 x 80
R.1992-8.12

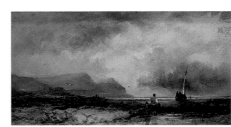

Bright, Henry 1814–1873
Coast Scene with Figures c.1840–c.1873
oil on panel 21.5 x 38
R.1906-24

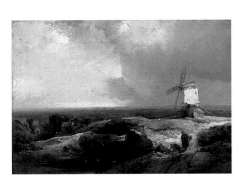

Bright, Henry 1814–1873
Landscape with Windmill 1841
oil on canvas 38.7 x 53.3
R.1921-2

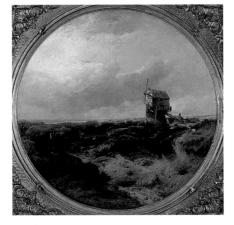

Bright, Henry 1814–1873
Landscape with Windmill 1854
oil on canvas 90
R.1955-96.4

Bright, Henry 1814–1873
Landscape with Cottage
oil on canvas 28 x 39
C.025

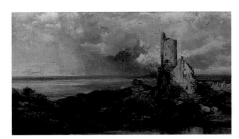

Bright, Henry 1814–1873
Ruins on the Heath
oil on canvas 25.5 x 36
R.1931-28.39

Bright, Henry 1814–1873
Scene on the Coast, North Wales
oil on canvas 22 x 40
R.1924-92

Bright, Henry 1814–1873
Scene on the Coast, North Wales
oil on canvas 23 x 40
R.1924-92A

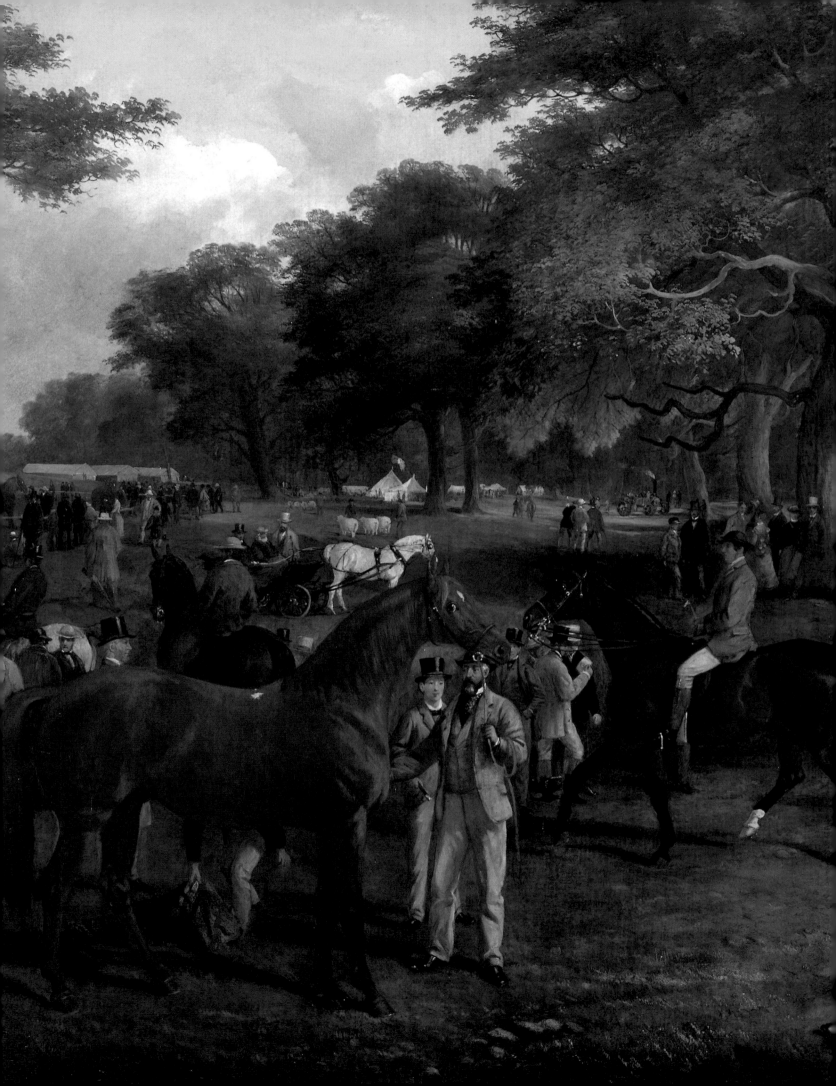

Bright, Henry 1814–1873
Tintern Abbey
oil on panel 26 x 36.5
R.1931-28.38

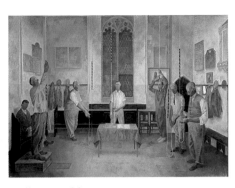

Brill, Reginald 1902–1974
Bell Ringers, Lavenham c.1963
oil on canvas 119.5 x 162.5
R.1994-30

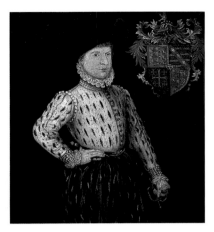

British (English) School
Peter Withipoll (1549–c.1613) 1570
oil on canvas 38.2 x 35
R.1936-82

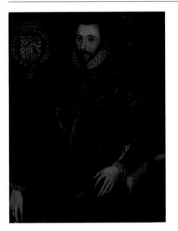

British (English) School
Walter Devereux (1541?–1576), 2nd Viscount Hereford, Created 1st Earl of Essex 1572
oil on panel 107 x 79.3
R.1948-248

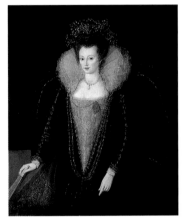

British (English) School
Catherine Killigrew (1579–1640) c.1595–c.1600
oil on canvas 127.8 x 102
R.1919-60

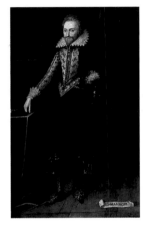

British (English) School
Francis Manners, Earl Rutland c.1613–c.1615
oil on canvas 206 x 162.5
R.1952-205

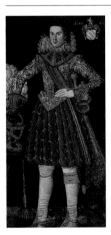

British (English) School
Sir William Playters (1590–1668) 1615
oil on canvas 175 x 82
R.1951-269

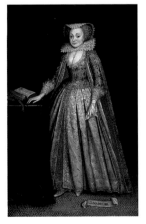

British (English) School
Cecily Manners, Countess Rutland c.1615–c.1620
oil on canvas 203 x 126
R.1952-206

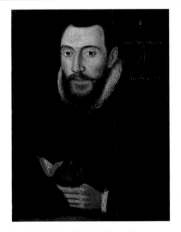

British (English) School
Samuel 'Watch' Ward (1577–1640) 1620
oil on canvas 61.4 x 47
R.1983-143.1

Facing page: Duval, John, 1816–1892, *Suffolk Show in Christchurch Park* (detail), 1869, Ipswich Borough Council Museums and Galleries, (p. 84)

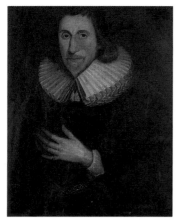

British (English) School
Possibly William Booth c.1620
oil on canvas 71 x 58.5
R.1985-79.17

British (English) School
Oliver St John, Earl of Bolingbroke c.1625
oil on panel 56 x 43
R.1959-276

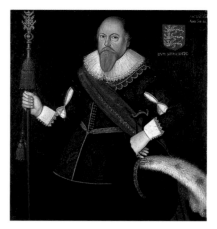

British (English) School
Tobias Blosse (c.1565–c.1630) 1627–1628
oil on canvas 106.7 x 98.8
R.1958-211

British (English) School
Ann Cotton (d.1638) c.1627–c.1628
oil on canvas 125.3 x 105.2
R.1957-125

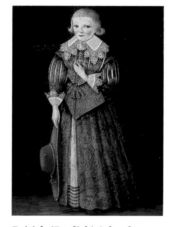

British (English) School
Young Boy (possibly a member of the Theobald family) 1630
oil on canvas 95.5 x 68
R.1918-40

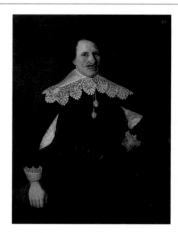

British (English) School
Thomas Edgar (1594–1657) c.1635
oil on canvas 117 x 89.5
R.1938-37

British (English) School
John Dowsing c.1645–c.1655
oil on canvas 75.8 x 63
R.1931-127

British (English) School
Gentleman of the Gooding or Goodwin Family c.1650
oil on canvas 70 x 62
R.1950-122.16

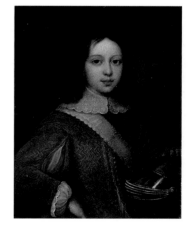

British (English) School
Boy and Helmet 1650s
oil on canvas 63.8 x 49.7
R.1944-154

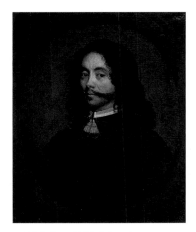

British (English) School
A Gentleman c.1650–c.1659
oil on canvas 80 x 65
R.1935-307

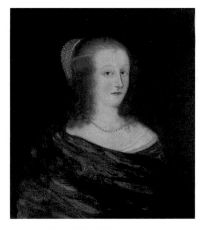

British (English) School
Lady of the Gooding or Goodwin Family
c.1650–c.1659
oil on canvas 65.5 x 58
R.1950-122.15

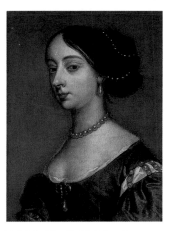

British (English) School
Woman in Blue Dress c.1650–c.1660
oil on canvas 52.5 x 39
R.1952-236

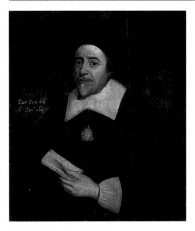

British (English) School
Nathanial Bacon (1593–1660) 1657
oil on canvas 74 x 62
R.1983-143.2

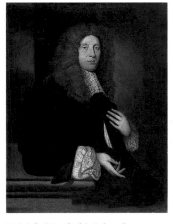

British (English) School
Dr Ralph Cotton c.1660–c.1669
oil on canvas 112 x 87
R.1957-127

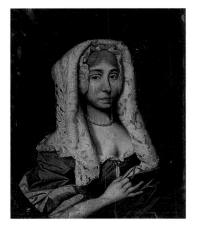

British (English) School
Possibly Marguerite Fonnereau 1670–1680
oil on canvas 67 x 55
R.1985-79.18

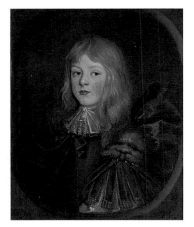

British (English) School
Thomas Killigrew as a Boy 1674
oil on canvas 76.5 x 63.5
R.1937-78

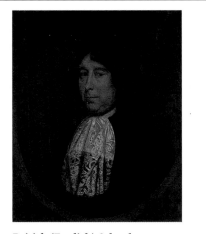

British (English) School
Possibly Zacharie Fonnereau (b.1636) c.1680
oil on canvas 75.5 x 63
R.1985-79.24

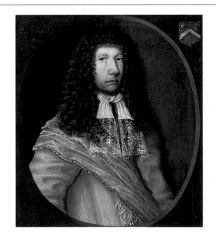

British (English) School
Captain Allen Cotton (c.1635–1699) 1681
oil on canvas 74 x 66
R.1957-126

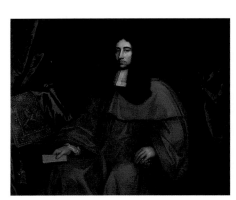

British (English) School
Sir George Hutchins (d.1705) 1690–1693
oil on canvas 125 x 160
R.1960-1

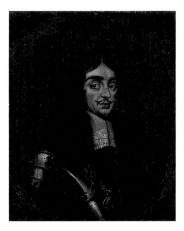

British (English) School 17th C
Charles II (1630–1685)
oil on canvas 30 x 25.5
R.1959-280

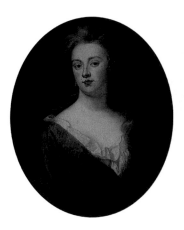

British (English) School
Sarah, Duchess of Marlborough c.1700–c.1710
oil on canvas 76 x 63
R.1936-185

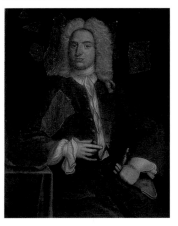

British (English) School
Ralph Meadows Theobald c.1710–c.1730
oil on canvas 92 x 71.5
R.1966-62

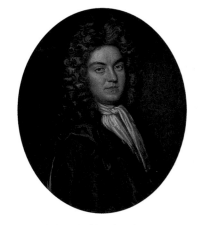

British (English) School
Ralph Cotton 1711
oil on canvas 77 x 64
R.1957-128

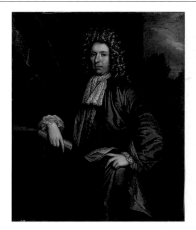

British (English) School
John Goodwin c.1720
oil on canvas 125 x 103
R.1950-122.13

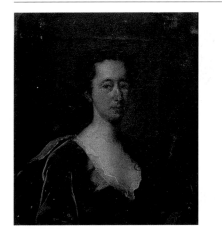

British (English) School
Lady of the Fonnereau Family, in Blue c.1720
oil on canvas 20 x 17.5
R.1985-79.10

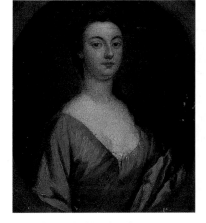

British (English) School
Lady of the Fonnereau Family, in Green
c.1720
oil on canvas 21 x 17
R.1985-79.11

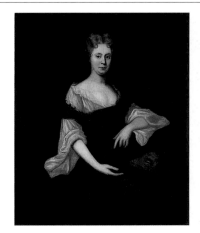

British (English) School
Mrs John Goodwin c.1720
oil on canvas 125 x 103
R.1950-122.14

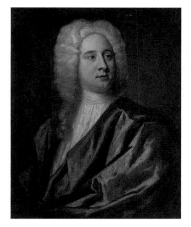

British (English) School
Joseph Addison c.1720–c.1730
oil on canvas 76 x 64
R.1898-17

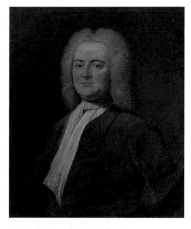

British (English) School
Claude Fonnereau (1677–1740) c.1725
oil on canvas 69 x 58
R.1985-79.1

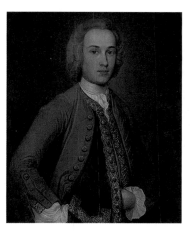

British (English) School
Gentleman of the Fonnereau Family c.1729
oil on canvas 76 x 60
R.1944-86B

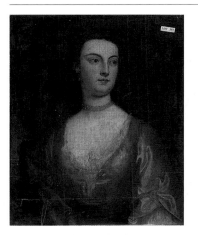

British (English) School
Lady of the Fonnereau Family 1730–1740
oil on canvas 76 x 63
R.1985-79.28

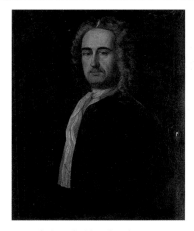

British (English) School
Gentleman of the Fonnereau Family c.1740
oil on canvas 76 x 64
R.1985-79.20

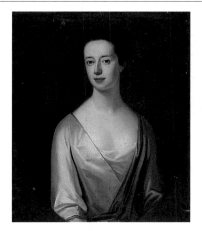

British (English) School
Lady of Fonnereau Family, in White c.1740
oil on canvas 76 x 64
R.1985-79.31

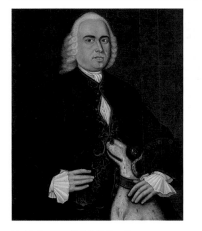

British (English) School
Thomas Taylor, Ipswich Merchant, Aged 40
1747
oil on canvas 91 x 75
R.1940-42

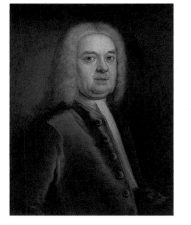

British (English) School
Sir Robert Harland 1748
oil on canvas 67 x 54
R.1934-166

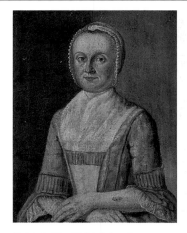

British (English) School
Lady in a Blue Dress c.1750
oil on canvas 52 x 41
R.1947-42.X

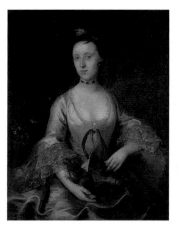

British (English) School
Lady of the Fonnereau Family c.1750–c.1760
oil on canvas 92 x 71.5
R.1985-79.4

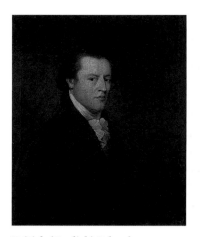

British (English) School
Gentleman of the Fonnereau Family 1790–
1800
oil on canvas 76 x 63
R.1985-79.21

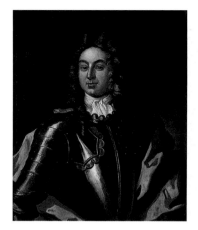

British (English) School 18th C
Captain Hill Mussenden, MP
oil on canvas 78 x 65
R.1992-8.26

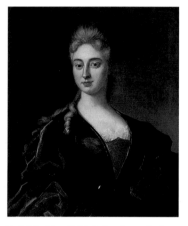

British (English) School 18th C
Mrs Hill Mussenden
oil on canvas 84 x 69
R.1992-8.30

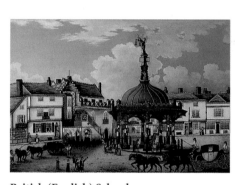

British (English) School
The Cornhill, Ipswich c.1800
oil on board 52 x 65
R.1954-124

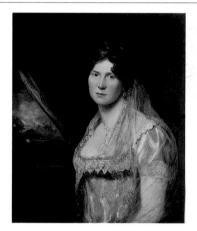

British (English) School
Mrs Frances Power (née Mannock) c.1800–
c.1810
oil on canvas 78 x 62
R.1952-158

British (English) School
Battle for the Standard c.1815
oil on canvas 91 x 71
R.1950-122.18

British (English) School
Officer Killed at the Battle of Waterloo c.1815
oil on canvas 73 x 60.5
R.1950-122.17

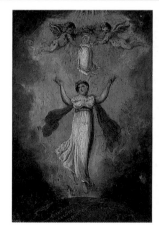

British (English) School
Princess Charlotte Ascending c.1817
oil on panel 36.5 x 25.5
R.1978-34

British (English) School
Admiral Benjamin W. Page (1765–1845)
c.1820
oil on canvas 29.5 x 24.5
R.1966-42

British (English) School
Mrs Benjamin W. Page c.1820
oil on canvas 29.5 x 24.5
R.1966-43

British (English) School
Reverend Charles William Fonnereau (1764–1840) 1820–1830
oil on canvas 90 x 66
R.1985-79.6

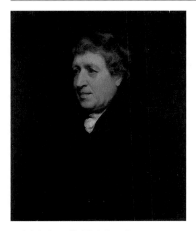

British (English) School
Gentleman in a Black Coat c.1830
oil on canvas 76 x 64
R.1943-27

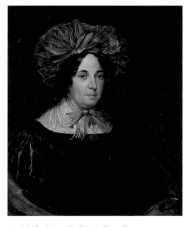

British (English) School
Mrs John Childs c.1830
oil on panel 76 x 63
R.1952-266.B

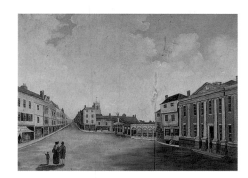

British (English) School
The Cornhill c.1830
oil on canvas 61 x 84
R.1897-14

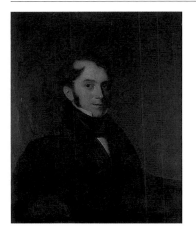

British (English) School
Gentleman of the Fonnereau Family 1830–1840
oil on canvas 77 x 64
R.1985-79.22

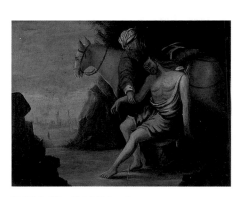

British (English) School
The Good Samaritan 1830–1850
oil on canvas 76 x 102
R.1990-58.22

British (English) School
John Nottidge 1836
oil on canvas 140 x 115
R.1983-90.1

British (English) School
Possibly Reverend Charles Fonnereau (1764–1840) c.1840
oil on canvas 69.5 x 51
R.1960-174

British (English) School
Thomas Clarkson (1760–1846) c.1840
oil on canvas 77 x 63
R.1955-144

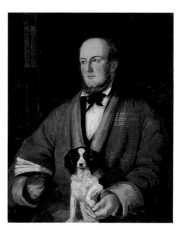

British (English) School
William Charles Fonnereau c.1840
oil on canvas 93 x 72
R.1911-37

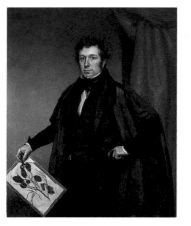

British (English) School
Professor John S. Henslow (1796–1861), President of Ipswich Subscription Museum, 1850 c.1840–c.1850
oil on canvas 127 x 102
R.1960-185

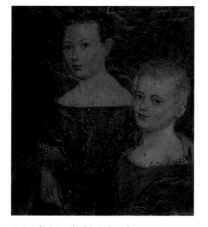

British (English) School
Edgar Shreeve and John Trigg Scrivener 1850
oil on canvas 78 x 64
R.1943-29.6

British (English) School
Captain William Raymer c.1850
oil on canvas 76.5 x 64.5
R.1987-152

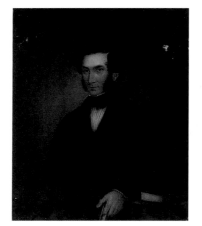

British (English) School
Portrait of a Man, with Books c.1850
oil on canvas 76.5 x 64
R.1960-178

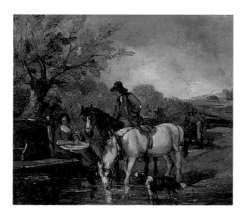

British (English) School
Resting at the Ford c.1860
oil on panel 15 x 18
R.1931-28.106

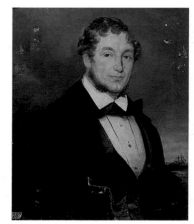

British (English) School
Portrait of Man in a Blue Coat c.1860–c.1870
oil on canvas 64 x 53.7
R.1960-188

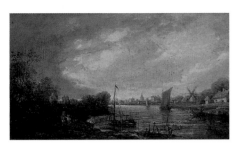

British (English) School
View on the Thames c.1860–c.1870
oil on panel 15.5 x 25.5
R.1943-30.3

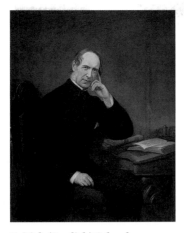

British (English) School
Lord Gwydyr 1874
oil on canvas 148 x 118
R.1990-58.8

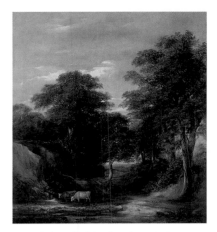

British (English) School 19th C
Cows Drinking at Woodland Spring
oil on canvas 90 x 60
R.1970-130

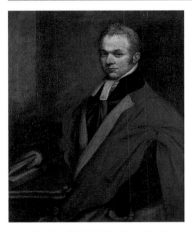

British (English) School 19th C
William Henry Williams
oil on canvas 92 x 76
R.1990-58.31

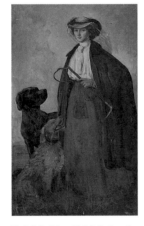

British (English) School
Woman with Dogs c.1909
oil on canvas 152 x 92
R.1960-186

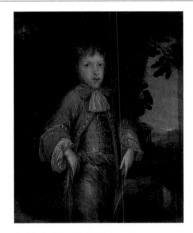

British (English) School
Boy in 17th Century Dress
oil on canvas 32.5 x 26
R.1943-1

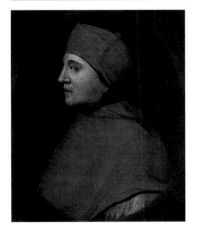

British (English) School
Cardinal Wolsey
oil on board 36.5 x 30.5
R.1898-6

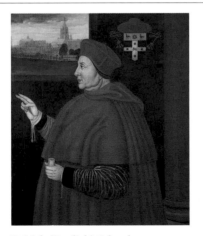

British (English) School
Cardinal Wolsey
oil on panel 49 x 40
R.1959-167

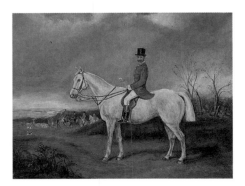

British (English) School
Colonel Alderson on a Horse
oil on canvas 42 x 56
R.1960-187

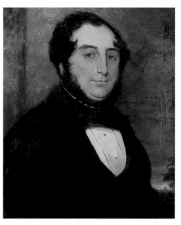

British (English) School
Edgar Goodwin
oil on canvas 61 x 51
R.1943-29.1

British (English) School
Edward VI (1537–1553)
oil on panel 118 x 73
R.1952-121

British (English) School
Going to Market
oil on panel 15 x 18
R.1931-28.105

British (English) School
John Grubbe
oil on canvas 125 x 102
L.1940-57.F

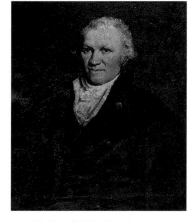

British (English) School
John Meadows Theobald
oil on canvas 76 x 64
R.1966-63

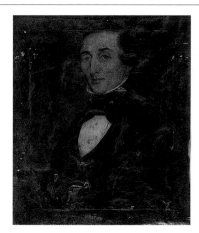

British (English) School
John Trigg Scrivener
oil on canvas 64 x 53
R.1943-29.4

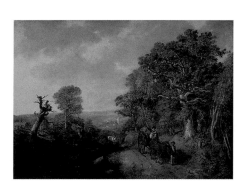

British (English) School
Landscape, Man and Woman in a Cart
oil on canvas 42 x 58
R.1952-62.X

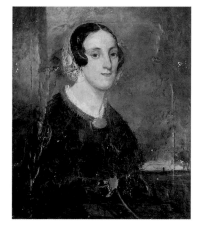

British (English) School
Martha Shreeve
oil on canvas 63 x 53
R.1943-29.5

British (English) School
Mary Ann Goodwin (née Shreeve)
oil on canvas 61.5 x 51
R.1943-29.2

Facing page: Brill, Reginald, 1902–1974, *Bell Ringers, Lavenham* (detail), c.1963, Ipswich Borough Council
Museums and Galleries, (p. 57)

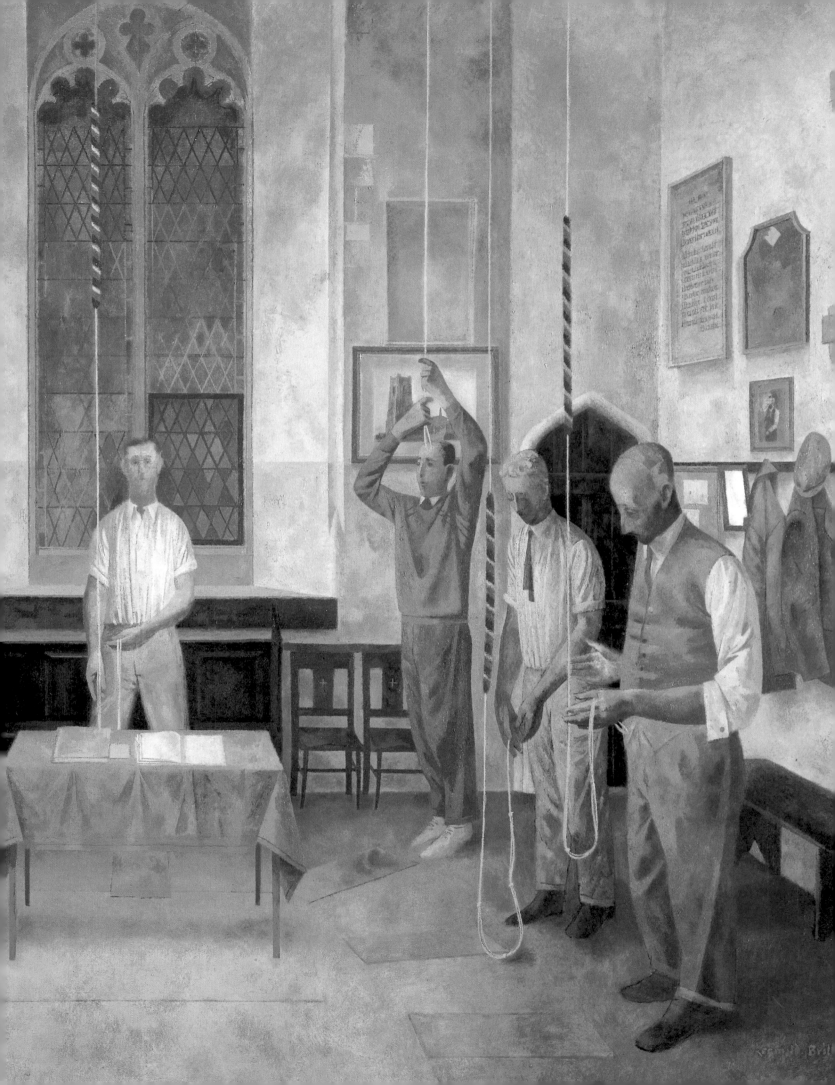

British (English) School
Portrait of a Lady
oil on canvas 80 x 65
L.1951-61Q

British (English) School
Reverend Matthew Scrivener
oil on canvas 77 x 64
R.1945-44

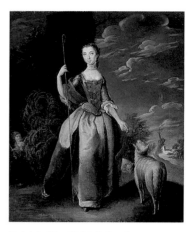

British (English) School
Shepherdess with Sheep
oil on canvas 74 x 61
R.1960-190

British (English) School
The Poet Reverend George Crabbe (1754–1832)
oil on canvas 75.5 x 63.5
R.1952-132

British (English) School
The Thatcher with a Sickle
oil on canvas 56 x 42.5
R.1960-170

British (English) School
Thomas Cromwell
oil on board 35.5 x 30.5
R.1898-7

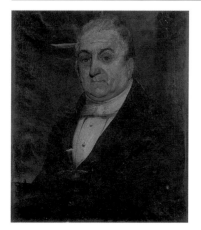

British (English) School
Thomas Shreeve
oil on canvas 61 x 50
R.1943-29.3

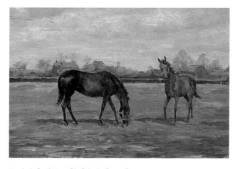

British (English) School
Two Horses in a Field
oil on panel 16 x 23
R.1945-97.F80

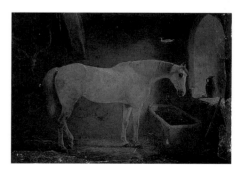

British (English) School
White Horse in Stable
oil on canvas 41 x 58.5
R.1961-163

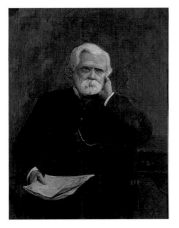

British (English) School
Wickham Tozer
oil on canvas 110 x 85
R.1960-179

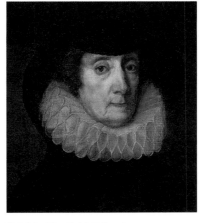

British (English) School
Widow Devereux
oil on canvas 43 x 41
R.1948-249

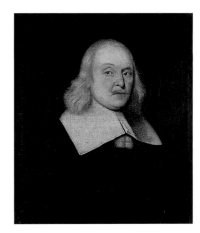

British (English) School
William Smith of Laxfield
oil on canvas 72.5 x 63
R.1931-126

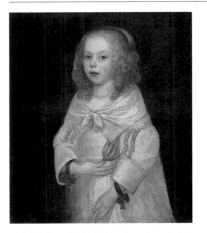

British (English) School or Dutch School
Frances Cotton c.1655
oil on canvas 72.5 x 63
R.1957-129

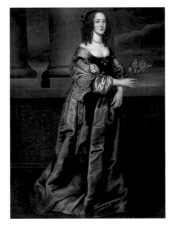

British (English) School or Dutch School
Henrietta Jermyn (b.1632) 1657
oil on canvas 186.3 x 137.3
R.1952-207

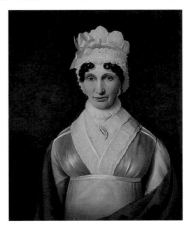

British (English) School or Dutch School
Lady in Lace Cap c.1800
oil on canvas 76 x 63.5
R.1944-39

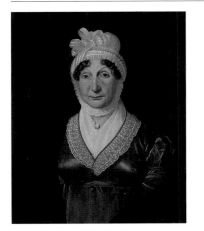

British (English) School or Dutch School
Lady in Lace Cap c.1800
oil on canvas 76 x 64
R.1944-40

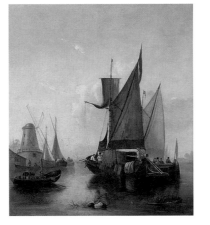

British (English) School or Dutch School
19th C
River Scene with Shipping
oil on canvas 67 x 58.5
R.1967-99

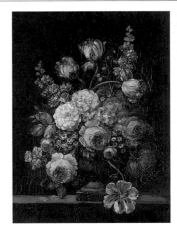

British (English) School or Dutch School
Flower Piece
oil on canvas 67 x 51
R.1952-248

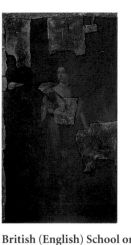

British (English) School or Dutch School
Portrait of a Queen (possibly Mary II)
oil on canvas 271 x 151
R.1990-58.1

Brown, Frederick 1851–1941
Whin Hill, the Common, Southwold c.1888
oil on canvas 49.5 x 74.8
R.1976-92

Brown, John Alfred Arnesby 1866–1955
Spring c.1925
oil on canvas 80 x 95 (E)
R.1925-130

Browning, Amy Katherine 1882–1978
Lime Tree Shade 1913
oil on canvas 114 x 107
R.1995-46

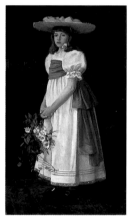

Buck, Lucy Margaret active 1892–1894
Ethel Mary Turner (1883–1984) 1894
oil on canvas 99 x 57
R.1990-44

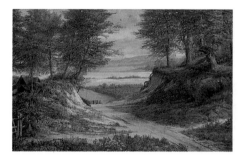

Buck, William active 1864–1899
Gainsborough Lane, Ipswich 1877–1878
oil on canvas 36 x 53.5
R.1950-56

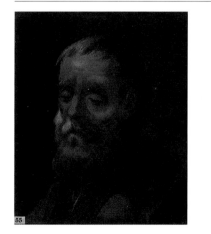

Bunbury, Henry William (attributed to)
1750–1811
Old Man, Possibly a Saint
oil on canvas 49 x 41
R.1960-176

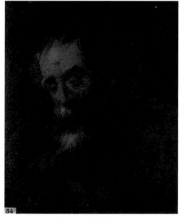

Bunbury, Henry William (attributed to)
1750–1811
Old Man, Possibly a Saint
oil on canvas 49 x 41
R.1960-177

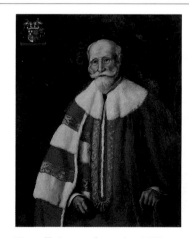

Burrell, Semonda active 1890s
Lord Gwydyr 1899
oil on canvas 108 x 84
R.1900-3

Burrows, Robert 1810–1883
Back of Cauldwe!l Hall c.1840–c.1883
oil on canvas 51 x 76
R.1952-60

Burrows, Robert 1810–1883
Gipping near Oil Mills c.1840–c.1883
oil on canvas 25.5 x 35.5
R.1936-55

Burrows, Robert 1810–1883
Old Cauldwell, Ipswich c.1840–c.1883
oil on canvas 61 x 92
R.1951-95.B

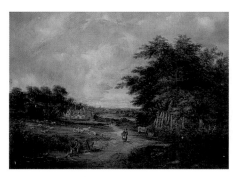

Burrows, Robert 1810–1883
Old Gippeswyck Hall c.1840–c.1883
oil on canvas 46 x 61
R.1944-62

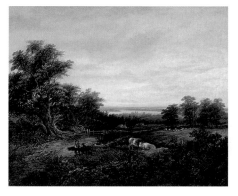

Burrows, Robert 1810–1883
Orwell from Bridleway, Ipswich c.1840–c.1883
oil on canvas 63 x 78
R.1932-40

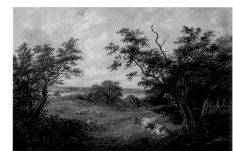

Burrows, Robert 1810–1883
River Orwell from Gainsborough Lane c.1840–c.1883
oil on canvas 68 x 92
R.1932-56

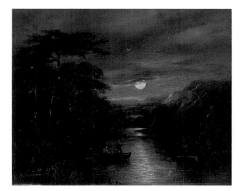

Burrows, Robert 1810–1883
River Scene c.1840–c.1883
oil on canvas 22.5 x 28
R.1951-251.1

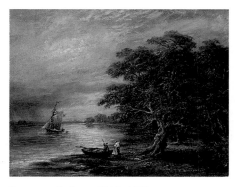

Burrows, Robert 1810–1883
Riverside Scene c.1840–c.1883
oil on canvas 23 x 31
R.1951-251.2

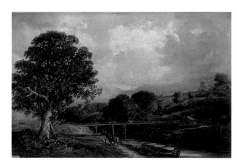

Burrows, Robert 1810–1883
Bridge, West of Stoke Bridge c.1847
oil on canvas 45 x 67
R.1932-164

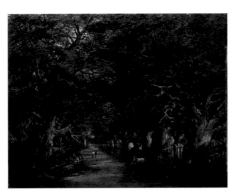

Burrows, Robert 1810–1883
Christchurch Park, Now Park Road c.1860–
c.1880
oil on canvas 85 x 105
R.1961-189

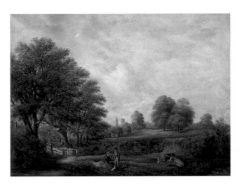

Burrows, Robert 1810–1883
Landscape in Christchurch Park c.1860–
c.1880
oil on canvas 60 x 90
R.1919-57

Burrows, Robert 1810–1883
Foxhall Road, Ipswich 1867
oil on canvas 30.6 x 41
R.1936-442

Burrows, Robert 1810–1883
Park Road, Ipswich before 1874
oil on canvas 71 x 91
R.1911-18

Burwood, George Vemply c.1845–1917
Landscape with Sheep 1895
oil on canvas 18 x 22
R.1971-147

Butler, George Edmund (attributed to)
1872–1936
Harbour Scene
oil on board 18 x 27
R.1950-160

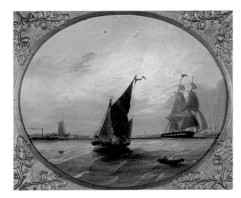

Calvert, Charles 1785–1852 **or Calvert,
Frederick** 1811–1844
Shipping off the Coast
oil on canvas 24 x 28
R.1931-28.102

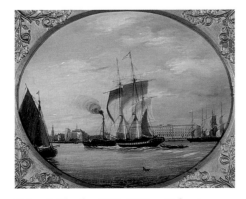

Calvert, Charles 1785–1852 **or Calvert,
Frederick** 1811–1844
Shipping with Riverside Buildings
oil on canvas 24 x 28
R.1931-28.101

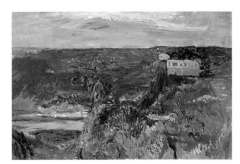

Camp, Jeffery b.1923
The Grey North Sea c.1959
oil on board 67 x 100
R.1992-58

Campbell, Peter 1931–1989
Tower and Churchyard 1985
oil on board 76 x 48 (E)
R.1986-8

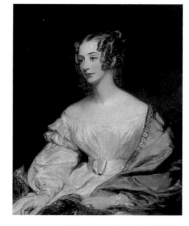

Carpenter, Margaret Sarah 1793–1872
Eleonora Long, née Montagu (c.1811–1900)
c.1840
oil on canvas 92 x 74
R.1958-254.7

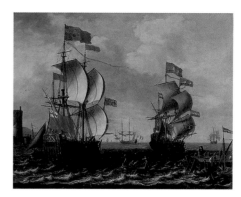

Castro, Lorenzo de active 1678–c.1700
Men O'War and Shipping off a Jetty c.1700
oil on canvas 103.5 x 128
R.1992-8.10

Churchyard, Thomas 1798–1865
Clump of Trees c.1820–c.1865
oil on board 25 x 20 (E)
R.1941-122.8

Churchyard, Thomas 1798–1865
Landscape with Cart Track c.1820–c.1865
oil on board 27.5 x 36.5
R.1945-140.A

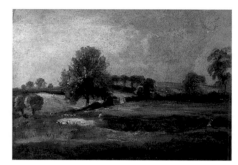

Churchyard, Thomas 1798–1865
Landscape with Sheep c.1820–c.1865
oil on paste board 24 x 31
R.1929-82

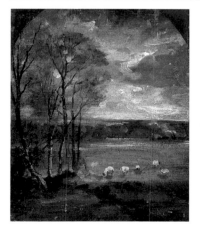

Churchyard, Thomas 1798–1865
Landscape with Sheep and Trees c.1820–
c.1865
oil on board 28 x 25
R.1961-190

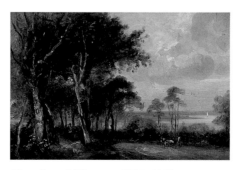

Churchyard, Thomas 1798–1865
River Deben below Kyson Point c.1820–c.1865
oil on panel 16 x 25
R.1942-110

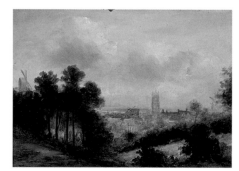

Churchyard, Thomas 1798–1865
Woodbridge c.1820–c.1865
oil on panel 16 x 22
R.1942-109

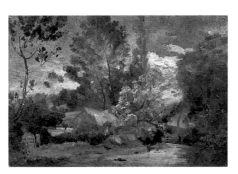

Churchyard, Thomas 1798–1865
Wooded Landscape c.1820–c.1865
oil on millboard 22.8 x 31.7
R.1932-167

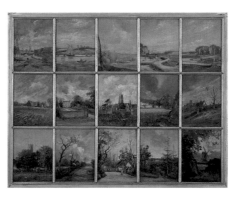

Churchyard, Thomas 1798–1865
Fifteen Scenes of Melton and Woodbridge
oil on panel 56 x 68 (E)
R.1959-263

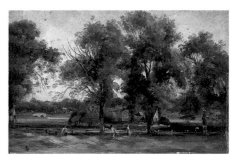

Churchyard, Thomas 1798–1865
Melton Quay
oil on panel 20.2 x 30.5
R.1971-108

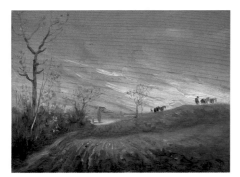

Churchyard, Thomas 1798–1865
Ploughing
oil on pine panel 13.7 x 17.9
R.1913-2.2

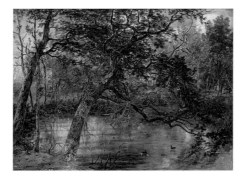

Churchyard, Thomas 1798–1865
Pond with Trees
oil on board 38 x 52
R.1931-28.77

Churchyard, Thomas 1798–1865
Ufford Stocks
oil on canvas 9 x 13
R.1961-184

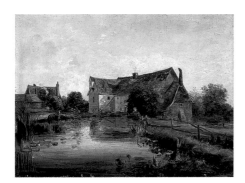

Churchyard, Thomas 1798–1865
Watermill at Campsea Ashe
oil on board 29.2 x 40
R.1941-65

Churchyard, Thomas 1798–1865
Woodland Ride
oil on canvas 56 x 42
R.1949-50

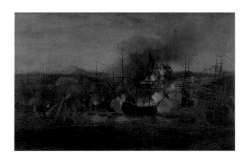

Cleveley, John c.1712–1777
Bombardment of Castillo de San Lorenzo by Admiral Vernon 1740
oil on canvas 89.5 x 141
R.1936-298

Cleveley, John c.1712–1777
View of Ipswich 1753
oil on canvas 120 x 305
R.1897-35

Clough, Prunella 1919–1999
Sweetpack 1988
oil on canvas 137 x 149
R.2000-19-2

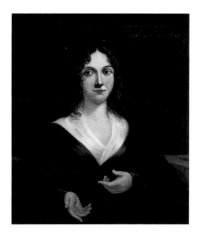

Cobbold, Richard 1797–1877
Margaret Catchpole c.1840
oil on canvas 102 x 85
R.1934-219.A

Coe, Alfred
Chantry Drawing Room
oil on board 43 x 66
R.1990-58.28

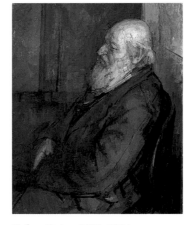

Coker, Peter 1926–2004
Portrait of an Old Man 1951
oil on canvas 77.5 x 61.5
R.1986-16.3

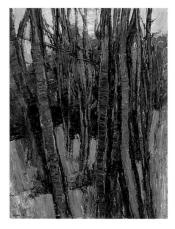

Coker, Peter 1926–2004
Epping Forest III 1959
oil on board 122 x 95
R.1969-49

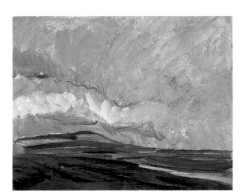

Coker, Peter 1926–2004
Horse Island from Acheniver 1985
oil on canvas 79 x 100
R.1986-16.6

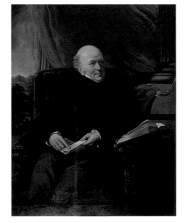

Cole, Charles
Robert Harland c.1850
oil on canvas 142.5 x 111.5
R.1934-141

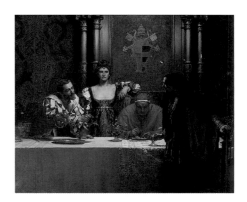

Collier, John 1850–1934
A Glass of Wine with Caesar Borgia 1893
oil on canvas 140 x 240 (E)
R.1913-22

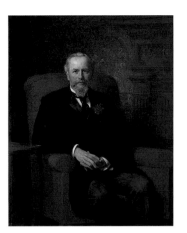

Collier, John 1850–1934
Felix Thornley Cobbold (1841–1909) 1897
oil on canvas 144 x 111
R.1960-181

Collins, Cecil 1908–1989
Fool (Head) 1970
oil & tempera on board 15 x 10
R.2001-2.1

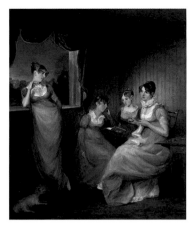

Constable, John 1776–1837
The Ladies of the Family of Mr William Mason of Colchester 1802–1806
oil on canvas 61 x 50.8
R.2002-48

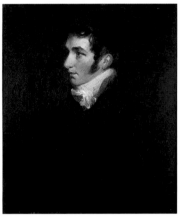

Constable, John 1776–1837
Abram Constable, the Artist's Brother c.1806
oil on canvas 76.2 x 63.5
R.1925-25

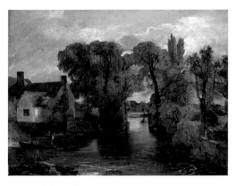

Constable, John 1776–1837
The Mill Stream, Willy Lott's House 1814–1815
oil on canvas 71.1 x 91.5
R.1941-72

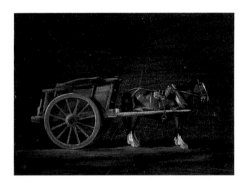

Constable, John 1776–1837
Farm Cart, Horse in Harness c.1814
oil on canvas 15 x 25.5
R.1990-80

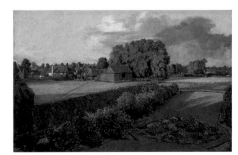

Constable, John 1776–1837
Golding Constable's Flower Garden 1815
oil on canvas 33 x 50.8
R.1955-96.1

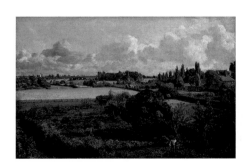

Constable, John 1776–1837
Golding Constable's Kitchen Garden c.1815
oil on canvas 33 x 50.8
R.1955-96.2

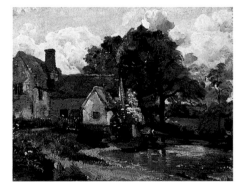

Constable, John 1776–1837
Willy Lott's House 1816
oil on canvas 19.4 x 23.8
R.1929-57

Constable, John 1776–1837
Avenue of Trees
oil on canvas 52 x 36
R.1916-12

Constable, John (after) 1776–1837
The Cornfield after 1837
oil on canvas 140 x 121 (E)
R.1978-1

Constable, John (after) 1776–1837
Hampstead Heath
oil on canvas 35.7 x 45.7
R.1950-129

Constable, John (after) 1776–1837
West End Fields Looking to Harrow
oil on canvas 24.7 x 36.8
R.1950-128

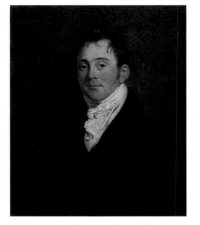

Constable, John (attributed to) 1776–1837
Thomas Gosnall c.1815–c.1820
oil on canvas 76.5 x 64
R.1933-254

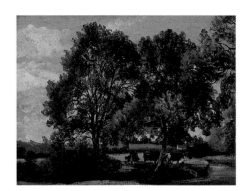

Constable, Lionel Bicknell (attributed to)
1828–1887
Meadow Scene with Trees
oil on panel 26 x 35.5
R.1914-13

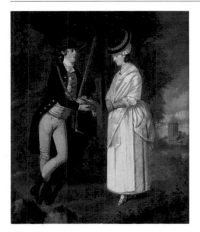

Cooper, Daniel 1749–1882
The Courtship 1777
oil on canvas 76.3 x 63.7
R.1972-13

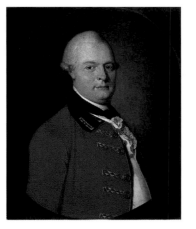

Copley, John Singleton 1738–1815
Major George Leathes, Royal Dragoons c.1780
oil on canvas 76.5 x 63.3
R.1992-8.28

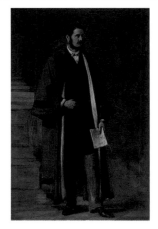

Corbould, Alfred active 1831–1875
J. P. Cobbold
oil on canvas 215 x 143
R.1983-143.13A

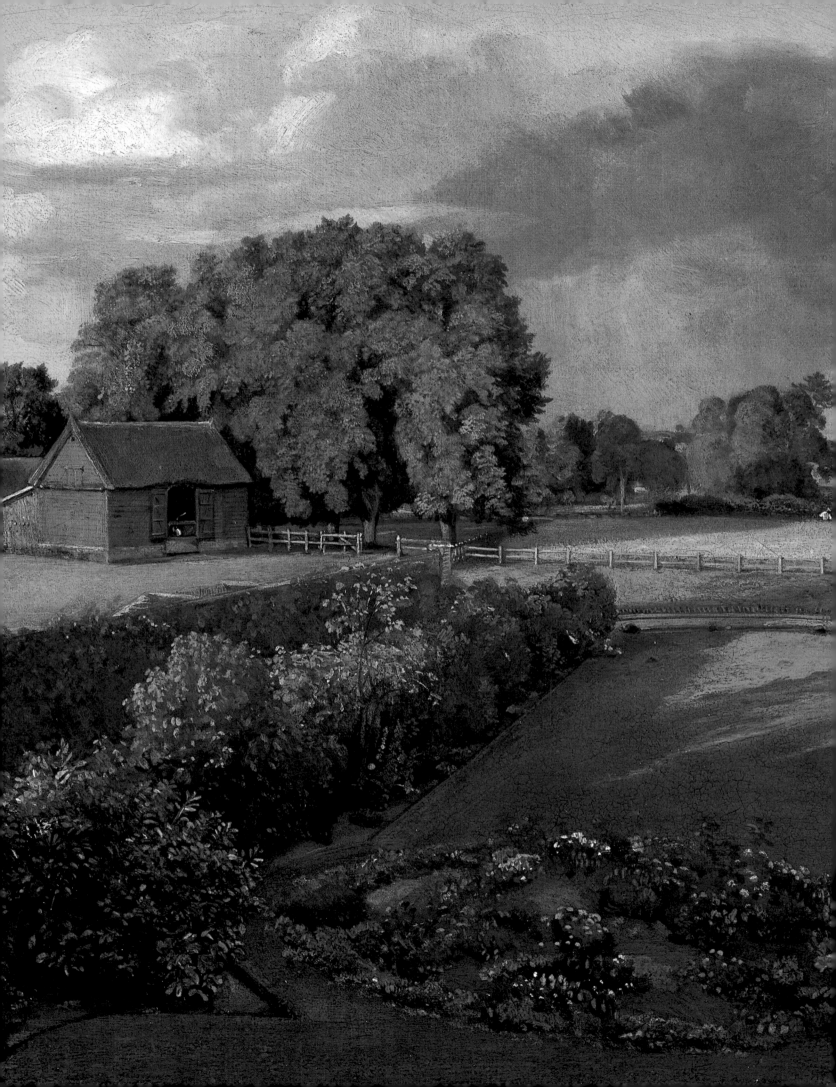

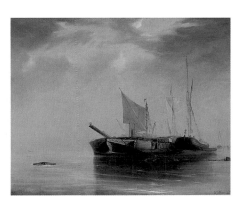

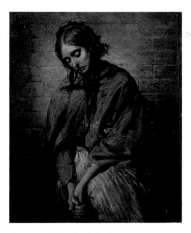

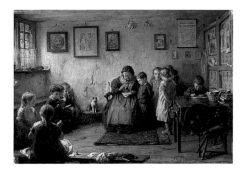

Cotman, Frederick George 1850–1920
Morning Mist on the Orwell 1867
oil on canvas 62 x 76
R.1946-10

Cotman, Frederick George 1850–1920
The Widow c.1870–c.1880
oil on canvas 28 x 24
R.1928-9

Cotman, Frederick George 1850–1920
The Dame School 1887
oil on canvas 36 x 50.2
R.1961-177

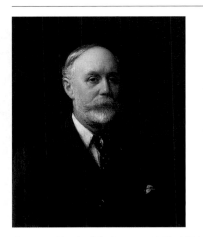

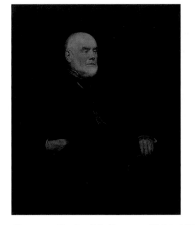

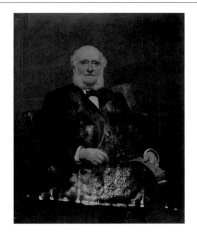

Cotman, Frederick George 1850–1920
Sir Edward Packard 1898
oil on canvas 63 x 53
R.1899-6

Cotman, Frederick George 1850–1920
Nathaniel Catchpole 1902
oil on canvas 127 x 102
R.1983-143.13G

Cotman, Frederick George 1850–1920
Alderman Walton Turner 1903
oil on canvas 127 x 102
R.1983-143.13F

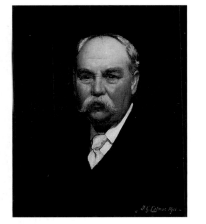

Cotman, Frederick George 1850–1920
*Frank Woolnough, Ipswich Museum Curator
(1893–1920)* 1910
oil on canvas 61 x 51
R.1930-168

Cotman, Frederick George 1850–1920
Landscape, Sunset c.1910–c.1912
oil on panel 18 x 30.5
R.1990-57.13

Cotman, Frederick George 1850–1920
Farmyard and Dovecote, Nettlestead 1912
oil on canvas 23.3 x 38.8
R.1958-36

Facing page: Constable, John, 1776–1837, *Golding Constable's Flower Garden* (detail), 1815, Ipswich Borough Council
Museums and Galleries, (p. 76)

Cotman, Frederick George 1850–1920
Harwich Harbour 1913
oil on canvas 74 x 125
R.1913-7

Cotman, Frederick George 1850–1920
Valley of the Gipping 1913
oil on canvas 75 x 125
R.1958-35

Cotman, John Sell (attributed to) 1782–1842
Mountain Landscape
oil on canvas 30 x 43.5
R.1931-28.18

Courtois, Jacques (circle of) 1621–1676
Battle Piece
oil on board 63 x 75
R.1915-54

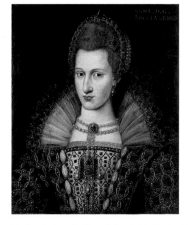

Critz, John de the elder (attributed to) 1551/1552–1642
Anne of Denmark (1574–1619), Queen of James I c.1603
oil on panel 65.3 x 52
R.1935-306

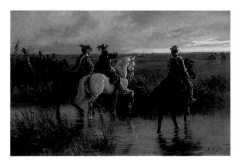

Crofts, Ernest 1847–1911
Prince Rupert and Staff 1875
oil on canvas 21.6 x 31.7
R.1931-28.30

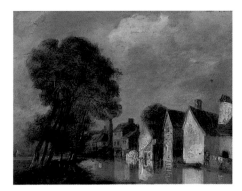

Crome, John (after) 1768–1821
The Tanning Mills, Norwich
oil on panel 25.2 x 34
R.1953-97

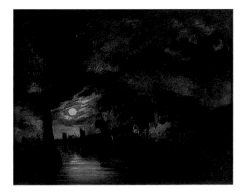

Crome, John Bernay 1794–1842
Moonlight on the River at Norwich
oil on millboard 24 x 35
R.1933-37

Crome, John Bernay (after) 1794–1842
Moonlight Landscape with Windmill
oil on canvas 63 x 76
R.1961-179

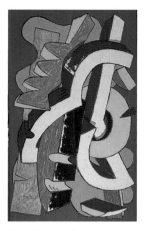

Crowley, Graham b.1950
Curt, November 1976 1976
acrylic & chalk on canvas 153 x 92
R.1977-42

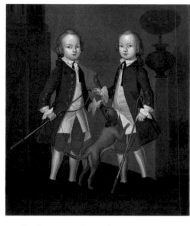

Cufaude, Francis active 1745–1749
The Gosnall Twins 1749
oil on canvas 124 x 107
R.1933-163

Cutler, David
Lock and Stagg Corner, Wolsey Street c.1965
oil on board 45 x 62.5
R.1988-4.2

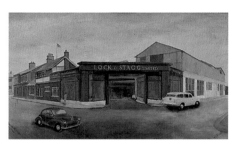

Cutler, David
Lock and Stagg, Ipswich c.1965
oil on board 46 x 79
R.1988-4.1

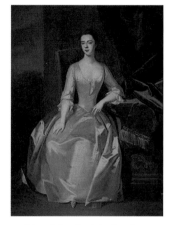

Dahl, Michael I (circle of) 1656/1659–1743
Mrs Charles Long (née Mary North)
oil on canvas 181 x 133
R.1958-254.8

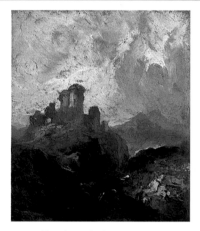

Daniell, Edward Thomas 1804–1842
Mountain Landscape, Castle Ruins c.1825–
c.1842
oil on panel 15 x 13
R.1931-28.34

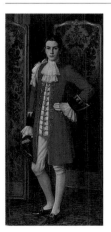

Daniell, Frank 1868–1932
George Ronald Lane (1894–1916) 1909
oil on canvas 197 x 94
R.1972-100

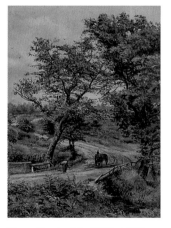

Davy, Frederick 1833–1890
Landscape, Suffolk View c.1880
oil on canvas 28.2 x 20.7
R.1970-69.5

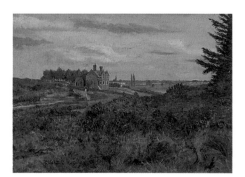

Davy, Frederick 1833–1890
Manor House in Landscape c.1880
oil on panel 21.6 x 29
R.1970-69.4

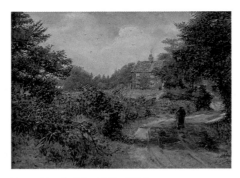

Davy, Frederick 1833–1890
Ipswich from Willoughby Road c.1880–c.1890
oil on canvas 22.8 x 38.1
R.1967-71

Davy, Frederick 1833–1890
Man in Lane Approaching House 1881
oil on panel 18.5 x 25.5
R.1970-69.3

Davy, Frederick 1833–1890
Landscape with Sheep and a Bridge 1884
oil on canvas 28.5 x 38.5
R.1970-69.1

Davy, Frederick 1833–1890
Rural Lane with Figure
oil on canvas 27 x 37.4
R.1970-69.2

Davy, Henry 1793–1865
17th Century Barn
oil on board 25.5 x 31
R.1970-68.1

Davy, Henry (attributed to) 1793–1865
St Stephen's Church, Ipswich
oil on canvas 33 x 48.3
R.2004-18

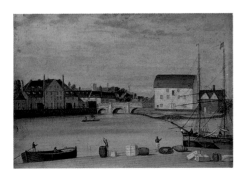

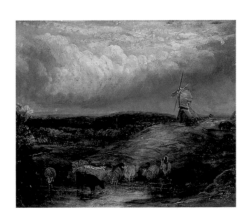

Dedham, Jacob (attributed to)
Stoke Bridge, Ipswich c.1810
oil on board 35.5 x 51
R.1961-162

Delamotte, William Alfred (circle of)
1775–1863
Cattle and Windmill
oil on panel 26.5 x 32
R.1931-28.45

Denner, Balthasar (circle of) 1685–1749
Possibly Marguerite Fonnereau as an Elderly Lady c.1700
oil on canvas 76 x 63
R.1985-79.23

Dodgson, John Arthur 1890–1969
Crusader's Moon c.1964
oil on canvas 63 x 77
R.1997-26

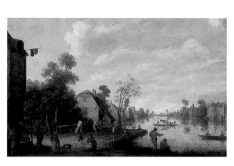

Droochsloot, Joost Cornelisz. 1586–1666
A Dutch Canal Scene
oil on panel 57 x 87
R.1921-105

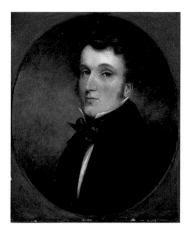

Dunthorne, John IV 1798–1832
Self Portrait c.1820
oil on canvas 30.5 x 25.5
R.1968-89

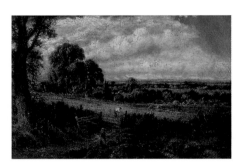

Dunthorne, John IV (attributed to)
1798–1832
Landscape, Cornfield
oil on canvas 44.5 x 66.5
R.1956-65

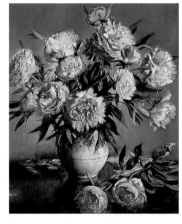

Durose, Anthea b.1933
Peonies 1978
oil on canvas 76 x 63.6
R.1992-68.1

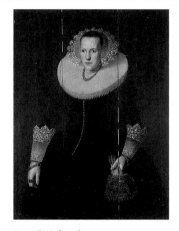

Dutch School
Portrait of a Lady 1629
oil on panel 115 x 84
R.1949-135.A

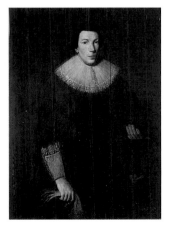

Dutch School
Portrait of a Man 1629
oil on panel 115 x 84
R.1949-135.B

Dutch School
Old Woman Eating
oil on canvas 62 x 51
R.1990-58.27

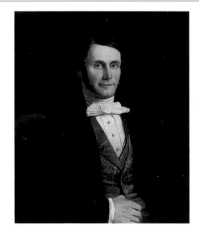

Duval, John 1816–1892
Frederick Worts (b.1806) 1852
oil on canvas 76.2 x 63.5
R.1974-41

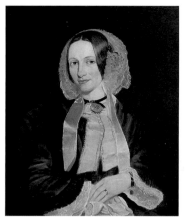

Duval, John 1816–1892
Mrs Frederick Worts (née Elizabeth Blomfield)
c.1852
oil on canvas 75 x 62
R.1974-42

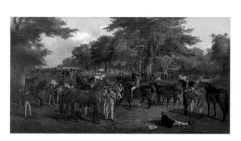

Duval, John 1816–1892
Suffolk Show in Christchurch Park 1869
oil on canvas 82.3 x 153
R.1939-98

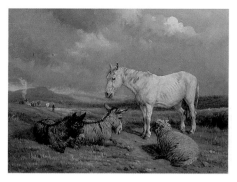

Duval, John 1816–1892
A Common Lot with a Pony, Donkeys and Sheep c.1886
oil on canvas 22 x 29.5
R.1993-68.3

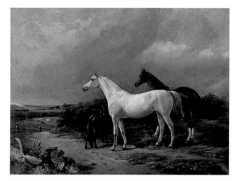

Duval, John 1816–1892
Horses in Stoke Park
oil on canvas 93 x 121
R.1951-95.A

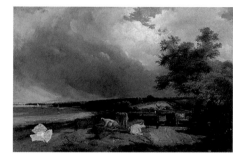

Duval, John 1816–1892
Orwell and Woolverstone Estate
oil on canvas 60 x 90
R.1939-103

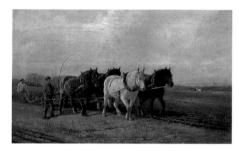

Duval, John 1816–1892
The Kentish Plough
oil on canvas 43 x 68
R.1912-10

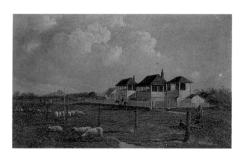

Duval, John (attributed to) 1816–1892
Ipswich Racecourse
oil on canvas 35.5 x 56
R.1928-139.1

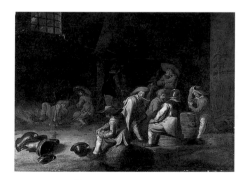

Duyster, Willem Cornelisz. c.1598–1635
Interior Guardroom, Soldiers off Duty
c.1620–c.1635
oil on panel 51.3 x 70
R.1992-8.3

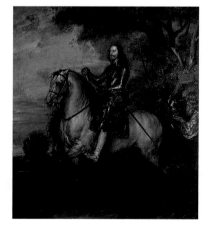

Dyck, Anthony van (after) 1599–1641
Charles I (1600–1649)
oil on canvas 96.5 x 86.5
R.1919-58

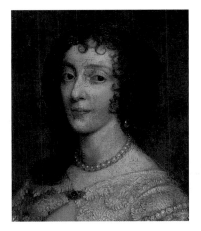

Dyck, Anthony van (after) 1599–1641
Henrietta Maria
oil on canvas 41 x 36
R.1927-18

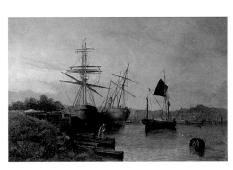

Edwards, John active 1880–1909
Ballast Quay, Ipswich Dock 1884
oil on canvas 51 x 76
R.1953-180

Ellison, R.
Oak Trees 1850–1880
oil on canvas 28 x 27
R.1942-79

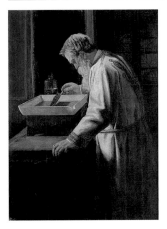

Esmond, Jane
An Etcher Biting (Edwin Edwards)
oil on canvas 106.5 x 76.5
R.1924-107

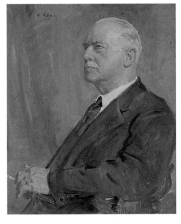

Eves, Reginald Grenville 1876–1941
Lord Woodbridge, Arthur Churchman
oil on canvas 76 x 63
R.1990-58.20

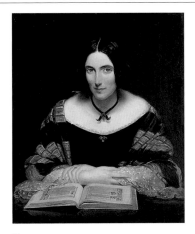

Fancourt
The Hon. Mrs E. Mills 1845
oil on canvas 78 x 63
R.1982-62

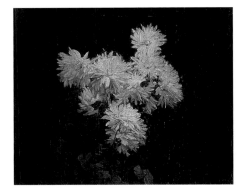

Fantin-Latour, Henri 1836–1904
Winter Blossoms
oil on canvas 31.5 x 38.5
R.1940-17

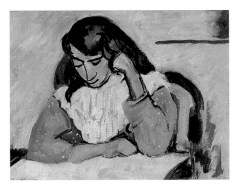

Farley, William 1895–1963
Girl Reading
oil on canvas 30.5 x 41
R.1985-77.2

Farley, William 1895–1963
Railway near Paris c.1945–1963
oil on canvas 40.5 x 51
R.1985-77.1

Fiske, George 1847–1932
Willy Lott's House, Flatford 1928
oil on canvas 25.5 x 31
R.1947-19

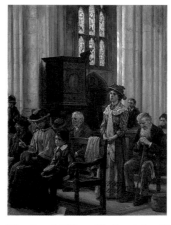

Fletcher, William Teulon Blandford
1858–1936
The Anthem c.1910
oil on canvas 120 x 90
R.1922-13

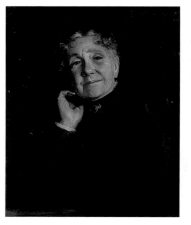

Folkard, Julia B. 1849–1933
Mary Anne Keeley (1805–1899) c.1870–
c.1880
oil on canvas 62 x 51
R.1915-33

Fonnereau
Brook and Trees, Study c.1920
oil on canvas 41 x 51
R.1920-46

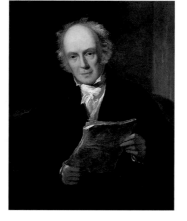

Fonnereau, Kate Georgina
William Charles Fonnereau (1804–1855) 1850
oil on canvas 85 x 69
R.1985-79.7

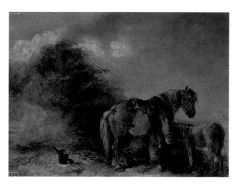

Fonnereau, Kate Georgina
Pony and Donkey 1852
oil on canvas 43 x 56
R.1939-74

Forbes, Stanhope Alexander 1857–1947
Forging the Anchor 1892
oil on canvas 263 x 221
R.1913-23.B0000

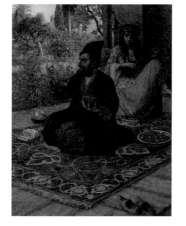

Forestier, Amédée 1854–1930
A Scene from Omar Khayyam c.1880–c.1890
oil on canvas 51 x 41.5
R.1933-265

Foster, Judy b.1937
Triangular Fruit c.1987
oil on board 30.5 x 44
R.1987-139.3

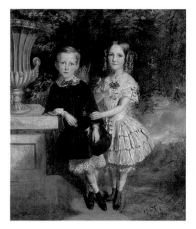

Fox, A. H. active 1840–1856
Boy and Girl in Landscape 1856
oil on canvas 76 x 64
R.1951-3

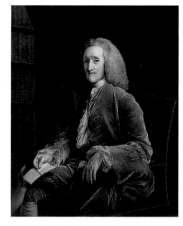

French School
Portrait of a Man in a Library c.1760–c.1761
oil on canvas 127 x 102
R.1949-59

Friswell, Harry P. Hain 1857–after 1906
Moments of Colour Harmony c.1900
oil on canvas 143 x 183
R.1961-187

Friswell, Harry P. Hain 1857–after 1906
Cornfield in Constable's Country
oil on panel 35 x 46
R.1933-223

Frost, George 1754–1821
Bramford and Ipswich Postwoman c.1800
oil on canvas 91.8 x 62.5
R.1922-115

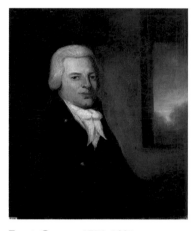

Frost, George 1754–1821
Self Portrait c.1800
oil on canvas 75 x 64
R.1906-23

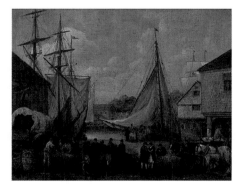

Frost, George 1754–1821
The Common Quay, Ipswich 1820
oil on canvas 45.7 x 59.7
R.1927-37

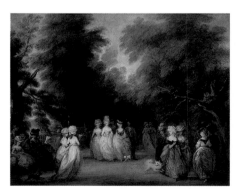

Frost, George 1754–1821
Ladies in the Mall c.1820
oil on canvas 93.5 x 119
R.1985-78

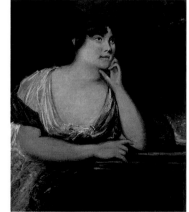

Frost, George (attributed to) 1754–1821
Mrs Elizabeth Cobbold (1765–1824) c.1800–
c.1820
oil on canvas 92 x 76
R.1946-113.A

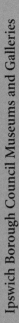

Frost, George (attributed to) 1754–1821
John Cobbold (1746–1835) c.1810
oil on canvas 91.5 x 76
R.1946-113.B

Frost, George (attributed to) 1754–1821
Westgate, St Matthew's, Ipswich
oil on panel 22 x 38
R.1922-8

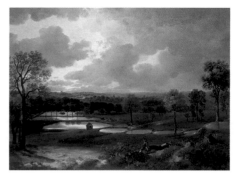

Gainsborough, Thomas 1727–1788
Holywells Park, Ipswich 1748–1750
oil on canvas 48.5 x 65
R.1992-5

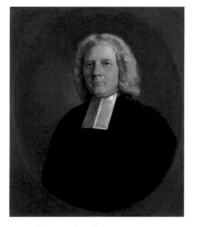

Gainsborough, Thomas 1727–1788
Reverend Robert Hingeston (1699–1776)
1750s
oil on canvas 75 x 62
R.2000-20

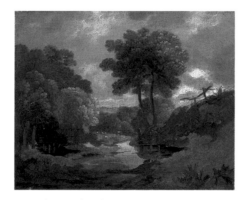

Gainsborough, Thomas 1727–1788
Pool in the Woods 1750–1755
oil on canvas 25 x 30
R.1924-81

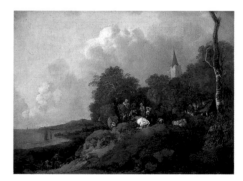

Gainsborough, Thomas 1727–1788
View near the Coast 1750–1755
oil on canvas 81.2 x 107.7
R.1941-76

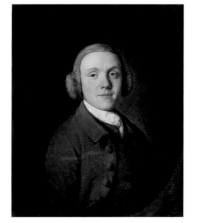

Gainsborough, Thomas 1727–1788
Samuel Kilderbee (1725–1813) 1750–1759
oil on canvas 72 x 63
R.1935-261

Gainsborough, Thomas 1727–1788
Tom Pear Tree c.1750–c.1759
oil on shaped panel 38 x 42
R.1902-10

Gainsborough, Thomas 1727–1788
John Sparrowe, Bailiff of Ipswich 1752–1759
oil on canvas 76.2 x 63.5
R.1971-69

Facing page: Browning, Amy Katherine, 1882–1978, *Lime Tree Shade* (detail), 1913,
Ipswich Borough Council Museums and Galleries, (p. 70)

Gainsborough, Thomas 1727–1788
Miss Edgar 1755–1765
oil on canvas 123.2 x 100.3
R.1951-141

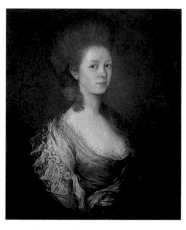

Gainsborough, Thomas 1727–1788
Mrs Kilderbee, née Mary Wayth (1723–1811)
1755–1765
oil on canvas 75 x 62
R.1959-130

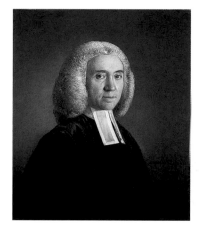

Gainsborough, Thomas 1727–1788
Reverend Canning (1708–1775) 1757
oil on canvas 74 x 62
R.1958-136

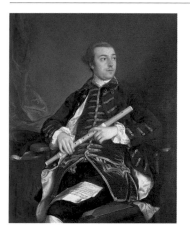

Gainsborough, Thomas 1727–1788
William Wollaston (1730–1797) c.1759
oil on canvas 127.5 x 100.3
R.1946-29

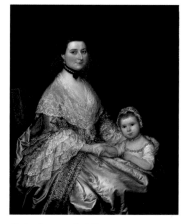

Gainsborough, Thomas 1727–1788
Mrs Bedingfield and Her Daughter 1760–1770
oil on canvas 128.3 x 102.8
R.1973-106

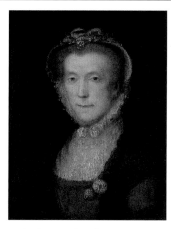

Gainsborough, Thomas 1727–1788
Duchess of Montagu (1711–1775) c.1760–
c.1770
oil on canvas 57.5 x 44
R.1953-98

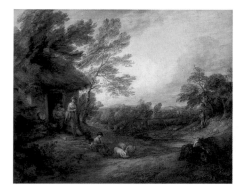

Gainsborough, Thomas 1727–1788
Cottage Door with Girl and Pigs c.1786
oil on canvas 98 x 124
R.1982-91

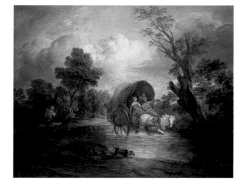

Gainsborough, Thomas 1727–1788
Country Cart Crossing a Ford c.1786
oil on canvas 98 x 124
R.1982-90

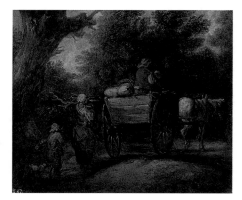

Gainsborough, Thomas (after) 1727–1788
A Country Cart c.1770
oil on canvas 47 x 56.5
R.1927-14

Gainsborough, Thomas (after) 1727–1788
Rustic Courtship
oil on canvas 75 x 115
C.047

Gainsborough, Thomas (attributed to)
1727–1788
George Dashwood of Peyton Hall 1758
oil on canvas 74 x 62
R.1947-34

Gardner, Daniel c.1750–1805
Golding Constable, the Artist's Father c.1805
oil on canvas 74 x 62
R.1925-24

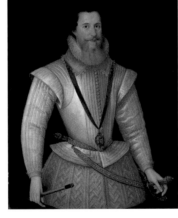

Gardner, Daniel c.1750–1805
Lord Henniker (1724–1803) (after Joshua Reynolds)
oil on canvas 76 x 63.5 (E)
R.1937-77

Geeraerts, Marcus the younger (attributed to) 1561–1635
Robert Devereux (1566–1601), 2nd Earl of Essex c.1596
oil on canvas 106.7 x 85.1
R.1950-179

George, Patrick b.1923
Francis Hoyland (b.1930) c.1956
oil on board 183 x 92
R.2001-5.1

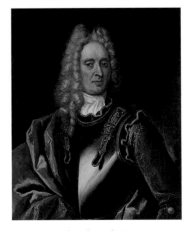

German (Bavarian) School
Horseman and Hounds
oil on canvas 82 x 64
R.1928-200.B

German (Bavarian) School
Legend of St Hubert
oil on canvas 81.5 x 66.5
R.1928-200.A

German School 18th C
Colonel Moses Leathes, Governor of Ghent
oil on canvas 82.5 x 66
R.1992-8.27

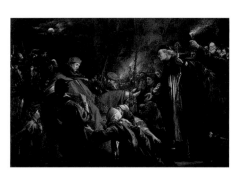

Gilbert, John 1817–1897
Cardinal Wolsey at Leicester Abbey 1876–1877
oil on canvas 137 x 198
R.1949-119

Gilman, Harold 1876–1919
Seated Girl in Blue c.1912–c.1913
oil on canvas 40.7 x 30.7
R.1974-129

Ginner, Charles 1878–1952
The Old Paper Mill c.1941–1942
oil on canvas 50 x 62
R.1973-33

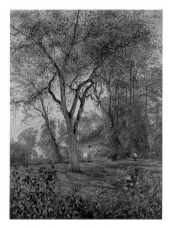

Goddard, J. Bedloe b.c.1850
Landscape with Thatched Cottage 1881
oil on canvas 61 x 45.5
R.1998-9.1

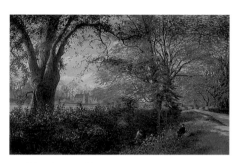

Goddard, J. Bedloe b.c.1850
View of a Lane with a House through Trees
1881
oil on canvas 35.5 x 53.4
R.1998-9.2

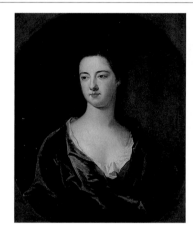

Godfrey
Lady of the Fonnereau Family c.1720
oil on canvas 76 x 63
R.1985-79.5

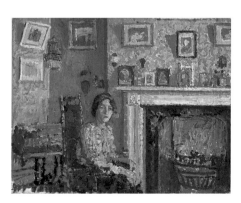

Gore, Spencer 1878–1914
Interior, Mornington Crescent 1910
oil on canvas 40.6 x 51
R.1968-38

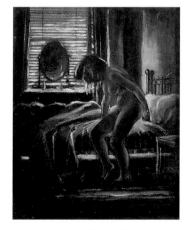

Govier, James 1910–1974
Putting on the Slipper c.1955
oil on board 36 x 29
R.1992-52.3

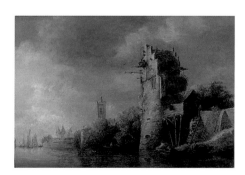

Goyen, Jan van (attributed to) 1596–1656
River Scene
oil on panel 49.5 x 71
R.1953-167

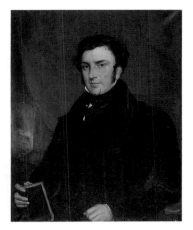

Grant, Francis 1803–1878
William Long (1802–1875) c.1840–c.1850
oil on canvas 92 x 74
R.1958-254.6

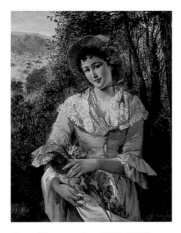

Gray, Kate active 1870–1897
Girl in Landscape with Flowers 1889
oil on canvas 91 x 71
R.1945-63

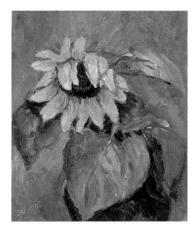

Grayson, Stanley b.1898
Sunflower 1955
oil on board 24.5 x 20
R.1967-74.C

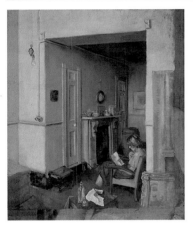

Grayson, Stanley b.1898
Interior with Girl Reading c.1955
oil on canvas 61 x 51
R.1967-74.A

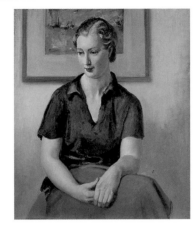

Grayson, Stanley b.1898
Seated Girl c.1955
oil on canvas 76 x 63
R.1967-74.B

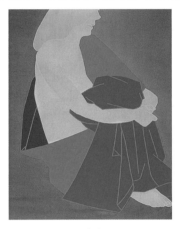

Greaves, Derrick b.1927
Listening to Music
acrylic on canvas 175 x 132
R.2002-16.7

Green, Anthony b.1939
Trimming, October 1994
oil on shaped board 107 x 183
R.1998-11

Griffiths, W. T. active 1878–1880
White Horse Corner c.1880
oil on canvas 47 x 40
R.1956-109

Gritten, A.
Yacht Race and Britannia
oil on canvas 35 x 46
R.1961-180

Grone, Ferdinand E. c.1845–1920
Evening at Lexden
oil on panel 15 x 25
R.1913-83

Gysbrechts, Franciscus active c.1674
Still Life
oil on canvas 127 x 102
R.1938-273

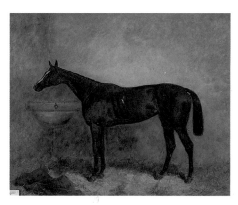

Hall, Harry 1814–1882
Fille de l'air 1865
oil on canvas 42 x 52
R.1945-97.F14

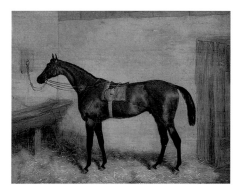

Hall, Harry 1814–1882
Ventre Saint Gris c.1868
oil on canvas 42 x 52 (E)
R.1945-97.F13

Hambling, Harry 1902–1998
Ray Watts c.1990
oil on board 53.5 x 40.5
R.1998-2

Hambling, Maggi b.1945
Teddy Wolfe and Blackie 1980
oil on canvas 54 x 72.5
R.1983-9

Hambling, Maggi b.1945
Champagne Laugh 1991
oil on canvas 213.4 x 152.4
R.1996-16

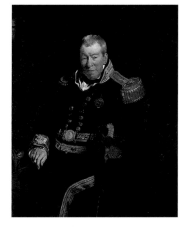

Hannah, Robert 1812–1909
Admiral Benjamin William Page c.1843–
c.1845
oil on canvas 125 x 98 (E)
R.1983-143.11

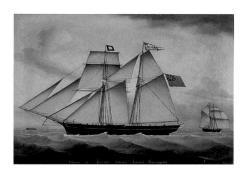

Hansen, E. B.
Alarm of Ipswich 1856
oil on canvas 52 x 76
R.1935-98

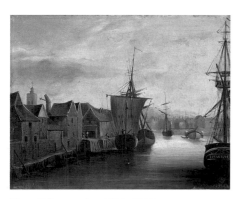

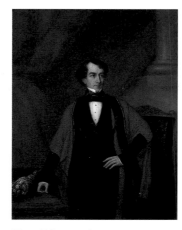

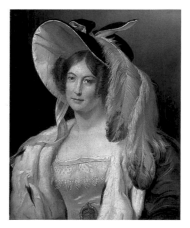

Hare, Jabez active 1820–1837
St Catherine's Quay, Ipswich c.1830
oil on board 43 x 54
R.1934-238

Hare, Jabez active 1820–1837
Alderman G. Sampson c.1836
oil on canvas 88 x 69 (E)
R.1983-143.15

Harlow, George Henry 1787–1819
Duchess of Kent (1786–1861)
oil on canvas 67 x 56
R.1947-210.15

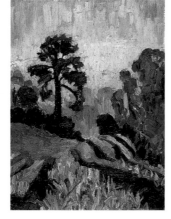

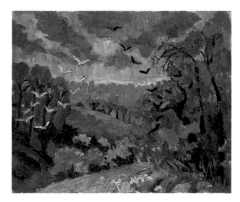

Harris, Tomás 1908–1964
Landscape, Palm Trees and Cacti 1954
oil on canvas 81 x 122
R.1975-39

Harwood, Lucy 1893–1972
Furrowed Fields c.1940–c.1972
oil on canvas 40.5 x 35.8
R.1987-1.1

Harwood, Lucy 1893–1972
Landscape with Gulls c.1940–c.1972
oil on canvas 51 x 61
R.1987-1.2

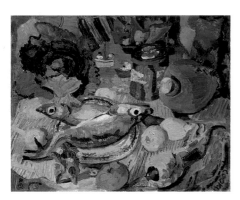

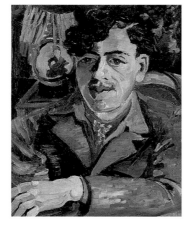

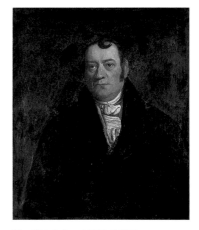

Harwood, Lucy 1893–1972
Still Life with Fish c.1940–c.1972
oil on canvas 61 x 77
R.1987-6

Harwood, Lucy 1893–1972
Glyn Morgan
oil on canvas 61 x 50.5
R.1988-2

Hazlitt, John 1767–1837
Thomas Clarkson (1760–1814) c.1805
oil on canvas 76 x 64
R.1932-39

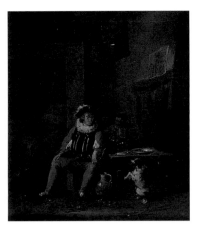

Heemskerck, Egbert van the elder
1634/1635–1704
Cavalier Seated in a Tavern
oil on canvas 61 x 52
R.1992-8.17

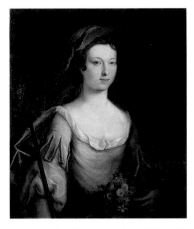

Heins, John Theodore Jr 1732–1771
Phoebe Fonnereau, as a Shepherdess 1765
oil on canvas 77 x 63
R.1985-79.26

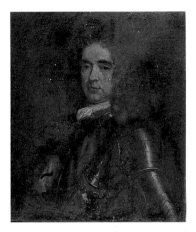

Helmont, Zeger Jacob van (circle of)
1683–1726
Duke of Marlborough 1714
oil on canvas 76.6 x 64
R.1992-8.23

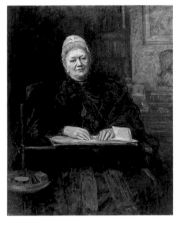

Herkomer, Herman 1863–1935
Mrs Phoebe Lankester 1895
oil on canvas 142 x 111
R.1934-175

Herman, Josef 1911–2000
Men at Table 1985–1987
oil & acrylic on canvas 71 x 94
R.1992-66-1

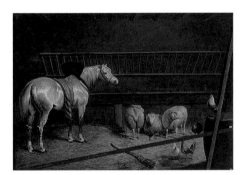

Herring, John Frederick I 1795–1865
Grey Horse in Stable 1827
oil on canvas 56.5 x 77
R.1945-97.F11

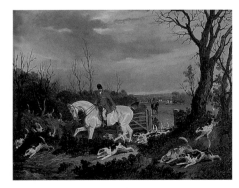

Herring, John Frederick I 1795–1865
Drawing the Covert c.1831
oil on canvas 28 x 36
R.1945-97.F5

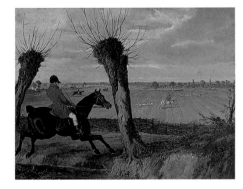

Herring, John Frederick I 1795–1865
Full Cry c.1831
oil on canvas 28 x 36
R.1945-97.F8

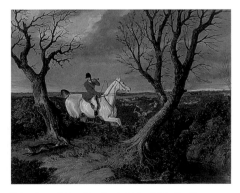

Herring, John Frederick I 1795–1865
Gone away c.1831
oil on canvas 28 x 36
R.1945-97.F6

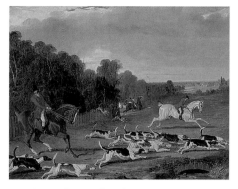

Herring, John Frederick I 1795–1865
Hounds Leaving Covert c.1831
oil on canvas 28 x 36
R.1945-97.F7

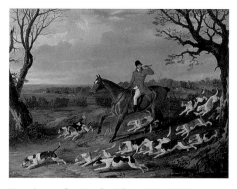

Herring, John Frederick I 1795–1865
Hunting Scene with Foxhounds c.1831
oil on canvas 71 x 92
R.1945-97.F10

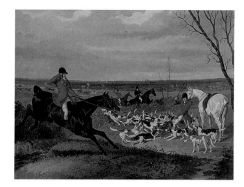

Herring, John Frederick I 1795–1865
The Kill c.1831
oil on canvas 28 x 36
R.1945-97.F9

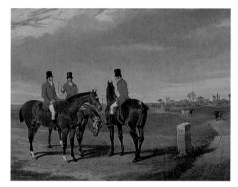

Herring, John Frederick I 1795–1865
The Meet c.1831
oil on canvas 18 x 24
R.1945-97.F4

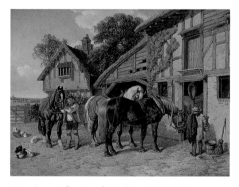

Herring, John Frederick I 1795–1865
Three Horses and Ducks in Stable 1838
oil on canvas 46 x 61
R.1945-97.F12

Herring, John Frederick I 1795–1865
Cotherstone, Winner of Derby 1843
oil on canvas 31 x 41
R.1945-97.F1

Herring, John Frederick I 1795–1865
Plenipo
oil on canvas 31 x 42
R.1945-97.F2

Herring, John Frederick I 1795–1865
Touchstone
oil on canvas 31.5 x 42
R.1945-97.F3

Hickey, Thomas (circle of) 1741–1824
Indian Woman and Two Servants
oil on canvas 127.5 x 99
R.1960-175

Hilton, Roger 1911–1975
March, 1955 1955
oil on canvas 86.4 x 112
R.1972-25

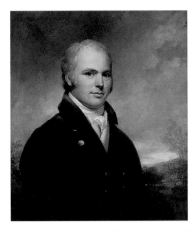

Howard, Henry (attributed to) 1769–1847
Joshua Kirby Trimmer c.1810
oil on canvas 76 x 64
R.1935-40

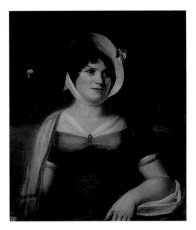

Howard, Henry (attributed to) 1769–1847
Mrs Kirby Trimmer c.1810
oil on canvas 77 x 64
R.1935-41

Howlin, John b.1941
Tedesco 1962–1965
acrylic on canvas 169 x 169
R.1976-33

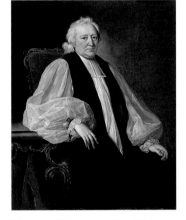

Hudson, Thomas 1701–1779
Reverend Sir Thomas Gooch (1674–1754)
1749
oil on canvas 125 x 100
R.1929-60

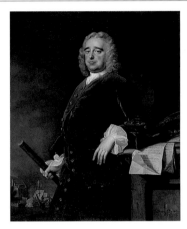

Hudson, Thomas 1701–1779
Admiral Edward Vernon (1684–1757) c.1739
oil on canvas 127 x 102
R.1934-164

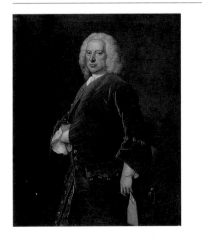

Hudson, Thomas (attributed to) 1701–1779
James Vernon (1675–1750)
oil on canvas 140 x 100 (E)
R.1934-163

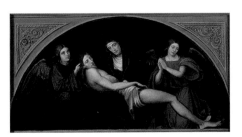

Hunter, Elizabeth active 1853–1883
Pietà
oil on canvas 25.5 x 47
R.1946-4

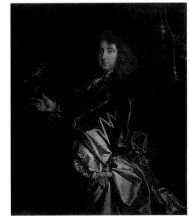

Huysman, Jacob c.1633–1696
Sir Samuel Barnardiston (1620–1707)
1660–1679
oil on canvas 130 x 107.5
R.1957-60

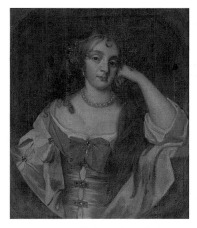

Huysman, Jacob (attributed to)
c.1633–1696
Lady of the Fonnereau Family c.1660
oil on canvas 77 x 64
R.1985-79.25

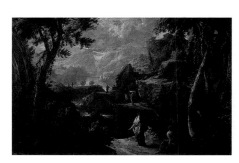

Italian School
Landscape
oil on canvas 104.5 x 160
R.1908-12

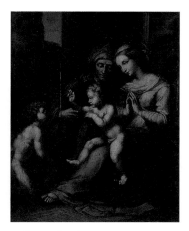

Italian School
Madonna and Child with St John and St Anne
oil on panel 47 x 38
R.1952-249

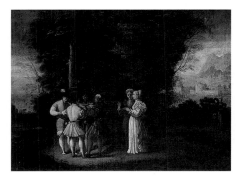

Italian (Venetian) School 17th C
Figures in Landscape
oil on canvas 49 x 65
R.1990-58.30

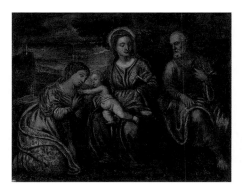

Italian (Venetian) School
Holy Family
oil on canvas 85 x 109
R.1961-174

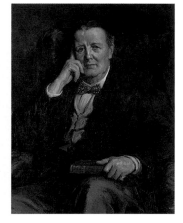

Jacomb-Hood, George Percy 1857–1930
Sir Edwin Ray Lankester, President of Ipswich Museum (c.1900–1929) c.1910–c.1920
oil on canvas 92 x 71
R.1922-105

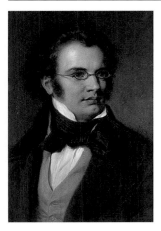

Jager, Carl
Franz Schubert 1870–1900
oil on canvas 65 x 46
R.1900-7.16

Jager, Carl
J. Ludwig Uhland 1870–1900
oil on canvas 65 x 46
R.1900-7.13

Jager, Carl
Johann Sebastian Bach 1870–1900
oil on canvas 65 x 46
R.1900-7.1

Jager, Carl
Johann Wolfgang von Goethe 1870–1900
oil on canvas 65 x 46
R.1900-7.7

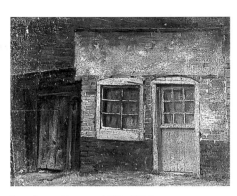

Jennings, George 1872–1930
Southwold, Suffolk
oil on canvas 19.6 x 25.2
R.1985-152.65

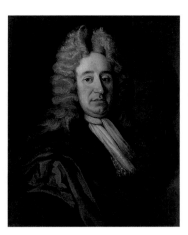

Jervas, Charles (attributed to) c.1675–1739
Gentleman of the Wright Family c.1700
oil on canvas 76.5 x 64
L.1937-138

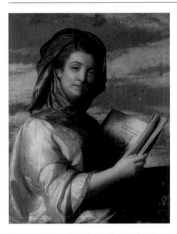

Jervas, Charles (attributed to) c.1675–1739
Lady Diana Beauclerk
oil on canvas 91 x 70
R.1933-157

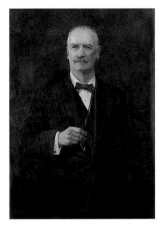

Johns, Edwin Thomas 1862–1947
Sir Daniel Ford Goddard 1923
oil on canvas 95.5 x 68
R.1967-48

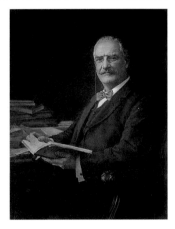

Johns, Edwin Thomas 1862–1947
Sir Daniel Ford Goddard
oil on canvas 104 x 76
R.1990-58.32

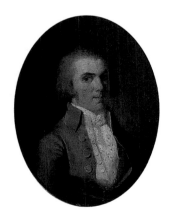

Johnson, William active 1780–1810
Self Portrait c.1780
oil on canvas 30 x 24
R.1964-8

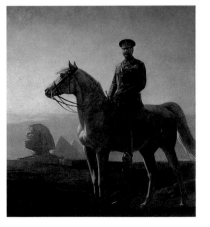

Jones, Adrian 1845–1938
Earl Kitchener of Khartoum 1916
oil on canvas 340 x 245 (E)
R.1983-143.4

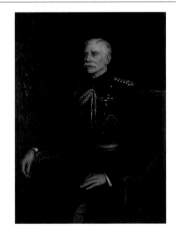

Jonniaux, Alfred 1882–1974
Lieutenant General Sir Ronald Lane, KCV
1915
oil on canvas 140 x 100
R.1972-99

Facing page: Cooper, Daniel, 1749–1822, *The Courtship* (detail), 1777, Ipswich Borough Council Museums and Galleries, (p. 77)

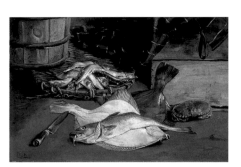

Keene, Charles Samuel 1823–1891
Still Life with Fish c.1860–1880
oil on canvas 57.5 x 87.5
R.1993-17

Kiddall, Helen D. 1888–1980
Albert Schweitzer 1950–1960
oil on board 42 x 33
R.1982-17

Kiddall, Helen D. 1888–1980
African Mother c.1950–c.1960
oil on board 32 x 25
R.1982-18

Kiddall, Helen D. 1888–1980
New World c.1950–c.1960
oil on board 34 x 24
R.1982-15

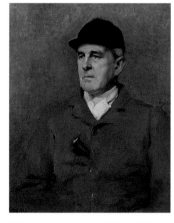

Kiddall, Helen D. 1888–1980
A Huntsman c.1952
oil on canvas 77 x 64
R.1952-180

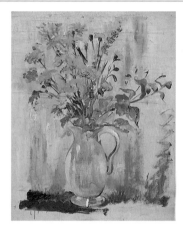

Kiddall, Helen D. 1888–1980
Flowers in a Jug
oil on canvas 50 x 40
R.1982-25.O

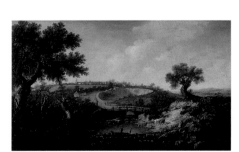

Kirby, John Joshua 1716–1774
Sandpit near Sudbury
oil on canvas 74 x 124
R.1949-188

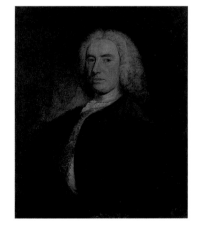

Kneller, Godfrey 1646–1723
Sir Philip Meadows (1626–1718) c.1710
oil on canvas 74.2 x 61.6
R.1966-61

Kneller, Godfrey (attributed to) 1646–1723
George I (1660–1727), as Elector of Hanover
oil on canvas 236 x 147
R.1952-276

Kneller, Godfrey (circle of) 1646–1723
Edward Russell (1653–1727), 1st Lord Orford
c.1700
oil on canvas 73.7 x 61
R.1937-79

Kneller, Godfrey (follower of) 1646–1723
George I (1660–1727), in Armour
oil on canvas 78.1 x 64.1
R.1992-8.24

Kneller, Godfrey (follower of) 1646–1723
Lieutenant Jeremiah Mussenden
oil on canvas 78.8 x 64.2
R.1992-8.25

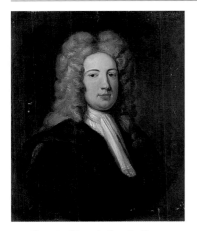

Kneller, Godfrey (school of) 1646–1723
Gentleman of the Fonnereau Family c.1710
oil on canvas 76 x 63 (E)
R.1985-79.19

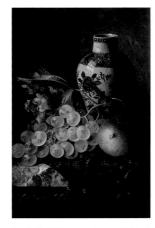

Ladell, Ellen active c.1886–1898
Still Life
oil on canvas 35 x 24
R.1925-98

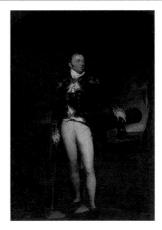

Lane, Samuel (attributed to) 1780–1859
Admiral Sir P. Bowes Vere Broke, Bt (1776–1840) c.1814
oil on canvas 147.5 x 110
R.1983-143.14

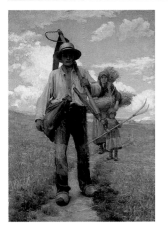

Laugée, Georges 1853–1928
French Peasants in a Stubble Field 1882
oil on canvas 167 x 117
R.1922-14

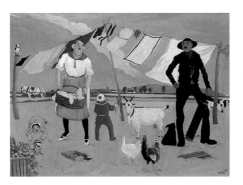

Lay, Cecil Howard 1885–1956
Contrasts No.2 1933
oil on hardboard 56 x 76.5
R.1987-91.8

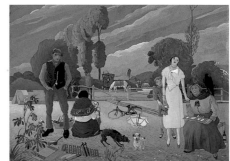

Lay, Cecil Howard 1885–1956
Forecasting a Loss No.2 1933
oil on panel 56 x 76
R.1995-44

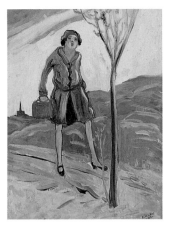

Lay, Cecil Howard 1885–1956
Woman in Gray Coat with a Bag 1933
oil on board 33 x 24
R.1984-102.4

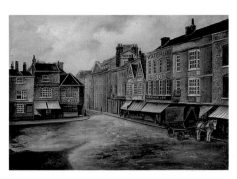

Leggett, W. J. active 1842–1906
The Cornhill, 1842 1842
oil on canvas 76.5 x 101.5
R.1936-86.6

Leggett, W. J. active 1842–1906
Dog's Head Street in 1886 1886
oil on canvas 56 x 76.5
R.1936-86.13

Leggett, W. J. active 1842–1906
Old Warehouse, Turret Lane 1886
oil on canvas 51 x 63.5
R.1936-86.31

Leggett, W. J. active 1842–1906
Upper Orwell Street, Ipswich, 1903 1903
oil on canvas 56 x 76
R.1936-86.12

Leggett, W. J. active 1842–1906
Corner, Brook Street, Old Buttermarket 1906?
oil on canvas 76 x 102
R.1936-86.3

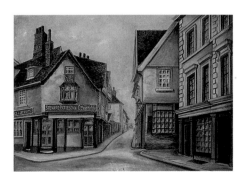

Leggett, W. J. active 1842–1906
Angel Lane, Fore Street, Tavern
oil on unmounted paper/card 48 x 61
R.1950-166.7

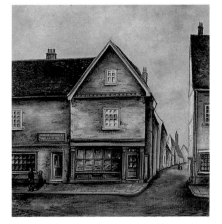

Leggett, W. J. active 1842–1906
Carr Street
oil on canvas 54 x 51
R.1936-86.37

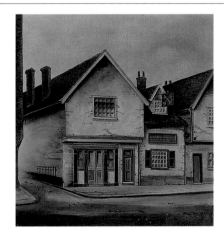

Leggett, W. J. active 1842–1906
Carr Street
oil on canvas 53.5 x 51
R.1936-86.41

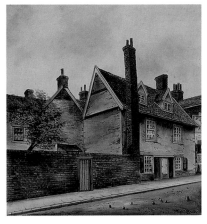

Leggett, W. J. active 1842–1906
Clay Lane
oil on canvas 53.5 x 51
R.1936-86.36

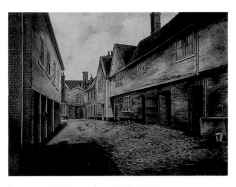

Leggett, W. J. active 1842–1906
Coach and Horses Yard, Upper Brook Street
oil on canvas 56 x 76
R.1936-86.14

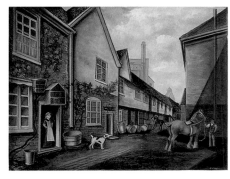

Leggett, W. J. active 1842–1906
Coach and Horses Yard, Upper Brook Street
oil on canvas 56 x 76
R.1936-86.15

Leggett, W. J. active 1842–1906
Crown and Anchor Tap
oil on canvas 46 x 61
R.1936-86.23

Leggett, W. J. active 1842–1906
Crown and Anchor Yard
oil on canvas 46 x 35
R.1950-166.10

Leggett, W. J. active 1842–1906
Crown Street, Pretty Factory
oil on canvas 56 x 76
R.1936-86.10

Leggett, W. J. active 1842–1906
Fore Street
oil on canvas 45
R.1936-81.40

Leggett, W. J. active 1842–1906
Fore Street
oil on canvas 47 x 62.5
R.1936-86.21

Leggett, W. J. active 1842–1906
Inns and Taverns, Upper Orwell Street
oil on canvas 66 x 86.5
R.1956-38

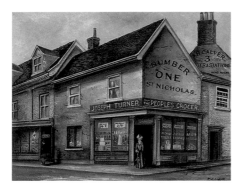

Leggett, W. J. active 1842–1906
Joseph Turner, People's Grocer, St Nicholas'
Street
oil on canvas 32 x 43
R.1950-166.6

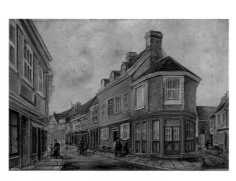

Leggett, W. J. active 1842–1906
Junction, Lower Orwell Street, Fore Street
oil on canvas 61 x 88
R.1936-86.9

Leggett, W. J. active 1842–1906
Northgate Street, Oak Lane Corner
oil on canvas 44 x 33
R.1950-166.9

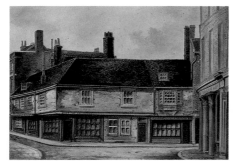

Leggett, W. J. active 1842–1906
Old Buttermarket
oil on canvas 34 x 46
R.1950-166.1

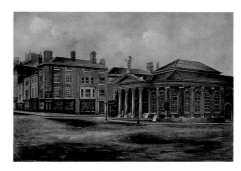

Leggett, W. J. active 1842–1906
Old Corn Exchange, Pulled down in 1880
oil on canvas 76.5 x 102.5
R.1936-86.2

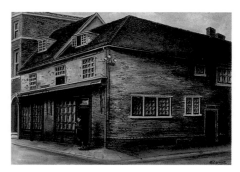

Leggett, W. J. active 1842–1906
Old Corner, St Mary Elms
oil on unmounted paper/card 33 x 45.7
R.1950-166.2

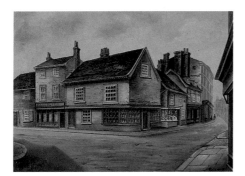

Leggett, W. J. active 1842–1906
Old Corner, Tacket Street
oil on canvas 32 x 45
R.1950-166.5

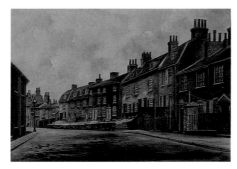

Leggett, W. J. active 1842–1906
Old Foundry Road
oil on canvas 76 x 101.5
R.1936-86.4

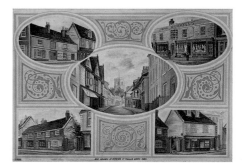

Leggett, W. J. active 1842–1906
Old Houses, St Peter's Street
oil on canvas 62 x 88.5
R.1936-86.8

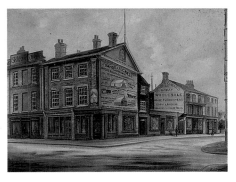

Leggett, W. J. active 1842–1906
Prince's Street
oil on canvas 53 x 65
R.1936-86.30

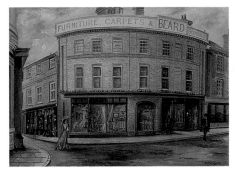

Leggett, W. J. active 1842–1906
Queen Street
oil on canvas 51 x 64
R.1936-86.29

Leggett, W. J. active 1842–1906
St Helen's Street, Corner Grove Lane
oil on canvas 46 x 61
R.1936-86.22

Leggett, W. J. active 1842–1906
St Matthew's Street
oil on canvas 75.5 x 101.5
R.1936-86.1

Leggett, W. J. active 1842–1906
St Matthew's Street
oil on canvas 56 x 71
R.1936-86.17

Leggett, W. J. active 1842–1906
St Nicholas' Street
oil on canvas 56 x 71
R.1936-86.18

Leggett, W. J. active 1842–1906
St Nicholas' Street
oil on canvas 53.5 x 51
R.1936-86.35

Leggett, W. J. active 1842–1906
St Peter's Street
oil on canvas 53 x 73.5
R.1936-86.19

Leggett, W. J. active 1842–1906
St Peter's Street
oil on canvas 56 x 71
R.1936-86.20

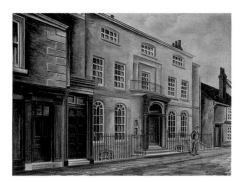

Leggett, W. J. active 1842–1906
St Peter's Street
oil on canvas 47 x 62.5
R.1936-86.24

Leggett, W. J. active 1842–1906
St Peter's Street
oil on canvas 46 x 61
R.1936-86.28

Leggett, W. J. active 1842–1906
St Peter's Street
oil on canvas 54 x 51
R.1936-86.39

Leggett, W. J. active 1842–1906
St Peter's Street
oil on canvas 51.5 x 54
R.1936-86.42

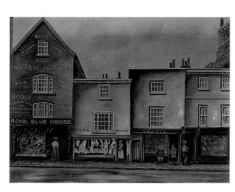

Leggett, W. J. active 1842–1906
Tavern Street
oil on canvas 46 x 61
R.1936-86.27

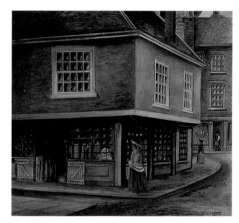

Leggett, W. J. active 1842–1906
The Grasshopper Shop, Throughfare
oil on unmounted paper/card 48 x 61
R.1950-166.8

Leggett, W. J. active 1842–1906
The Oak, Northgate Street
oil on canvas 61.5 x 46
R.1936-86.33

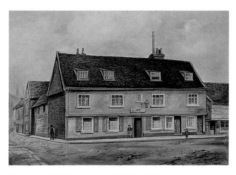

Leggett, W. J. active 1842–1906
The Plough Inn, Dog's Head Street
oil on canvas 51 x 63.5
R.1936-86.32

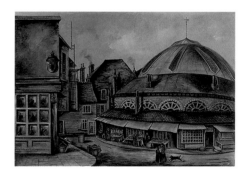

Leggett, W. J. active 1842–1906
The Rotunda, Cornhill
oil on canvas 78.5 x 102
R.1936-86.5

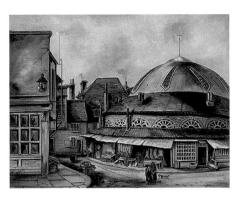

Leggett, W. J. active 1842–1906
The Rotunda, Market, Cornhill
oil on canvas 57 x 77
R.1936-86.11

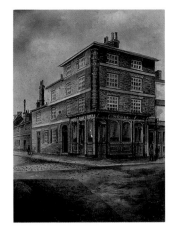

Leggett, W. J. active 1842–1906
The Sickle Inn, King Street
oil on canvas 46 x 34
R.1950-166.3

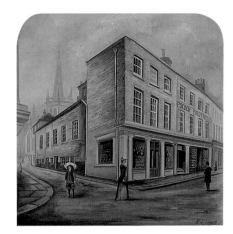

Leggett, W. J. active 1842–1906
Tower Street
oil on canvas 53.5 x 51
R.1936-86.34

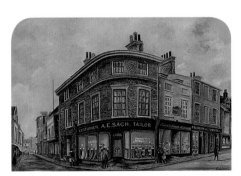

Leggett, W. J. active 1842–1906
Upper Brook Street, Corner Tavern Street
oil on canvas 76 x 101.5
R.1936-86.7

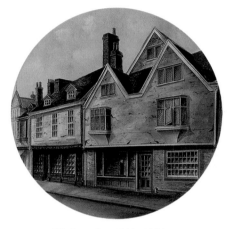

Leggett, W. J. active 1842–1906
*Upper Brook Street, Underwood's First
Premises and Pallants' Refreshment Rooms*
oil on canvas 51 x 53.5
R.1936-86.38

Leggett, W. J. active 1842–1906
Upper Orwell Street
oil on canvas 56 x 76.5
R.1936-86.16

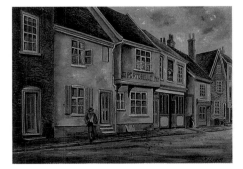

Leggett, W. J. active 1842–1906
Upper Orwell Street
oil on canvas 46 x 61
R.1936-86.26

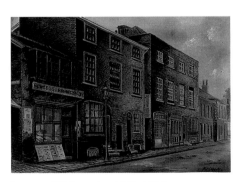

Leggett, W. J. active 1842–1906
Upper Orwell Street, Shops
oil on canvas 46 x 61.5
R.1936-86.25

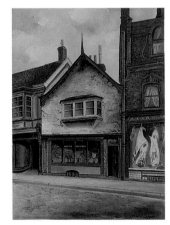

Leggett, W. J. active 1842–1906
Westgate Street
oil on canvas 45 x 33
R.1950-166.4

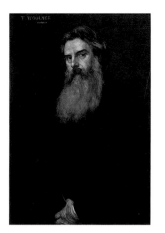

Legros, Alphonse 1837–1911
Thomas Woolner
oil on canvas 85 x 57
R.1921-106

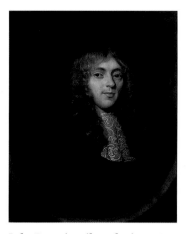

Lely, Peter (after) 1618–1680
Charles II (1630–1685) c.1680
oil on canvas 76.8 x 63.8
R.1953-93

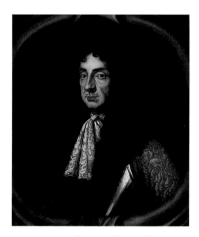

Lely, Peter (attributed to) 1618–1680
*Charles Vesey (d.1681–1685) of Hintlesham
Hall* 1670–1675
oil on canvas 76.4 x 63.7
R.1906-25

Lessore, John b.1939
St James' Church, Peckham
oil on board 51.5 x 75
R.2002-16.9

Linnell, John 1792–1882
Katherine Georgina Fonnereau 1846
oil on canvas 93 x 72.5
R.1985-79.8

Lithiby, Beatrice Ethel 1889–1966
Helen D. Kiddall c.1961
oil on unmounted paper/card 19.3 x 15.9
R.1982-19

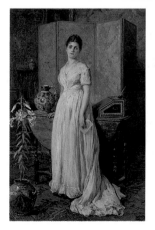

Lucas, Seymour 1849–1923
Yesterday (The Letter) c.1880
oil on canvas 68 x 52
R.1932-148

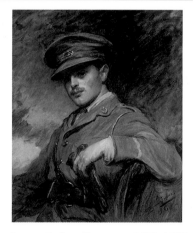

Lucas, Sydney Seymour 1888–1954
Courtenay Barry 1916
oil on canvas 78 x 65
L.1950-242

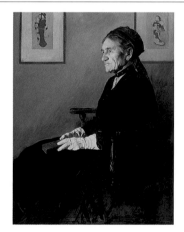

Lucas, Sydney Seymour 1888–1954
Mrs Ernest Crofts 1937
oil on canvas 131 x 98.5
R.1939-17

Facing page: Mead, Rose, 1867–1946, *Barbara Stone* (detail), c.1940, St Edmundsbury Museums, (p.25)

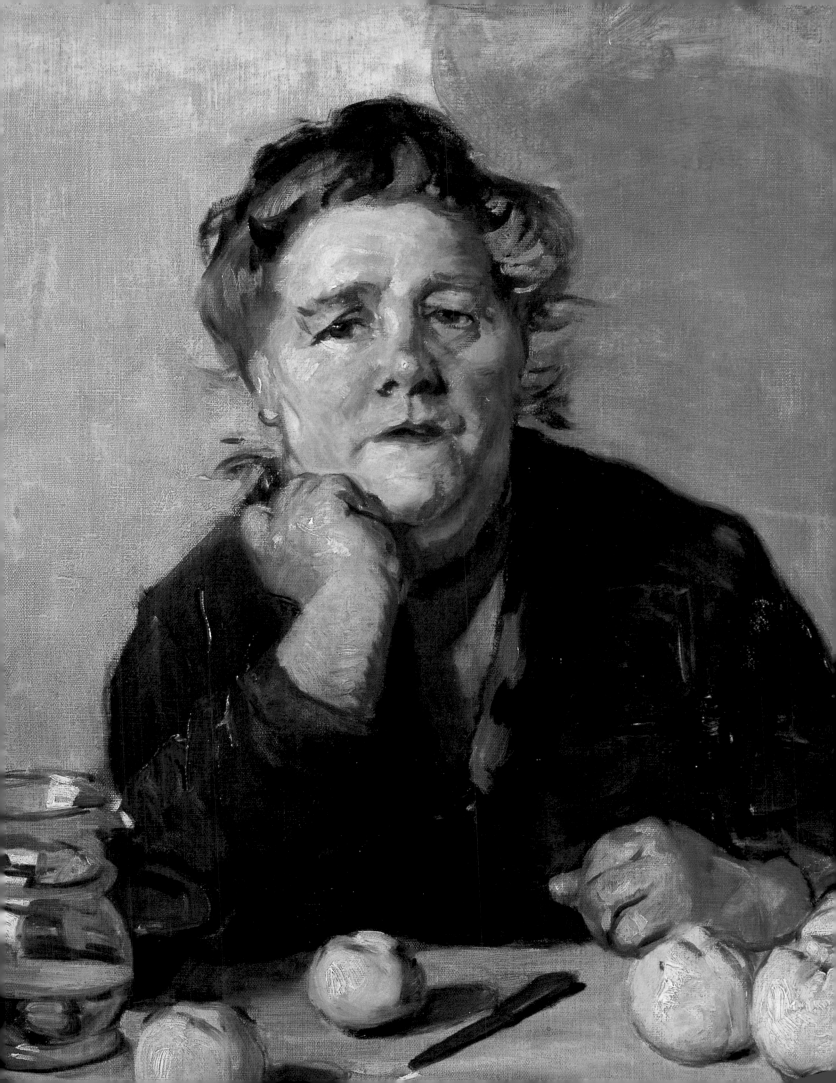

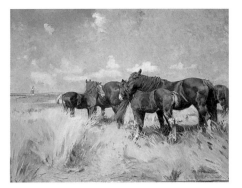

Lucas, Sydney Seymour 1888–1954
Suffolk Punches, Mares and Foals c.1938
oil on canvas 66 x 77
R.1938-232

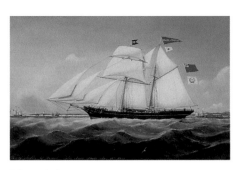

Mann, John
Pride of Mistley, off Harwich 1866
oil on board 50 x 73
R.1952-191

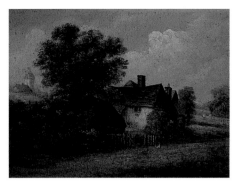

Mascall, Christopher Mark 1846–1933
Belstead Road, Ipswich c.1890–c.1920
oil on board 33 x 41.5
R.1943-123

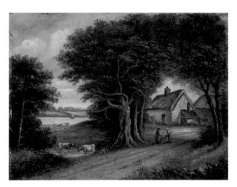

Mascall, Christopher Mark 1846–1933
Pond Hall and River Orwell c.1890–c.1920
oil on board 29 x 37.5
R.1943-122

Mascall, Christopher Mark 1846–1933
Felix Thornley Cobbold c.1900
oil on panel 27.5 x 20
R.1952-271

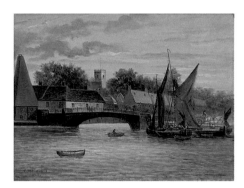

Mascall, Christopher Mark 1846–1933
Stoke Bridge 1913
oil on panel 35.5 x 46
R.1936-219

Mascall, Christopher Mark 1846–1933
Mr Fish
oil on canvas 74 x 63
C.024

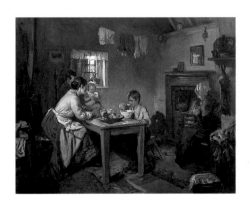

Mead, Rose 1867–1946
Cottage Interior c.1908
oil on canvas 101.5 x 126
R.1928-189

Mellis, Margaret b.1914
Scarlet Green Square 1966
oil on hardboard 92 x 92
R.2002-16.11

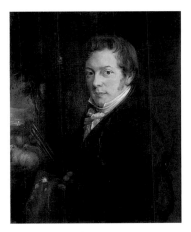

Mendham, Robert 1792–1875
Self Portrait c.1810
oil on canvas 72 x 61
R.1938-211

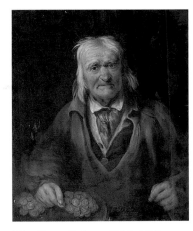

Mendham, Robert 1792–1875
The Miser of Eye c.1820
oil on canvas 76.5 x 64
R.1978-23

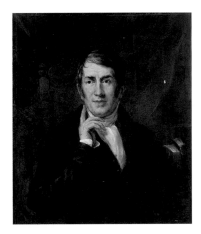

Mendham, Robert 1792–1875
Bernard Barton c.1831
oil on canvas 76 x 64
R.1956-10.1

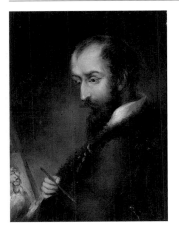

Mendham, Robert 1792–1875
Portrait of a Man (after Correggio) c.1850
oil on board 26.5 x 19.5
R.1951-193.A

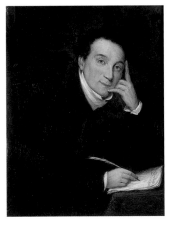

Mendham, Robert 1792–1875
Reverend Richard Cobbold c.1850
oil on canvas 38 x 29
R.1917-19.1

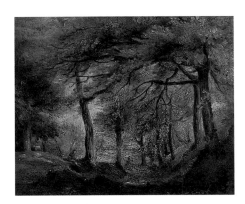

Mendham, Robert 1792–1875
Ice House, Back of Broome Hall 1851
oil on panel 20 x 26
R.1948-198

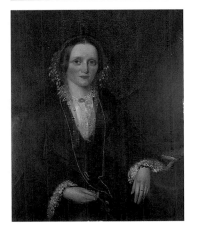

Mendham, Robert 1792–1875
Susanna Hewitt, née Garnham (1807–1891)
1856
oil on board 30 x 25
R.1956-10.4

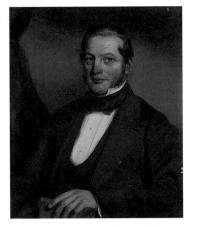

Mendham, Robert 1792–1875
William Robert Hewitt (1806–1887) c.1856
oil on board 31 x 25
R.1956-10.3

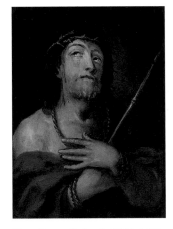

Mendham, Robert 1792–1875
Christ with Thorns
oil on panel 24 x 18
R.1951-193.C

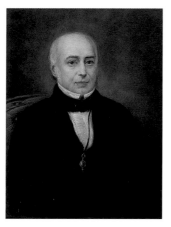

Mendham, Robert 1792–1875
Portrait of a Man
oil on board 30.5 x 22.5
R.1951-193.D0000

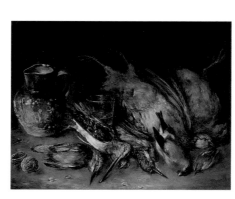

Mendham, Robert 1792–1875
Still Life
oil on canvas 36 x 46
R.1951-193

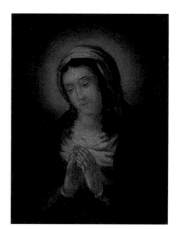

Mendham, Robert 1792–1875
Virgin Mary
oil on panel 24.5 x 18
R.1951-193.B

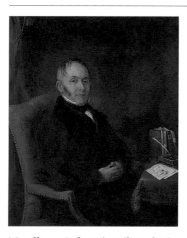

Mendham, Robert (attributed to)
1792–1875
Joseph Welham (1785–1842)
oil on panel 46 x 39.5
R.1956-10.2

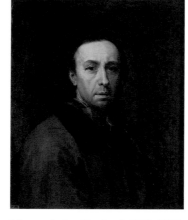

Mengs, Anton Raphael 1728–1779
Self Portrait
oil on canvas 66.5 x 54.5
R.1911-4

Meredith, Francis V.
St Francis Blessing Assisi c.1855
oil on canvas 100 x 220
R.1946-103

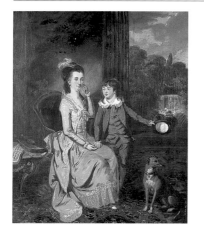

Metz, Conrad Martin 1749–1827
*Mrs Elizabeth Mary Ivory (née Fonnereau)
and Her Son, John Thornay* 1776
oil on canvas 86.3 x 71.4
R.1971-47

Michau, Theobald 1676–1765
Rocky Landscape with Peasants
oil on canvas 51 x 66
R.1992-8.15

Momper, Joos de 1564–1635 **& Brueghel, Jan
the elder** 1568–1625
River with Castle, Horsemen and Woodcutters
oil on panel 47.5 x 74.5
R.1992-8.14

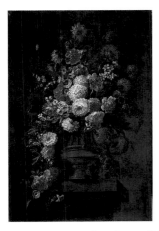

Monnoyer, Jean-Baptiste 1636–1699
Summer Flowers in Bronze Urn c.1665–c.1699
oil on canvas 121 x 82
R.1992-8.8

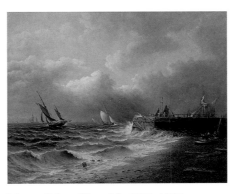

Moore, John of Ipswich 1820–1902
Seapiece c.1840–c.1902
oil on canvas 91 x 117
R.1911-32

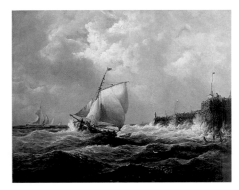

Moore, John of Ipswich 1820–1902
Shipping at Harbour Mouth c.1840–c.1902
oil on canvas 43 x 54
R.1913-82

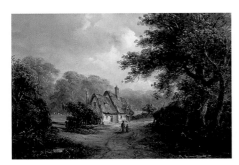

Moore, John of Ipswich 1820–1902
Cottage in a Wood c.1850–c.1902
oil on canvas 26 x 38.5
R.1931-28.7

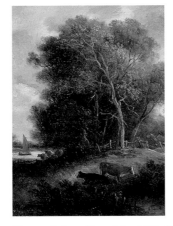

Moore, John of Ipswich 1820–1902
Distant View of an Estuary c.1850–c.1902
oil on panel 24 x 20
R.1931-28.16

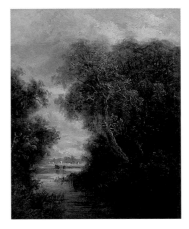

Moore, John of Ipswich 1820–1902
Landscape with Cattle c.1850–c.1902
oil on canvas 33.5 x 28
R.1931-28.14

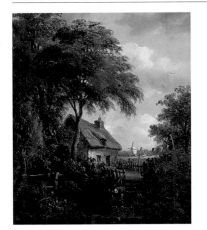

Moore, John of Ipswich 1820–1902
Landscape with Girl at Pool c.1850–c.1902
oil on panel 30 x 25
R.1931-28.12

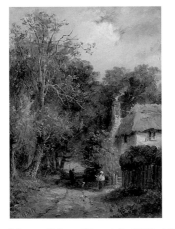

Moore, John of Ipswich 1820–1902
Lane and Cottage, Wherstead Road c.1850–c.1902
oil on canvas 23 x 18
R.1931-28.3

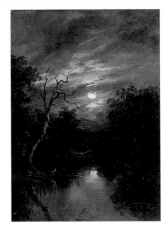

Moore, John of Ipswich 1820–1902
Moonlit Landscape c.1850–c.1902
oil on panel 34 x 25
R.1931-28.92

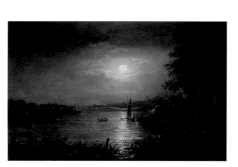

Moore, John of Ipswich 1820–1902
Moonlit River Landscape c.1850–c.1902
oil on canvas 25 x 38
R.1931-28.6

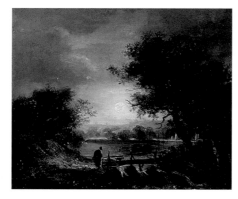

Moore, John of Ipswich 1820–1902
Moonlit Scene and Footbridge c.1850–c.1902
oil on panel 16.5 x 20.5
R.1931-28.87

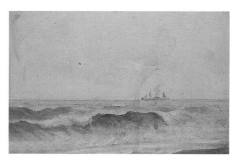

Moore, John of Ipswich 1820–1902
Off Yarmouth, Seascape c.1850–c.1902
oil on canvas 18.5 x 26
R.1961-183

Moore, John of Ipswich 1820–1902
Seascape c.1850–c.1902
oil on panel 30.5 x 41
R.1928-197

Moore, John of Ipswich 1820–1902
Seascape c.1850–c.1902
oil on canvas 39.5 x 46
R.1928-98

Moore, John of Ipswich 1820–1902
Seascape, Fishing c.1850–c.1902
oil on canvas 61 x 92
R.1949-4

Moore, John of Ipswich 1820–1902
Shipping in a Breeze c.1850–c.1902
oil on panel 33.5 x 31
R.1925-175.2

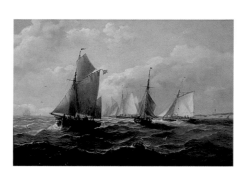

Moore, John of Ipswich 1820–1902
Shipping in a Breeze on a Rolling Sea
c.1850–c.1902
oil on panel 30.3 x 45.7
R.1931-28.8

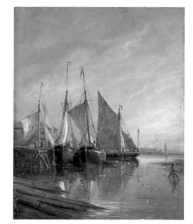

Moore, John of Ipswich 1820–1902
Shipping, Low Tide c.1850–c.1902
oil on panel 26 x 20
R.1931-28.10

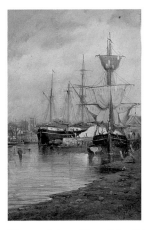

Moore, John of Ipswich 1820–1902
Ships in Ipswich Dock c.1850–c.1902
oil on unmounted paper/card 21 x 17
R.1950-62.A

Moore, John of Ipswich 1820–1902
Palette with Scenes, Sketches c.1870–c.1900
oil on panel 33.2 x 45.7
R.1953-193

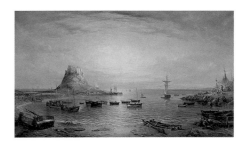

Moore, John of Ipswich 1820–1902
Holy Island, Northumberland 1877
oil on canvas 105 x 181 (E)
R.1932-227

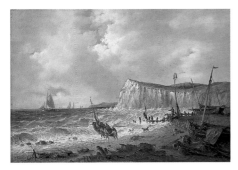

Moore, John of Ipswich 1820–1902
Northumberland Coast c.1877–c.1880
oil on panel 39.4 x 56
R.1938-135

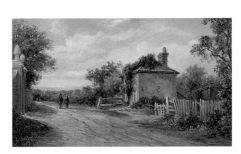

Moore, John of Ipswich 1820–1902
Old Park Road, Ipswich 1879
oil on canvas 14.5 x 23.5
R.1924-105

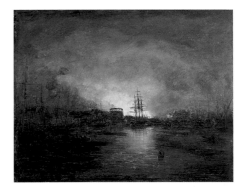

Moore, John of Ipswich 1820–1902
Ipswich Docks with Distant Conflagration
1879?
oil on canvas 21 x 26.5
R.1971-136

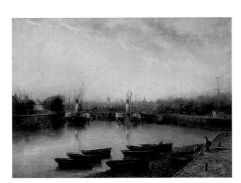

Moore, John of Ipswich 1820–1902
New Cut, West Entrance to Old Dock, Ipswich
c.1880
oil on canvas 57 x 72
R.1939-162

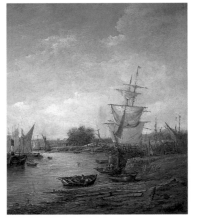

Moore, John of Ipswich 1820–1902
River Front, Ipswich Docks c.1880
oil on canvas 76 x 66
R.1928-129

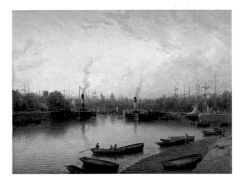

Moore, John of Ipswich 1820–1902
The Promenade and River Steamers, Ipswich
1882
oil on canvas 57 x 77
R.1938-133

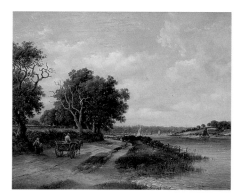

Moore, John of Ipswich 1820–1902
River Orwell from the Strand 1883
oil on canvas 40 x 50
R.1949-92

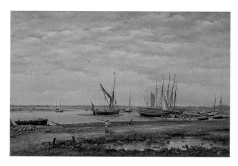

Moore, John of Ipswich 1820–1902
Slaughden Quay 1883
oil on canvas 30.5 x 46
R.1941-64

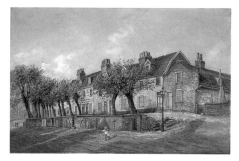

Moore, John of Ipswich 1820–1902
Tower Ramparts, Ipswich 1887
oil on canvas 41 x 61
R.1945-42

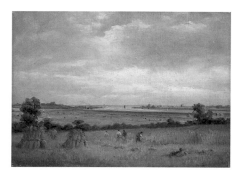

Moore, John of Ipswich 1820–1902
Bawdsey Ferry near Felixstowe
oil on canvas 33 x 43
R.1917-8

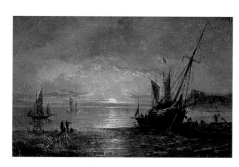

Moore, John of Ipswich 1820–1902
Boat on Beach, Sunset
oil on panel 16 x 24
R.1931-28.4

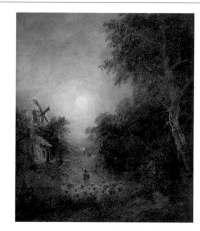

Moore, John of Ipswich 1820–1902
Evening Landscape
oil on panel 25 x 20
R.1931-28.17

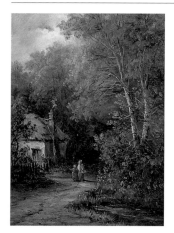

Moore, John of Ipswich 1820–1902
Lane and Cottage
oil on panel 22.3 x 16.6
R.1931-28.11

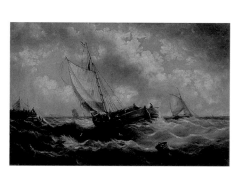

Moore, John of Ipswich 1820–1902
Shipping
oil on canvas 61.5 x 91.5
R.1942-111.29

Moore, John of Ipswich 1820–1902
Village Scene with Two Figures
oil on board 26 x 23
R.1993-68.2

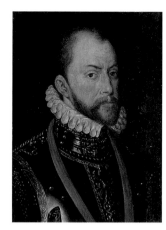

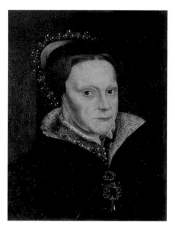

Moorhouse, F. N.
Heifer and Young Bull 1857
oil on board 15 x 23
R.1931-28.56

Mor, Antonis (after) 1512–1516–c.1576
Philip of Spain
oil on panel 29 x 22
R.1942-54

Mor, Antonis (after) 1512–1516–c.1576
Queen Mary I (1516–1558)
oil on panel 29 x 22
R.1942-53

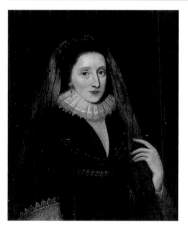

Mor, Antonis (attributed to)
1512–1516–c.1576
Lady of the Boleyn Family (possibly Mary Boleyn)
oil on panel 76 x 62
R.1972-61

Morgan, Glyn b.1926
Cedric Morris in His Garden c.1957
oil on board 51 x 63
R.1992-59 ✿

Morland, George (attributed to) 1763–1804
Landscape with Gypsy Figures at a Fire in a Wood
oil on canvas 39.5 x 32.5
R.1925-111

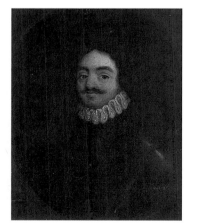

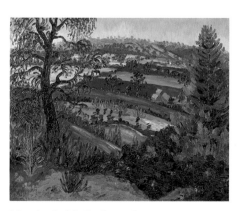

Moroni, Giovanni Battista (attributed to)
c.1525–1578
Sir Walter Raleigh 1577
oil on canvas 30.5 x 25.5
R.1959-275

Morris, Cedric Lockwood 1889–1982
The River Stour in Flood 1930
oil on canvas 61 x 77
R.1987-5

Morris, Mali b.1945
Athabasca Trail
acrylic on canvas 152.5 x 84
R.2002-16.13

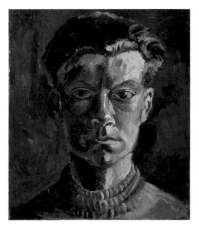

Moss, Colin b.1914
Self Portrait 1934
oil on canvas 35.5 x 31
R.1985-64.4

Moss, Colin b.1914
Gaumont Cinema Audience 1948
oil on unmounted paper/card 28 x 38
R.1985-64.16

Moss, Colin b.1914
Gladioli 1954
oil on board 90 x 60
R.1985-64.2

Moss, Colin b.1914
Man with a Drill c.1959
oil on board 120 x 89
R.1982-47

Moss, Colin b.1914
Dustbin 1960
oil on board 101 x 74
R.1985-64.5

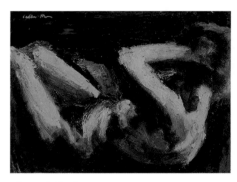

Moss, Colin b.1914
Rolling Nude 1966
oil on board 75 x 101
R.1985-64.3

Moss, Colin b.1914
Landscape 1976
oil on canvas 75 x 100
R.1985-64.1

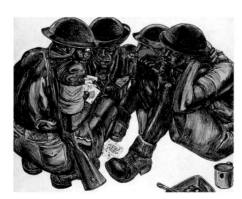

Moss, Colin b.1914
Playing Soldiers 1978
oil & collage on canvas 98 x 120
R.1982-46

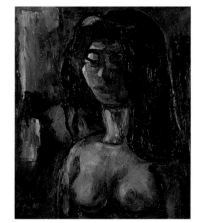

Moss, Colin b.1914
The Japanese Model 1982
oil on canvas 81 x 50.5
R.1985-64.6

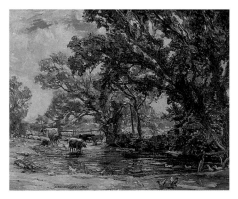

Moss, Sidney Dennant 1884–1946
Constable's County
oil on canvas 80 x 100
R.1949-104

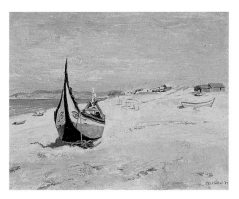

Müller, P.
Costa de Caparica, Portugal 1957
oil on canvas 60 x 84
C.033

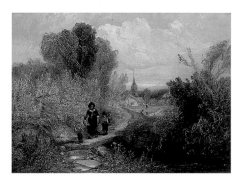

Müller, William James 1812–1845
Landscape with Figures c.1830–c.1845
oil on canvas 29 x 40
R.1906-26

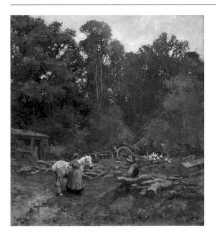

Munnings, Alfred James 1878–1959
Landscape at Crostwick c.1905
oil on canvas 43.2 x 39.3
R.1945-101

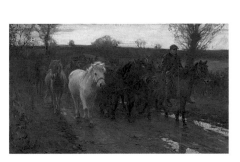

Munnings, Alfred James 1878–1959
Travellers 1910
oil on canvas 76.5 x 126.8
R.1911-10

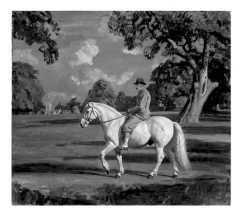

Munnings, Alfred James 1878–1959
*King George V Riding His Favourite Pony 'Jock'
in Sandringham Great Park* c.1935
oil on canvas 93 x 103
R.1936-350

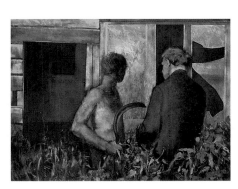

Murfin, Michael b.1954
An Afternoon 1978
acrylic on canvas 96.5 x 129.5
R.2002-16.15

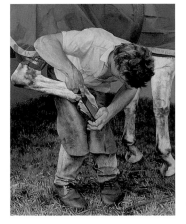

Murfin, Michael b.1954
The Farrier 1985
tempera on canvas 69 x 54
R.1989-3

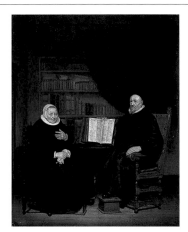

Musscher, Michiel van 1645–1705
Burgomaster and His Wife c.1665–c.1705
oil on panel 42.5 x 33
R.1992-8.4

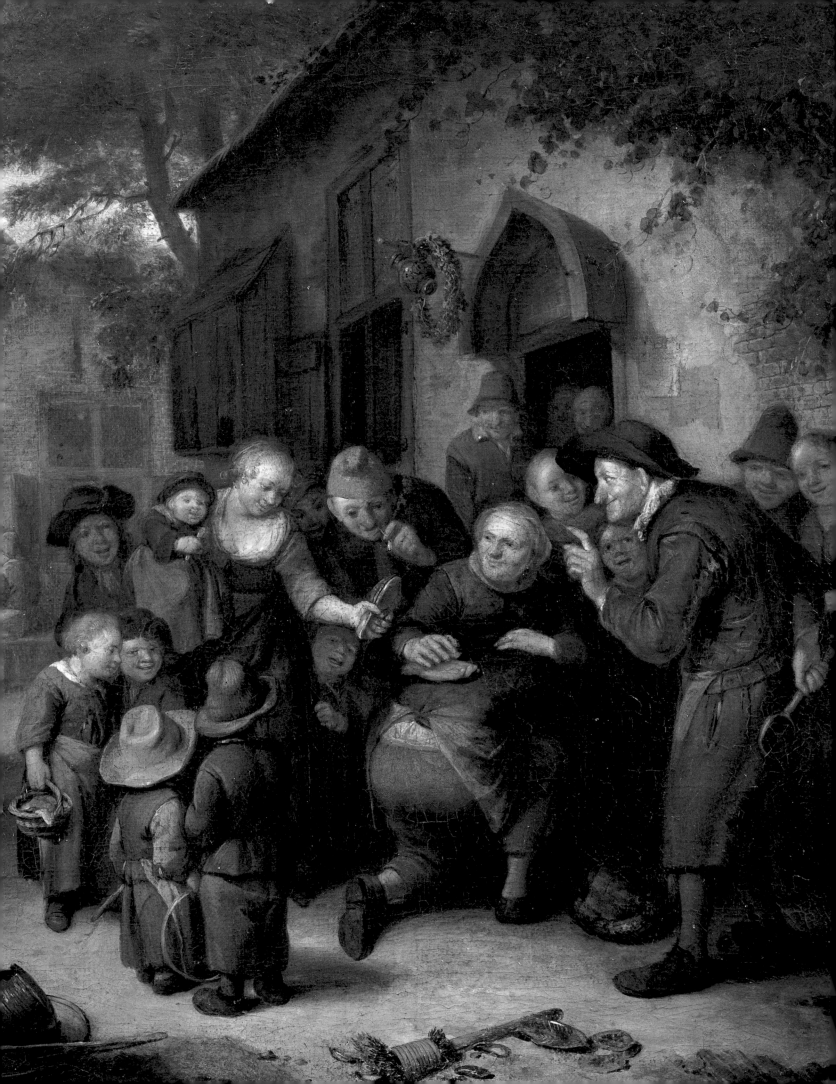

Myn, Frans van der (attributed to)
c.1719–1783
Charles Long III (1748–1813) c.1755
oil on canvas 123 x 101
R.1958-254.10

Myn, Frans van der (attributed to)
c.1719–1783
Dudley Long North (1749–1829) c.1755
oil on canvas 124.5 x 101
R.1958-254.9

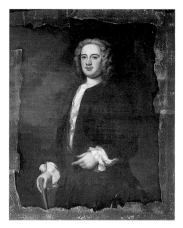

Myn, Frans van der (attributed to)
c.1719–1783
Dudley North (1706–1764)
oil on canvas 125 x 99
R.1958-254.4

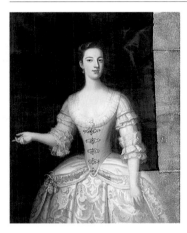

Myn, Frans van der (attributed to)
c.1719–1783
Lady Barbara Herbert, Mrs D. North
oil on canvas 127 x 102
R.1958-254.3

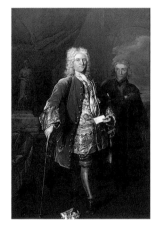

Myn, Herman van der 1684–1741
William Leathes, Ambassador Brussels
1710–1711
oil on canvas 241 x 149.5
R.1992-8.1

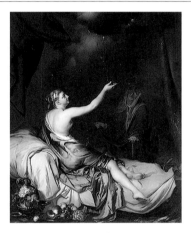

Myn, Herman van der 1684–1741
Danae
oil on panel 70 x 60
R.1992-8.7

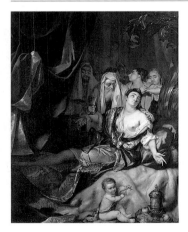

Myn, Herman van der 1684–1741
Death of Sophonisba
oil on panel 74 x 51
R.1992-8.13

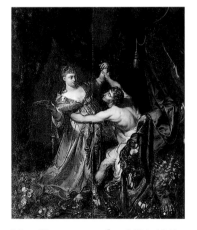

Myn, Herman van der 1684–1741
Tamar and Ammon
oil on panel 70 x 60
R.1992-8.11

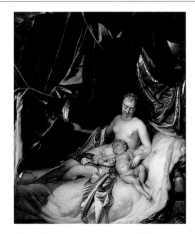

Myn, Herman van der 1684–1741
Venus and Cupid
oil on panel 71 x 59
R.1992-8.6

Facing page: Ostade, Adriaen van, 1610–1685, *Hot Cockles* (detail), Ipswich Borough Council Museums and Galleries, (p. 126)

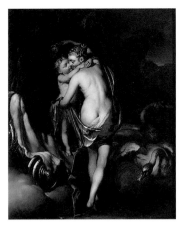

Myn, Herman van der 1684–1741
Venus and Cupid
oil on panel 52.3 x 43
R.1992-8.18

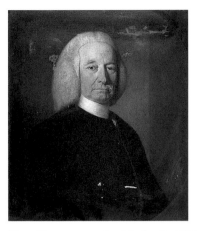

Myn, Herman van der (circle of) 1684–1741
Carteret Mussenden Leathes
oil on canvas 77 x 66
R.1992-8.29

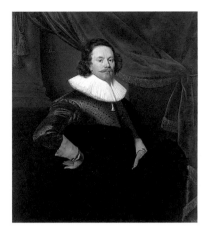

Mytens, Daniel I c.1590–before 1648
John Cotton c.1627–1628
oil on canvas 123 x 108
R.1957-124

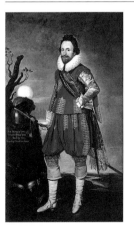

Mytens, Daniel I (attributed to)
c.1590–before 1648
Sir Henry Peyton (d.1622–1623) c.1621
oil on canvas 217 x 130.8
R.1940-25.A0000

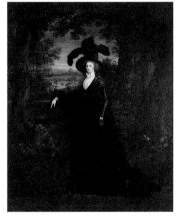

Nasmyth, Alexander 1758–1840
Mrs Merry or Mrs Leathes c.1790
oil on canvas 72 x 58
R.1992-8.33

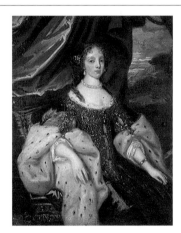

Netscher, Caspar (school of) 1639–1684
Catherine of Braganza
oil on canvas 44.5 x 35.5
R.1937-76.B

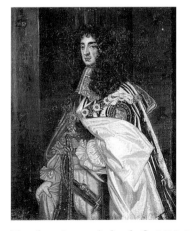

Netscher, Caspar (school of) 1639–1684
Charles II (1630–1685)
oil on canvas 44.5 x 35.5
R.1937-76.A

Newcomb, Mary b.1922
*There are no Raindrops on the Branches where
the Birds are Sitting* 1981
oil on canvas 77.5 x 77.5
R.2002-16.16

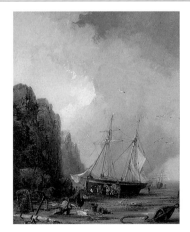

Niemann, Edmund John 1813–1876
Whitby
oil on canvas 39.5 x 34.5
R.1931-28.26

Niemann, Edmund John (attributed to)
1813–1876
At Flatford
oil on panel 14 x 36
R.1961-167

Niemann, Edmund John (attributed to)
1813–1876
Harrow from Hampstead
oil on panel 12.5 x 36
R.1961-166

Norman, George P. 1840–1914
Hayfield before 1914
oil on canvas 51 x 89
R.1961-173

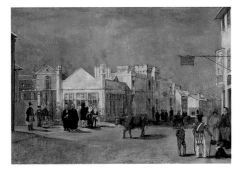

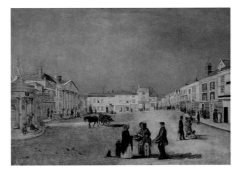

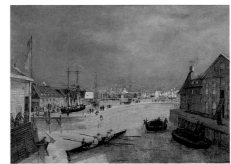

Nursey, Claude Lorraine Richard Wilson
1816–1873
The County Gaol, St Helen's Street c.1840–
c.1850
oil on canvas 90 x 124
R.1961-186

Nursey, Claude Lorraine Richard Wilson
1816–1873
The Cornhill, Ipswich c.1842
oil on canvas 94 x 127
R.1970-105

Nursey, Claude Lorraine Richard Wilson
1816–1873
The Wet Dock, Ipswich c.1842
oil on canvas 89 x 125
R.1970-127

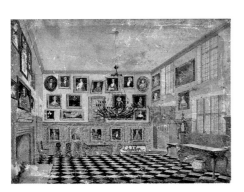

Nursey, Claude Lorraine Richard Wilson
(after) 1816–1873
Interior of Christchurch Mansion, Seat of C. W.
Fonnereau Esq.
oil over etching on board 27.5 x 37
R.1988-5.98B

Oliver
Belstead Road 1929
oil on canvas 27.5 x 20
R.1951-250.22

Orchardson, William Quiller 1832–1910
In the Conservatory 1894
oil on canvas 65 x 47
R.1948-184

Ostade, Adriaen van 1610–1685
Hot Cockles
oil on canvas 41.5 x 49.5
R.1992-8.5

Paling, Isaack 1664–c.1720
Duke of Marlborough, Churchill 1703
oil on canvas 78 x 64
R.1934-137

Parsons, Richard 1925–2000
Walberswick Boats 1982
acrylic on board 40 x 117
R.2004-10

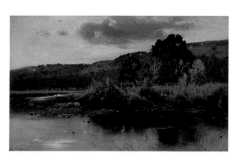

Parton, Ernest 1845–1933
Streatley Hill on the Thames 1875–1930
oil on canvas 43 x 67
R.1931-28.54

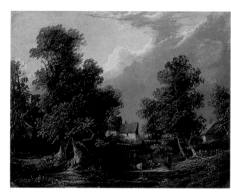

Paul, Joseph 1804–1887
Landscape
oil on panel 22 x 27
R.1920-12

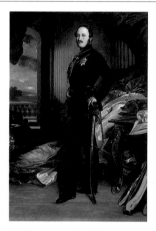

Phillips, Frank Albert c.1849–1913
Prince Albert (1819–1861) 1875
oil on canvas 237 x 155
R.1983-143.12B

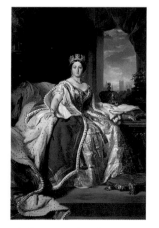

Phillips, Frank Albert c.1849–1913
Queen Victoria (1819–1901) 1875
oil on canvas 241 x 157
R.1983-143.12A

Piper, J. D. 1818–1900
Monument to Dr Roland Taylor
oil on card 39 x 29.5
R.1946-182

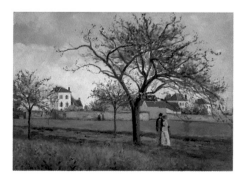

Pissarro, Camille 1831–1903
La maison du père Gallien à Pontoise 1866
oil on canvas 40.3 x 55.2
R.1976-63

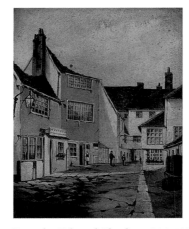

Pissarro, Lucien 1863–1944
The Stour at Stratford St Mary 1934
oil on canvas 55.3 x 46.4
R.1976-40

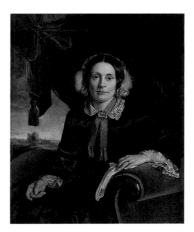

Pococke, Edward Charles 1846–1905
*The Old Yard of the Crown and Anchor,
Ipswich* 1887
oil on board 32 x 26
R.1924-106.6

Poole, L. T.
Lady Fillingham on a Red Sofa 1851
oil on canvas 92 x 77.5
R.1948-200

Prentice, W. Charles 1858–1933
St Stephen's Lane, Ipswich c.1900–c.1930
oil on panel 25.5 x 15.5
R.1931-28.74

Prentice, W. Charles 1858–1933
Buttermarket, Looking West 1917
oil on canvas 98.5 x 68
R.1970-125

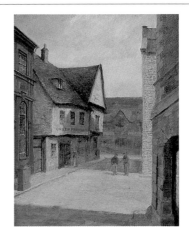

Prentice, W. Charles 1858–1933
Entrance, Unitarian Chapel 1920
oil on panel 32 x 20.5
R.1921-83

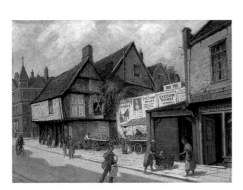

Prentice, W. Charles 1858–1933
No.2 Tacket Street 1920–1930
oil on panel 24 x 37
R.1934-145.4

Prentice, W. Charles 1858–1933
Back of Manning's Wine Store, Cornhill 1922
oil on canvas 41 x 31
R.1934-145.3

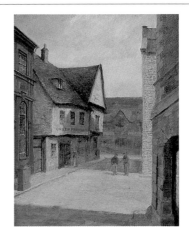

Prentice, W. Charles 1858–1933
Green Man Inn, Salthouse Street c.1931
oil on canvas 41 x 30.5
R.1931-168

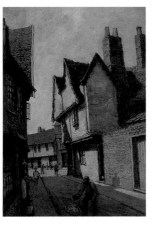

Prentice, W. Charles 1858–1933
Angel Lane, Ipswich 1933
oil on panel 35 x 25
R.1934-145.2

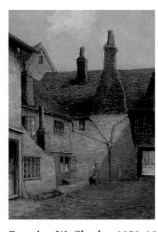

Prentice, W. Charles 1858–1933
Cooke's Court, St Clement's
oil on board 31 x 22
R.1936-315

Priest, Alfred 1810–1850
The Shipwreck c.1830–c.1850
oil on canvas 56 x 91.5
R.1913-81

Priestman, Bertram 1868–1951
Walberswick Marshes 1921
oil on canvas 59 x 70.8
R.1928-185

Priestman, Bertram 1868–1951
The Port of Ipswich 1930
oil on board 40 x 50
R.1931-167

Quinton, Alfred Robert 1853–1934
The Monkey's Revel
oil on canvas 46 x 61
R.1990-58.26

Rayson, David b.1966
Blackham Road 1999
acrylic on board 90 x 122
R.2000-19-1

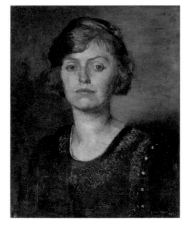

Reeve, Russell Sidney 1895–1970
Portrait of an Unknown Woman 1922
oil on canvas 50 x 40
R.2000-6.2

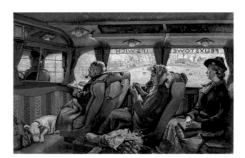

Reeve, Russell Sidney 1895–1970
The Felixstowe to Ipswich Coach 1940–1950
oil on canvas 78 x 120
R.1977-13

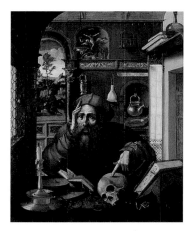

Reymerswaele, Marinus van (follower of)
c.1490–c.1567
St Jerome with a Skull
oil on panel 104 x 87
R.1932-74

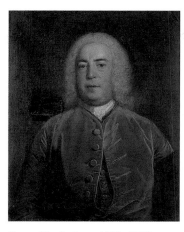

Reynolds, Joshua 1723–1792
Sir Hutchins Williams (1701–1758) 1756
oil on canvas 76 x 63.5
R.1977-61

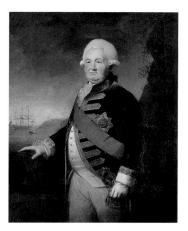

Reynolds, Joshua 1723–1792
Admiral Sir Edward Hughes (1720–1794)
c.1787–c.1792
oil on canvas 126 x 100
R.1983-143.10

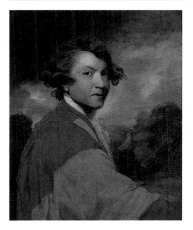

Reynolds, Joshua (after) 1723–1792
Joshua Reynolds (1723–1792) c.1773
oil on canvas 73.6 x 60.9
R.1949-147

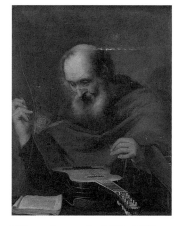

Ribera, Jusepe de 1591–1652
Man Re-stringing a Guitar
oil on canvas 89 x 71
R.1960-173

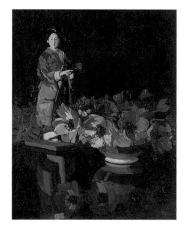

Richter, Herbert Davis 1874–1955
Lady of Japan c.1920
oil on canvas 46 x 38
R.1922-56

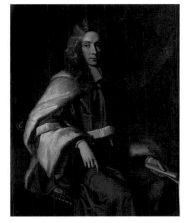

Riley, John 1646–1691
Sir Peyton Ventris
oil on canvas 125 x 105
R.1940-99

Robertson, Henry Robert 1839–1921
River Orwell at Ipswich 1885
oil on canvas 24 x 38
R.1953-66

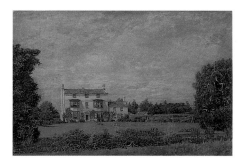

Robertson, Henry Robert (attributed to)
1839–1921
Henley Hall, Suffolk 1889
oil on canvas 33 x 49.5
R.1966-64

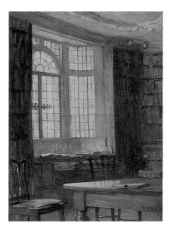

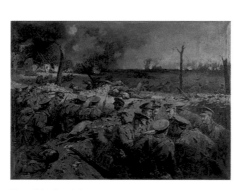

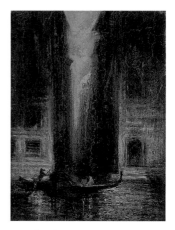

Roe, Fred 1864–1947
In Mr Sparrowe's House 1887
oil on card 40 x 28
R.1947-200.1

Roe, Fred 1864–1947
4th Suffolks at Neuve Chapelle 1918
oil on canvas 80 x 110.5
R.1918-59

Roesler Franz, Ettore 1845–1907
Venetian Scene 1888
oil on canvas 40 x 29
R.1961-161

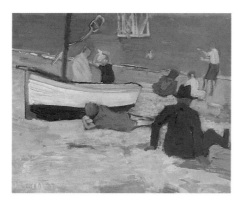

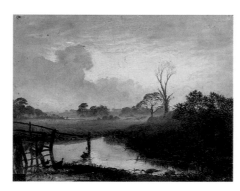

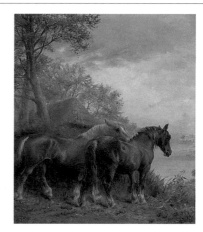

Rogers, Claude 1907–1979
Figures on Aldeburgh Beach 1937
oil on canvas 41.3 x 61
R.1976-83

Rope, George Thomas 1845–1929
Landscape with Stream 1894
oil on canvas 36 x 46
R.1961-165

Rope, George Thomas 1845–1929
Suffolk Horses
oil on board 53 x 47
R.1913-32

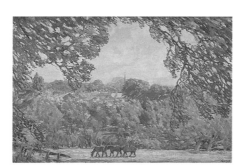

Rose, George 1882–1955
Chipping Ongar c.1930–c.1953
oil on canvas 61 x 92
R.1953-172

Rose, George 1882–1955
The Usurper's Field c.1930–c.1953
oil on canvas 77 x 102
R.1953-171

Rose, George 1882–1955
Fyfield, Essex c.1951
oil on panel 61 x 91
R.1951-197

Rowe, George 1807–1883
River Deben below Waldringfield 1830
oil on panel 14.8 x 22.8
R.1954-72

Rowe, George 1807–1883
Martlesham, Suffolk
oil on panel 18 x 24
R.1954-71

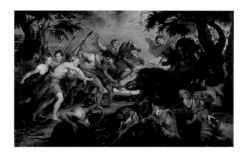

Rubens, Peter Paul (after) 1577–1640
Atlanta and Meleager in Pursuit of the Calydon Boar
oil on panel 78 x 105
R.1992-8.22

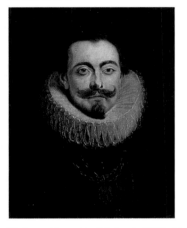

Rubens, Peter Paul (after) 1577–1640
Man in a Ruff
oil on canvas 56 x 46
R.1990-58.23

Rubens, Peter Paul (circle of) 1577–1640
Landscape with Peasants
oil on canvas 135 x 191
R.1949-60

Rushton, George Robert 1868–1948
Canal, Bruges c.1900–c.1948
oil on canvas 64 x 77
R.1987-90.1

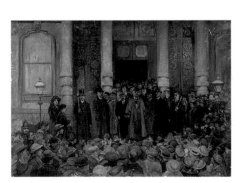

Rushton, George Robert 1868–1948
Mayor and Councillors at the Town Hall at the Declaration of Peace, 1918 c.1918
oil on canvas 115 x 160
R.1961-185

Rushton, George Robert 1868–1948
Self Portrait c.1920–c.1940
oil on panel 51 x 42 (E)
R.1987-90.5

Ryan, Adrian 1920–1998
Cyril Cobbett in a Garden 1953
oil on canvas 52 x 41
R.1986-24

Ryan, Malcolm
Airfield 1977
oil on canvas 102 x 163
R.2002-16.19

Sarto, Andrea del (after) 1486–1530
Madonna and Child with St John
oil on canvas 133 x 102
R.1903-37

Schalcken, Godfried (after) 1643–1706
Boy Blowing on a Firebrand
oil on panel 41 x 31
R.1952-247

Schalcken, Godfried (after) 1643–1706
Youth by Candlelight
oil on panel 41 x 31
R.1952-246

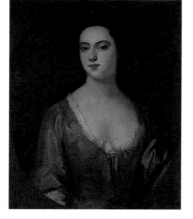

Seemann, Enoch the younger 1694–1744
Lady of the Fonnereau Family c.1720
oil on canvas 76 x 64
R.1985-79.29

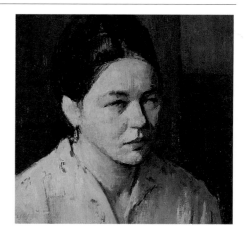

Self, Lawrence 1924–2002
Portrait of a Model 1952
oil on canvas 30 x 40
R.1992-16.1

Self, Lawrence 1924–2002
The Bridge 1955
oil on canvas 54 x 121
R.1992-17.1

Self, Lawrence 1924–2002
Kettlebaston 1960
oil on panel 13 x 18.5
R.1992-16.3

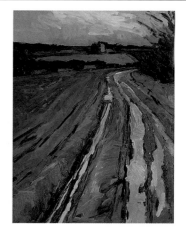

Self, Lawrence 1924–2002
Track in Winter 1963
oil on canvas 90 x 70
R.1992-17.2

Facing page: Waller, Arthur Henry Naunton, 1906–1995, *Summer, Suffolk Coast* (detail), 1981,
Ipswich Borough Council Museums and Galleries, (p.152)

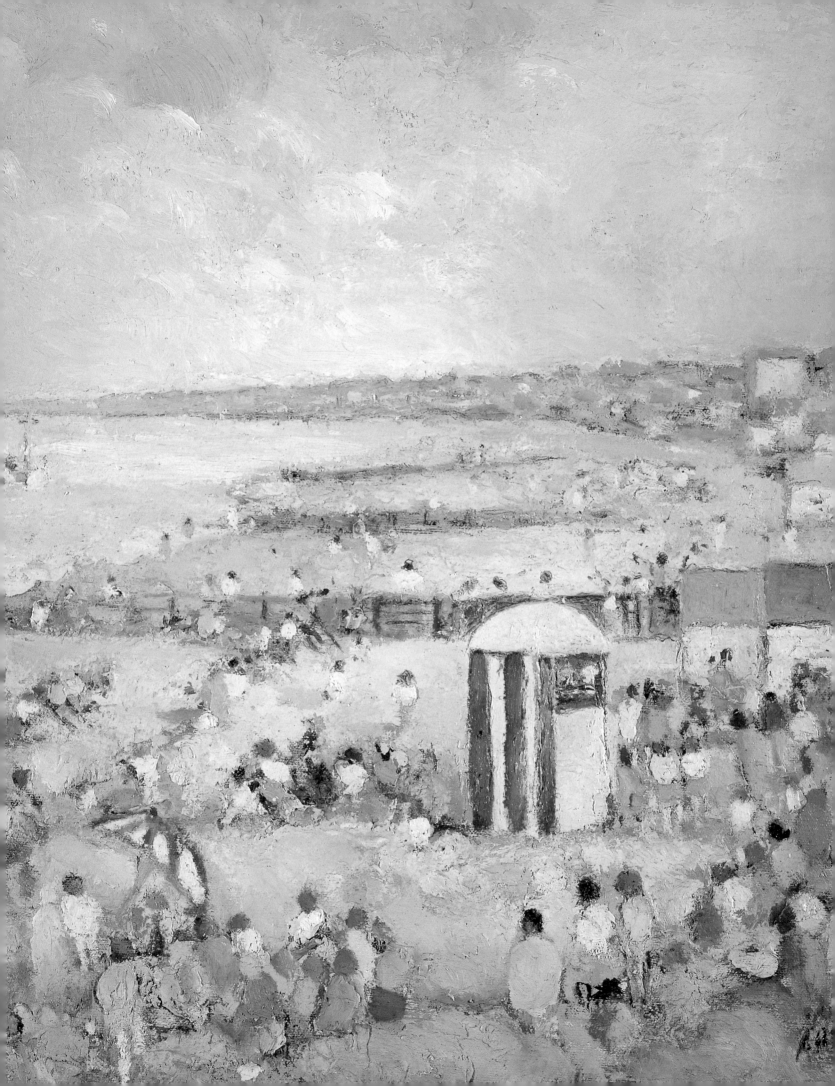

Serres, Dominic 1722–1793
The Action off Negapatam 1782
oil on canvas 114 x 190
R.1983-143.9D

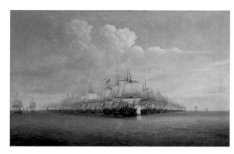

Serres, Dominic 1722–1793
The Action off Porto-Novo 1782
oil on canvas 114 x 180
R.1983-143.9C

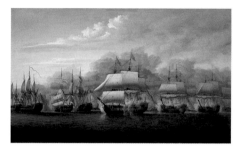

Serres, Dominic 1722–1793
The Action off Providien 1782
oil on canvas 91 x 158
R.1983-143.9B

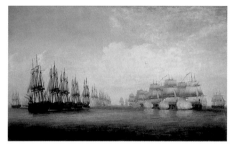

Serres, Dominic 1722–1793
The Action off Sadras 1782
oil on canvas 112 x 182
R.1983-143.9F

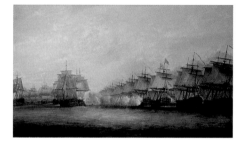

Serres, Dominic 1722–1793
The Action off Trincomalee 1782
oil on canvas 111 x 182
R.1983-143.9E

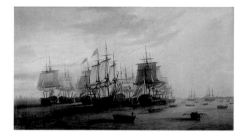

Serres, Dominic 1722–1793
The English Fleet at Madras 1782
oil on canvas 91 x 158
R.1983-143.9A

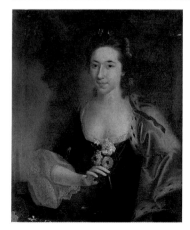

Seymour, Edward c.1664–1757
Helen Fonnereau 1745
oil on canvas 76 x 62.5
R.1985-79.27

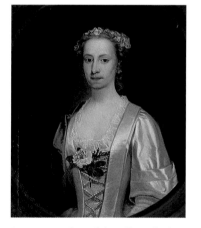

Seymour, Edward (attributed to) c.1664–
1757
Mrs Ann Fonnereau (née Boehm) c.1740
oil on canvas 72 x 64
R.1985-79.9

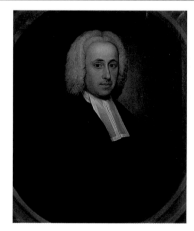

Seymour, Edward (attributed to) c.1664–
1757
Claudius Fonnereau (1701–1785) c.1740–
c.1750
oil on canvas 72 x 60
R.1985-79.3

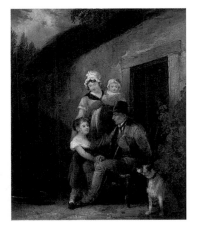

Shayer, William 1788–1879
Cottage Door Scene
oil on panel 31 x 25
R.1931-28.31

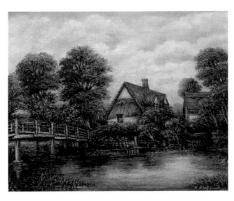

Sheppard, Francis C. b.1900
Flatford Bridge, East Bergholt 1973
oil on canvas 33 x 41
R.1973-105

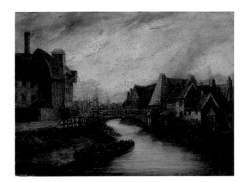

Sheppard, Isaac 1842–1899
Stoke Bridge
oil on canvas 23.5 x 31
R.1990-58.35

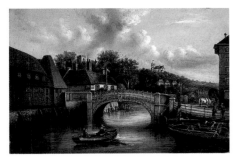

Sheppard, Isaac 1842–1899
View of Stoke Bridge 1880
oil on canvas 41 x 61
R.1933-175.A

Sheppard, Isaac 1842–1899
Freston Tower c.1880
oil on canvas 18.5 x 29
R.1967-72

Sheppard, Isaac 1842–1899
Freston Tower 1887
oil on canvas 50.5 x 75
R.1974-113

Sheppard, Isaac 1842–1899
Carr Street, Ipswich 1888
oil on unmounted paper/card 50 x 42
R.1952-61

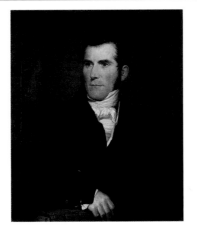

Shepperson, M.
John Childs (b.1784) 1828
oil on canvas 76 x 65
R.1952-266.A

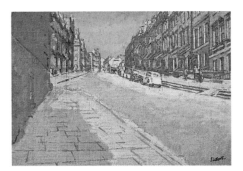

Sickert, Walter Richard 1860–1942
Belmont, Bath c.1939–c.1941
oil on canvas 53.5 x 78
R.1973-101

Sickert, Walter Richard (attributed to)
1860–1942
Village Scene
oil on unmounted paper/card 10 x 20
R.1988-67.80

Simone, D. (attributed to)
Aux Steam, Yacht Valhalla 1908
oil on canvas 44 x 64
R.1961-169

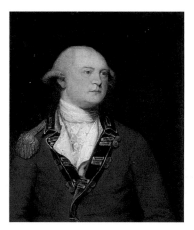

Smart, John c.1752–1838
Captain William Ivory c.1780
oil on canvas 70 x 59
R.1985-79.13

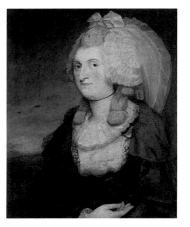

Smart, John c.1752–1838
Elizabeth Ivory (née Fonnereau) c.1780
oil on canvas 70 x 59
R.1985-79.12

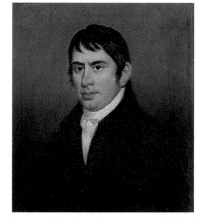

Smart, John (attributed to) c.1752–1838
Bernard Barton 1820–1830
oil on canvas 32 x 26
R.1941-119

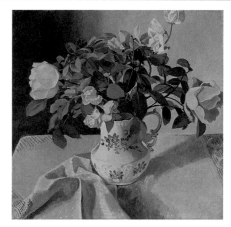

Smith, Ivy b.1945
Roses and Sweetpeas
oil on canvas 41 x 41
R.2002-16.20

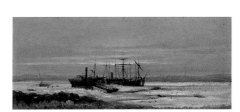

Smith, Walter A. active 1885–1892
Ice Block on the Orwell 1887
oil on board 13 x 31
R.1923-75

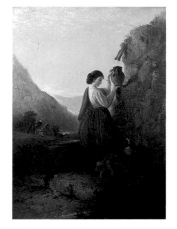

Smythe, Edward Robert 1810–1899
Girl at a Spring c.1840–c.1860
oil on canvas 62.2 x 45
R.1975-42

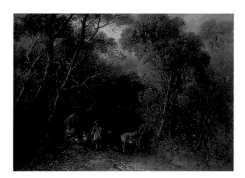

Smythe, Edward Robert 1810–1899
Gypsy Encampment c.1840–c.1883
oil on panel 19 x 27
R.1931-28.15

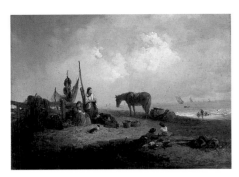

Smythe, Edward Robert 1810–1899
Beach Scene c.1840–c.1899
oil on canvas 40.7 x 56
R.1931-28.21

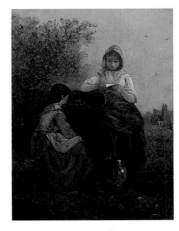

Smythe, Edward Robert 1810–1899
Reading the Letter c.1840–c.1899
oil on canvas 26 x 20.5
R.1931-28.20

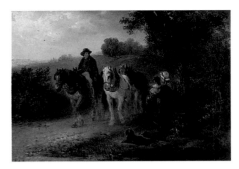

Smythe, Edward Robert 1810–1899
Returning from Work c.1840–c.1899
oil on canvas 34.5 x 49.5
R.1961-164

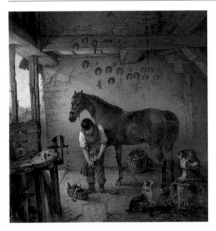

Smythe, Edward Robert 1810–1899
The Shoeing Smith c.1840–c.1899
oil on canvas 101 x 94
R.1918-4

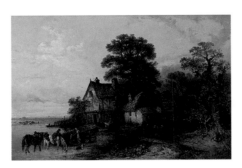

Smythe, Edward Robert 1810–1899
The Watering Place c.1840–c.1899
oil on canvas 61.5 x 91.5
R.1932-43

Smythe, Edward Robert 1810–1899
Travelling Family and Donkey c.1840–c.1899
oil on panel 16.5 x 23
R.1931-28.19

Smythe, Edward Robert 1810–1899
Winter c.1840–c.1899
oil on canvas 51.3 x 91.6
R.1932-42

Smythe, Edward Robert 1810–1899
Colne Valley Viaduct 1850
oil on canvas 92 x 137.5
R.1939-194

Smythe, Edward Robert 1810–1899
Hounds c.1850–c.1899
oil on canvas 85 x 130
R.1902-6

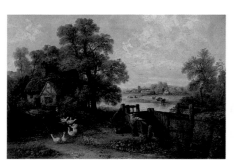

Smythe, Edward Robert 1810–1899
Suffolk Scene, a Cottage and Some Geese 1870
oil on canvas 60 x 90
R.1939-137

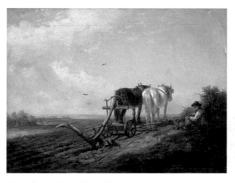

Smythe, Edward Robert 1810–1899
Resting Ploughman
oil on canvas 29.2 x 39.4
R.1931-28.100

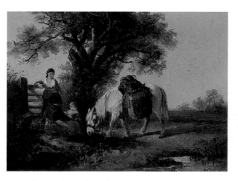

Smythe, Edward Robert 1810–1899
Two Women, Child and Pony
oil on canvas 28 x 38
R.1946-225.A

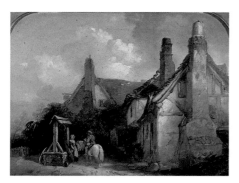

Smythe, Edward Robert (attributed to)
1810–1899
The Old Gardener's Arms
oil on canvas 31 x 41
R.1931-28.104

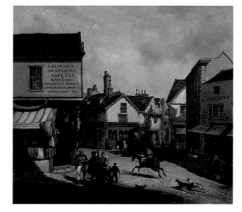

Smythe, Thomas 1825–1907
Angel Corner, Ipswich c.1850
oil on canvas 50 x 55
R.1947-54

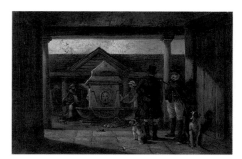

Smythe, Thomas 1825–1907
Fountain in Old Provision Market c.1850–
c.1900
oil on canvas 30.5 x 46
R.1961-181

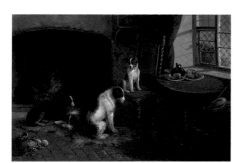

Smythe, Thomas 1825–1907
Interior with Four Dogs c.1850–c.1900
oil on canvas 42 x 63
R.1965-1

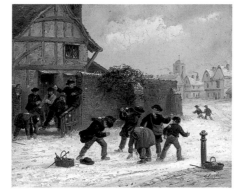

Smythe, Thomas 1825–1907
Children Snowballing c.1850–c.1906
oil on canvas 25 x 30
R.1931-28.25

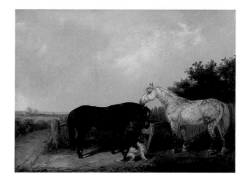

Smythe, Thomas 1825–1907
Study of Horses with Dog c.1850–c.1906
oil on canvas 30.5 x 41
R.1949-51.B

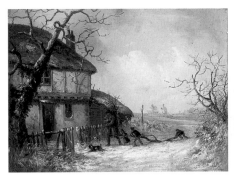

Smythe, Thomas 1825–1907
Carrying Home the Firewood
oil on canvas 30 x 40
R.1931-28.103

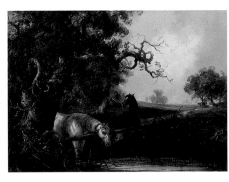

Smythe, Thomas 1825–1907
Study of Horses
oil on canvas 30.5 x 41
R.1949-51.C

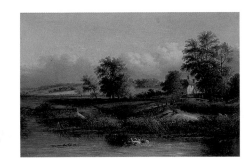

Smythe, Thomas 1825–1907
The Weir, Handford Hall
oil on canvas 50 x 76
R.1953-174

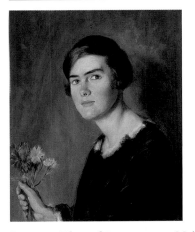

Someren, Edmund Lawrence van Major
1875–1963
Aline Mary Williamson (1906–1987) 1927
oil on canvas 56 x 46
R.1994-15.1

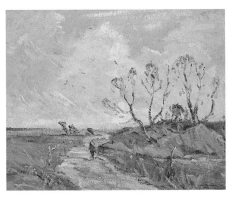

Somerville, Peggy 1918–1975
Country Lane, Walcheren Island, Holland
c.1936
oil on canvas 26 x 30
R.1997-19.3

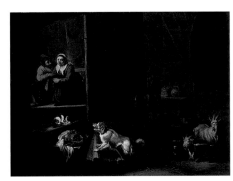

Sorgh, Hendrik Martensz. 1609/1611–1670
Doorway, Couple Embracing
oil on canvas 52 x 70
R.1992-8.16

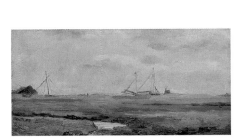

Sothern, Arthur
Walberswick, Suffolk 1900
oil on unmounted paper/card 18 x 35.5
R.1985-152.64

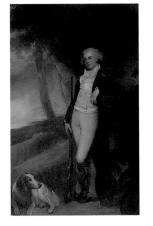

Spencer, F.
Sir Robert Harland (1765–1848)
oil on canvas 238 x 149
R.1934-165

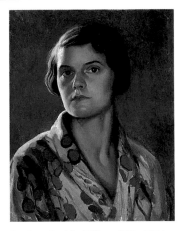

Spring-Smith, Effie 1907–1974
Self Portrait c.1932
oil on canvas 47 x 36
R.1933-199

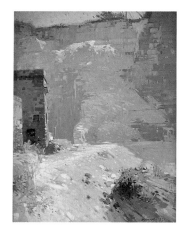

Squirrell, Leonard 1893–1979
Chalk Pit, Noon 1921
oil on canvas 48 x 37
R.1921-82

Squirrell, Leonard 1893–1979
In the Big Quarry 1933
oil on canvas 35 x 48
R.2002-17.1

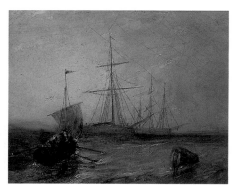

Stannard, Alfred George (attributed to)
1828–1885
Pilot Boat Going off
oil on panel 16 x 21
R.1931-28.88

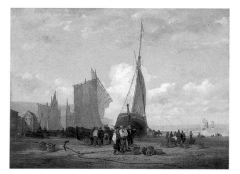

Stannard, Alfred George (attributed to)
1828–1885
Seascape or Coastal Scene
oil on canvas 30 x 49
R.1934-146

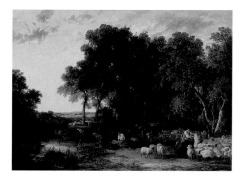

Stark, James 1794–1859
Sheep Washing, Morning 1824
oil on canvas 82.6 x 113
R.1955-96.3

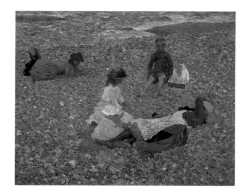

Steer, Philip Wilson 1860–1942
Knucklebones, Walberswick 1888
oil on canvas 61 x 76.2
R.1947-31.23

Steer, Philip Wilson 1860–1942
Girl on a Sofa 1891
oil on canvas 68 x 72
R.1987-98

Steer, Philip Wilson 1860–1942
Mother and Daughter, Boulogne c.1894
oil on prepared panel 20.8 x 27
R.1971-12

Steer, Philip Wilson 1860–1942
Girl with a St Bernard Dog 1899
oil on panel 21 x 27.2
R.1971-14

Steer, Philip Wilson 1860–1942
Woman Reading on a Couch c.1899
oil on panel 20.8 x 27
R.1971-13

Steer, Philip Wilson 1860–1942
The Black Bow 1904
oil on canvas 81.5 x 66
R.1947-31.21

Steer, Philip Wilson 1860–1942
River Bend near Ludlow 1906
oil on canvas 64 x 76
R.1947-31.24

Steer, Philip Wilson 1860–1942
The Blue Dress (Miss Montgomery) 1911–
1913
oil on canvas 61 x 51
R.1947-31.22

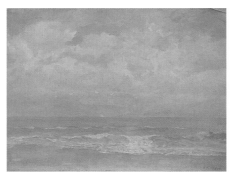

Stokoe, Charles John active 1907–1914
Evening
oil on canvas 32 x 42
R.1921-84

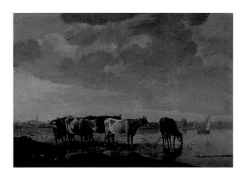

Strij, Jacob van (attributed to) 1756–1815
Cows by River
oil on metal 68.5 x 98
R.1967-98

Symonds, William Robert 1851–1934
*Edward Christian, Principal of Ipswich
Working Men's Club* c.1870–c.1880
oil on canvas 128 x 103
L.1977-12

Symonds, William Robert 1851–1934
*James Alan Ransome, Vice President of Ipswich
Working Men's Club* c.1870–c.1880
oil on canvas 127 x 101.5
L.1977-11

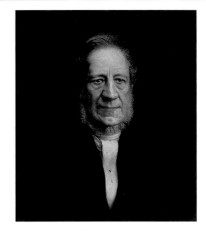

Symonds, William Robert 1851–1934
Robert Ransome 1875
oil on canvas 59 x 49.5
R.1939-177.A

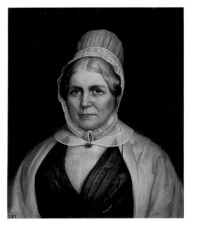

Symonds, William Robert 1851–1934
Mrs Mary Ransome c.1875
oil on canvas 61 x 51
R.1939-177.B

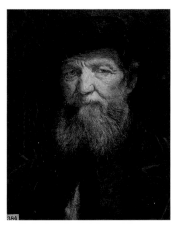

Symonds, William Robert 1851–1934
Study of a Man 1879
oil on canvas 51 x 40.5
R.1943-25

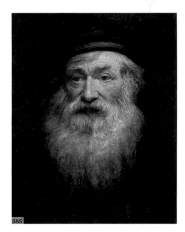

Symonds, William Robert 1851–1934
Study of a Man 1879
oil on canvas 51 x 41
R.1943-26

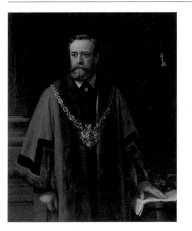

Symonds, William Robert 1851–1934
Portrait of an Unidentified Ipswich Mayor
1880
oil on canvas 124 x 98
R.1990-58.5

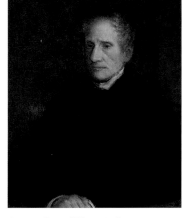

Symonds, William Robert 1851–1934
Archdeacon R. H. Groome (1810–1889)
c.1880
oil on canvas 74.7 x 62.3
R.1947-196

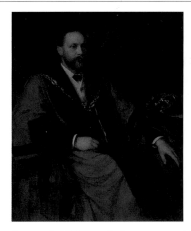

Symonds, William Robert 1851–1934
Edward Packard, Mayor of Ipswich 1887
oil on canvas 127 x 102
R.1983-143.13C

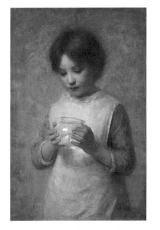

Symonds, William Robert 1851–1934
Girl and Silver Fish 1889
oil on canvas 74 x 48
R.1911-9

Symonds, William Robert 1851–1934
Old Man with Churchwarden's Pipe
oil on canvas 76 x 63
R.1960-189

Symonds, William Robert (attributed to)
1851–1934
Dr E. Beck, MD of Ipswich
oil on panel 46 x 35
R.1946-193

Thompson, David b.1939
The Cliff Collapse, Dunwich 1996
acrylic on canvas 45 x 37
R.2002-17.21

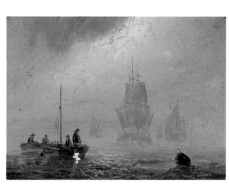

Thornley, Georges William 1857–1935 **&
Hurneen, F. W.**
Lifting Mists c.1875
oil on canvas 15.5 x 20.5
R.1931-28.46

Thornton, Valerie 1931–1991
Mystra, the Peribleptos 1989
oil on canvas 122 x 76
R.1994-13

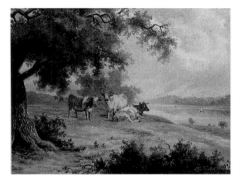

Todd, Henry George 1847–1898
Landscape with Cattle c.1870–c.1898
oil on canvas 18 x 23.5
R.1931-28.49

Todd, Henry George 1847–1898
Gainsborough Lane 1888
oil on canvas 30.8 x 40.8
R.1931-28.52

Todd, Henry George 1847–1898
Gainsborough Lane 1889
oil on canvas 21 x 40 (E)
R.1931-28.53

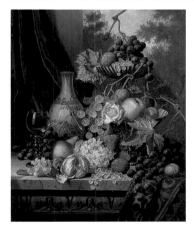

Todd, Henry George 1847–1898
Still Life with Delft Vase 1890–1898
oil on canvas 61.2 x 51
R.1961-170

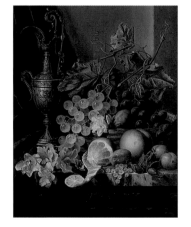

Todd, Henry George 1847–1898
Still Life 1892
oil on canvas 50 x 40
R.1931-28.51

Tollemache, Duff 1859–1936
After the Catch c.1881–c.1920
oil on canvas 62 x 44
R.1928-10

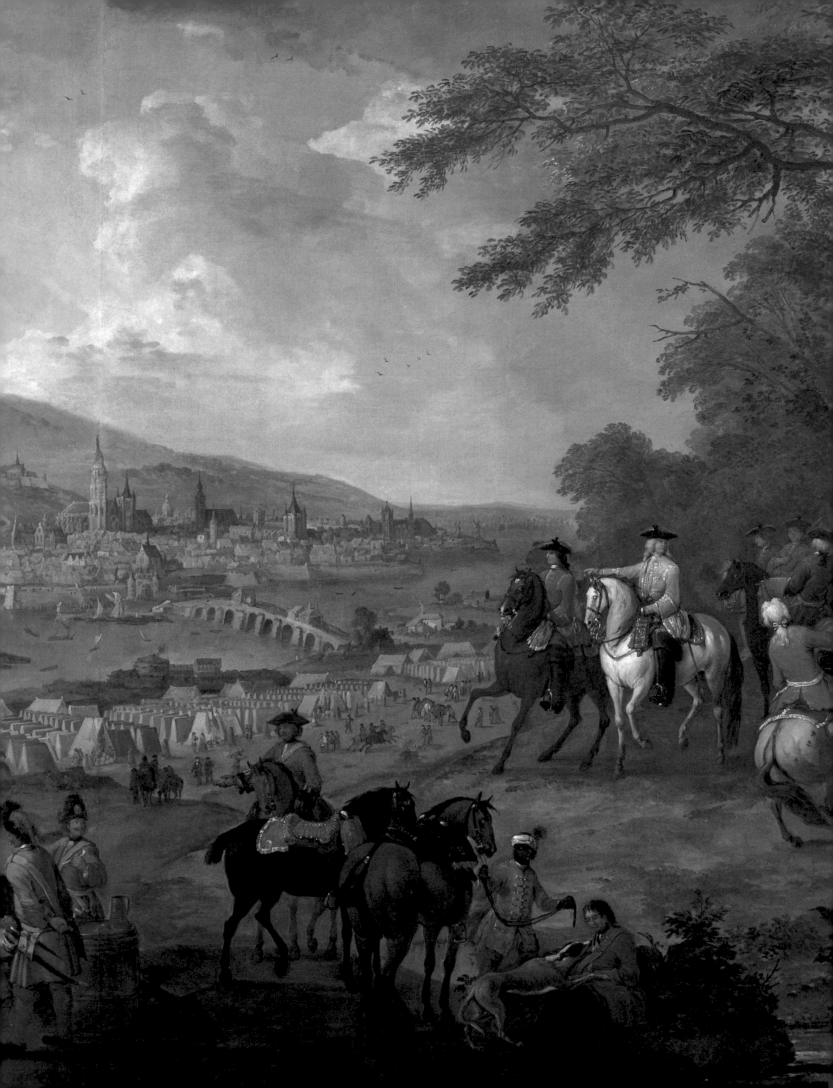

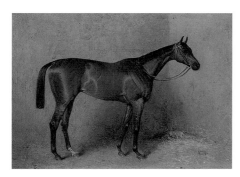

Townshend, Arthur Louis active 1880–1912
Butterfly c.1880
oil on canvas 11.5 x 19.5
R.1945-97.F17

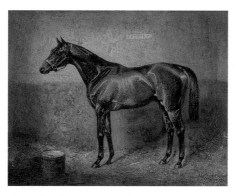

Townshend, Arthur Louis active 1880–1912
Catmint c.1880
oil on panel 15 x 20.5
R.1945-97.F16

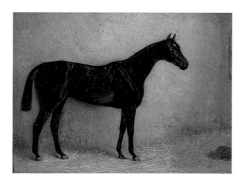

Townshend, Arthur Louis active 1880–1912
Hauteur c.1880
oil on canvas 15 x 20
R.1945-97.F18

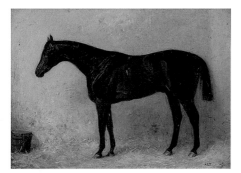

Townshend, Arthur Louis active 1880–1912
Ladislas c.1880
oil on canvas 15 x 20.5
R.1945-97.F19

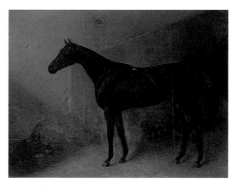

Townshend, Arthur Louis active 1880–1912
Mamia c.1880–c.1900
oil on panel 15.5 x 21
R.1945-97.F21

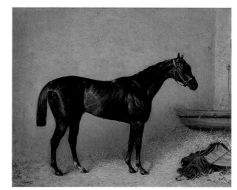

Townshend, Arthur Louis active 1880–1912
Tristan 1883
oil on canvas 51 x 61
R.1945-97.F15

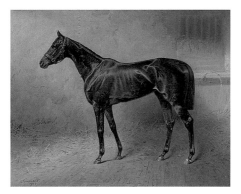

Townshend, Arthur Louis active 1880–1912
Winfreda 1900
oil on canvas 20 x 25
R.1945-97.F20

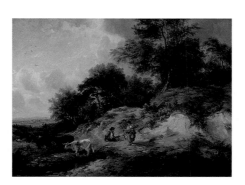

Turner, George II (circle of) 1843–1910
Landscape, Peasants and Cattle
oil on canvas 38 x 54
R.1931-28.1

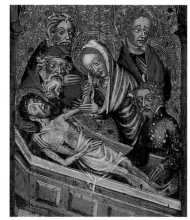

unknown artist
The Entombment of Christ c.1400
oil on panel 62 x 46
R.1936-41

Facing page: Verdussen, Jan Peeter, c.1700–1763, *The Assault on the Town of Oudenarde* (detail), Ipswich
Borough Council Museums and Galleries, (p. 152)

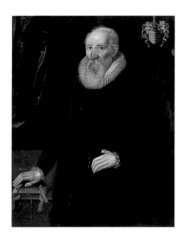

unknown artist
Robert Gosnold of Otley (1532–1615)
c.1600–c.1615
oil on canvas 110 x 86
R.1961-44

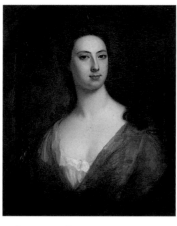

unknown artist
Lady of the Fonnereau Family c.1720
oil on canvas 77 x 64
R.1959-274

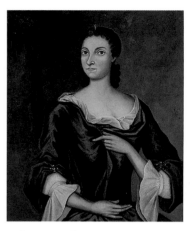

unknown artist
Mrs Anne Taylor 1747
oil on canvas 90 x 75
R.1940-43

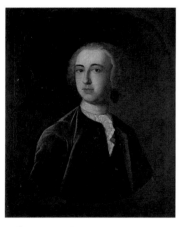

unknown artist
Charles Fonnereau c.1750
oil on canvas 76.5 x 63.5
R.1959-273.A

unknown artist
The Old Cansor, Stoke Street, Ipswich c.1880
oil on board 26 x 33
R.1993-69

unknown artist
A Wood in Autumn
oil on board 32 x 38
R.1940-27

unknown artist
Battle
oil on board 51 x 65
C.027

unknown artist
Boat at Sea
oil on canvas 46 x 61
C.019

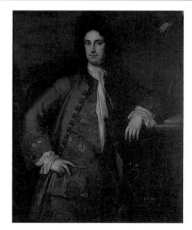

unknown artist
C. Long, MP for Dunwich
oil on canvas 125 x 100
C.021

unknown artist
Cattle and Cottage
oil on canvas 36 x 45
C.056

unknown artist
Cottage and Trees
oil on canvas 35 x 42
C.034

unknown artist
Cottage, Arboretum, Christchurch Park
oil on canvas 30.5 x 38
R.1952-172

unknown artist
Cow in a Landscape
oil on panel 16.5 x 21
R.1990-58.29

unknown artist
Edward Grimwade, Mayor of Ipswich
oil on canvas 141 x 112
R.1983-143.13E

unknown artist
Elderly Man in Blue Coat Wearing a Wig
oil on canvas 76.5 x 64
R.1947-44

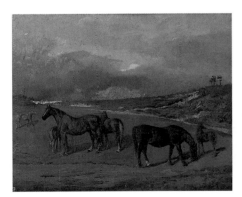

unknown artist
Horses in a Landscape
oil on panel 50 x 60
R.1990-58.15

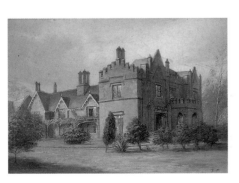

unknown artist
House Surrounded by Shrubs
oil on panel 20 x 24
R.1988-53.63

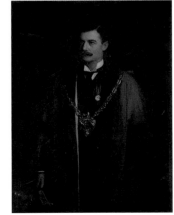

unknown artist
Ipswich Mayor
oil on canvas 135 x 102
R.1983-143.13B

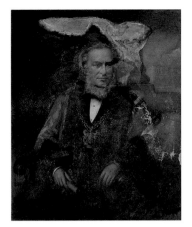

unknown artist
Ipswich Mayor
oil on canvas 126 x 101
R.1983-143.13H

unknown artist
Italian Scene, Castle and Figures
oil on canvas 30.5 x 41
R.1931-28.80

unknown artist
J. Hervey, Mayor of Ipswich
oil on canvas 77 x 64
R.1990-58.25

unknown artist
Landscape
oil on canvas 11 x 14
R.1916-3

unknown artist
Landscape with Cattle
oil on canvas 45 x 65
C.030

unknown artist
Landscape with Church and Sheep
oil on board 41 x 54
C.057

unknown artist
Landscape with Figures and Cattle
oil on canvas 94 x 132
R.1961-175

unknown artist
Lanterns
oil on canvas 34 x 43
C.038

unknown artist
Oulton High House
oil on board 23 x 32
R.1936-300.A0000

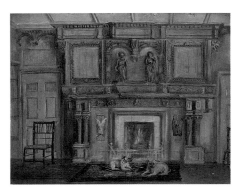

unknown artist
Oulton High House, Interior
oil on board 26 x 33
R.1936-300.B000C

unknown artist
Peter Bartholomew Long
oil on canvas 142 x 112
R.1983-143.13D

unknown artist
Portrait of a Gentleman
oil on canvas 77 x 62
C.028

unknown artist
Portrait of a Gentleman
oil on canvas 36 x 25
C.043

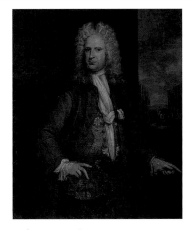

unknown artist
Portrait of a Gentleman
oil on canvas 125 x 104 (E)
C.049

unknown artist
Portrait of a Gentleman
oil on canvas 113 x 60
C.055

unknown artist
Portrait of a Lady
oil on canvas 55 x 44 (E)
C.029

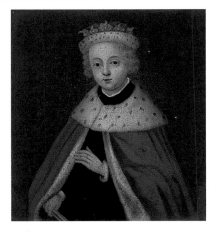

unknown artist
Possibly Edward VI (1537–1553)
oil on canvas 20 x 18
R.1992-8

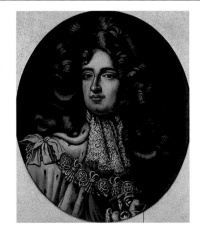

unknown artist
Prince George of Denmark
oil on canvas 62 x 48
R.1951-193.F

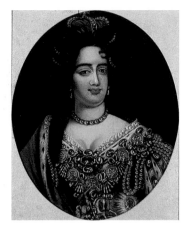

unknown artist
Queen Anne
oil on canvas 70 x 55
R.1951-193.E

unknown artist
Seated Gentleman
oil on canvas 105 x 80
C.022

unknown artist
Seated Lady
oil on canvas 93 x 62
C.023

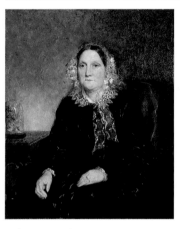

unknown artist
Seated Lady
oil on canvas 52 x 41
C.026

unknown artist
Shepherds and Sheep by Stream
oil on canvas 66 x 49
C.020

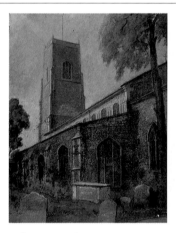

unknown artist
St Clement's Church, Ipswich
oil on canvas 90 x 70
R.1983-90.2

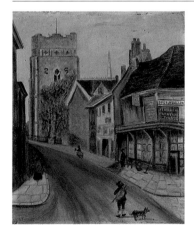

unknown artist
St Stephen's Church, Ipswich
oil on board 24 x 17
R.1948-76.2

unknown artist
St Stephen's Lane, Ipswich
oil on canvas 53 x 40
C.037

unknown artist
Suffolk Punch Colt
oil on board 36 x 45
R.1973-66

unknown artist
Sutton Hoo, Suffolk
oil on board 19 x 68
C.035

unknown artist
Temple Ruins
oil on canvas 51 x 100
C.054

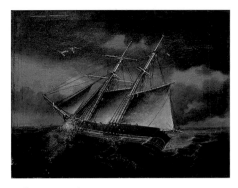

unknown artist
The Compass at Sea
oil on canvas 35 x 40
C.041

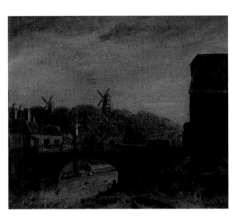

unknown artist
Town Scene and Bridge
oil on board 18 x 22
C.058

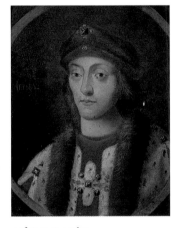

unknown artist
Unknown Nobleman
oil on canvas 29 x 19
C.039

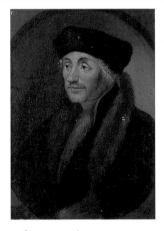

unknown artist
Unknown Nobleman
oil on canvas 29 x 19
C.040

unknown artist
Water Mill
oil on canvas 59 x 43
C.048

unknown artist
Waterfall and Wooded Bank
oil on canvas 110 x 153
C.011

unknown artist
Wooden Bridge and Cattle
oil on board 30 x 41
C.036

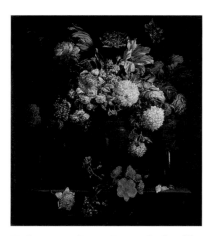

Verbruggen, Gaspar Peeter de the elder
1635–1681
Flower Piece after 1658
oil on canvas 80 x 74
R.1919-55

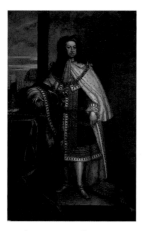

Verbruggen, John c.1694–1739
George I (1660–1727)
oil on canvas 238 x 149
L.1937-219

Verbruggen, John c.1694–1739
Jane Modyford (née Beeston, later Long)
oil on canvas 124.5 x 101
R.1958-254.2

Verbruggen, John (circle of) c.1694–1739
North Family Group, Little Glenham Hall
c.1715–c.1716
oil on copper 44.5 x 54
R.1958-254.5

Verdussen, Jan Peeter c.1700–1763
The Assault on the Town of Oudenarde
oil on canvas 113 x 162
R.1992-8.9

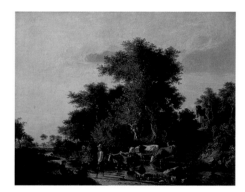

Vincent, George 1796–1831
The Travelling Tinker
oil on canvas 100 x 125.5
R.1947-134

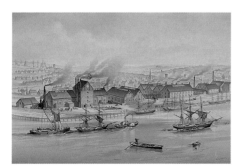

Visser, Cor 1903–1982
Waterside Works, Ransomes and Rapier, 1875
1960
oil on canvas 96.5 x 142
R.1987-156

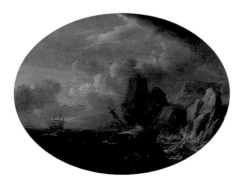

Vlieger, B. de active 18th C
Shipwreck Scene
oil on canvas 39 x 53
R.1935-305

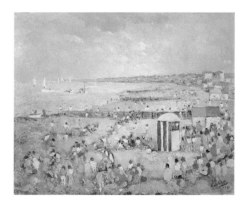

Waller, Arthur Henry Naunton 1906–1995
Summer, Suffolk Coast 1981
oil on canvas 50 x 60
R.2002-17.17

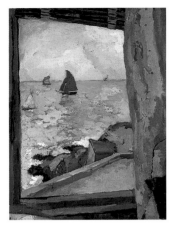

Walton, Allan 1891–1948
By the Green Blind 1930–1948
oil on canvas 61 x 48
R.1987-4

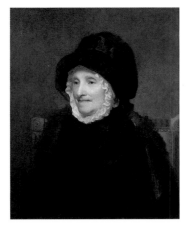

Walton, Henry 1746–1813
Mrs Rogers (1736–1808) c.1800
oil on canvas 75 x 63
R.1955-19

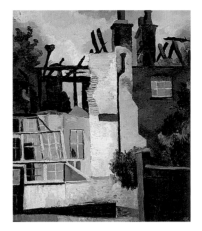

Warburton, Joan 1920–1996
Burned School 1939
oil on canvas 61 x 51
R.1996-39.1

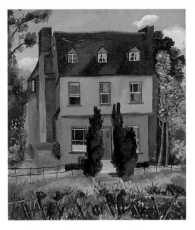

Warburton, Joan 1920–1996
Benton End 1960
oil on canvas 61 x 51
R.1996-39.2

Warnes, Robin b.1952
Umbrellas 1980
oil on canvas 102 x 135
R.1987-135

Warnes, Robin b.1952
Orwell Bridge, Study 1984
oil on canvas 25 x 30
R.1988-59-2

Warsop, Mary b.1929
Coastal Suffolk 1981
oil on canvas 103 x 94
R.1990-82

Warsop, Mary b.1929
Nine Suffolk Scenes 1992
acrylic on canvas 54 x 37
R.2002-17.9

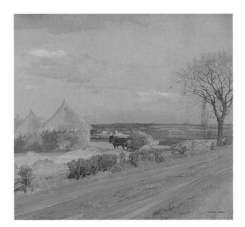

Watt, Millar 1895–1975
Higham from Langham c.1927
oil on canvas 53 x 61
R.1927-71

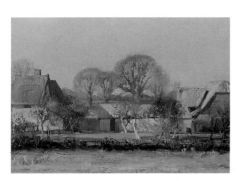

Watt, Millar 1895–1975
Rookery Farm, Dedham c.1932
oil on canvas 43 x 62
R.1932-176

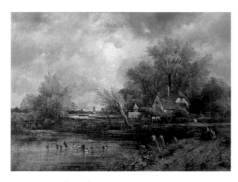

Watts, Frederick W. 1800–1862
View of Dedham
oil on canvas 56 x 76
R.1948-9

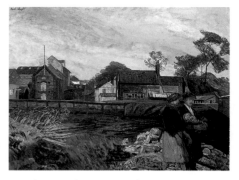

Weight, Carel Victor Morlais 1908–1997
The Maltings, Snape 1960
oil on canvas 74 x 100
R.1965-66

Wells, Josiah Robert active 1872–1896
Ashore for a Tide 1888?
oil on canvas 23 x 33
R.1961-182

West, William (attributed to) 1801–1861
Moonlight Scene
oil on canvas 60 x 110
R.1961-172

Williamson, Frederick 1835–1900
A View in North Wales
oil on canvas 76 x 126
R.1961-171

Wilson, John H. 1774–1855
In the Firth of Forth c.1800–c.1855
oil on canvas 23.5 x 52
R.1931-28.81

Winn, Connie 1899–1985
Girl in a Yellow Hat c.1973
oil on panel 36 x 30
R.1985-66.2

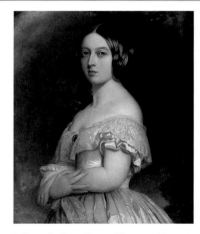

Winterhalter, Franz Xaver 1805–1875
Queen Victoria (1819–1901) c.1840–c.1850
oil on canvas 74 x 62 (E)
R.1983-143.3

Facing page: Gainsborough, Thomas, 1727–1788, *Portrait of an Unknown Youth (The Pitminster Boy)* (detail), c.1768, Gainsborough's House, (p.233)

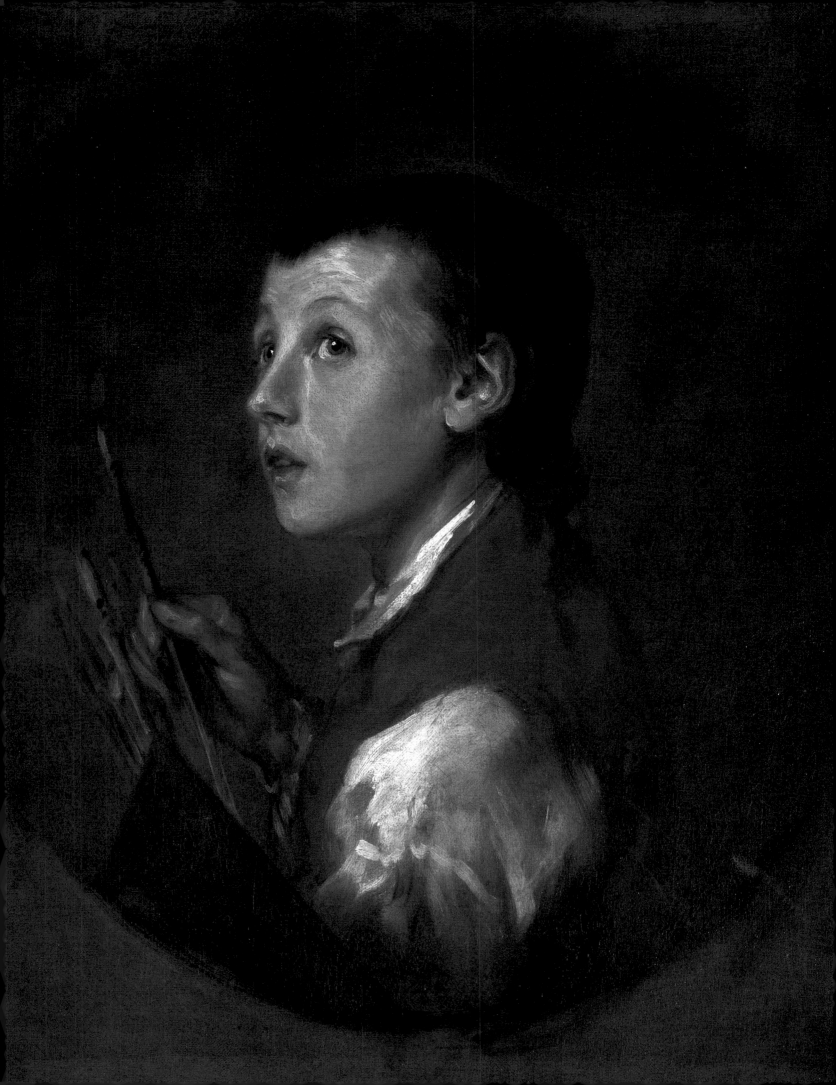

Wirth-Miller, Denis b.1915
Road in a Landscape c.1960
oil on canvas 86 x 111
R.1996-39.4

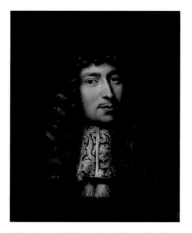

Wissing, Willem (attributed to) c.1656–1687
James Scott, 1st Duke of Monmouth and Buccleuch (1649–1685) c.1680
oil on canvas 56 x 48
R.1952-174

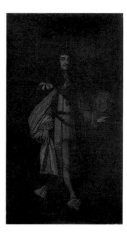

Wissing, Willem (circle of) c.1656–1687
Charles II (1630–1685)
oil on canvas 271 x 151
R.1990-58.2

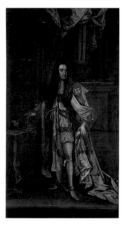

Wissing, Willem (circle of) c.1656–1687
William III (1650–1702)
oil on canvas 268 x 148
R.1990-58.34

Witte, Emanuel de c.1617–1692
The Interior of the Oude Kerk, Amsterdam (after 1658)
oil on canvas 35 x 43.5
R.1919-56

Wonnacott, John b.1940
Shingle Laboratory No.3 with Lighthouse, Orford Ness 1994–1996
oil on board 94 x 123.2
R.1997-10

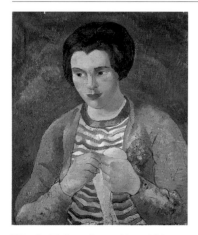

Wood, Christopher 1901–1930
Girl Darning c.1925–c.1930
oil on canvas 60 x 49
R.1978-13

Wood, John Barlow 1862–1949
Evening, Martlesham Creek c.1910–c.1930
oil on canvas 61 x 93
R.1931-14

Wood, John Barlow 1862–1949
Frost, Fir and Shine c.1910–c.1930
oil on canvas 51 x 31
R.1931-13

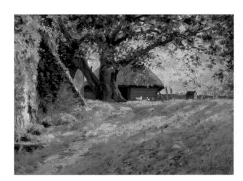

Wood, John Barlow 1862–1949
Sunshine and Shadow c.1911
oil on canvas 30 x 40
R.1911-14

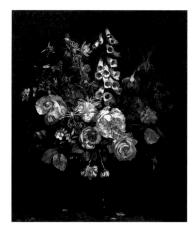

Wood, William Thomas 1877–1958
June Flowers 1926
oil on canvas 61 x 51
R.1982-40

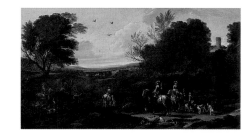

Wyck, Jan c.1640–1700
Hawking Party c.1700
oil on canvas 90 x 150
R.1935-304

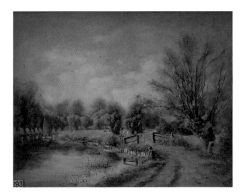

Wykes, H. J.
The Gipping, Sproughton 1906
oil on board 41 x 51
R.1935-223

Ipswich County Library

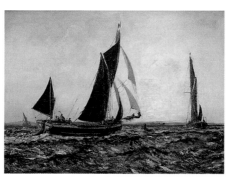

Cobb, Charles David b.1921
The Barge Race c.1955
oil on board 75 x 101
LP.02

Cole, Tennyson Philip 1862–1939
Alderman William F. Paul
oil on canvas 50 x 40 (E)
LP.04

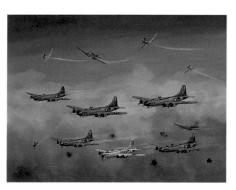

Cooper, David O.
Bleak Encounter
oil on board 95 x 120 (E)
LP.03

Devas, Anthony 1911–1958
George Alfred Scott 1949
oil on canvas 90 x 65 (E)
LP.01

Ipswich Hospital NHS Trust

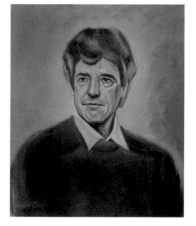

Alexander
David Poole (1936–1995)
oil on canvas 60 x 50 (E)
SP.17

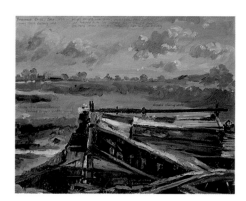

Poole, David 1936–1995
Beaumont Creek, Essex 1974
oil on card 39 x 49 (E)
C16.1

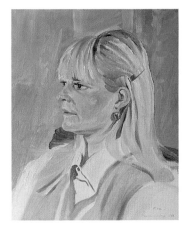

Poole, David 1936–1995
Roz, Wensum Lodge 1988 1988
oil on board 52 x 42 (E)
S.S1

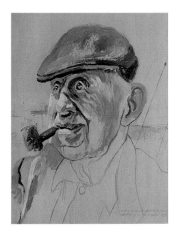

Poole, David 1936–1995
Man in Cap with Pipe 1992
oil & pencil on board 60 x 52 (E)
C5.9

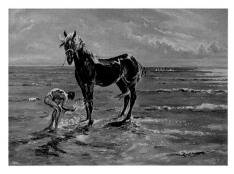

Poole, David 1936–1995
At the Seashore
oil on board 76 x 114 (E)
CP.1

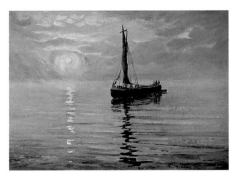

Poole, David 1936–1995
Barge at Sunrise
oil on board 45 x 60 (E)
S2.1

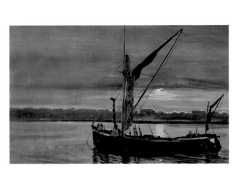

Poole, David 1936–1995
Barge at Sunset
oil on canvas 40 x 64 (E)
SP.19

Poole, David 1936–1995
Bearded Man
oil on card 36 x 22 (E)
C10.4

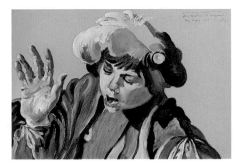

Poole, David 1936–1995
Boy Singing (after Hendrick ter Brugghen)
oil on canvas 38 x 56 (E)
SP.18

Poole, David 1936–1995
Cattle in Field
oil & bodycolour on board 15 x 26 (E)
NP2.3

Poole, David 1936–1995
Cattle in Field with Windmill
oil & bodycolour on board 15 x 27 (E)
NP2.4

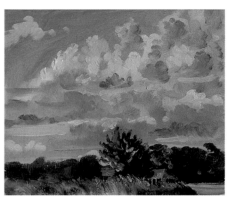

Poole, David 1936–1995
Clouds (after John Constable)
oil on board 24 x 29 (E)
C4.9

Poole, David 1936–1995
Clouds (after John Constable)
oil on card 17 x 36 (E)
C8.3

Poole, David 1936–1995
Clouds over Woodland
oil on board 19 x 24 (E)
NP2.5

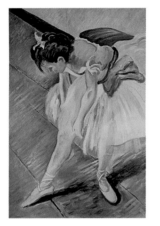

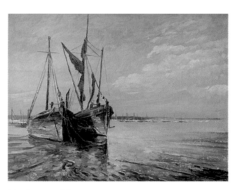

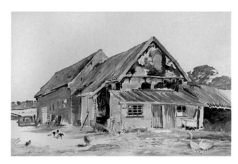

Poole, David 1936–1995
Dancer (after Edgar Degas)
oil & bodycolour on board 116 x 76 (E)
S10.1

Poole, David 1936–1995
Estuary Scene
oil & acrylic on card 40 x 50 (E)
C13.7

Poole, David 1936–1995
Farm Buildings
oil on board 40 x 50 (E)
D.04

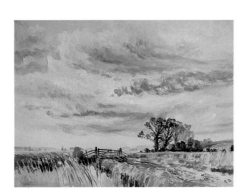

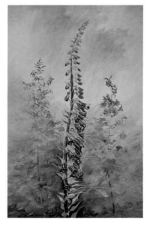

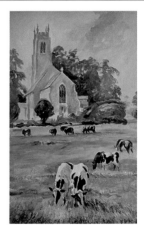

Poole, David 1936–1995
Field Dyke
oil on board 45 x 59 (E)
NP2.1

Poole, David 1936–1995
Foxglove
oil on board 116 x 72 (E)
S10.3

Poole, David 1936–1995
Grazing Cattle near Church
oil & bodycolour on board 115 x 76 (E)
NP2.6

Poole, David 1936–1995
Grazing Cattle on Marshland
oil on card 23 x 31 (E)
NP2.2

Poole, David 1936–1995
Heavy Horses
oil on board 60 x 90 (E)
C15.1

Poole, David 1936–1995
Horse and Cart
oil on board 23 x 29 (E)
C13.5

Poole, David 1936–1995
Landscape (after John Constable)
oil on card 22 x 30 (E)
C13.6

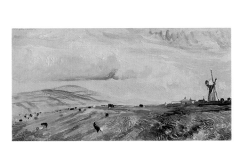

Poole, David 1936–1995
*Landscape with Windmill (after John
Constable)*
oil on card 19 x 40 (E)
C8.4

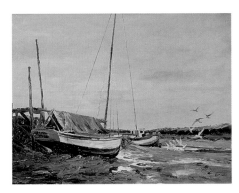

Poole, David 1936–1995
Low Tide
oil on board 45 x 60 (E)
C13.8

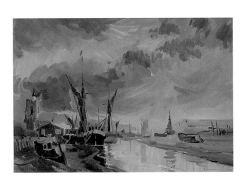

Poole, David 1936–1995
Maldon, Essex
oil on card 25 x 38 (E)
CP.6

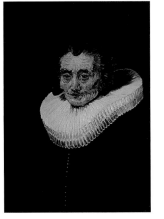

Poole, David 1936–1995
Margarita de Geer (after Rembrandt van Rijn)
oil on board 72 x 60 (E)
C17.1

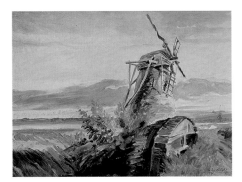

Poole, David 1936–1995
Mill in Landscape (after Henry Bright)
oil on board 45 x 60 (E)
D.02

Poole, David 1936–1995
Nan
oil & bodycolour on board 55 x 37 (E)
NI.6

Poole, David 1936–1995
Pigot Lane, Poringland
oil on board 79 x 120 (E)
D.05

Poole, David 1936–1995
Ploughman's Lunch
oil & bodycolour on board 59 x 89 (E)
D.03

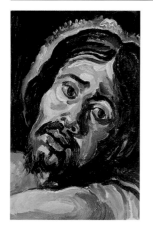

Poole, David 1936–1995
Portrait of a Man (after Diego Velázquez)
oil on card 40 x 28 (E)
NI.1

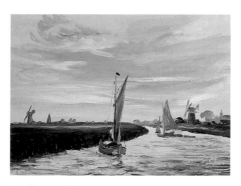

Poole, David 1936–1995
Sailing Barges in the Evening
oil on card 26 x 38 (E)
CP.2

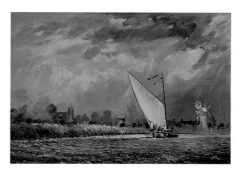

Poole, David 1936–1995
Sailing Wherry on the River
oil on board 57 x 86 (E)
C4.3

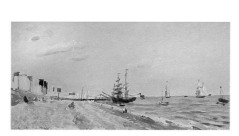

Poole, David 1936–1995
Seafront with Ships (after John Constable)
oil on card 18 x 40 (E)
C8.5

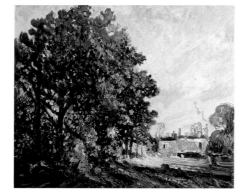

Poole, David 1936–1995
Setting Sun
oil on card 35 x 41 (E)
C8.1

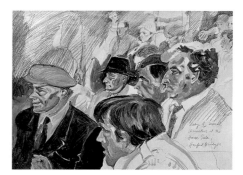

Poole, David 1936–1995
Study of Characters at Horse Sale
oil & pencil on board 42 x 56 (E)
D.01

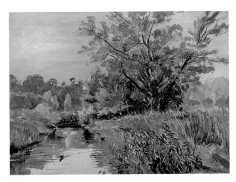

Poole, David 1936–1995
Summer River Bank
oil on card 37 x 50 (E)
C13.1

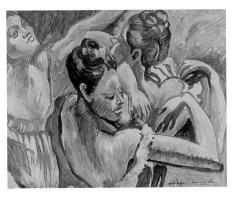

Poole, David 1936–1995
The Dancers (after Edgar Degas)
oil on card 64 x 89 (E)
S5.1

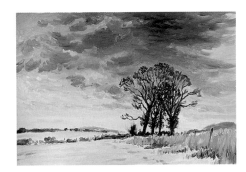

Poole, David 1936–1995
Winter Scene
oil on board 40 x 58 (E)
C7.1

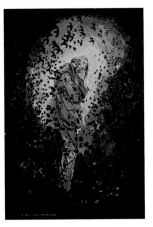

Snook, Reg b.1938
(i) Paradise Lost and Regained, Autumn 2004
oil on board 178 x 117
WW01

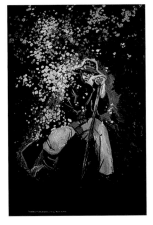

Snook, Reg b.1938
(ii) Paradise Lost and Regained, Winter 2004
oil on board 178 x 117
WW02

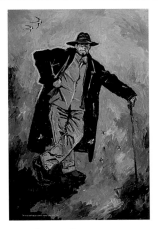

Snook, Reg b.1938
(iii) Paradise Lost and Regained, Spring 2004
oil on board 178 x 117
WW.03

Ipswich Record Office

Burton, Alice Mary b.1893
The 4th Earl of Cranbrook, Chairman of East Suffolk County Council (1950–1957) 1958
oil on canvas 100 x 75
T12882.3

Cope, Arthur Stockdale 1857–1940
John Major, 5th Lord Henniker, Chairman of East Suffolk County Council (1889–1896) 1896
oil on canvas 127 x 102
T12882.1

Herkomer, Hubert von 1849–1914
*Colonel Nathaniel Barnardiston, First
Chairman of West Suffolk County Council*
1892
oil on canvas 127 x 102
T12882.6

Sancha, Carlos Luis 1920–2001
*Colonel Sir Robert Gooch Bt, Chairman of East
Suffolk County Council (1957–1967)* 1967
oil on canvas 91 x 71
T12882.4

Whelan, Leo 1892–1956
*James Douglas Craig, Chairman of East Suffolk
County Council (1947–1950)*
oil on canvas 78 x 66
T12882.2

Zinkeisen, Anna Katrina 1901–1976
*The Hon. C. B. A. Bernard, Chairman of East
Suffolk Council (1967–1974)*
oil on canvas 90 x 72
T12882.5

Ipswich Transport
Museum

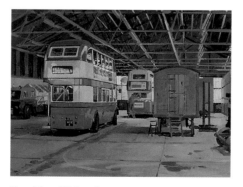

Berridge, Richard
Priory Heath Depot in 1984 1984
oil on board 33 x 44
01

Berridge, Richard
Trolleybus 46 at the Cornhill, Ipswich in 1935
1994
oil on board 49 x 60
02

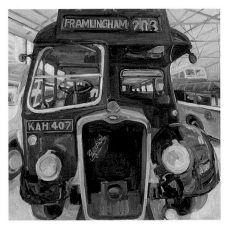

Irwin, Valerie b.1947
Bristol Bus 2004
oil on board 61 x 61
03

Suffolk Fire and Rescue Service Headquarters

Castle
Fire at Mason's 1950s
oil on board 85 x 74 (E)
01

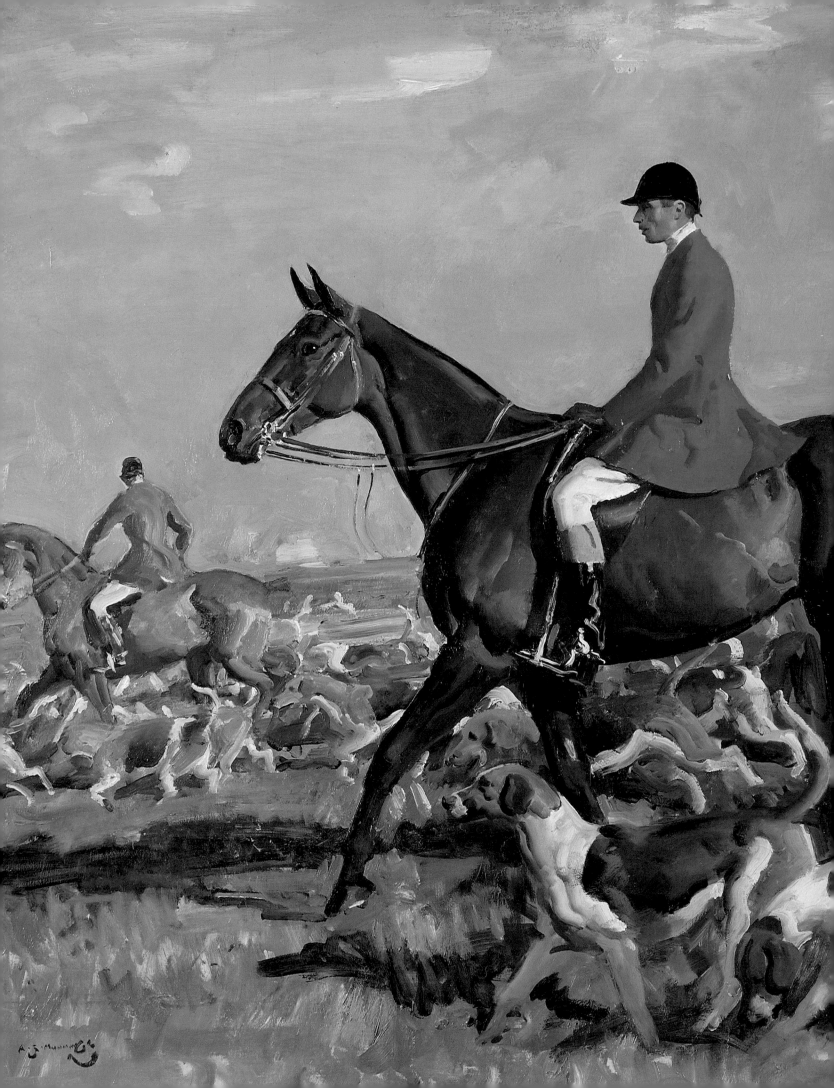

Long Shop Museum

The Long Shop Museum at Leiston stands in the original works site of Richard Garrett & Sons, once world famous manufacturers of steam engines and other agricultural machinery. The Long Shop itself, built in 1852, was a prototype for assembly line production.

The Garrett Works was founded in 1778 by Richard Garrett (1757–1839) and the firm began its rapid rise after 1806 when it started producing the first practical threshing machine. This machine had been invented by John Balls of Hethersett, and two portraits of Sarah Balls, his daughter and wife of the founder's son, form part of the museum's collection.

The portraits in the collection represent members of the extended Garrett family. Richard Garrett (1807–1866), the founder's grandson, brought steam engine production to Leiston in the 1840s and was for many years a committee member of the Royal Society of Arts. There are portraits of his wife, Elizabeth Garrett (daughter of John and Elizabeth Dunnell), as well as their daughter, Betsey Maria Grimwood (1835–1922). Elizabeth's sister Louisa married Richard's brother Newson who built up Snape Maltings.

Other paintings relate directly to the history of Leiston or the Garrett Works. W. Lambert's *Straffed Zeppelin* is a copy of a postcard produced by Leiston photographer J. S Waddell in 1917. In 1932 the Beyer Peacock Company bought the Garrett Works and produced the Beyer Garrett locomotives that were sold to South Africa. In the 1940s Edward Swann was commissioned to produce a series of paintings of the Garrett Works which included the painting of the gun manufacturing shops. Graham Lightfoot, who painted the derelict Long Shop building, was on the original coordinating committee that met in 1976 to set up a museum on the former Garrett Works site. The Museum was officially opened in 1984.

Stephen Mael, Museum Manager

Fryer, Wilfred Moody (attributed to)
1891–1967
The Royal Train, South Africa
oil on board 64 x 232
LESLS.714

Lambert, W.
Straffed Zeppelin, 17 June 1917 1917
oil on canvas 27 x 37
LESLS.716

Lightfoot, Graham C.
The Long Shop, Leiston 1976
oil on canvas 27 x 31
LESLS.P.129

Facing page: Munnings, Alfred James, 1878–1959, *The 6th Earl Winterton MFH* (detail), British Sporting Art Trust, (p. 201)

Swann, Edward
*Four Inch Twin Naval Gun Mounting in
Garrett Works*
oil on canvas 51 x 76
LESLS.715

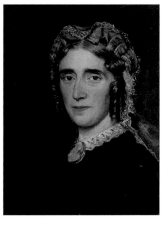

unknown artist
Elizabeth Garrett (1806–1884) c.1850
oil on canvas 47 x 37
LESLS.588

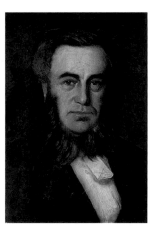

unknown artist
Richard Garrett (1807–1866) c.1850
oil on canvas 55 x 36
LESLS.589

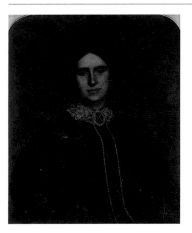

unknown artist
*Betsey Maria Grimwood, née Garrett
(1835–1922)*
oil on canvas 78 x 63
LESLS.710

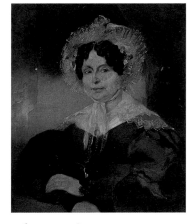

unknown artist
Elizabeth Dunnell (b.1785)
oil on canvas 75 x 63
LESLS.713

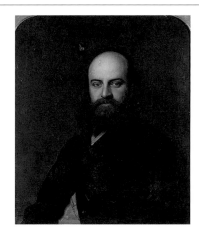

unknown artist
George Augustus Grimwood (1826–1883)
oil on canvas 78 x 63
LESLS.711

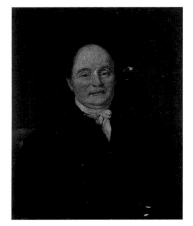

unknown artist
John Dunnell (1781–1866)
oil on canvas 75 x 63
LESLS.712

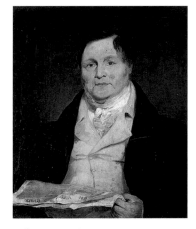

unknown artist
Richard Garrett (1779–1837)
oil on canvas 75 x 61
LESLS.622

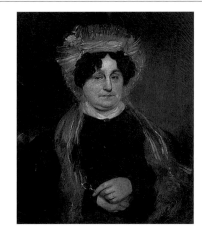

unknown artist
Sarah Garrett, née Balls (1776–!851)
oil on canvas 75 x 61
LESLS.623

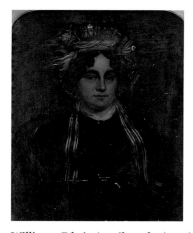

Williams, Edwin (attributed to) active
1843–1875
Sarah Garrett, née Balls (1776–1851)
oil on canvas 78 x 63
LESLS.709

Lowestoft and East Suffolk Maritime Museum

The Lowestoft and East Suffolk Maritime Society was formed in 1958 by a small number of local enthusiasts interested in ships and the sea. Their objective was the collection and preservation of all items relating to the heritage of the shipping and fishing port of Lowestoft and the East Anglian fisheries. Amongst the founder members were Captain E. G. Malet-Warden, Captain N. C. Darnell and Skipper Lieutenant W. Soloman. The latter, as recorder, was responsible for acquiring over the years a substantial part of the collection now at the Maritime Museum. His portrait is on display at the museum.

Prominent in the Collection are the oil paintings by the local 'pierhead' painters who specialised in painting portraits of ships for the seamen who crewed them. Typically the paintings were of a broadside view with the sails set. Although they were free from formal painting techniques they were exact and generally technically accurate. The 'pierhead' painters needed to work quickly so that that their prospective clients had not left port before the paintings were finished and sold.

Possibly the most prolific 'pierhead' painter at Lowestoft was George Race (1872–1957). He worked mostly in oil on board and a speciality of his was paintings in lifebelt frames, a number of which are in the Maritime Museum collection. George Vemply Burwood (1845–1917) was an early 'pierhead' painter and was among the most accomplished painters. He was a cooper by trade but turned to ship portraits with such success that he adopted the style 'Marine Illuminator and Artist'. Ernest George Tench (1885–1942) was considered one of the most consistent of the Lowestoft painters. In the early 1900s he developed a very precise and colourful style, usually in oil on wood. Claude Mowle (1871–1950) and Kenneth Luck (1874–1936) worked together on ship portraits in the early 20th century. Mowle would photograph the ship and take proofs to solicit orders and the paintings were done by Luck, using Mowle's photographs. The paintings of Joe Crowfoot (b.1946) continue the long tradition of the Lowestoft painters.

Peter Parker, Chairman and Curator

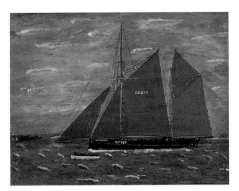

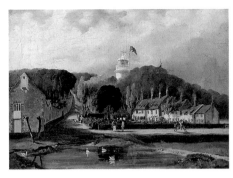

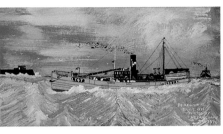

W. J. A.
Wildflower LT557
oil on board 35 x 47
LOWMS.1997.403

Adams, Caroline 1792–1886
Lowestoft Lighthouse
oil on board 26 x 35
LOWMS.1999.426

Beauchamp, J.
Peace Wave LT47 1976
oil on board 27 x 43
LOWMS.2003.42

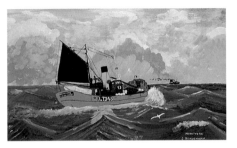

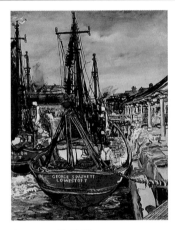

Beauchamp, J.
Primevere LT345
oil on board 24 x 42
LOWMS.1997.349

Beere, A. Howard
Self Portrait 1959
oil on canvas 34 x 25
LOWMS.2004.174

Bennett, G. F. K.
George Spashett 1963
oil on board 74 x 53
LOWMS.2002.353

Bennett, G. F. K.
Fish Market
oil on board 58 x 89
LOWMS.2002.303

Bunce, Mary C.
Lydia Eva YH89 1972
oil on board 56 x 85
LOWMS.1999.817

Burwood, George Vemply c.1845–1917
St Margaret's Church 1885
oil on canvas 24 x 40
LOWMS.1997.45

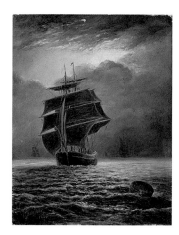

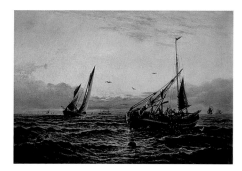

Burwood, George Vemply c.1845–1917
Ravine Bridge 1887
oil on canvas 42 x 63
LOWMS.1997.87

Burwood, George Vemply c.1845–1917
Square Rig Sail Ship 1887
oil on canvas 24 x 18
LOWMS.1998.700

Burwood, George Vemply c.1845–1917
YH151 1887
oil on canvas 45 x 63
LOWMS.1997.44

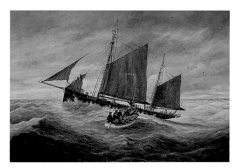

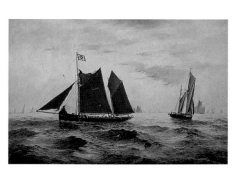

Burwood, George Vemply c.1845–1917
Wildflower LT557 1895
oil on canvas 58 x 84
LOWMS.1997.43

Burwood, George Vemply c.1845–1917
Golden Oriole LT292
oil on canvas 61 x 92
LOWMS.1997.42

Cable, L. J.
Lowestoft Fish Market Scene 1920
oil on board 45 x 35
LOWMS.1997.68

Cable, L. J.
Lowestoft Fish Market Scene 1920
oil on board 45 x 36
LOWMS.1997.69

Chapman, D.
Sunbeam LT9 1968
oil on board 30 x 38
LOWMS.2000.112

Cross, Keith
Warship 1970
oil on board 50 x 74
LOWMS.2003.45

Crowfoot, Joe b.1946
Covent Garden LT1258 1986
oil on board 49 x 74
LOWMS.1997.08

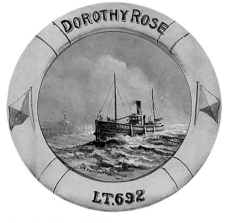

Crowfoot, Joe b.1946
Dorothy Rose LT692
oil & bodycolour on board 19
LOWMS.1997.65

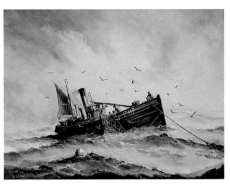

Crowfoot, Joe b.1946
East Briton LT447
oil on board 34 x 45
LOWMS.1997.01

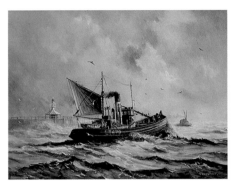

Crowfoot, Joe b.1946
Fisher Queen LT679
oil on board 33 x 45
LOWMS.1997.02

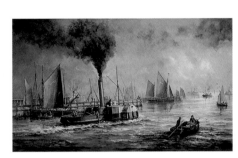

Crowfoot, Joe b.1946
Paddle Tug
oil on board 118 x 194 (E)
LOWMS.1997.13

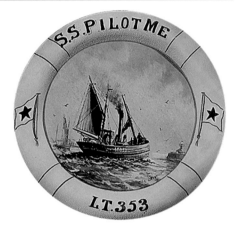

Crowfoot, Joe b.1946
Pilot Me LT353
oil & bodycolour on board 17.5
LOWMS.1997.96

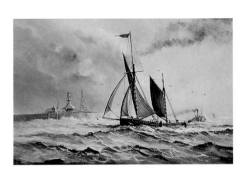

Crowfoot, Joe b.1946
Running for Cover, Heather LT767
oil on canvas 49 x 74
LOWMS.1997.07

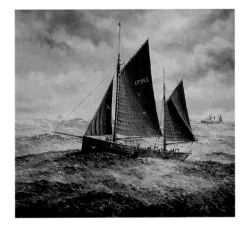

Crowfoot, Joe b.1946
Sincerity LT952
oil on canvas 100 x 101
LOWMS.1997.09

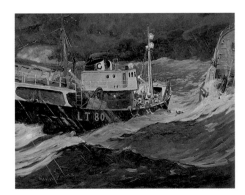

Fisher, Rowland 1885–1969
Granby Queen LT80, Rescuing a Trawler 1962
oil on canvas 100 x 124
LOWMS.1997.62

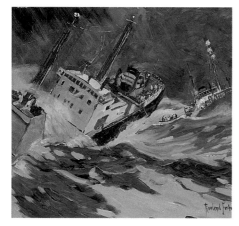

Fisher, Rowland 1885–1969
Trinidad LT210
oil on board 37 x 45
LOWMS.1998.57

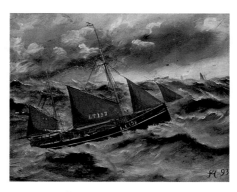

Gregory, John 1841–1917
Sweet Hope LT157 1893
oil on board 45 x 57
LOWMS.1997.98

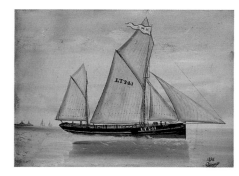

Gregory, John 1841–1917
H. M. C. LT741 1898
oil on board 45 x 60
LOWMS.1997.389

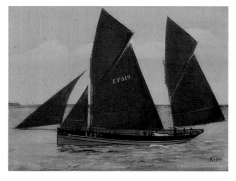

Gregory, John 1841–1917
Bessie LT519 1900
oil on board 45 x 62
LOWMS.1997.37

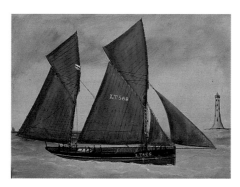

Gregory, John 1841–1917
Fisherman LT568 1900
oil on board 44 x 59
LOWMS.1997.326

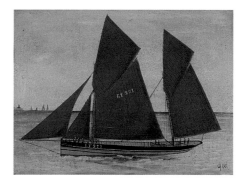

Gregory, John 1841–1917
Maggie May LT371 1900
oil on board 45 x 63
LOWMS.1997.327

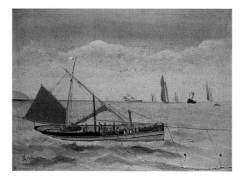

Gregory, John 1841–1917
Watchful LT659 1900
oil on board 45 x 62
LOWMS.1999.500

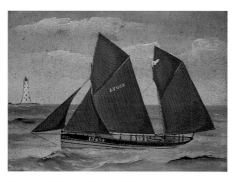

Gregory, John 1841–1917
Watchful LT659 1900
oil on board 45 x 62
LOWMS.1999.701

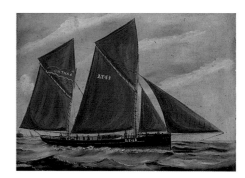

Gregory, John 1841–1917
Xantho LT41 1901
oil on board 54 x 73
LOWMS.1997.333

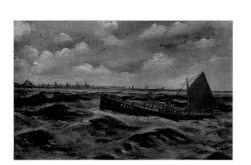

Gregory, John 1841–1917
Majestic LT937 1902
oil on board 50 x 76
LOWMS.1997.83

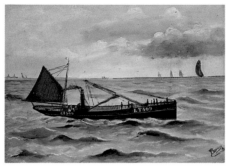

Gregory, John 1841–1917
Recompence LT509 1902
oil on board 45 x 60
LOWMS.1997.89

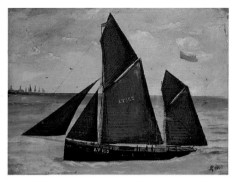

Gregory, John 1841–1917
Sweet Hope LT157 1903
oil on board 46 x 60
LOWMS.1997.390

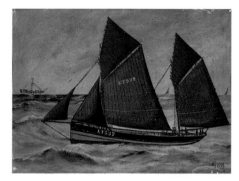

Gregory, John 1841–1917
Children's Friend LT537 1906
oil on board 45 x 61
LOWMS.1997.305

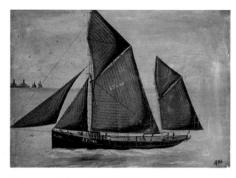

Gregory, John 1841–1917
Emerald LT296 1906
oil on board 45 x 61
LOWMS.1997.304

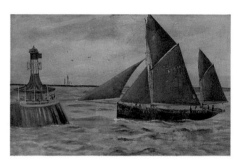

Gregory, John 1841–1917
Illustrious LT546 1913
oil on board 48 x 71
LOWMS.1997.328

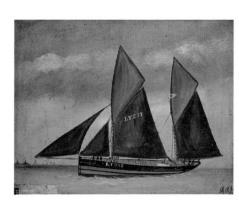

Gregory, John (attributed to) 1841–1917
Active LT237 1898
oil on board 37 x 46
LOWMS.1997.97

Gregory, John (attributed to) 1841–1917
Wave Crest LT744 1911
oil on board 61 x 48
LOWMS.1997.336

L. W. H.
Consolation LT718 1971
oil on board 19 x 22
LOWMS.1997.53

Harper, N. R. active 1970–1974
Ada Kerby LT72 1974
oil on board 40 x 50
LOWMS.1997.35

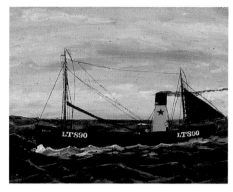

Harvey, S. E.
Lord Hood LT20 1972
oil & bodycolour on board 38 x 51
LOWMS.1997.47

Hurr, E. J. active 1909–1912
Doris LT890 1909
oil on board 22 x 29
LOWMS.1997.51

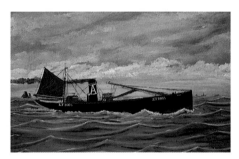

Hurr, E. J. active 1909–1912
Drake LT1068 1912
oil on board 49 x 75
LOWMS.1997.55

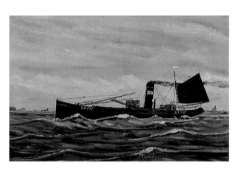

Hurr, E. J. active 1909–1912
Young Fred LT717 1912
oil on board 48 x 76 (E)
LOWMS.1997.320

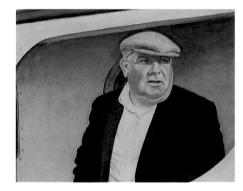

Ives, L. G.
Jumbo Fiske, Skipper
oil on board 41 x 54
LOWMS.1997.14

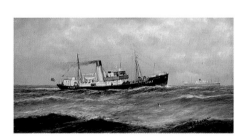

Jaarsma, Haaike Abraham 1881–1970
Sir Lancelot LT263 1953
oil on board 38 x 68
LOWMS.1997.90

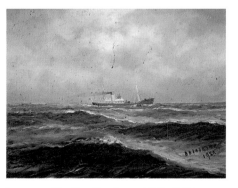

Jaarsma, Haaike Abraham 1881–1970
A Trinity House Vessel 1954
oil on board 22 x 29
LOWMS.1997.59

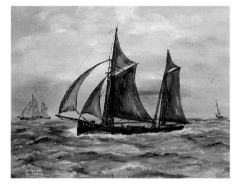

John, C.
Boats at Sea
oil on board 24 x 30
LOWMS.2004.149

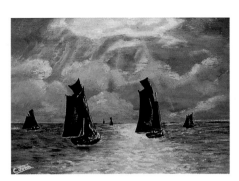

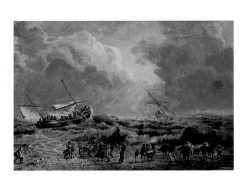

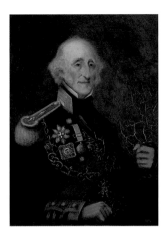

John, C.
Boats at Sea
oil on board 17 x 25
LOWMS.2004.150

Joy, William (after) 1803–1867
Lowestoft Lifeboat Goes to the Rescue
oil on canvas 33 x 51
LOWMS.1997.36

N. de L.
Sir Charles Bullen KCH, KCB, GCB (1768–1853)
oil on canvas 80 x 54 (E)
LOWMS.1997.63

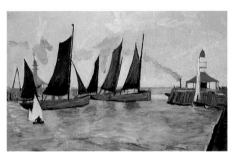

Love, F.
Iverna LT514 1899
oil on board 46 x 65
LOWMS.1997.352

Love, F.
Fear Not LT688
oil on board 43 x 65
LOWMS.1997.329

Mitchell, I. J.
Sail Smacks Leaving Lowestoft 1976
oil on board 59 x 89
LOWMS.1997.334

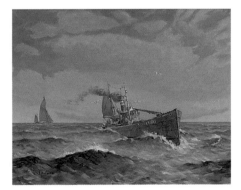

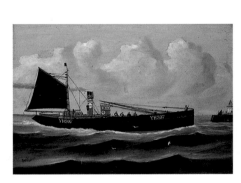

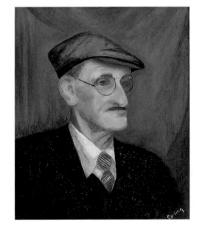

Morgan, I.
Ocean Breeze LT341
oil on board 39 x 49
LOWMS.2000.115

Mowle, Claude 1871–1950 **& Luck, Kenneth** 1874–1936
Ocean Retriever YH307 1912
oil on board 42 x 58
LOWMS.1997.91

Purling, A.
Albert, Fisherman 1962
oil on board 50 x 38
LOWMS.1997.344

Facing page: Berridge, Richard, *Trolleybus 46 at the Cornhill, Ipswich in 1935* (detail), 1994, Ipswich Transport Museum, (p. 164)

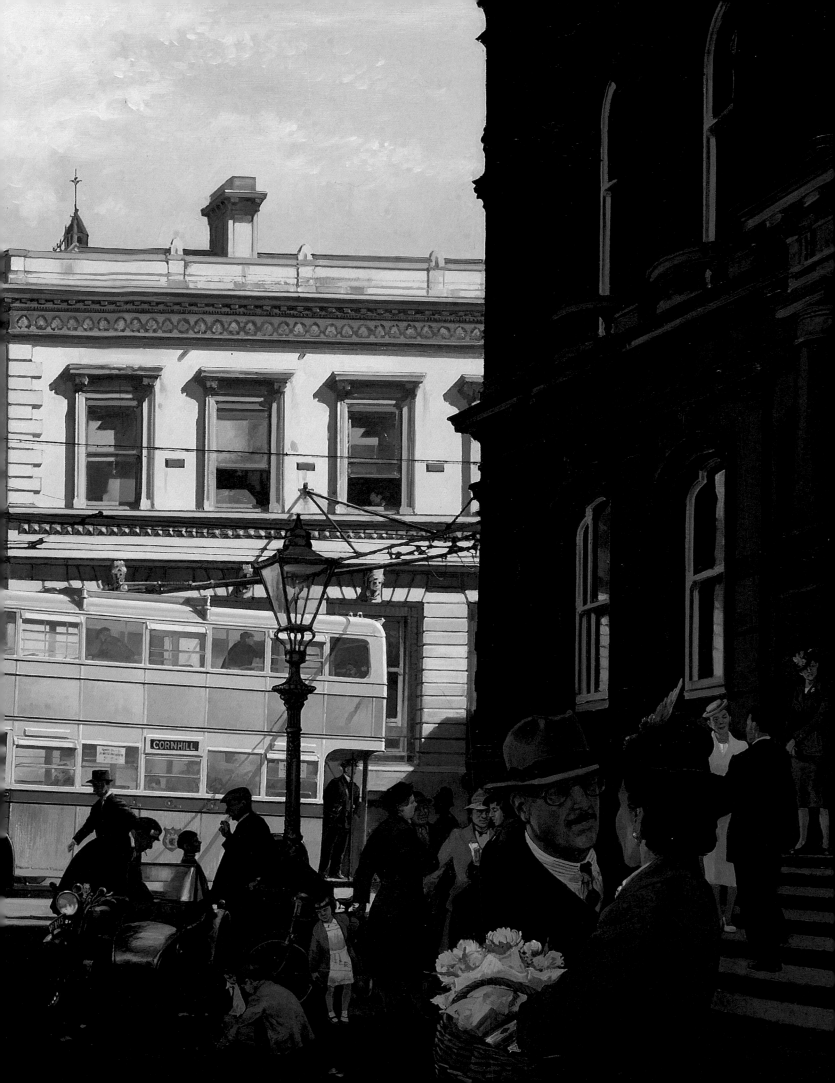

Race, George 1872–1957
Dawn of Day LT617 1905
oil on board 29 x 46
LOWMS.1997.04

Race, George 1872–1957
Harry 1905
oil on board 20 (E)
LOWMS.1997.18

Race, George 1872–1957
Harry YH359 1905
oil on board 28 x 46
LOWMS.1997.79

Race, George 1872–1957
Request LT629 1906
oil on board 19
LOWMS.1997.312

Race, George 1872–1957
Laburnum LT1051 1907
oil on board 27 x 44
LOWMS.1997.67

Race, George 1872–1957
Vigilant LT1025 1907
oil on board 27 x 44
LOWMS.1997.57

Race, George 1872–1957
Carnation LT50 1909
oil on board 13 x 19
LOWMS.1997.54

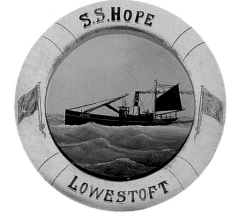

Race, George 1872–1957
Hope LT1075 1909
oil on board 16.5
LOWMS.1997.64

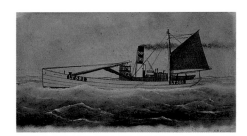

Race, George 1872–1957
Incentive LT581 1910
oil on board 23 x 42
LOWMS.1997.313

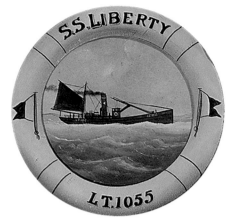

Race, George 1872–1957
Liberty LT1055 1910
oil & bodycolour on board 17.5
LOWMS.1997.19

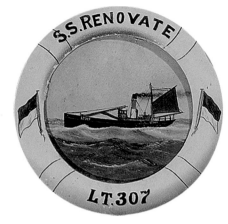

Race, George 1872–1957
Renovate LT307 1910
oil & bodycolour on board 17.5
LOWMS.1997.20

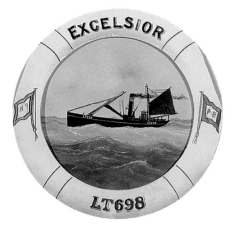

Race, George 1872–1957
Excelsior LT698 1911
oil on board 27
LOWMS.1997.310

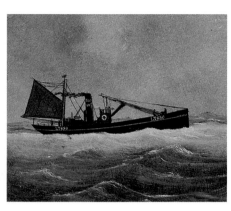

Race, George 1872–1957
Mary Adeline LT650 1911
oil on board 17 x 20
LOWMS.1997.52

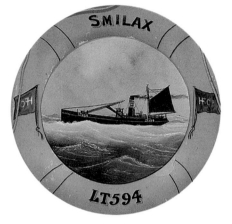

Race, George 1872–1957
Smilax LT594 1911
oil on board 19
LOWMS.1997.311

Race, George 1872–1957
Silver King LT1034 1912
oil on board 30 x 59
LOWMS.1997.95

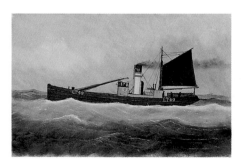

Race, George 1872–1957
Cenwulf LT49 1913
oil on board 31 x 47
LOWMS.1999.721

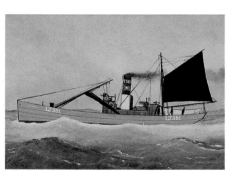

Race, George 1872–1957
Incentive LT581 1913
oil on board 27 x 38
LOWMS.1997.60

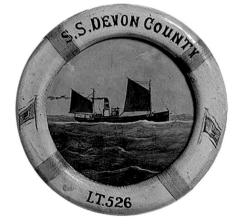

Race, George 1872–1957
Devon County LT526 1921
oil on board 24 (E)
LOWMS.1997.17

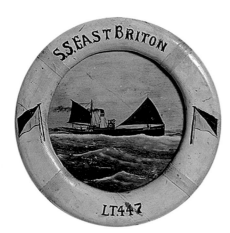

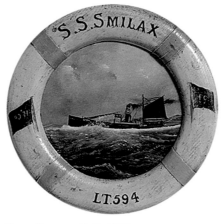

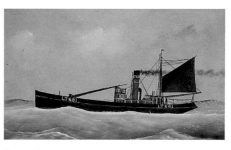

Race, George 1872–1957
East Briton LT447 1921
oil on board 24 (E)
LOWMS.1997.15

Race, George 1872–1957
Smilax LT594 1921
oil on board 24 (E)
LOWMS.1997.16

Race, George 1872–1957
Sincere LT681 1923
oil on board 28 x 43
LOWMS.1997.66

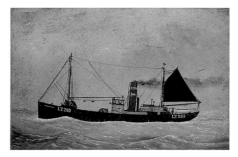

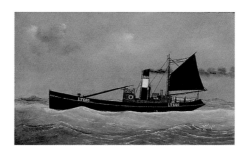

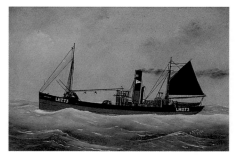

Race, George 1872–1957
John and Norah LT203 1924
oil on board 29 x 44
LOWMS.1997.92

Race, George 1872–1957
Lord Cavan LT680 1924
oil on board 28 x 41
LOWMS.1997.34

Race, George 1872–1957
Craighall LH273 1925
oil on board 28 x 41
LOWMS.1997.06

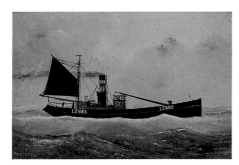

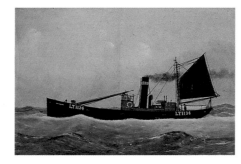

Race, George 1872–1957
Norford Suffling LT685 1925
oil on board 27 x 41
LOWMS.1997.71

Race, George 1872–1957
Shipmates LT1134 1925
oil on board 29 x 46
LOWMS.1997.22

Race, George 1872–1957
Smilax LT594 1925
oil on board 28 x 43
LOWMS.1998.59

Race, George 1872–1957
Bountiful LT1151 1927
oil on board 28 x 41
LOWMS.1997.315

Race, George 1872–1957
Boy Roy LT1167 1927
oil on board 28 x 42
LOWMS.1997.61

Race, George 1872–1957
Locarno LT275 1927
oil on board 28 x 41
LOWMS.1997.05

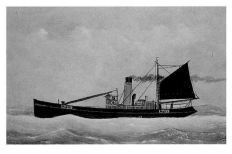

Race, George 1872–1957
Supporter LT119 1927
oil on board 29 x 43
LOWMS.2002.02

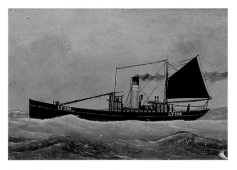

Race, George 1872–1957
Renascent LT288 1928
oil on board 27 x 39
LOWMS.1997.314

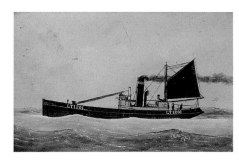

Race, George 1872–1957
Wilmington LT1201 1929
oil on board 27 x 43
LOWMS.1997.21

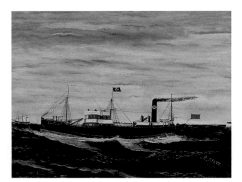

Reeve, R.
Sunniside
oil & bodycolour on board 45 x 60
LOWMS.1997.325

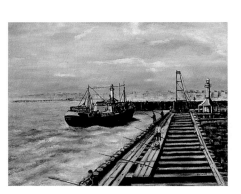

Richards, Francis
Ludham Queen LT87
oil on board 38 x 49
LOWMS.2002.89

Robertson, W.
Ted Ellis and Children
oil on board 62 x 45 (E)
LOWMS.1999.79

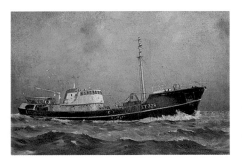

Russell, Clifford 1919–2003
Boston Swallow LT328
oil on board 21 x 30
LOWMS.1997.386

H. S.
Sutterton BN39 1907
oil on board 29 x 45
LOWMS.1997.337

I. M. S.
Brothers LT216
oil on board 28 x 44
LOWMS.1997.73

Sansom, K.
HMS Northern Sky 1991
oil on board 25 x 41
LOWMS.1999.435

Swan, G.
Fancy LT366
oil on board 45 x 75
LOWMS.1997.301

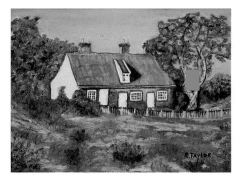

Taylor, R.
The Warren House
oil on board 30 x 40
LOWMS.1998.713

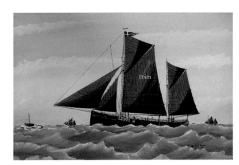

Tench, Ernest George 1885–1942
Spring Flower LT971 1906
oil on board 47 x 74
LOWMS.1997.81

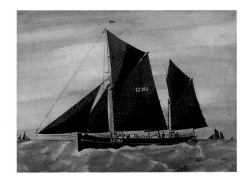

Tench, Ernest George 1885–1942
Defender LT183 1907
oil on board 50 x 67
LOWMS.1997.318

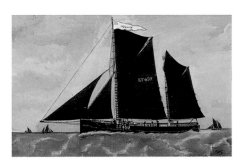

Tench, Ernest George 1885–1942
Nelson LT459 1907
oil on board 43 x 70
LOWMS.1997.323

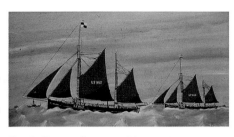

Tench, Ernest George 1885–1942
Sincerity LT952 and Boy Russell LT346 1907
oil on board 53 x 97
LOWMS.1997.309

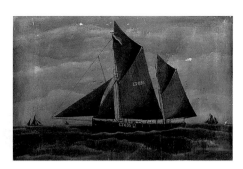

Tench, Ernest George 1885–1942
Chrysolite LT635 1908
oil on board 52 x 90
LOWMS.1997.330

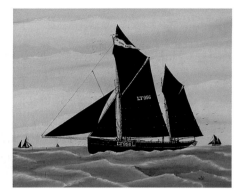

Tench, Ernest George 1885–1942
George Borrow LT956 1908
oil on board 58 x 74
LOWMS.1997.319 (P)

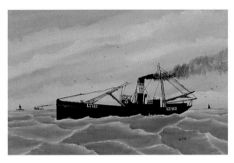

Tench, Ernest George 1885–1942
Good Friend LT112 1908
oil on board 51 x 75
LOWMS.1997.84

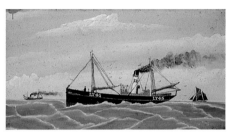

Tench, Ernest George 1885–1942
Herring Fisher LT45 1908
oil on board 37 x 63
LOWMS.1997.78

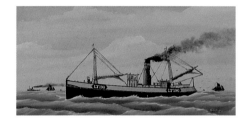

Tench, Ernest George 1885–1942
Indomitable LT196 1908
oil on board 43 x 78
LOWMS.1997.11

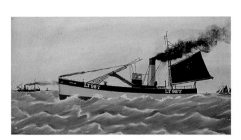

Tench, Ernest George 1885–1942
Internos LT987 1908
oil on board 38 x 68
LOWMS.1997.56

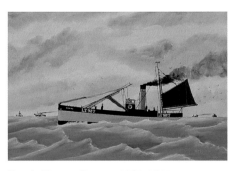

Tench, Ernest George 1885–1942
Internos LT987 1908
oil on board 52 x 79
LOWMS.1997.306

Tench, Ernest George 1885–1942
John Lincoln LT140 1908
oil on board 53 x 78
LOWMS.1997.80

Tench, Ernest George 1885–1942
True Vine LT52 1908
oil on board 71 x 99
LOWMS.2001.258

Tench, Ernest George 1885–1942
Boy George LT441 1909
oil on board 51 x 80
LOWMS.1997.12

Tench, Ernest George 1885–1942
Boy Ramah LT308 1909
oil on board 53 x 78
LOWMS.1997.308

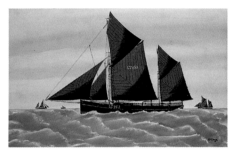

Tench, Ernest George 1885–1942
Girl Annie LT953 1909
oil on board 52 x 80
LOWMS.1997.321

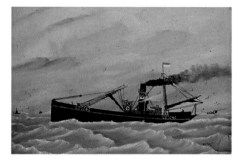

Tench, Ernest George 1885–1942
Girl Hilda LT1040 1909
oil on board 53 x 76
LOWMS.1997.99

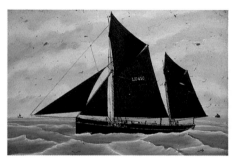

Tench, Ernest George 1885–1942
Roma LT410 1909
oil on board 54 x 80
LOWMS.2001.41

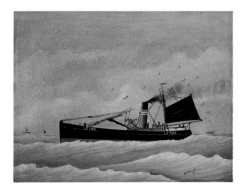

Tench, Ernest George 1885–1942
Midas LT585 1910
oil on board 59 x 75
LOWMS.1997.316

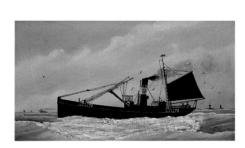

Tench, Ernest George 1885–1942
Osprey LT1076 1911
oil on board 45 x 87
LOWMS.1997.332

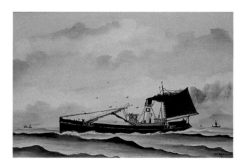

Tench, Ernest George 1885–1942
John Alfred LT470 1913
oil on board 54 x 77
LOWMS.1997.317

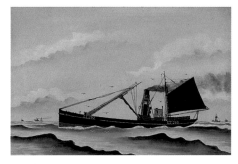

Tench, Ernest George 1885–1942
Searcher LT290 1913
oil on board 54 x 78
LOWMS.1997.388

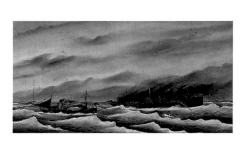

Tench, Ernest George 1885–1942
E. W. B. LT1124 1922
oil on board 66 x 134
LOWMS.1997.82

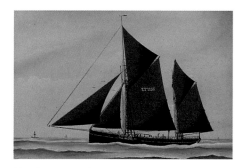

Tench, Ernest George 1885–1942
Telesia LT1155
oil on board 52 x 79
LOWMS.1997.322

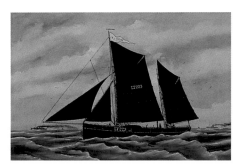

Tench, Ernest George (attributed to)
1885–1942
W. E. Brown LT223
oil on board 52 x 79
LOWMS.1997.335

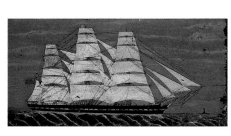

unknown artist
A Sailing Clipper
oil on wood 37 x 75
LOWMS.1997.410

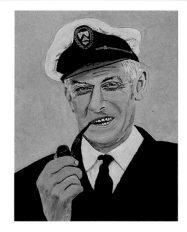

unknown artist
*Bill Soloman, Founder Member of Lowestoft
Maritime Society*
oil on board 45 x 33
LOWMS.1997.345

unknown artist
Fish Market Scene
oil on board 34 x 60
LOWMS.1997.347

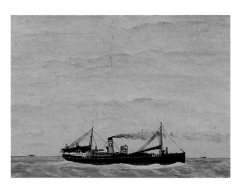

unknown artist
John Alfred LT470
oil & bodycolour on board 36 x 51
LOWMS.1997.406

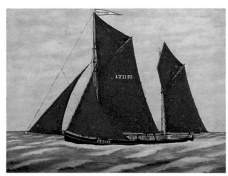

unknown artist
Keewaydin LT1192
oil on board 34 x 43
LOWMS.1997.93

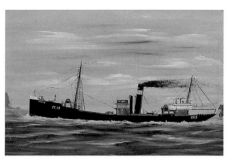

unknown artist
Kyoto CF19
oil on canvas 38 x 58
LOWMS.1997.408

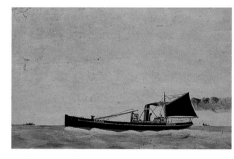

unknown artist
LT226
oil on board 45 x 62
LOWMS.1999.722

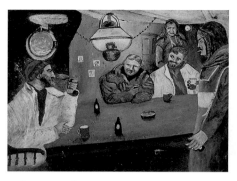

unknown artist
Men around a Messdeck Table
oil on board 32 x 43
LOWMS.2000.180

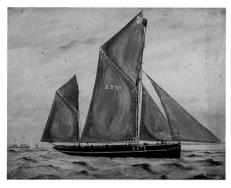

unknown artist
Norfolk LT55
oil on board 45 x 59
LOWMS.1997.331

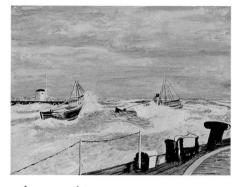

unknown artist
Vessels Returning to Harbour
oil on board 48 x 63
LOWMS.1998.878

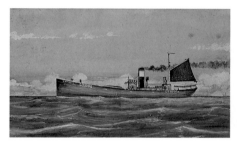

unknown artist
W. A. Massey LT1090
oil & bodycolour on board 30 x 50
LOWMS.1997.76

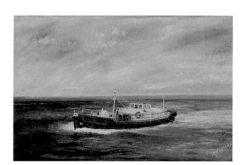

Whaley, M. J.
Frederick Edward Crick
oil on board 31 x 54
LOWMS.1997.49

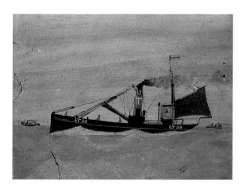

Yallop, A. V.
Carnation LT50 1907
oil on board 46 x 59
LOWMS.1998.56

Lowestoft Museum at Broad House

The majority of paintings on display illustrate local scenes, many having changed over the years; some have disappeared altogether.

The highly finished and detailed painting *St John's Church, Lowestoft 1861* by Caroline Adams (1792–1886), was painted shortly after its erection as part of Morton Peto's development south of the harbour. It was presented to the museum by the Vicar and Churchwardens of St John's in 1973. The church was demolished five years later.

Just above the inside of the Museum's entrance is *Frost's Alley Score Lowestoft*, by an unknown artist. The score – a path leading from the street to the beach – was destroyed by enemy action in the early 1940s and never rebuilt. Its remains lie beneath Lowestoft Police Station in Old Nelson Street.

Several paintings by Lowestoft artist George Vemply Burwood (1845–1917) are on display. *Lowestoft Inner Harbour, Lake Lothing* shows a scene bustling with waterborne activity which contrasts with today's tranquil vista. *Belle Vue Park, 1886* shows the ravine with the lighthouse in the background.

Two evocative early 19th century paintings by Peter La Cave are considered particular centrepieces of the Museum's collection. *Yarmouth Jetty, 1803* shows a beach populated with naval and other seafarers landing from a line of frigates anchored in the Yarmouth Roads. The companion painting, *Lowestoft Beach, 1803* portrays fishermen landing skeps of fish to waiting buyers on the beach. Kirkley Church appears in the distance.

A portrait of the last mayor before the abolition of the Lowestoft Corporation, *Alderman Donald G. Durrant* by Mildred Crimp, also forms part of the Museum's collection.

Michael Chester, Acting Porcelain Keeper

Adams, Caroline 1792–1886
St John's Church, 1861 1861
oil on canvas 39 x 54
WP.084

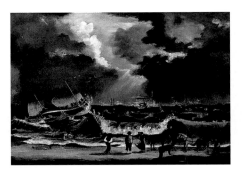

Barrett, R. M.
Lowestoft Lifeboat Launching to Vessel in Distress (after William Joy)
oil on canvas 45 x 61
WP.035

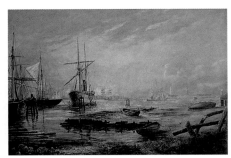

Burwood, George Vemply c.1845–1917
Lowestoft Inner Harbour, Lake Lothing 1880s
oil on canvas 61 x 90
WP.037

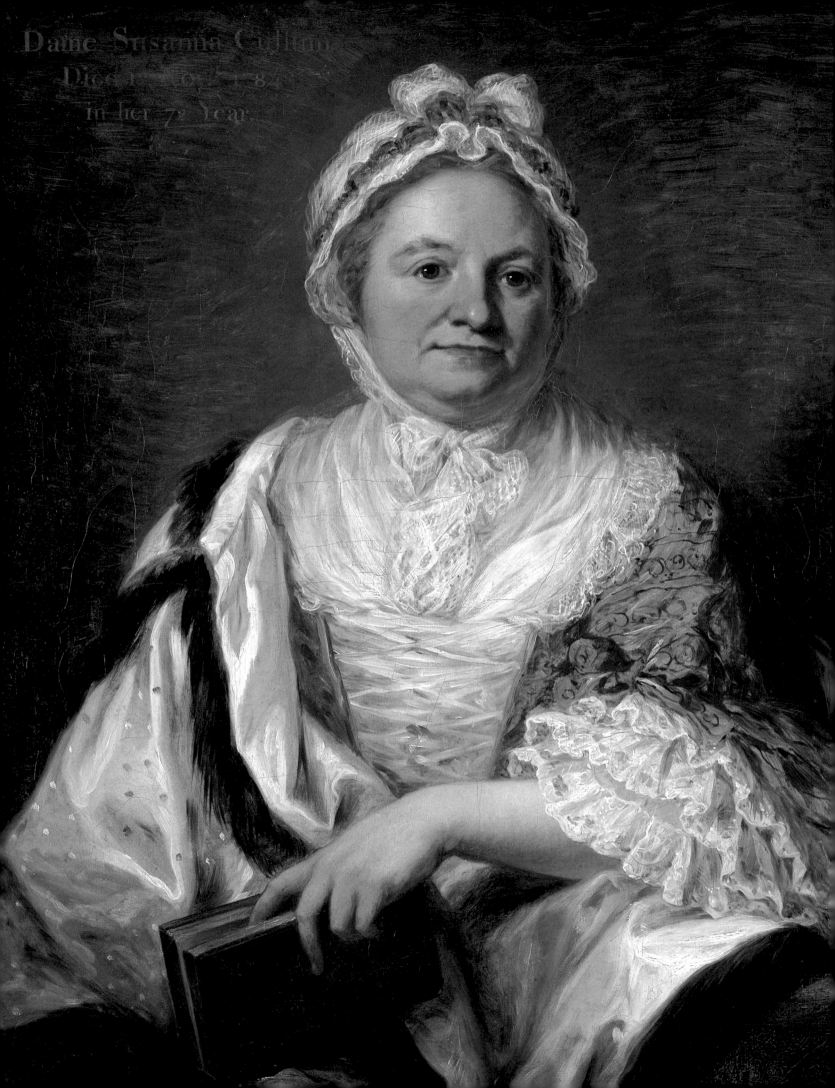

Dame Susanna Cullum
Died 1st Nov. 1784
in her 72 Year

Burwood, George Vemply c.1845–1917
Belle Vue Park, 1886 1886
oil on canvas 46 x 67
WP.070

Burwood, George Vemply c.1845–1917
The High Light, Lowestoft Score 1887
oil on canvas 25 x 60
P.789

Cave, Peter le 1769–1801
Lowestoft Beach, 1803
oil on canvas 64 x 84
WP.031

Cave, Peter le 1769–1801
Yarmouth Jetty, 1803
oil on canvas 64 x 84
WP.032

Crimp, Mildred F.
Alderman D. G. Durrant 1974
oil on canvas 116 x 76
WP.100

Green, G. Colman 1893–1964
Bittern Sailing on Zuyder Zee
oil on board 20 x 43
WP.045

Green, G. Colman 1893–1964
Lowestoft Yacht Basin, Regatta 1906
oil on board 42 x 83
WP.050

Green, G. Colman 1893–1964
Yawls Racing at Lowestoft Regatta 1951
oil on board 27 x 62
WP.046

Harper, N. R. active 1970–1974
LT55 Approaching Port 1970
oil on canvas 45 x 61
WP.094

Facing page: Kauffmann, Angelica, 1741–1807, *Susanna, Lady Cullum* (detail), c.1780, St Edmundsbury Museums, (p. 20)

K. T.
Frost Alley Score, Lowestoft 1890
oil on canvas 30 x 20 (E)
WP.025

Wouwerman, Philips (after) 1619–1668
Gypsy Encampment 1870
oil on canvas 44 x 53
WP.026

Waveney District Council

Burwood, George Vemply c.1845–1917
Ravine Bridge, Lowestoft 1887
oil on canvas 40 x 56
WP086

Burwood, George Vemply c.1845–1917
Smack Wildflower Rescuing Survivors of SS Elbe 1895
oil on canvas 80 x 122 (E)
WP005

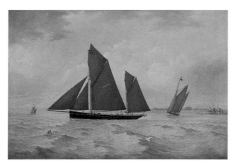

Burwood, George Vemply c.1845–1917
Acme LT651
oil on canvas 60 x 91 (E)
WP001

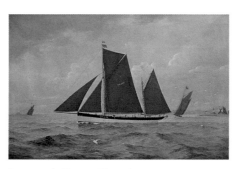

Burwood, George Vemply c.1845–1917
Viola LT1026
oil on canvas 60 x 91 (E)
WP015

Capps-Jenner, B.
View from 15 Stanley Street 1969–1970
oil on board 92 x 92
WP095

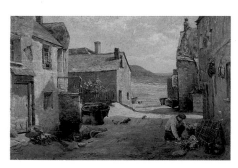

Craft, Percy Robert 1856–1934
Cornish Village
oil on canvas 50 x 76
WP002

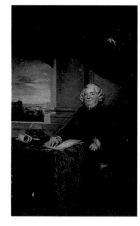

Eaton, G. C.
John Barker (1707–1787) (copy of Joshua Reynolds)
oil on canvas 116 x 72
WP007

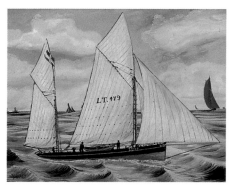

Gregory, John 1841–1917
Mirand LT479 1883
oil on card 36 x 47
WP096

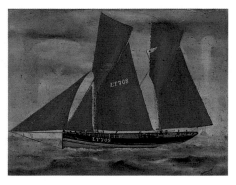

Gregory, John 1841–1917
Forward LT708 1897
oil on board 48 x 63
WP048

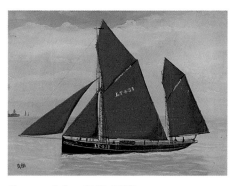

Gregory, John 1841–1917
Speranza LT431 Entering Harbour 1901
oil on board 46 x 61
WP051

Gregory, John 1841–1917
Speranza LT431 in a Storm 1901
oil on board 44 x 58
WP052

Gregory, John 1841–1917
Lowestoft Smack off Claremont Pier 1914
oil on card 51 x 41
WP056

Jensen, Alfred 1859–1935
SS Copenhagen 1915
oil on canvas 50 x 68
WP059

Kerris
Cottage and Bridge Crossing
oil on board 35 x 59
WP.T1

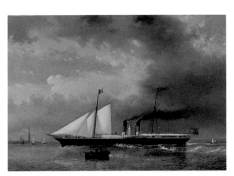

Linnig, Egidius 1821–1860
Paddle Steamer Cygnus 1855
oil on canvas 59 x 80
WP003

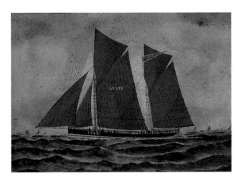

Love, F. (attributed to)
Lily LT572 1909
oil on board 47 x 63
WP060

Phillips, Marjorie
Diketa Entering Lowestoft
oil on board 36 x 46
WP.T2

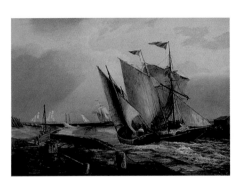

Preston, T.
Smacks at Lowestoft Harbour Entrance 1839
oil on canvas 47 x 66
WP008

Rees, G. J.
Belle Vue Park 1875
oil on canvas 50 x 60
WP018

Smith, David 1920–1998
Lowestoft Old Extension Pier Head 1974
oil on canvas 50 x 65
WP.T3

unknown artist
Captain Woods, Trinity House Pilot c.1850
oil on canvas 38 x 33
WP020

unknown artist
Mrs Woods c.1850
oil on canvas 38 x 33
WP021

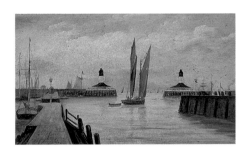

unknown artist
Leaving Lowestoft Harbour
oil on card 28 x 44
WP089

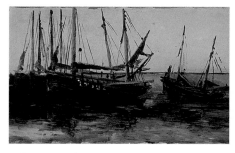

unknown artist
Study of Lowestoft Smacks
oil on board 19 x 29
WP033A

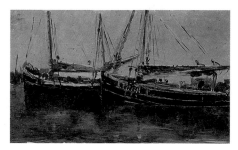

unknown artist
Study of Lowestoft Smacks
oil on board 19 x 29
WP033B

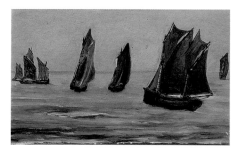

unknown artist
Study of Lowestoft Smacks
oil on board 19 x 29
WP033C

unknown artist
Study of Lowestoft Smacks
oil on board 19 x 29
WP033D

unknown artist
Study of Lowestoft Smacks
oil on board 19 x 29
WP033E

unknown artist
Study of Lowestoft Smacks
oil on board 19 x 29
WP033F

unknown artist
The Open Book of Scriptures
oil on canvas 44 x 35
WP011

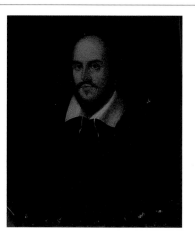

unknown artist
William Shakespeare (copy of 'The Chandos Portrait')
oil on board 72 x 60
WP012

Martlesham Heath Control Tower Museum

Cooper, David O.
P51 Mustangs, 343 Fighter Squadron
oil & acrylic on board 50 x 58
0161

Fairbairn, Gordon R.
B-26 Marauder 1995
oil on board 31 x 42
LN.MT.03 (P)

Fairbairn, Gordon R.
Air Sea Rescue Launch 2001
oil on board 31 x 42
LN.MT.02 (P)

Fairbairn, Gordon R.
Boulton Paul Defiant 2001
oil on board 31 x 45
LN.MT.01 (P)

Hall, Charles
*Slipstream on the Heath, Hawker Fury
Number 1 Squadron*
oil on board 76 x 102
A0807

Kempster, R.
Fairey Battle, France 1940
oil on board 16 x 40
A1286

Newson, Barry
356th Fighter Group 2000
oil on board 90 x 120
A0866

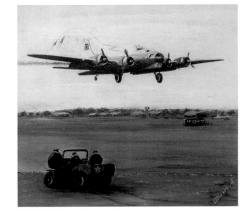

Newson, Barry
Home Alone
oil on board 29 x 33
A7080

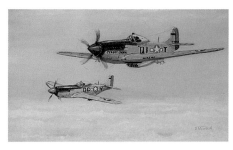

Newson, Barry
Martlesham Pair, P51 Mustangs
oil on board 25 x 37
0173

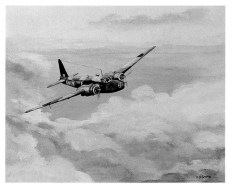

Smith, Harry J. d.1983
Vickers Wellington
oil on board 40 x 50
0432

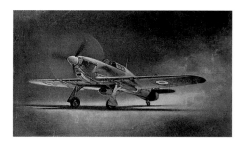

unknown artist
Hawker Hurricane
oil on canvas 40 x 69
A1403

Mildenhall and District Museum

Dagley
Old Cemetery Chapel, Mildenhall 1990
oil & acrylic on canvas 41 x 48
K.82

Davis, James d.1995–1996
The Last Chapter 1980
oil & acrylic on canvas 50 x 120
MT.01

Smith, Harry J. d.1983
Lancaster Bombing Raid 1980
oil & acrylic on canvas 54 x 75
MT.02

Statham, F. J. N.
The Mill at Barton Mills
oil on board 35 x 48
MT.03

British Sporting Art Trust

The British Sporting Art Trust Collection housed in Newmarket has been built up over the past 27 years through a combination of bequests, gifts and purchases. The Collection spans three centuries of sporting artists and engravers, starting from the 18th century. The Trust has been fortunate to have either been given or left some fine examples of the works of Alfred Munnings and Lionel Edwards, which form the basis of the 20th century collection (the Edwards paintings are watercolours and are therefore not included in this catalogue).

Alfred Gates left us a fine Herring Senior and a Stubbs; eight paintings, from the estate of Victor Morley Lawson, were allocated to us by the Secretary of State for National Heritage; Roger Bickley left us six; the late Paul Mellon, KBE, left us 34 paintings as well as three sculptures.

Our first gift was two paintings of dogs by George Stubbs from Lady Price and we have had numerous other gifts and bequests from benefactors, some of whom have included contemporary artists.

The first painting purchased in 1978 by the Trust was a large oil on canvas of the *Pinckney Family Coursing at Stonehenge*, by Samuel Spode. In 1984 the Trust purchased 100 engravings from the British Council and over the years we have purchased some 30 bronzes, sculptures and engravings. Our latest acquisition is the gift of 40 early boxing engravings from Mr Marke Zervudachi. Since the Trust was founded it has built up a Sporting Library which is also housed at Newmarket.

We continue to expand the collection with the best examples from all periods. The works illustrated in this catalogue are the oil paintings from the Collection but the Trust is proud to own a fine selection of sporting prints covering subjects such as racing, fishing, hunting, shooting, archery and rowing.

Marigold Lawton, Secretary

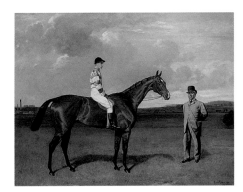

Adam, Emil 1843–1924
Mimi with Rickaby up with Her Trainer, Mr Matthew Dawson, 1891 1891
oil on canvas 109 x 135
1979/001

Alken, Samuel Henry 1810–1894
The 1850 Cambridgeshire Stakes: Start of the Race 1850
oil on canvas 43.5 x 60.5
1999/001

Alken, Samuel Henry 1810–1894
The 1850 Cambridgeshire Stakes: The Finish 1850
oil on canvas 34 x 51
1999/002

Alken, Samuel Henry 1810–1894
Jockey Mounting (Set of Four Racing Scenes)
oil on board 22 x 29.5
1993/005C

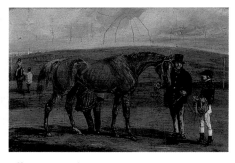

Alken, Samuel Henry 1810–1894
Preparing for a Race (Set of Four Racing Scenes)
oil on board 22 x 29.5
1993/005A

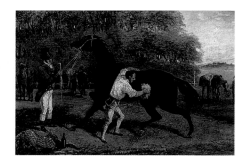

Alken, Samuel Henry 1810–1894
Rubbing Down (Set of Four Racing Scenes)
oil on board 22 x 29.5
1993/005D

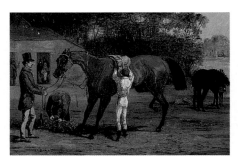

Alken, Samuel Henry 1810–1894
Saddling (Set of Four Racing Scenes)
oil on board 22 x 29.5
1993/005B

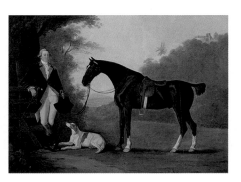

Best, John active 1750–1792
Officer of the Royal Horse Guards With His Charger and Dog 1776
oil on canvas 78 x 102
1990/004

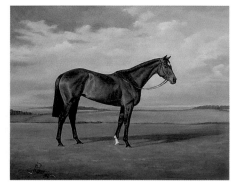

Bowman, Jean b.1917
Berkeley Springs 1967
oil on canvas 70 x 85
1999/004

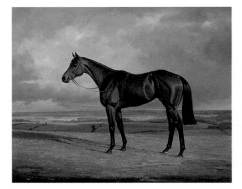

Bowman, Jean b.1917
Silly Season 1967
oil on canvas 70 x 85
1999/003

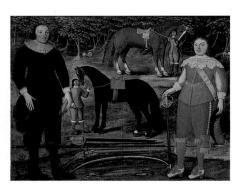

British (English) School
Hardolph Wasteaeys (1612–1673) with His Tutor at Headon Hall 1638
oil on canvas 139 x 186
BSL/006 (P)

Cooper, Abraham 1787–1868
Studies of Sixteen Jockeys I
oil on paper laid on board 48 x 37
1999/005

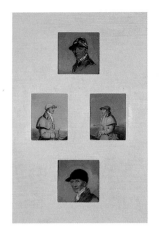

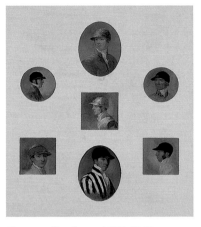

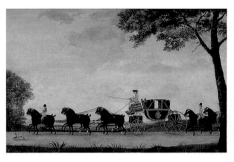

Cooper, Abraham 1787–1868
Studies of Sixteen Jockeys II
oil on paper laid on board 55.5 x 39
1999/006

Cooper, Abraham 1787–1868
Studies of Sixteen Jockeys III
oil on paper laid on board 56 x 51
1999/007

Cordrey, John active 1765–1825
The Marquess of Queensberry's Coach 1792
oil on canvas 59 x 90
1990/002

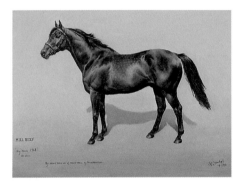

Crawford, Susan b.1941
Mill Reef 1978
oil on canvas 64.5 x 79
1999/008

De Alarcen, Richard
Park House Stables, Kingsclere 1983
oil on canvas 71 x 114
1993/008

Dedreux, Alfred 1810–1860
The Trainer
oil on canvas 62.5 x 81.5
1999/022

Henderson, Charles Cooper 1803–1877
A London Cab
oil on canvas 54.4 x 65
1993/001

Henderson, Charles Cooper 1803–1877
A Paris Diligence
oil on canvas 54.5 x 65
1993/002

Herring, John Frederick I 1795–1865
Sluggard with Flatman up 1832
oil on canvas 67.5 x 88
1988/002

Facing page: Burwood, George Vemply, c.1845–1917, *Smack Wildflower Rescuing Survivors of SS Elbe* (detail), 1895,
Waveney District Council, (p. 190)

Herring, John Frederick I 1795–1865
The Match between 'Priam' and 'Augustus', 20 October 1831 1832
oil on canvas 45.5 x 57
1999/014

Herring, John Frederick I 1795–1865
Euclid, with Jockey Connolly and Trainer Pettit
oil on panel 61.5 x 71.5
1993/003

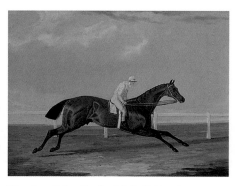

Herring, John Frederick I 1795–1865
Tarrare, with George Nelson up
oil on canvas 47 x 58
1999/013

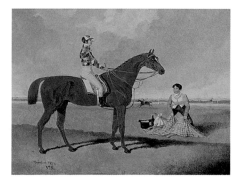

Herring, John Frederick II 1815–1907
Barefoot, with Goodison up, 1829 (Series of Four)
oil on canvas 31 x 38.5
1999/009

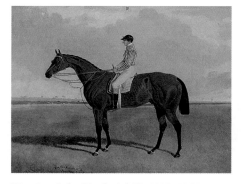

Herring, John Frederick II 1815–1907
Bay Middleton, with Robinson up, 1836 (Series of Four)
oil on canvas 22 x 29
1999/010

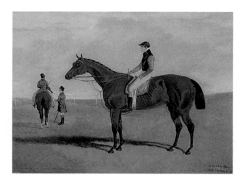

Herring, John Frederick II 1815–1907
Matilda, with Robinson up, 1827 (Series of Four)
oil on canvas 22 x 29
1999/011

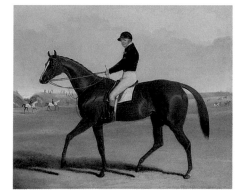

Herring, John Frederick II 1815–1907
Preserve, with Flatman up at Newmarket, 1835
oil on canvas 62 x 73
1993/004

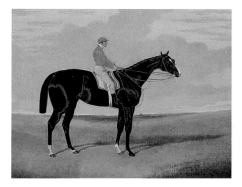

Herring, John Frederick II 1815–1907
Queen of Trumps, with Lye up, 1836 (Series of Four)
oil on canvas 28.5 x 36
1999/012

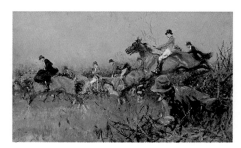

Holiday, Gilbert Joseph 1879–1937
Hunting Scene, Full Cry
oil on canvas 58.5 x 94
1986/001

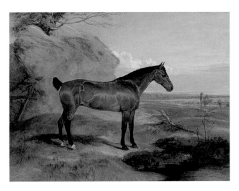

Landseer, Edwin Henry 1802–1873
Lord Henniker's Bay Mare, Brunette 1823
oil on canvas 69 x 90
BSL/002 (P)

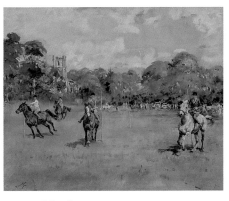

Lyne, Michael 1912–1989
A Pony Club Bending Race 1959
oil on canvas 65 x 76
2000/002

Morland, George 1763–1804
Ferreting 1792
oil on canvas 44.5 x 52
1987/001

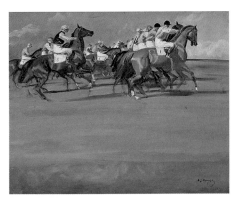

Munnings, Alfred James 1878–1959
Moving up to the Start, Newmarket
oil on board 72 x 82
1999/017

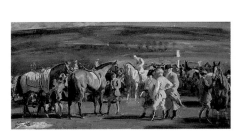

Munnings, Alfred James 1878–1959
Study for 'The Saddling Paddock, Cheltenham March Meeting'
oil on board 46 x 81.5
1999/021

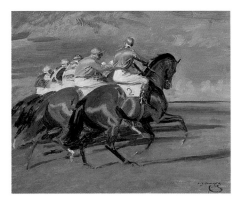

Munnings, Alfred James 1878–1959
Study for 'Under Starter's Orders, Newmarket'
oil on board 51 x 61
1999/016

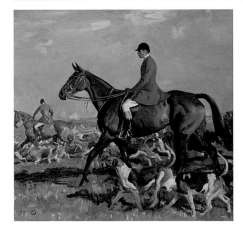

Munnings, Alfred James 1878–1959
The 6th Earl Winterton, MFH
oil on canvas 91.5 x 94
1999/020

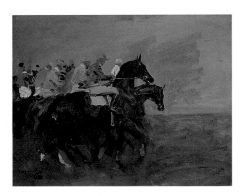

Munnings, Alfred James 1878–1959
The Start, October Meeting, Newmarket
oil on board 44 x 54.5
1999/015

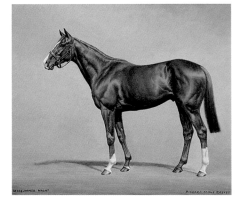

Reeves, Richard Stone 1919–2005
Midsummer Night 1962
oil on board 34 x 39.5
1999/018

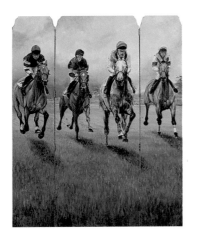

Sanders, Philip
Worcester Races
oil on wood panel 201 x 157
1991/002

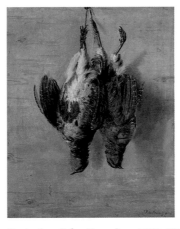

Sartorius, John Francis c.1775–1831
Brace of English Partridge 1808
oil on canvas 65 x 54
1988/003

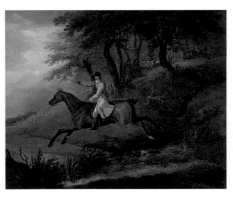

Sartorius, John Nost 1759–1828
*Thomas Oldaker, Huntsman to the Berkeley,
on His Hunter 'Magic' Breaking Cover, 1811*
1811
oil on canvas 55 x 65
1979/002

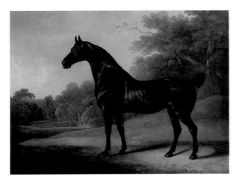

Schwanfelder, Charles Henry 1774–1837
A Bay Horse in a Wooded Landscape 1814
oil on canvas 80 x 100
1986/004

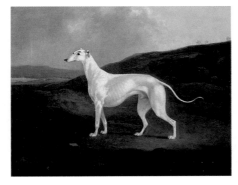

Schwanfelder, Charles Henry 1774–1837
A Greyhound in a Landscape 1817
oil on canvas 81 x 99
1986/005

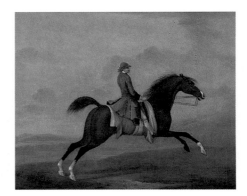

Seymour, James (after) 1702–1752
Flying Childers, with Jockey up
oil on canvas 44.5 x 53
1990/003

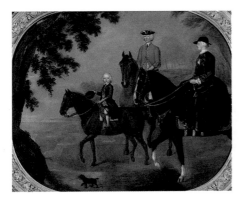

Slaughter, Stephen 1697–1765
Sir George Hampson and Family 1738?
oil on canvas 55 x 66
1990/001

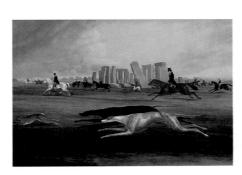

Spode, Samuel active 1825–1858
The Pinckney Family Coursing at Stonehenge
1845
oil on canvas 145.5 x 210
1987/001B

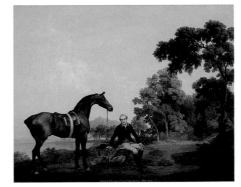

Stubbs, George 1724–1806
Lord Clanbrassil with Hunter Mowbrary 1769
oil on canvas 101 x 128
BSL/004 (P)

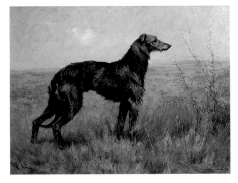

Stubbs, George 1724–1806
A Pointer (a pair)
oil on paper on panel 61 x 71
1978/002

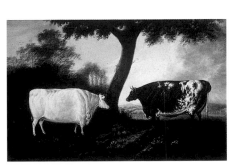

Stubbs, George 1724–1806
A Spaniel (a pair)
oil on canvas 61 x 71
1978/003

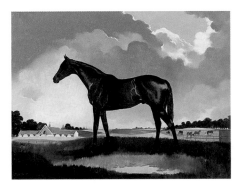

Stubbs, George 1724–1806
Fighting Stallions 1791
oil on canvas 62.5 x 75
1988/001

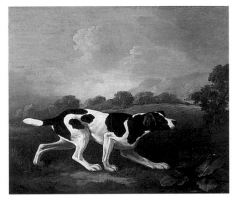

Wardle, Arthur 1864–1949
Portrait of a Deerhound, Champion Earl II
1896
oil on board 69 x 89
BSL/003 (P)

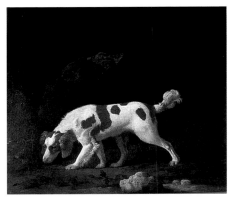

Wilson, Thomas Fairbairn active 1806–1846
Two Shorthorn Cattle: The White Heifer Which Travelled and Red Rose 1806
oil on canvas 80 x 120 (E)
1984/001

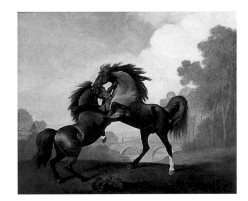

Zinkeisen, Doris Clare 1898–1991
Mill Reef
oil on canvas 88 x 108.5
1992/001

National Horseracing Museum

For a nation that takes it art and its leisure seriously, it seems strange that we underplay three of our great inventions – sporting painting, the thoroughbred horse and the codification of sports such as football, cricket and racing. The history of horseracing in Britain encompasses all three, and indeed parallels the economic and social history of our country itself. Add a healthy dose of intrigue, murder, extreme eccentricity, huge amounts of money and larger than life personalities, and you find a fascinating slice of British history.

Hence the National Horseracing Museum in Newmarket contains a vast and surprising collection of objects and paintings, many of which are not only of the highest quality but of considerable social interest. For example, Daniel Quigley's delightful portrait of *The Godolphin Arabian* shows an animal destined to become one of the three founding fathers of the thoroughbred, from whom all current racehorses are descended. He looks mournfully at the spot by his stable door where his companion, the cat Grimalkin, is buried – he would never allow another cat to take her place. Even today many highly-strung racehorses have a stable companion, such as a goat, rabbit or football, which will travel with them when they go to the races.

A more recent acquisition is the portrait of *Violante* (foaled 1802) *with Frank Buckle up*, by Henry Bernard Chalon. Violante, a very successful mare, ran many of her races at Newmarket, winning 23 out of 27 of them. Buckle, commonly known as 'The Pocket Hercules', was himself a phenomenon, whose record of 27 classic wins was only broken by Lester Piggott. We are lucky to have another very good portrait of him by Richard Jones, together with a set of his silks and other memorabilia.

Another purchase was *The 1839 Derby* by James Pollard (1792–1867). That year, the race took place in a May snowstorm, and was further distinguished by the fact that the winner, Bloomsbury, was almost certainly four years old rather than the three years stipulated for the race. Certainly a number of bookmakers won a great deal of money.

No discussion of our paintings should omit the very great debt that we owe to the Friends of the Museum and other supporters, including the Resource/ V&A Purchase Grant Fund, who have enabled us to make acquisitions which, as an independent museum, we would otherwise be unable to afford. We are also very grateful to our lenders. We have an unusually large number of important loans, which to their owners are effectively pictures of members of their family. Indeed in the 18th century it is said you would have paid more for a portrait of your racehorse than of your wife.

We are grateful to the Public Catalogue Foundation for including our paintings, which we feel deserve to be better known.

Hilary Bracegirdle, Former Director (1996–2004)

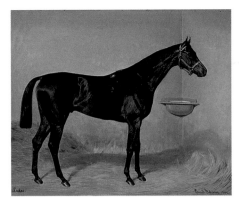

Adam, Emil 1843–1924
Ladas 1894
oil on canvas 33 x 39
1985.LN.63.11 (P)

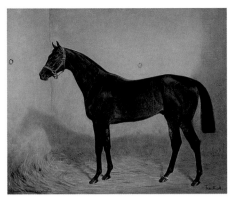

Adam, Emil 1843–1924
Troutbeck 1906
oil on canvas 32 x 39 (E)
1985.LN.63.12 (P)

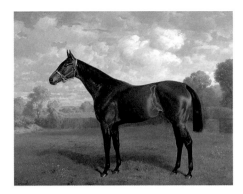

Adam, Emil 1843–1924
Sceptre
oil on canvas 72 x 93
1995.632

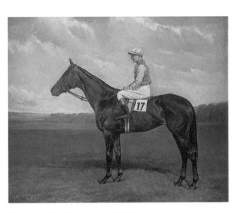

Anscombe, R. active 1950s
Meld, H. Carr up
oil on canvas 50 x 60 (E)
1997.744

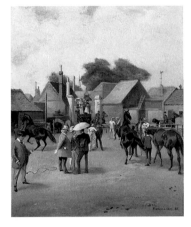

Ben, I.
Tattersalls Sales 1888
oil on canvas 27 x 22
1983.235.1

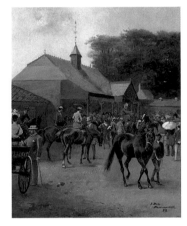

Ben, I.
Tattersalls Sales 1888
oil on canvas 27 x 22
1983.235.2

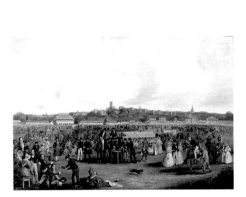

British (English) School
Wolverhampton Races
oil on canvas 60 x 86
1985.LN.137

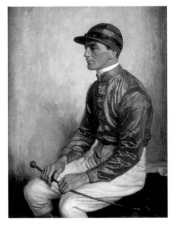

Broadhead, W. Smithson 1888–1960
Steve Donoghue 1924
oil on canvas 102 x 77
1991.435

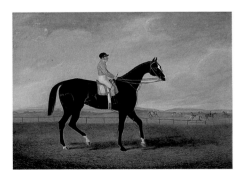

Bryan, John active 1826–1835
Queen of Trumps, J. Lye up 1835
oil on canvas 36 x 51
1985.LN.63.9 (P)

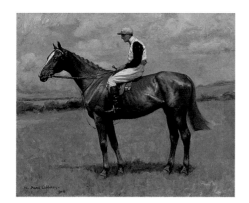

Calderon, William Frank 1865–1943
Atrato, Ivor Anthony up 1908
oil on canvas 51 x 59
1984.434

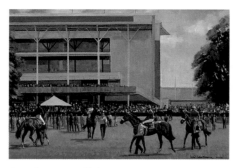

Cawthorne, Neil b.1936
*Newmarket Rowley Mile Millennium
Grandstand* 2000
oil on canvas 46 x 66
2002.24

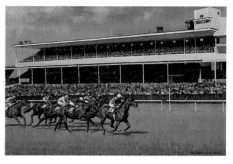

Cawthorne, Neil b.1936
Newmarket Rowley Mile Racecourse 2000
oil on canvas 46 x 66
2002.23

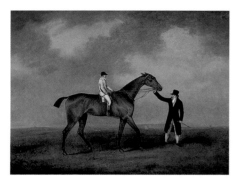

Chalon, Henry Bernard 1770–1849
Violante, F. Buckle up
oil on canvas 77 x 101
2002.77

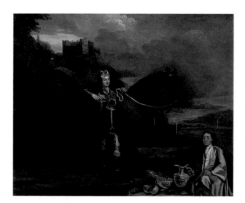

Closterman, John Baptist active c.1690–
1713
English Racehorse, c.1690
oil on panel 62 x 74
1994.579

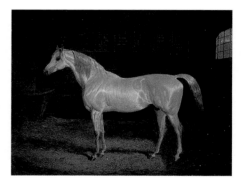

Cooper, Alfred Egerton (attributed to)
1883–1974
Grey Manus in Stables 1938
oil on canvas 36 x 47
1985.LN.63.10 (P)

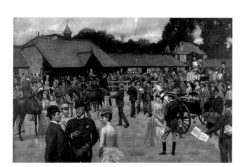

Cullin, Isaac active 1875–1920
The Paddock at Tattersalls, Newmarket
oil on canvas 99 x 146
1987.LN.538 (P)

Curling, Peter b.1955
Sir Peter O'Sullevan and Friends
oil on canvas 75 x 90
1998.LN.661 (P)

Delmé-Radcliffe, Charles 1864–1937
Hunting Scenes
oil on canvas 33 x 46 (E)
1984.363.1

Dighton, Joshua 1831–1908
Cloister 1893
oil on canvas 49 x 60
1995.636

Earl, Thomas P. active 1900–1933
Brown Betty 1933
oil on canvas 62 x 74
1983.8.4

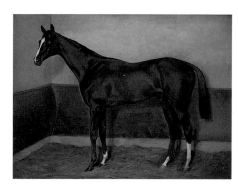

Gascoyne, George 1862–1933
Victor Wild 1895
oil on canvas 72 x 92
1994.588

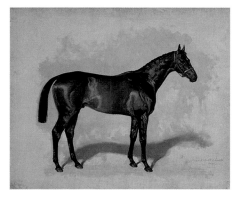

Haigh, Alfred G. 1870–1963
Sunstar 1911
oil on canvas 65 x 80
NS.1985.19.1

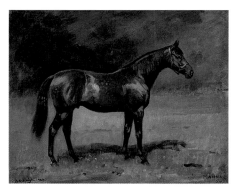

Haigh, Alfred G. 1870–1963
Manna 1927
oil on canvas 43 x 53
NS.1985.19.9

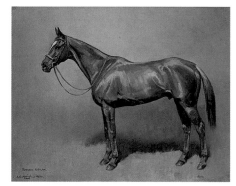

Haigh, Alfred G. 1870–1963
Shaun Goilin 1930
oil on canvas 41 x 52
NS.1985.19.5

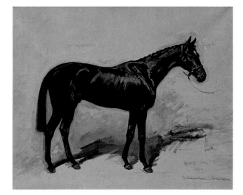

Haigh, Alfred G. 1870–1963
April the Fifth 1932
oil on canvas 51 x 63
NS.1985.19.8

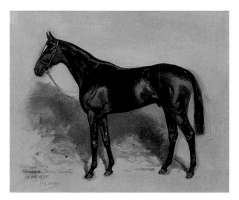

Haigh, Alfred G. 1870–1963
Bahram 1935
oil on canvas 51 x 63
NS.1985.19.12

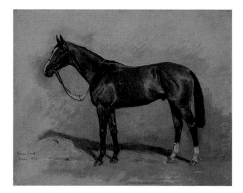

Haigh, Alfred G. 1870–1963
Ocean Swell 1944
oil on canvas 42 x 53
NS.1985.19.13

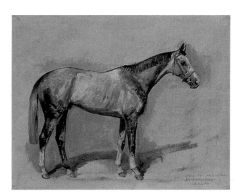

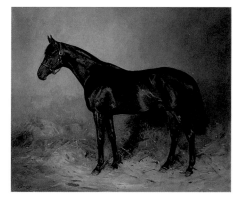

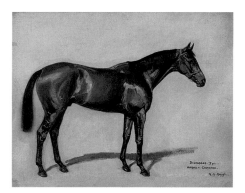

Haigh, Alfred G. 1870–1963
Airborne 1946
oil on canvas 42 x 53
NS.1985.19.7

Haigh, Alfred G. 1870–1963
Cannobie
oil on canvas 63 x 73
NS.1985.19.4

Haigh, Alfred G. 1870–1963
Diomedes
oil on canvas 41 x 52
NS.1985.19.3

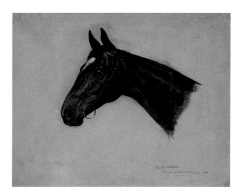

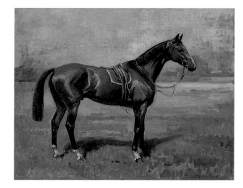

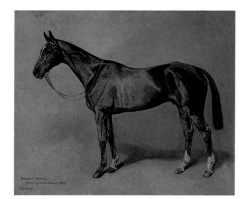

Haigh, Alfred G. 1870–1963
Jenkinstown
oil on canvas 41 x 52
NS.1985.19.6

Haigh, Alfred G. 1870–1963
Nothing Venture
oil on canvas 42 x 53
NS.1985.19.2

Haigh, Alfred G. 1870–1963
Sergeant Murphy
oil on canvas 51 x 60
1983.266.2

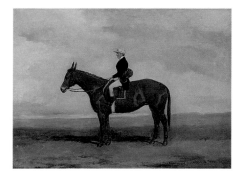

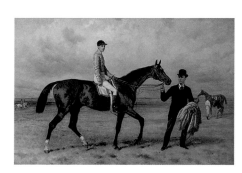

Hall, Harry 1814–1882
Old Sam Day 1842
oil on canvas 33 x 45
1984.295

Hall, Harry 1814–1882
Bertram, T. Osborne up 1869
oil on canvas 89 x 132
1983.21

Hall, Harry 1814–1882
John Day
oil on canvas 37 x 25
1985.LN.31.3 (P)

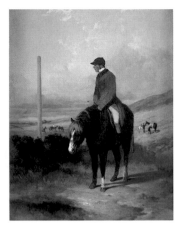

Hall, Harry 1814–1882
Nat Flatman
oil on canvas 74 x 56
1990.LN.612

Hall, Harry (attributed to) 1814–1882
Jockeys Chifney, Arnull, Robinson and Boyer
oil on canvas 54 x 40 (E)
1985.LN.31.2 (P)

Hall, Sydney Prior (attributed to) 1842–
1922
Harry Hall
oil on canvas 65 x 53
1992.503.1

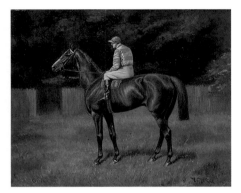

Havell, Alfred Charles 1855–1928
Cicero
oil on canvas 31 x 38
1985.LN.63.13 (P)

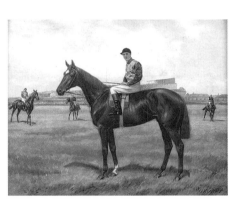

Havell, Alfred Charles 1855–1928
Pretty Polly
oil on canvas 31 x 43
1996.642.1

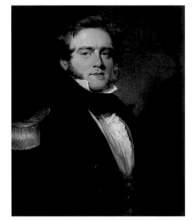

Hayter, George 1792–1871
Admiral Henry John Rous (1791–1877)
oil on canvas 75 x 61
1987.LN.540.2 (P)

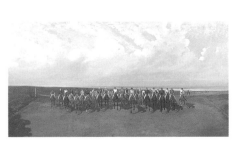

Herring, Benjamin II 1830–1871
The Start of the Cambridgeshire Stakes, 1867
1867
oil on canvas 78 x 152
1990.416

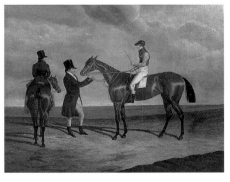

Herring, John Frederick I 1795–1865
Matilda 1824
oil on canvas 69 x 89
1994.578.1

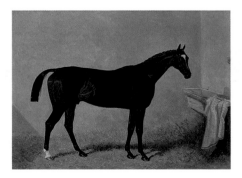

Herring, John Frederick I 1795–1865
Touchstone 1836
oil on canvas 37 x 48
1985.LN.63.7 (P)

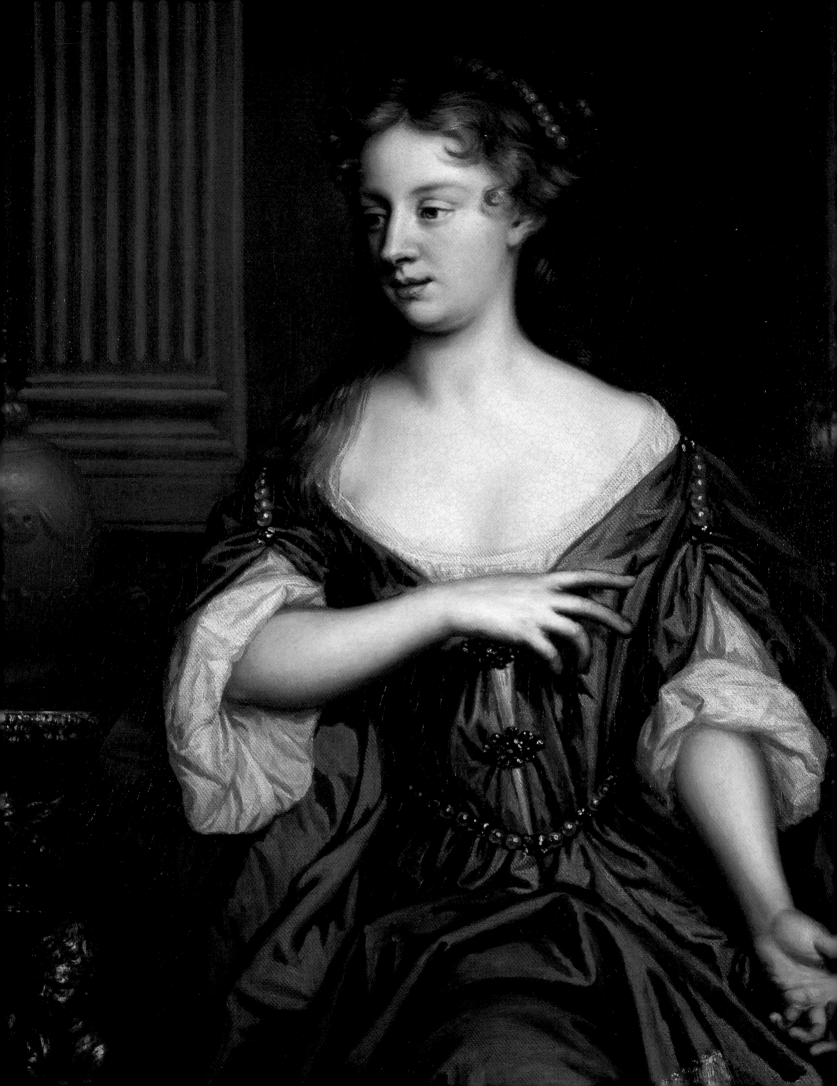

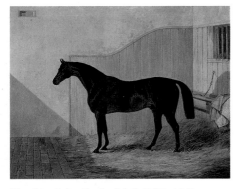

Herring, John Frederick I 1795–1865
Amato c.1838
oil on canvas 59 x 78
1998.75

Herring, John Frederick I 1795–1865
*The Flying Dutchman and Voltigeur at York,
1851* 1851
oil on canvas 69 x 101
1985.LN.316.2 (P)

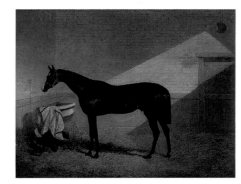

Herring, John Frederick I 1795–1865
Attila
oil on canvas 70 x 90
1986.LN.496 (P)

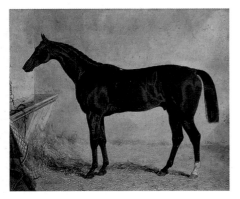

Herring, John Frederick I 1795–1865
Don John
oil on board 25 x 29
1985.LN.63.8 (P)

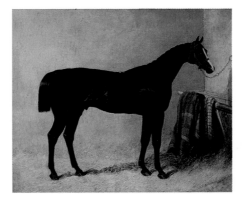

Herring, John Frederick I 1795–1865
Filho da puta
oil on board 28 x 33 (E)
1985.LN.63.6 (P)

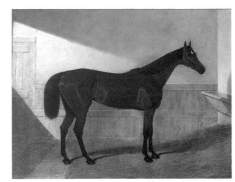

Herring, John Frederick I 1795–1865
Oxygen
oil on canvas 29 x 39
1986.LN.500 (P)

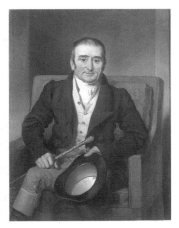

Jones, Richard 1767–1840
Frank Buckle c.1820
oil on canvas 95 x 74
1997.677

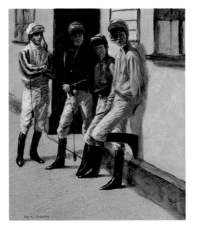

Koehler, Henry b.1927
Jockeys' Room Doorway, Newmarket 1991
oil on canvas 58 x 48
1991.442

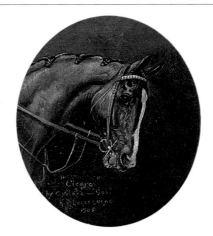

Lucas, Henry Frederick Lucas c.1848–1943
Cicero 1905
oil on canvas 15 x 13
1983.15

Facing page: Beale, Mary, 1633–1699, *Self Portrait* (detail), c.1675, St Edmundsbury Museums, (p. 9)

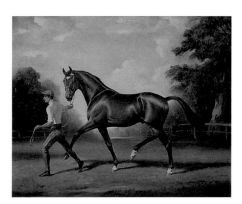

Marshall, Benjamin 1767–1835
Match between Eagle and Eleanor
oil on canvas 96 x 138
1994.59 (P)

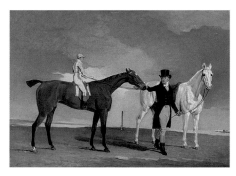

Marshall, Benjamin 1767–1835
Shrapnell, W. Arnull up with Trainer Dixon Boyce
oil on canvas 67 x 93
2004.LN.5 (P)

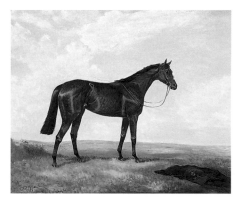

McLeod, Juliet b.1917
Carozza 1958
oil on canvas 67 x 78
1983.150.1

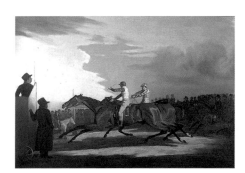

Millais, Raoul 1901–1999
Nijinsky
oil on canvas 62 x 76
1992.477

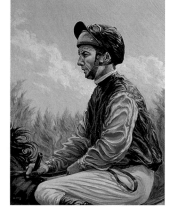

Miller, Roy b.1938
Lester Piggott 1973
oil on canvas 101 x 74
2003.1

Minaham, Lydia b.1942
Sweat Boxes of Fred Archer, Heath House Stables 1996
oil & mixed media on card 22 x 25
2000.87

Minaham, Lydia b.1942
The Blacksmith and Head Lass, Hurworth House 1996
oil & mixed media on card 27 x 15
2000.88

Minaham, Lydia b.1942
The Fountain, Palace House Stables 1996
oil & mixed media on card 34 x 50
2000.86

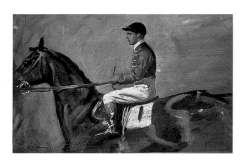

Munnings, Alfred James 1878–1959
Sun Chariot, Sir Gordon Richards up
oil on canvas 26 x 34
1984.342

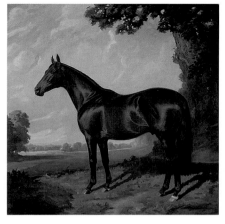

Palmer, James Lynwood 1865–1941
Gainsborough 1921
oil on canvas 104 x 104
1998.1

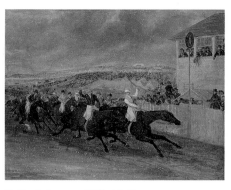

Pollard, James 1792–1867
The 1839 Derby, Bloomsbury Beating Deception 1839
oil on canvas 36 x 45
2001.22

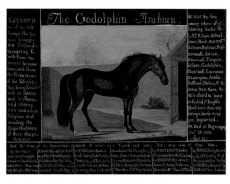

Quigley, Daniel active 1750–1773
The Godolphin Arabian (copy of David Morier)
oil on board 109 x 137
1992.467

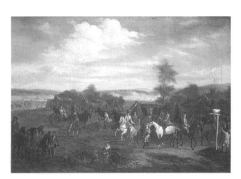

Ross, James I active 1709–1738
Meeting at Clifton and Rawcliffe Ings, York, 1709
oil on canvas 45 x 61
1992.502

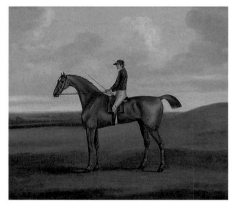

Sartorius, John Nost 1759–1828
Sir Thomas 1783
oil on canvas 30 x 36
1985.LN.63.2 (P)

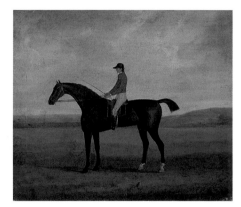

Sartorius, John Nost 1759–1828
Dungannon 1788
oil on canvas 31 x 35
1985.LN.63.3 (P)

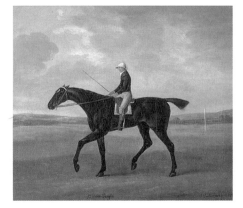

Sartorius, John Nost 1759–1828
Sir Peter Teazle 1788
oil on canvas 32 x 37
1985.LN.63.1 (P)

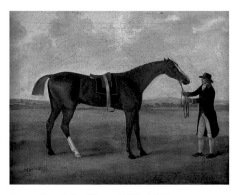

Sartorius, John Nost 1759–1828
Eclipse
oil on canvas 35 x 44
1985.LN.63.4 (P)

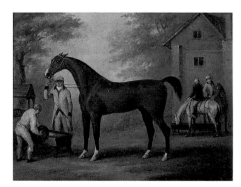

Sartorius, John Nost 1759–1828
Flying Childers
oil on canvas 21 x 27
1985.63.5C (P)

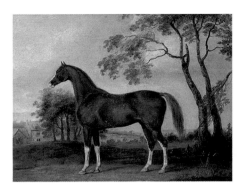

Sartorius, John Nost 1759–1828
Grosvenor Arabian
oil on canvas 21 x 27
1985.63.5D (P)

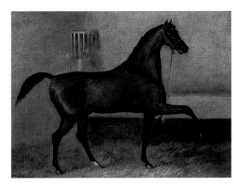

Sartorius, John Nost 1759–1828
Herod
oil on canvas 21 x 27
1985.63.5A (P)

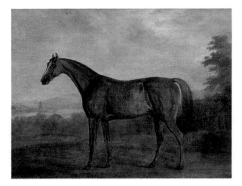

Sartorius, John Nost 1759–1828
Pot 8 Os
oil on canvas 21 x 27
1985.63.5B (P)

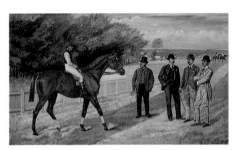

Sealy, Allen Culpeper 1850–1927
Kingwood, C. Wood up 1887
oil on canvas 74 x 126
1985.LN.318.2 (P)

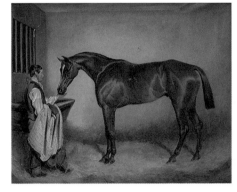

Sextie, William A. 1821–1887
Clothworker 1852
oil on canvas 39 x 49
2005.14

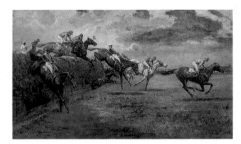

Stainforth, Martin active 1895–1934
Golden Miller in the Grand National 1934
oil on canvas 46 x 76
1995.633

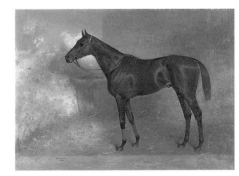

Townshend, Arthur Louis active 1880–1912
St Simon
oil on canvas 67 x 89
1987.221

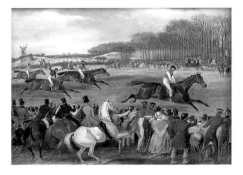

Turner, Francis Calcraft c.1782–1846
Windsor Grand Military Steeplechase, 1840
1840
oil on canvas 39 x 53
1994.589.1

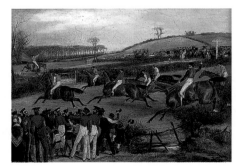

Turner, Francis Calcraft c.1782–1846
Windsor Grand Military Steeplechase, 1840
1840
oil on canvas 39 x 53.3
1994.589.2

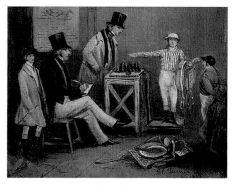

Turner, Francis Calcraft c.1782–1846
Jockeys' Weighing Room
oil on canvas 9 x 11
2000.92

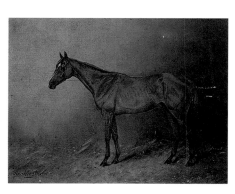

unknown artist
Archiestown 1915
oil on board 23 x 29
2002.5

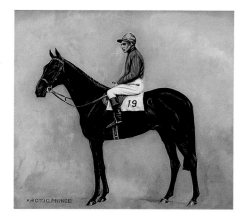

unknown artist
Arctic Prince
oil on canvas 31 x 46
2001.3

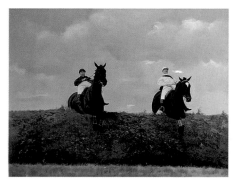

unknown artist
The Last Fence, Jerry M. in the Grand National
oil on wood panel 71 x 92
1985.31 (P)

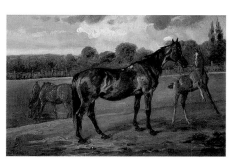

Wheeler, Alfred 1851–1932
The Life of a Thoroughbred c.1890
oil on canvas 13 x 19
1998.13A

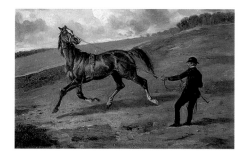

Wheeler, Alfred 1851–1932
The Life of a Thoroughbred c.1890
oil on canvas 13 x 19
1998.13B

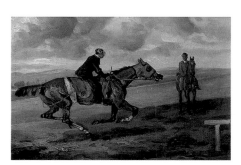

Wheeler, Alfred 1851–1932
The Life of a Thoroughbred c.1890
oil on canvas 13 x 19
1998.13C

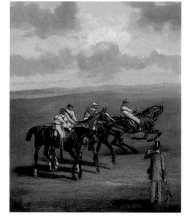

Wheeler, Alfred 1851–1932
The Life of a Thoroughbred c.1890
oil on canvas 25 x 21
1998.13D

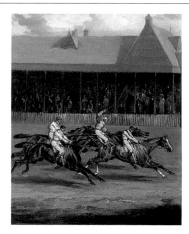

Wheeler, Alfred 1851–1932
The Life of a Thoroughbred c.1890
oil on canvas 25 x 21
1998.13E

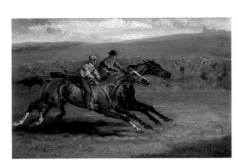

Wheeler, Alfred 1851–1932
The Life of a Thoroughbred c.1890
oil on canvas 13 x 19
1998.13F

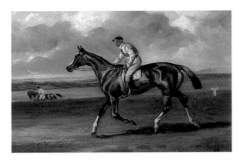

Wheeler, Alfred 1851–1932
The Life of a Thoroughbred c.1890
oil on canvas 13 x 19
1998.13G

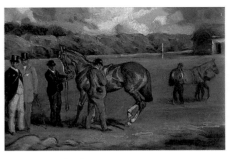

Wheeler, Alfred 1851–1932
The Life of a Thoroughbred c.1890
oil on canvas 13 x 19
1998.13H

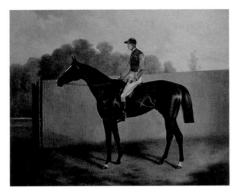

Wheeler, Alfred 1851–1932
Florizel II
oil on canvas 65 x 83
1997.743

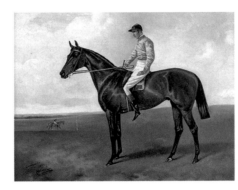

Wheeler, Alfred 1851–1932
Ormonde, F. Archer up
oil on canvas 34 x 44
1986.146

Wootton, John (attributed to) c.1682–1765
William Tregonwell Frampton (1641–1727)
1728
oil on canvas 37 x 33
1983.141

Saxmundham
Museum

Talbot, William active 1890s
Hay Wain in a Country Lane 1898
oil on board 44 x 63
WT3

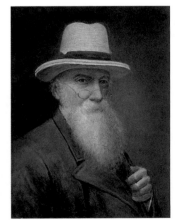

Talbot, William active 1890s
Self Portrait
oil on board 60 x 47
WT1

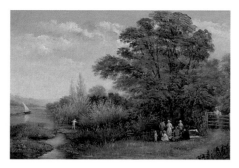

Talbot, William active 1890s
Suffolk River Scene
oil on board 39 x 55
WT2

Snape Parish Council

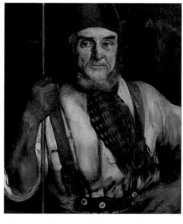

Christie, James Elder 1847–1914
G. Whiting 1888
oil on panel 60.5 x 50 (E)
11

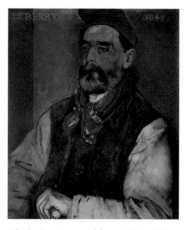

Christie, James Elder 1847–1914
James Berry 1888
oil on panel 60.5 x 50 (E)
09

Christie, James Elder 1847–1914
Louisa Garrett, née Dunnell (1813–1903)
1888
oil on panel 60.5 x 50 (E)
07

Christie, James Elder 1847–1914
Newson Garrett (1812–1893) 1888
oil on panel 60.5 x 50 (E)
06

Christie, James Elder 1847–1914
R. Howell 1888
oil on panel 60.5 x 50 (E)
08

Christie, James Elder 1847–1914
R. Manning 1888
oil on panel 60.5 x 50 (E)
13

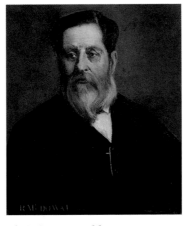

Christie, James Elder 1847–1914
R. McDowal 1888
oil on panel 60.5 x 50 (E)
12

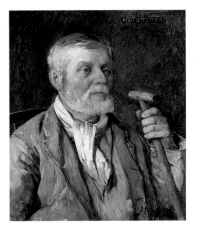

Cotman, Frederick George 1850–1920
George Chatten 1899
oil on panel 60.5 x 50 (E)
10

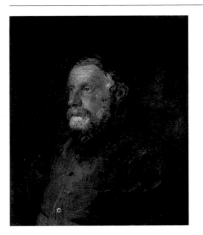

Cotman, Frederick George 1850–1920
Robert Thorpe 1899
oil on panel 60.5 x 50 (E)
02

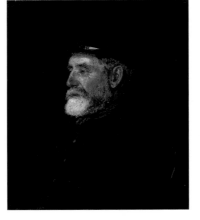

Cotman, Frederick George 1850–1920
Thomas Green 1899
oil on panel 60.5 x 50 (E)
01

unknown artist
An Unknown Maltster
oil on panel 60.5 x 50 (E)
05

unknown artist
An Unknown Maltster
oil on panel 60.5 x 50 (E)
04

unknown artist
James Osborne
oil on panel 60.5 x 50 (E)
03

Southwold Museum

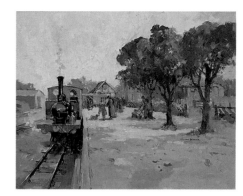

Benner, William 1884–1964
Blyburgh Station at Time of Closing Down of Southwold Railway 1929
oil on board 49 x 62
SOWDM.1965.505

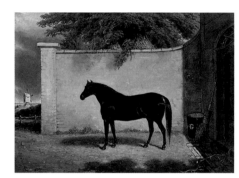

Benner, William 1884–1964
Southwold Station 1950s
oil on canvas 42 x 49
SOWDM.1981.77

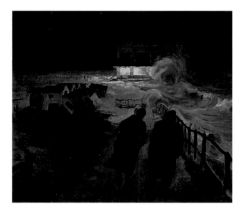

Forward, Frank c.1901–1974
1953 Floods at Southwold 1953
oil on board 39 x 45
SOWDM.1998.20

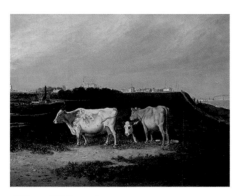

Gilbert, W. J. active 1835–1852
Southwold 1851, Cattle in Foreground 1851
oil on board 39 x 50
SOWDM.1960.380

Gilbert, W. J. (attributed to) active 1835–1852
Black Stallion 1852
oil on canvas 30 x 40
SOWDM.2003.24.2

Grubbe, Lawrence Carrington active 1889–1908
Mr Took of Southwold, Aged 86 1889
oil on board 30 x 25
SOWDM.1950.184

Grubbe, Lawrence Carrington active 1889–1908
Basil Hubert Howard Tripp, Mayor (1906–1907)
oil on canvas 52 x 43
SOWDM.2003.24.4

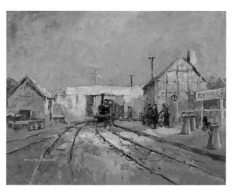

Knox, B. M.
Ernest George Naunton, Town Clerk (1920–1945) 1944
oil on canvas 55 x 40
SOWDM.2003.24.3

unknown artist
William Howard Elmy, Mayor (1894–1895)
oil on canvas 51 x 35 (E)
SOWDM.2003.24.5

Walton, Edward Arthur 1860–1922
Number 9 Park Lane, Southwold 1908
oil on canvas 60 x 40
SOWDM.2005.13

Wilcox, Eric
Locomotive Number 1, Southwold 1979
oil on canvas 49 x 60
SOWDM.1979.20

Southwold Sailors' Reading Room

Davidson, Allan D. 1873–1932
Frank Upcraft, Lifeboat Coxswain
oil on canvas 76 x 60 (E)
R.8

Dopita, Frank
Fishing Boats
acrylic on board 46 x 89 (E)
R.03

Lowsey, Ben
Loss of the Martina Maria, January 1881 1883
oil on board 50 x 70 (E)
R.02

Lowsey, Ben
Loss of the Martina Maria, January 1881
oil on board 50 x 67 (E)
R.01

Lowsey, Ben (attributed to)
Right Hon. W. E. Gladstone Passing by Southwold, 1883
oil on ticking 30 x 45 (E)
R.15

Facing page: Shee, Martin Archer (attributed to), 1769–1850, *General Sir Edward Kerrison Bt, KCB, GCH (1774–1853)* (detail),
Eye Town Council, (p. 32)

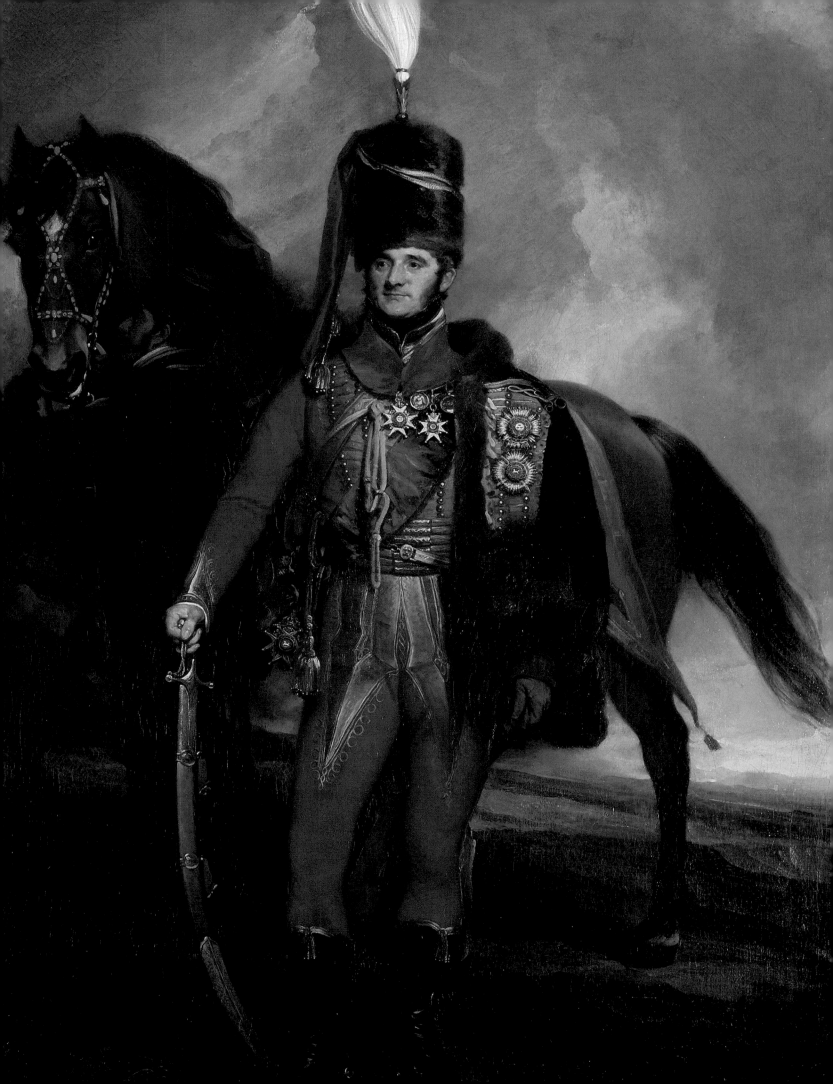

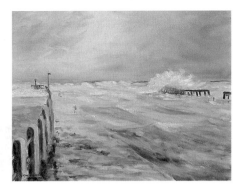

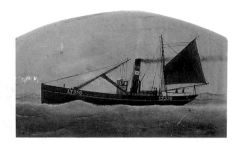

Monier-Williams, H. B.
Harbour, North Wall 1962
oil on board 50 x 65 (E)
R.17

Race, George 1872–1957
Au-Retour LT550 1909
oil on board 44 x 55 (E)
R.16

Reeve, John F. C.
Battle of Sole Bay
oil & household paint on board 95 x 457 (E)
R.14

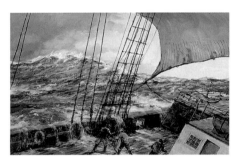

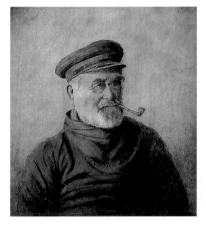

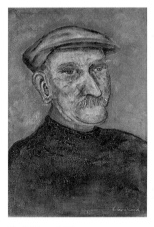

Scott, Henry
Cape Horn Highway
oil on canvas 53 x 69 (E)
R.13

Smith, A. B.
Jack 'Davy' Green
oil, acrylic & pastel on board 54 x 50 (E)
R.09

Strickland, E.
Local Fisherman
oil on board 47 x 32 (E)
R.10

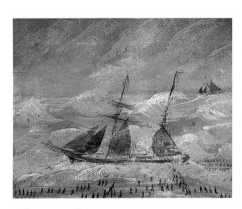

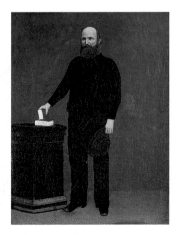

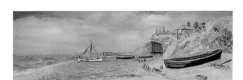

unknown artist
Wreck of the Elizabeth Kilner 1892
oil on board 23 x 29 (E)
R.4

unknown artist
Ben Herrington
oil on board 73 x 60 (E)
R.7

unknown artist
Gunhill Cliffs and White Lodge
acrylic on board 20 x 125 (E)
R.06

Southwold Town Council

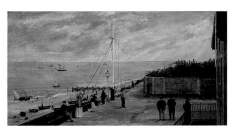

Blackett, R.
Southwold Seafront at the Sailors' Reading Room 1876
oil on canvas 41 x 77
TC.23

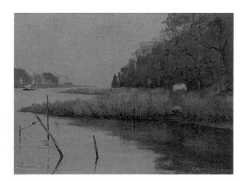

Currie-Bell, Thomas 1873–1946
Grey November, Founders' Landing, Southold, Long Island, USA
oil on canvas 29 x 37
TC.10

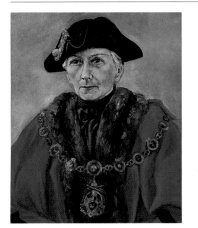

Denny, Jack W.
Florence Norah Cohen, Mayor of Southwold
oil on canvas 60 x 50
TC.12

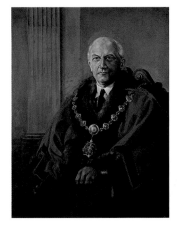

Denny, Jack W.
John Burlong Denny, Mayor of Southwold
oil on canvas 101 x 75
TC.15

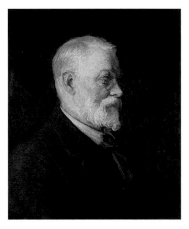

Eves, Reginald Grenville 1876–1941
Andrew Matthews
oil on canvas 60 x 50
TC.19

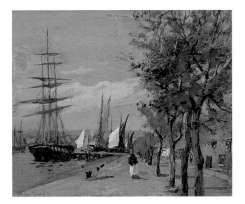

Eyles, Charles b.1851
Ipswich, 1898 1898
oil & gouache on paper 16 x 19
TC.13

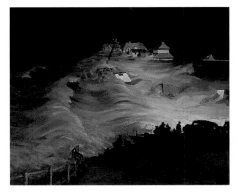

Forward, Frank c.1901–1974
1953 Floods from Gun Hill, Southwold 1953
oil on canvas 35 x 45
TC.09

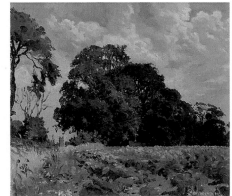

Forward, Frank c.1901–1974
Wangford Church
oil on canvas 40 x 47
TC.11

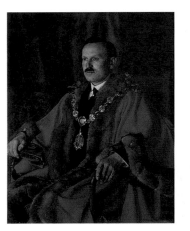

Green, John Kenneth 1905–1986
Andrew James Critten, Mayor of Southwold
1923
oil on canvas 101 x 80
TC.06

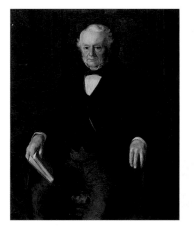

Grubbe, Lawrence Carrington
active 1889–1908
John Eustace Grubbe, Mayor of Southwold 1891
oil on canvas 107 x 86
TC.07

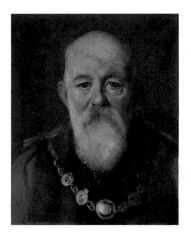

Grubbe, Lawrence Carrington
active 1889–1908
Eaton Womack Moore, Mayor of Southwold
oil on canvas 49 x 42
TC.20

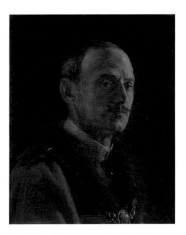

Grubbe, Lawrence Carrington
active 1889–1908
Edgar Pipe, Mayor of Southwold
oil on canvas 49 x 42
TC.22

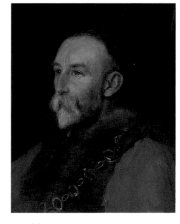

Grubbe, Lawrence Carrington
active 1889–1908
Edward Adolphous Holmes, Mayor of Southwold
oil on canvas 49 x 42
TC.21

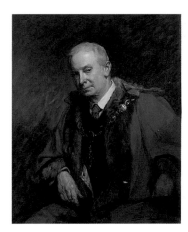

Lucas, Seymour 1849–1923
Eustace Edward Grubbe, Mayor of Southwold
1913
oil on canvas 90 x 72
TC.05

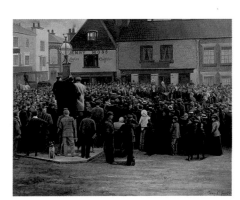

Saul, Henry C.
Market Place, Proclamation of Edward VII,
1901
oil on canvas 79 x 98 (E)
TC.18

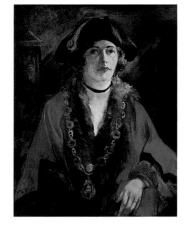

Ta 'Bois, J.
Dorothy Elsa Forbes Hope, Mayor of Southwold
oil on board 90 x 70
TC.14

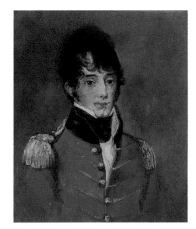

unknown artist
John Sutherland (1776–1852)
oil on canvas 34 x 30
TC.24

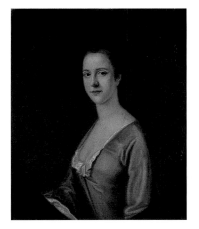

unknown artist
Mrs Thomas Nunn
oil on canvas 74 x 62
TC.16

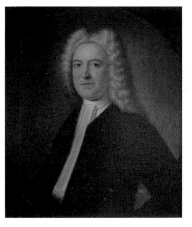

unknown artist
Thomas Nunn, Bailiff of Southwold
oil on canvas 74 x 62
TC.17

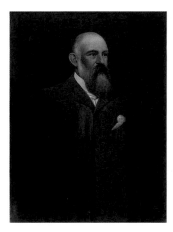

unknown artist
Unknown Gentleman
oil on canvas 59 x 45
TC.08

Museum of East Anglian Life

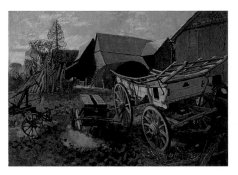

Aldridge, John Arthur Malcolm 1905–1983
Wood and Iron 1957
oil on canvas 54 x 75
75.A.111

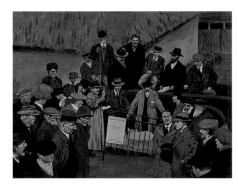

Butler, Philip J. active 1941–1956
Tithe Sale 1941
oil on canvas 62 x 83
A.911

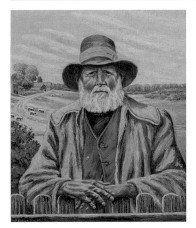

Butler, Philip J. active 1941–1956
Old Shepherd Mason of Coddenham 1956
oil on board 57 x 46
A.992

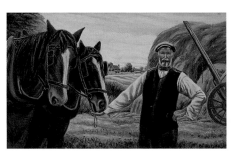

Butler, Philip J. active 1941–1956
*The Late Abner Pearl on His Small Holding at
Barking Tye, Suffolk* 1956
oil on board 39 x 66
A.991

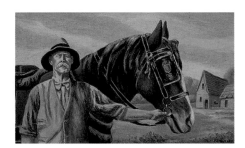

Butler, Philip J. active 1941–1956
*The Late George Andrews of Barking Tye,
Suffolk* 1956
oil on board 38 x 65
A.1077

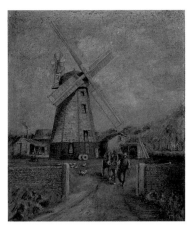

Cobbold, H. C.
Bradfield St George Mill 1906
oil on canvas 51 x 40
B.188A

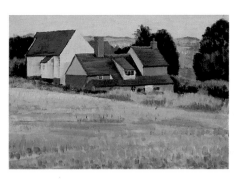

Hart, Colin
Alton Watermill 1970s
oil on canvas 25 x 36
79.A.39

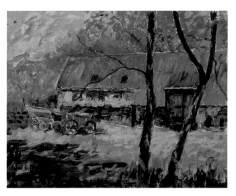

Longe, Vera
Abbotts' Hall Tithe Barn
oil on canvas 40 x 50
T.101

unknown artist
Manning Prentice 1860–1865
oil on canvas 59 x 40
1992.1.8

unknown artist
Wild Flowers
oil on canvas 50 x 29
1992.1.11

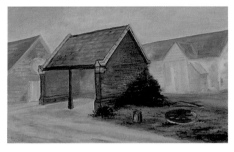

Wilding, G.
Cart Lodge
oil on board 47 x 75
T.100

Gainsborough's House

Gainsborough's House, the historic town house in Sudbury that was the birthplace of the great 18th century artist, Thomas Gainsborough, is a relatively new museum. While it has the air of being a long-established institution, its remarkable collection was in fact all acquired in the last 20 years or so.

Gainsborough's House Society was founded as a charity in 1958 in order to buy the house. Almost half of the purchase price was raised by the sale of a painting donated by Alfred Munnings, who lived and worked in nearby Dedham. Restoration then began on the historic house, partly funded by the sale of land to the rear of the property. The House opened to the public as a museum in April 1961.

The opening display consisted of loans of works by Gainsborough from several museums and private owners. However, a month or so later, nearly all the exhibits returned to their owners, leaving the House relatively bare. Amongst the few remaining works were six Suffolk period portraits of Lambe Barry (purchased in 2001) and members of the Vere and Acton families all lent from a local private collection. In 1967 a full-length portrait of Abel Moysey, still a key loan to the museum, was transferred from the Travellers' Club in London.

An early driving force in establishing a permanent collection was Cavendish Morton, Chairman of the Society from 1964 to 1977, who bought several prints and other items, which he later donated to the museum. It was not until 1984 that the first paintings were purchased for the House. These were portraits by Johann Theodore Heins of the artist's first cousins, Thomas and John Gainsborough that were acquired with grants and private donations, while later the same year, the first work by Thomas Gainsborough entered the collection – the early *Portrait of a Boy*. It became clear, following the cleaning of the canvas, that the painting was part of a considerably larger double portrait and seven years later another fragment, showing the head of the boy's sister, came to light and was quickly acquired, thus reuniting the siblings.

One of the major works in the collection, Gainsborough's late *Wooded Landscape with Cottage and Cattle by a Pool*, 1782 was purchased by private treaty sale after its failure to sell at auction in 1987. The purchase price was raised locally and through national grant-giving bodies. However, as independent museums were omitted from the legislation that governed such sales, it was necessary to acquire the work through Suffolk County Council, the first time that such a method of acquisition had been attempted. The process was later repeated by other similar museums, as well as by Gainsborough's House.

Also in 1987, an individual donor gave the National Art Collections Fund a painting by Canaletto to sell for the sole purpose of benefiting Gainsborough's House Society acquisitions and their associated conservation and framing. This magnificent gift helped establish an endowment fund to build a permanent collection for the future. Amongst the several important Gainsborough paintings purchased with this money were the early Suffolk landscape, *Wooded Landscape with Herdsman Seated* and *Harriet, Viscountess Tracy*. In an unprecedented arrangement between two museums, the very attractive early conversation piece, *Peter Darnell Muilman, Charles Crokatt and William Keable in a Landscape* was acquired jointly with Tate, and part-funded by a large contribution from the Society. Several purchases were made possible

with the help of generous individual donations, such as *Descent from the Cross (after Peter Paul Rubens)*, a highly unusual subject for the artist, which fits most suitably in a specialist Gainsborough collection.

Other Gainsborough paintings were acquired by gift, including the sensitive portrait of the artist's wife and the portrait of *Reverend Tobias Rustat*, or through the in-lieu arrangements, such as *Mrs Mary Cobbold with Her Daughter Anne*. The strengths of the painting collection lie mainly in Gainsborough's early Suffolk period works. However, there are representative examples from throughout the artist's career present in the collection.

While there are fine paintings at Gainsborough's House, they are surpassed in range by the outstanding collection of Gainsborough drawings. There are presently almost 30 drawings by Gainsborough, spanning his entire career and executed in a wide variety of media, several of which it was possible to purchase without the support from external funding.

To complement and to contextualise the core collection of paintings and drawings by Thomas Gainsborough, are some rare books, letters, documents and memorabilia, as well as a group of works by other artists. Many of these paintings, drawings and prints are by artists who influenced or were influenced by Gainsborough, such as Hubert-François Gravelot, Francis Hayman, Henry William Bunbury and the artist's nephew, Gainsborough Dupont. Others have a topographical interest, relating to the town of Sudbury or the wider East Anglian region.

The collection could not have been formed without the generous support of the National Heritage Memorial Fund, the Heritage Lottery Fund, the National Art Collections Fund, central government's Purchase Grant Fund and many other trusts, foundations and private donors. As a small, independent museum, the future growth of the collection will be dependent not only on finding sufficient funds but on the availability of suitable high-quality works on the market. The display of Gainsborough's work in the house of his birth will inevitably continue to be augmented by fine paintings or drawings that have been generously lent from private and public collections.

Diane Perkins, Director

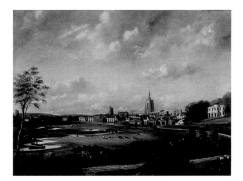

Bridgman, Henry 1831–1909
View of Sudbury from the South-East c.1860
oil on canvas 46 x 61
1995.031

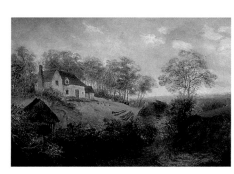

Bridgman, Henry 1831–1909
Abbas Hall before 1875
oil on board 30.5 x 46
2001.038

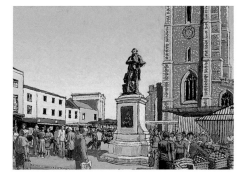

Bryant, Peter b.1916
Market Hill, Sudbury
acrylic on board 37 x 51
2001.046

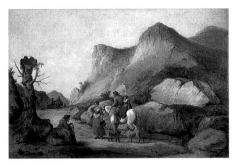

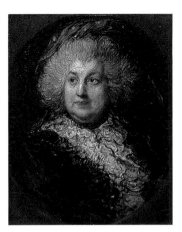

Bunbury, Henry William 1750–1811
Rustics in a Landscape c.1806
oil on canvas 39.4 x 57.2
1985.002

Dargan, John b.1961
Sudbury Common Lands 3 2000
oil on board 6.5 x 19
2000.098

Dupont, Gainsborough 1754–1797
Lady Mendip (1725–1803) c.1787
oil on paper on book board 15.4 x 11.8
1996.008

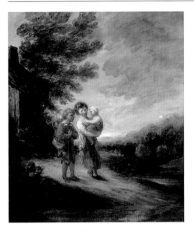

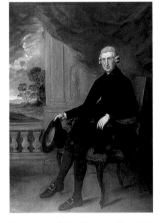

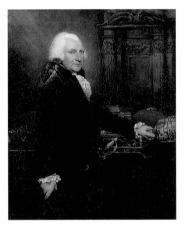

Dupont, Gainsborough 1754–1797
Landscape with Peasant Children outside a Cottage 1790s
oil on canvas 74.9 x 62.2
1987.002

Dupont, Gainsborough 1754–1797
Reverend Robert Heron (1724–1813) c.1790
oil on canvas 57.9 x 39.5
1993.083

Dupont, Gainsborough 1754–1797
John Clementson (1735–1805) 1792
oil on canvas 126 x 100.5
1997.134

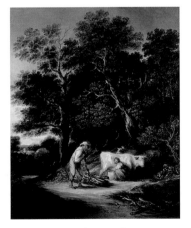

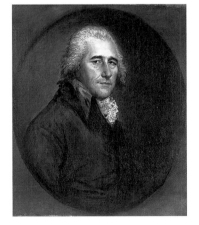

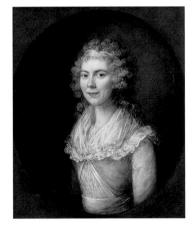

Dupont, Gainsborough 1754–1797
Wooded Landscape with Milkmaid and Woodman c.1792
oil on canvas 126 x 101
1996.259

Dupont, Gainsborough 1754–1797
William Townshend c.1794
oil on canvas 75 x 62.1
1997.023

Dupont, Gainsborough 1754–1797
Caroline Anne Horde c.1795
oil on canvas 76.2 x 62.9
1991.022

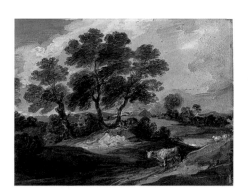

Dupont, Gainsborough 1754–1797
Landscape with Cow and Sheep c.1795
oil on paper 30.4 x 39.6
1992.099

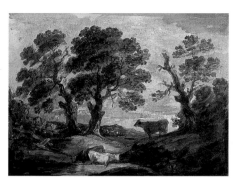

Dupont, Gainsborough 1754–1797
Wooded Landscape with Cows c.1795
oil on paper 29.9 x 40.1
1992.028

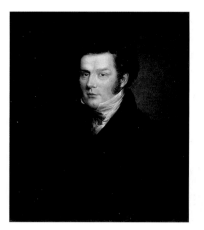

Dupont, Richard Gainsborough 1789–1874
Possibly Charles Harding
oil on canvas 76.2 x 63.5
1987.016

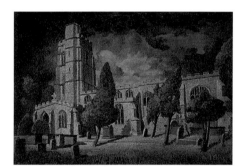

Earee, Paul 1888–1968
St Gregory's Church, Sudbury before 1952
oil on canvas 66.5 x 96
1995.097

Eastcott
St Peter's Church, Sudbury 1962
oil on board 30.6 x 42.8
1992.006

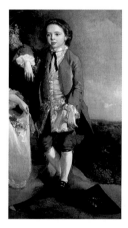

Gainsborough, Thomas 1727–1788
Portrait of a Boy (Fragment) c.1744
oil on canvas 133.3 x 72.4
1984.005

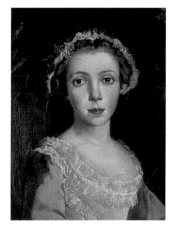

Gainsborough, Thomas 1727–1788
Portrait of a Girl (Fragment) c.1744
oil on canvas 44.8 x 33.5
1991.011

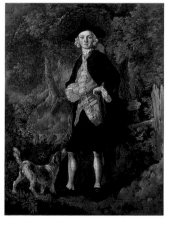

Gainsborough, Thomas 1727–1788
Man with a Dog in a Wood c.1746
oil on canvas 66.5 x 50
L.011 (P)

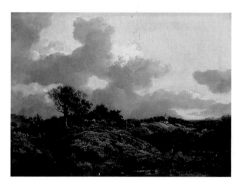

Gainsborough, Thomas 1727–1788
Wooded Landscape with Herdsman Seated
c.1748
oil on canvas 49 x 65.5
1990.087

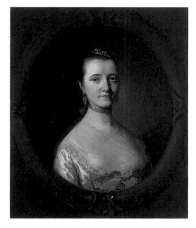

Gainsborough, Thomas 1727–1788
Mary, Mrs John Vere 1750s
oil on canvas 76.2 x 63.4
L.006 (P)

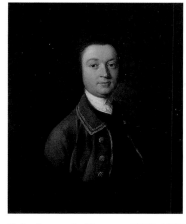

Gainsborough, Thomas 1727–1788
Mr John Vere 1750s
oil on canvas 76.2 x 63.4
L.005 (P)

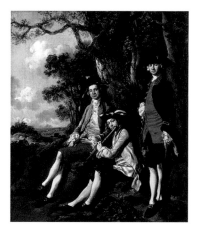

Gainsborough, Thomas 1727–1788
Peter Darnell Muilman, Charles Crokatt and William Keable in a Landscape c.1750
oil on canvas 76.3 x 63.5
1993.025

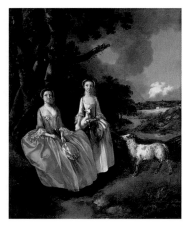

Gainsborough, Thomas 1727–1788
Mrs Mary Cobbold with Her Daughter Anne c.1752
oil on canvas 75.5 x 63
1998.075

Gainsborough, Thomas 1727–1788
Landscape with Peasant Reclining by a Weir c.1754
oil on canvas 77.5 x 94
L.002 (P)

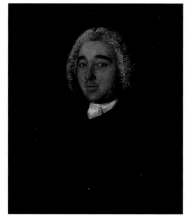

Gainsborough, Thomas 1727–1788
Reverend Tobias Rustat (1716–1793) c.1756
oil on canvas 75 x 62 (E)
1989.062

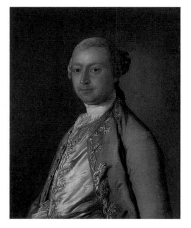

Gainsborough, Thomas 1727–1788
Thomas Vere c.1756
oil on canvas 76.2 x 63.4
L.008 (P)

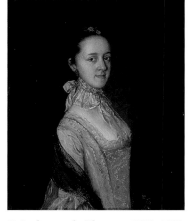

Gainsborough, Thomas 1727–1788
Caroline, Mrs Nathaniel Acton c.1758
oil on canvas 77.5 x 63.4
L.004 (P)

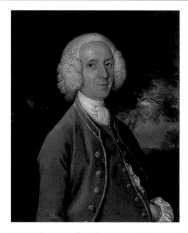

Gainsborough, Thomas 1727–1788
Nathaniel Acton c.1758
oil on canvas 76.2 x 63.4
L.007 (P)

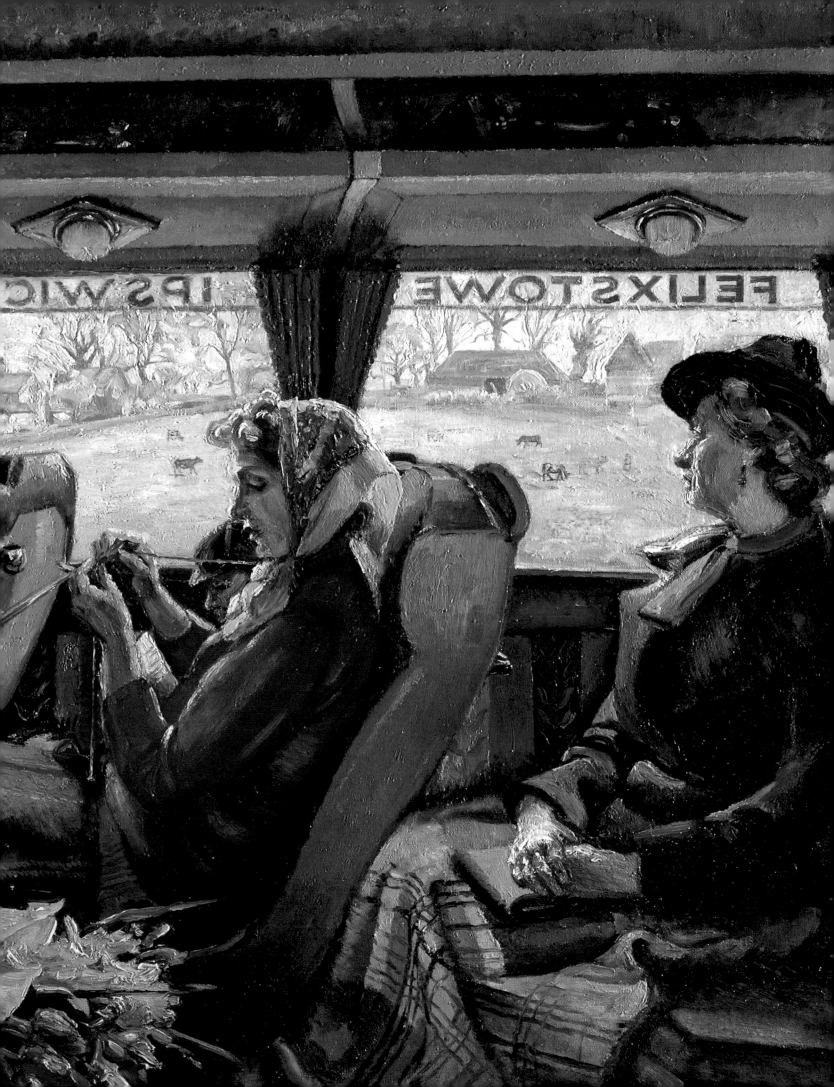

Gainsborough, Thomas 1727–1788
Lambe Barry c.1759
oil on canvas 75.5 x 63
2001.14

Gainsborough, Thomas 1727–1788
Lord Bernard Stuart (after Anthony van Dyck)
1760s
oil on canvas 73.7 x 59.7
1995.066

Gainsborough, Thomas 1727–1788
Descent from the Cross (after Peter Paul Rubens) late 1760s
oil on canvas 125.5 x 101.5
1998.126

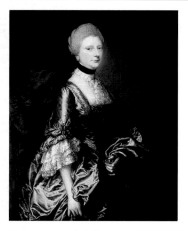

Gainsborough, Thomas 1727–1788
Harriet, Viscountess Tracy c.1763
oil on canvas 126.4 x 101
1992.001

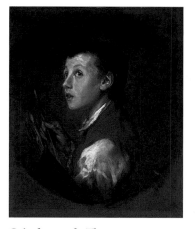

Gainsborough, Thomas 1727–1788
Portrait of an Unknown Youth (The Pitminster Boy) c.1768
oil on canvas 60.8 x 50.4
L.009 (P)

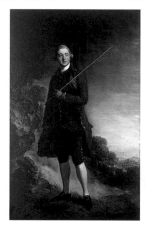

Gainsborough, Thomas 1727–1788
Abel Moysey, MP (1743–1831) 1771
oil on canvas 234.3 x 144.1
L.010 (P)

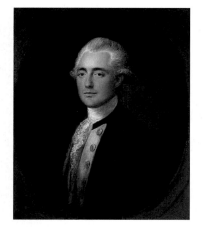

Gainsborough, Thomas 1727–1788
Richard, 5th Viscount Chetwynd 1780s
oil on canvas 76.2 x 63.4
L.003 (P)

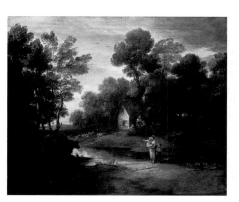

Gainsborough, Thomas 1727–1788
Wooded Landscape with Cattle by a Pool 1782
oil on canvas 120.4 x 147.6
1988.001

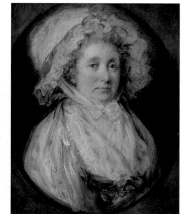

Gainsborough, Thomas 1727–1788
Mrs Thomas Gainsborough (1728–1797)
c.1785
oil on card 15.2 x 11.4
1998.131

Facing page: Reeve, Russell Sidney, 1895–1970, *The Felixstowe to Ipswich Coach* (detail), 1940–1950,
Ipswich Borough Council Museums and Galleries, (p. 128)

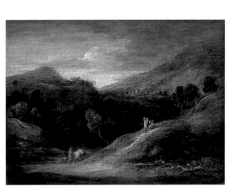

Gainsborough, Thomas 1727–1788
An Extensive Wooded Upland Landscape
c.1786
oil on canvas 49 x 59.1
L.012 (P)

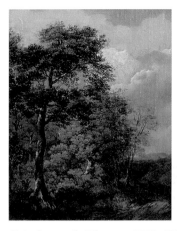

Gainsborough, Thomas 1727–1788
Wooded Landscape with Figure on a Winding Track
oil on canvas 22.2 x 17.9
TB.1485.LN

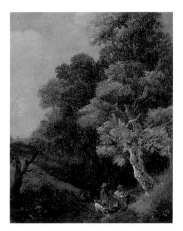

Gainsborough, Thomas 1727–1788
Wooded Landscape with Peasants Resting
oil on canvas 22.7 x 18.1
TB.1486.LN

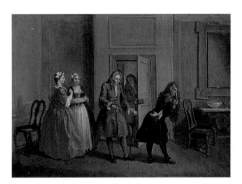

Gravelot, Hubert François Bourguignon
1699–1773
Le médecin malgre lui 1742
oil on canvas 27.2 x 36.2
2003.015

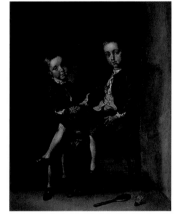

Hayman, Francis c.1708–1776
Portrait of Two Boys 1740–1742
oil on canvas 36.8 x 27.9
1992.024

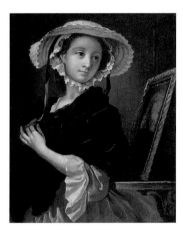

Hayman, Francis c.1708–1776
La vue 1753
oil on panel 30.5 x 24.2
2000.001

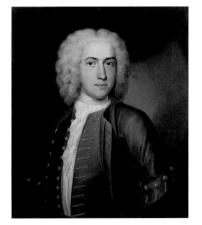

Heins, John Theodore Sr c.1697–1756
John Gainsborough (1711–1772) 1731
oil on canvas 74.8 x 63
1984.004

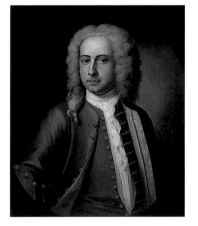

Heins, John Theodore Sr c.1697–1756
Thomas Gainsborough (1709–1739) 1731
oil on canvas 30 x 25
1984.003

Jackson, John 1778–1831
Richard James Lane 1820s
oil on canvas 44.5 x 38.7
1995.067

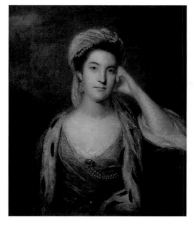

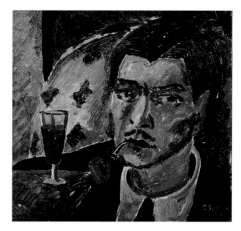

Kirby, John Joshua 1716–1774
Classical Landscape with Ruins 1761
oil on canvas 50.5 x 68.5
1992.011

Reynolds, Joshua 1723–1792
The Hon. Mrs John Barrington c.1758
oil on canvas 76.2 x 63.5
L.001 (P)

Suddaby, Rowland 1912–1972
Self Portrait 1936
oil on board 29.4 x 29.6
1994.175

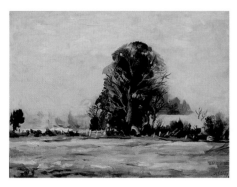

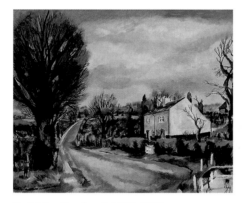

Suddaby, Rowland 1912–1972
Near Lamarsh 1948
oil on paper 43 x 55.5
1994.077

Suddaby, Rowland 1912–1972
East Anglia Stormy Day
oil on canvas 64 x 76
1995.013

Suddaby, Rowland 1912–1972
Stone Wall in Mountain Landscape
oil on paper 17.8 x 29.2
1995.014

Suddaby, Rowland 1912–1972
Winter River Scene
oil on paper 15.8 x 22.9
1988.016

Sudbury Town Council

British (English) School
Alderman George William Andrews
oil on board 41 x 36 (E)
STH.04

Brownlow, George Washington 1835–1876
The Moorhen's Nest c.1872
oil on canvas 112 x 86 (E)
STH.02

Burrows, Robert 1810–1883
Cattle Watering 1866
oil on canvas 63 x 90 (E)
STH.03

Humphry, K. Maude active 1883–1891
Sir George Murray Humphry (1820–1896)
oil on canvas 125 x 85 (E)
STH.01

unknown artist
Joseph Humphry, Mayor of Sudbury
oil on canvas 75 x 61 (E)
STH.05

Suffolk Punch Heavy Horse Museum

The nucleus of this collection is formed by the drawings and paintings of John Duval (1816–1892). He was engaged by the Suffolk Horse Society to depict selected horses to illustrate Volume 1 of the *Stud Book*, a beautifully bound and printed book unique in the literature of livestock breeding. This was published in 1880 and the Society has owned these pictures ever since; to these have been added gifts, the most significant being the painting of the mare *Parham Prunella and Her Foal* by Laura Knight. This was commissioned by the mare's owner, Miss E. M. Unwin and was exhibited at the Royal Academy in 1940. The painting came with two photographs of the artist at work with her easel and the subject, at the owner's home in Sussex.

Every picture and every item in the Suffolk Horse Museum relates specifically to the Suffolk Punch breed of horse. Each painting is of historical importance to the breed and many have a tale to tell. For example, the Duval

painting *Scot and Vanity* shows the mare Scot, the property of Richard Garrett, two days before she foaled. When the foal was born, Garrett was so pleased with her that he had Duval return with the painting so that he could add the portrait of the foal, Vanity, who thus is in the painting twice.

The earliest painting to feature in the collection is that of a Suffolk stallion by John Robert Hobart (1788–1863) who lived in Monks Eleigh and probably worked as a schoolmaster. W. Albert Clark (active 1917–1936), was a popular artist in East Anglia. There are three paintings by him, a Red Poll cow, *Royal Mavis* bred by King George V and two of Suffolks, *Sudbourne Bellman* and *Sudbourne Moonlight*. The Sudbourne stud was owned by Kenneth Clarke, the father of Lord Clarke and grandfather of the late Alan Clarke, MP.

Besides the Clark painting, the Museum contains two others belonging to the Red Poll Cattle Society, one dated 1841 but with no known artist, and another by S. G. Stearn of Brandeston.

Philip Ryder-Davies, Curator

Clark, W. Albert active 1917–1936
Sudbourne Bellman 1917
oil on canvas 50 x 61 (E)
PG.15

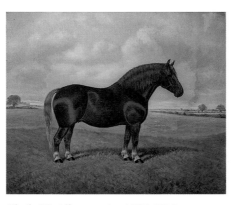

Clark, W. Albert active 1917–1936
Sudbourne Moonlight 1919
oil on canvas 50 x 60 (E)
PG.25

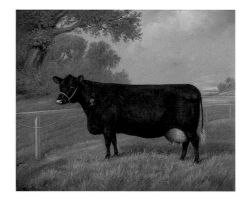

Clark, W. Albert active 1917–1936
Royal Mavis 1929
oil on canvas 62 x 76 (E)
PG.16

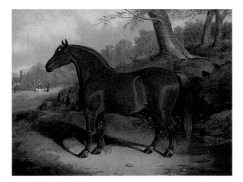

Corbet, E. active 1850–1876
Canterbury Pilgrim 1860
oil on canvas 38 x 50 (E)
PG.26

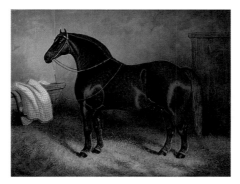

Corbet, E. active 1850–1876
Cup Bearer 1872
oil on canvas 44 x 59 (E)
PG.06

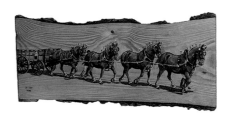

D. J. D.
Team of Suffolk Punches Drawing a Miller's Wagon 1986
oil on varnished wood 26 x 69 (E)
PG.20

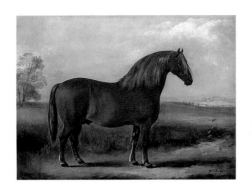

Davis, William Henry 1795–1885
Stallion 1846
oil on canvas 46 x 59 (E)
PG.21

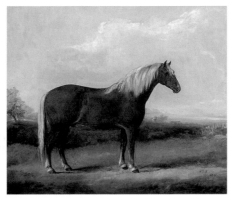

Davis, William Henry 1795–1885
Fairhead Boxer 405 1851
oil on canvas 57 x 65 (E)
PG.14 (P)

Duval, John 1816–1892
Canterbury Pilgrim
oil on canvas 40 x 52 (E)
PG.22

Duval, John 1816–1892
Cup Bearer III
oil on canvas 44 x 54 (E)
PG.02

Duval, John 1816–1892
Duchess
oil on canvas 42 x 55 (E)
PG.10

Duval, John 1816–1892
Leiston
oil on canvas 59 x 71 (E)
PG.01

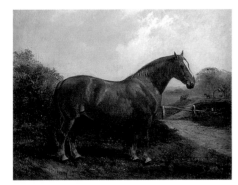

Duval, John 1816–1892
Matchet
oil on canvas 42 x 55 (E)
PG.09

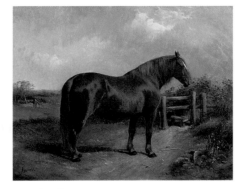

Duval, John 1816–1892
Pride
oil on canvas 55 x 69 (E)
PG.03

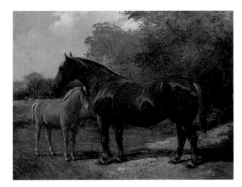

Duval, John 1816–1892
Scot and Vanity
oil on canvas 43 x 55 (E)
PG.08

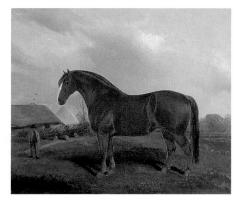

Duval, John 1816–1892
Unnamed Horse
oil on canvas 51 x 61 (E)
PG.04 (P)

Duval, John 1816–1892
Cup Bearer II 1876
oil on canvas 42 x 55 (E)
PG.07

Farley, Charles William 1893–1982
Joe Stearn with the Mare Rowhedge Myrtle,
with Alpheton Church in the Background
oil on canvas 70 x 93 (E)
PG.19

Grimshaw, J.
Rowhedge Myrtle
oil on canvas 60 x 68 (E)
PG.13

Hobart, John R. 1788–1863
Stallion
oil on canvas 34 x 51 (E)
PG.23

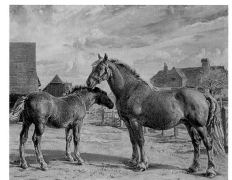

Knight, Laura 1877–1970
Parham Prunella and Her Foal
oil & gouache on canvas 76 x 92 (E)
PG.05

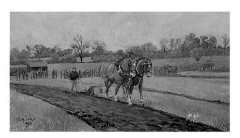

Laurie, Charlotte M. active 1960s onwards
Ploughing Match 1993
oil on canvas 33 x 60 (E)
PG.12

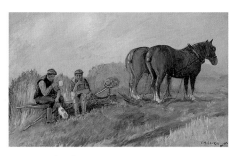

Laurie, Charlotte M. active 1960s onwards
Dinner Time
oil on canvas 37 x 59 (E)
PG.11

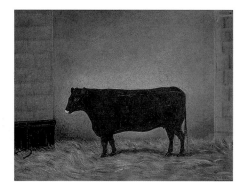

Stearn of Brandeston, S. G.
A Red Poll Cow 1880
oil on canvas 29 x 37 (E)
PG.LN.18 (P)

Thurlby, Fred active 1895–1926
Stallion 1926
oil on canvas 40 x 62 (E)
PG.24

unknown artist
Prize Heifer, 2 Years and 8 Months 1841
oil on canvas 62 x 76 (E)
PG.LN.17 (P)

unknown artist
Stallion
oil on canvas 50 x 61 (E)
PG.27

Woodbridge Museum

Churchyard, Thomas 1798–1865
Country Lane
oil on canvas 15 x 13
3273.2

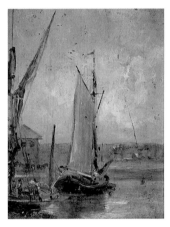

Churchyard, Thomas 1798–1865
River Scene with Barge
oil on canvas 17 x 12
3273.1

Moore, John of Ipswich 1820–1902
River Landscape 1882
oil on canvas 40 x 62
3453

Moore, John of Ipswich 1820–1902
Flood Gates
oil on canvas 32 x 28
3452

Woodbridge Town Council

Dean
John Amos Howe (1840–1923), Parish Clerk of St Mary's c.1920
oil on canvas 59 x 50
WTC.15

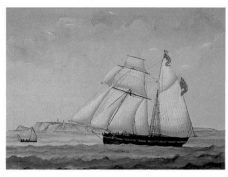

Pike, W.
The Sylph at Sea 1837
oil on canvas 43 x 59
WTC.17

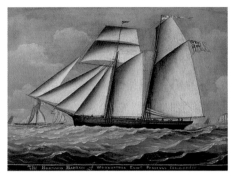

unknown artist
The Bernard Barton of Woodbridge
oil on canvas 65 x 88
WTC.16

Woolpit and District Museum

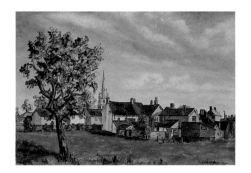

Arnold, C. W.
Woolpit 1980
oil on canvas 35 x 50
P.360

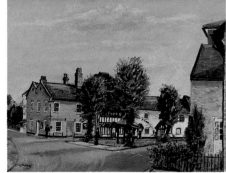

Arnold, C. W.
Woolpit Pump 1980
oil on board 36 x 45
P.359

Paintings Without Reproductions

This section lists all the paintings that have not been included in the main pages of the catalogue. They were excluded from the main pages as it was not possible to photograph them for this project. Additional information relating to acquisition credit lines or loan details is also included. For this reason the information below is not repeated in the Further Information section.

Ipswich Borough Council Museums and Galleries

Andrews, Florence C. b.1905, *Still Life, Flowers in a Basket*, 15.2 x 22.8, oil on card, R.1990-68.1, purchased, not available at the time of photography

Coe, Alfred *Anemones*, 26.3 x 29.6, oil on board, R.1990-68.4, purchased, not available at the time of photography

Moore, John of Ipswich 1820–1902, *Landscape with Cottages*, 20 x 24, oil on panel, R.1931-28.47, from the R. Allen Bequest, not available at the time of photography

Moss, Colin b.1915, *Fauve Nude*, 1985, 28 x 38 (E), oil on card, R.1985-64.40, gift from Colin Moss, not available at the time of photography

Prentice, Charles W. 1858–1933, *Fenner's Yard*, 35 x 25, oil on panel, R.1934-145.1, purchased with the assistance of the Felix Cobbold Bequest Fund, not available at the time of photography

Ryan, Vernon D. *Alderman Bantoft*, 1925, 81.5 x 71, oil on canvas, R.1990-58.21, not available at the time of photography

Stannard, William John active 1847–1848, *Battery at Harwich Harbour*, 1847, 20 x 25, oil on card, R.1943-29.A, purchased from Scrivener, not available at the time of photography

Symonds, William Robert 1851–1934, *Alderman Westhorpe*, 1886, 88 x 69 (E), oil on canvas, R.1983-143.19, transferred from Town Hall, not available at the time of photography

Todd, Henry George 1847–1898, *Landscape with Sheep*, c.1870–c.1898, 18.5 x 23, oil on canvas, R.1931-28.50, bequeathed by R. Allen, not available at the time of photography

Lowestoft Museum at Broad House

Tench, Ernest George 1885–1942, *Sinking of the Drifter 'Dawn of Day' LT617*, 1907, 40 x 60 (E), oil on card, WP.013, from the collection of Waveney District Council, not available at the time of photography

St Edmundsbury Museums

Kendall, J. active 1778–1780, *Encampment at Fornham*, 1778, 21.5 x 61.5, oil on canvas, 1992.9.393, gift, not available at the time of photography

Waveney District Council

Abbott *Rotterdam Cottages*, 1885, 23 x 30.5, oil on canvas, WP085, not available at the time of photography

Burwood, George Vemply c.1845–1917, *Fire on the South Pier*, 1887, 48 x 69, oil on canvas, WP004, not available at the time of photography

Gregory, John 1841–1917, *Three Cutter Rigged Yachts Racing*, 46 x 76, oil on canvas, WP057, not available at the time of photography

Gregory, John 1841–1917, *Three Masted Sailing Ship in Storm Sea*, 1895, 46 x 61, oil on card, WP058, not available at the time of photography

Preston, T. active 1839–1840, *Rotterdam House Looking towards St Margaret's*, c.1840, 15 x 33, oil on wood, WP041, not available at the time of photography

Preston, T. active 1839–1840, *St Margaret's from the South*, c.1840, 18 x 23, oil on wood, WP043, not available at the time of photography

Facing page: Hall, Harry, 1814–1882, *Nat Flatman* (detail), National Horseracing Museum, (p. 209)

Further Information

The paintings listed in this section have additional information relating to one or more of the five categories outlined below. Paintings listed in this section are divided into their respective collections and follow the same order as in the illustrated pages of the catalogue.

I The full name of the artist if this was too long to display in the illustrated pages of the catalogue. Such cases are marked in the catalogue with a (…).

II The full title of the painting if this was too long to display in the illustrated pages of the catalogue. Such cases are marked in the catalogue with a (…).

III Acquisition information or acquisition credit lines as well as information about loans, copied from the records of the owner collection.

IV Artist copyright credit lines where the copyright owner has been traced. Exhaustive efforts have been made to locate the copyright owners of all the images included within this catalogue and to meet their requirements. Any omissions or mistakes brought to our attention will be duly attended to and corrected in future publications.

V The credit line of the lender of the transparency if the transparency has been borrowed. Bridgeman images are available subject to any relevant copyright approvals from the Bridgeman Art Library at www.bridgeman.co.uk

The Aldeburgh Museum

Finch, H. H. active 1901–1922, *James Cable, First Coxswain Lifeboat (1887–1917)*
Moore, John of Ipswich 1820–1902, *View of Thorpeness*
Moore, John of Ipswich 1820–1902, *Slaughden Reach*
Pendred, S. *The Victor, Bound for Norway*
Thurlow, Thomas 1813–1899, *An Aldeburgh Worthy*
Thurlow, Thomas 1813–1899, *An Aldeburgh Worthy*
Thurlow, Thomas 1813–1899, *An Aldeburgh Worthy*
Thurlow, Thomas 1813–1899, *An Aldeburgh Worthy*
Thurlow, Thomas 1813–1899, *Robert Wilson of Lloyd's Signal Section*
Thurlow, Thomas 1813–1899, *The Town Worthies*
unknown artist *The Station Windmill, Aldeburgh*
unknown artist *St Peter's and St Paul's Church, Aldeburgh*
unknown artist *View of Slaughden*
unknown artist *Battle of Sole Bay, 1672*

Beccles and District Museum

Arnold, Joseph 1782–1819, *Joseph Arnold, MD of Beccles*
unknown artist *The Falcon Inn Yard, Beccles*
Wilkinson, H. *Puddingmoor, Beccles*

Bungay Museum

unknown artist *Bungay Castle*
unknown artist *The Thatched House, Flixton Road*, gift from Mrs Sidney Owles
unknown artist *Holy Trinity Church, South Side, Bungay*

Bury St Edmunds Record Office

Cotman, Frederick George (attributed to) 1850–1920, *Edward Greene, MP (1815–1891)*
unknown artist *Arthur Young of Bradfield Combust (1741–1820)*
unknown artist *Sir Walter Greene, Bt*

St Edmundsbury Museums

Anglo/Flemish School *Elizabeth Risby with Elizabeth*, gift
Anglo/Flemish School *Elizabeth Risby with John*, gift
Anglo/Flemish School *East Prospect of Bury St Edmunds*, gift
Beale, Charles 1660–c.1714, *Bartholomew Beale*, bequest from Richard Jeffree to the National Art Collections Fund
Beale, Charles 1660–c.1714, *Elizabeth Beale*, bequest from Richard Jeffree to the National Art Collections Fund
Beale, Mary 1633–1699, *Charles Beale*, purchased
Beale, Mary 1633–1699, *A Child as Bacchus*, bequest from Richard Jeffree to the National Art Collections Fund
Beale, Mary 1633–1699, *Charles*

Beale, bequest from Richard Jeffree to the National Art Collections Fund
Beale, Mary 1633–1699, *Charles Beale*, bequest from Richard Jeffree to the National Art Collections Fund
Beale, Mary 1633–1699, *Gilbert Burnett, DD*, bequest from Richard Jeffree to the National Art Collections Fund
Beale, Mary 1633–1699, *Jane Fox as a Shepherdess*, bequest from Richard Jeffree to the National Art Collections Fund
Beale, Mary 1633–1699, *Jane, Lady Twisden*, bequest from Richard Jeffree to the National Art Collections Fund
Beale, Mary 1633–1699, *Lady Essex Finch*, bequest from Richard Jeffree to the National Art Collections Fund
Beale, Mary 1633–1699, *Lady Norwich*, bequest from Richard Jeffree to the National Art Collections Fund
Beale, Mary 1633–1699, *Margaret Twisden, Lady Style*, bequest from Richard Jeffree to the National Art Collections Fund
Beale, Mary 1633–1699, *Self Portrait*, purchased
Beale, Mary 1633–1699, *Self Portrait*, bequest from Richard Jeffree to the National Art Collections Fund
Beale, Mary 1633–1699, *The Earl of Coventry*, bequest from Richard Jeffree to the National Art Collections Fund
Beale, Mary 1633–1699, *The Marchioness of Tweedale*, bequest from Richard Jeffree to the

National Art Collections Fund
Beale, Mary 1633–1699, *Unknown Widow*, bequest from Richard Jeffree to the National Art Collections Fund
Beale, Mary 1633–1699, *Charles Beale*, purchased
Beale, Mary 1633–1699, *Charles Beale*, bequest from Richard Jeffree to the National Art Collections Fund
Beale, Mary 1633–1699, *Girl with a Cat*, purchased
Beale, Mary 1633–1699, *Self Portrait of the Artist as a Shepherdess*, purchased
Beale, Mary 1633–1699, *Young Girl in Profile*, purchased
Beale, Mary 1633–1699, *Lady Sarah Hall*, purchased
Beale, Mary (attributed to) 1633–1699, *Thomas Cullum, Younger Brother of Sir Dudley Cullum, Bt*, bequest from Richard Jeffree to the National Art Collections Fund
Beale, Mary (circle of) 1633–1699, *Sir Roger Martin, Bt*, bequest from Richard Jeffree to the National Art Collections Fund
Blundell, Alfred Richard 1883–1968, *Snow Scene*, gift
Blundell, Alfred Richard 1883–1968, *River at Cavenham*
Bowring, G. *Eastgate Bridge, Bury St Edmunds, Suffolk*
Boxall, William 1800–1879, *Mrs Milner Gibson*, bequest
British (English) School *Jankyn Smith*
British (English) School *Thomas Bright*
British (English) School *Edmund Jermyn of Rushbrooke*
British (English) School *James I in*

His State Clothes, commissioned by the Guildhall feoffees
British (English) School *Portrait of a Gentleman Wearing a Black Coat*
British (English) School *Portrait of a Man Holding a Staff*
British (English) School *John Sutton*
British (English) School *Jacob Johnson*
British (English) School *Anne Cullum, Wife of John Cullum, Draper*, bequest
British (English) School *John Cullum*, bequest
British (English) School *Market Square c.1700*, gift
British (English) School *Market Square with Beasts, c.1700*, bequest
British (English) School *The Abbey Gate*
British (English) School *The Beast Market*
British (English) School *Reverend William Adamson*, gift
British (English) School *Arethusa, Lady Harland*, bequest
British (English) School *Churchyard Looking towards the Norman Tower*, gift
British (English) School *Orbell Ray Oakes*, gift
British (English) School *Arethusa, Lady Harland*, bequest
British (English) School *Bury Coach Arriving at the Great White Horse Inn, Ipswich*, gift
British (English) School *James Henry Oakes*, gift
British (English) School *Opening of the Railway from Ipswich to Bury St Edmunds, 1846*, gift
British (English) School *The Norman Tower*, purchased

British (English) School *Mrs Henry James Oakes*, gift

British (English) School *Thomas Ridley, Mayor of Bury St Edmunds, 1878 & 1882*

Campbell, Peter 1931–1989, *Church in Suffolk*, purchased

Campbell, Peter 1931–1989, *The Way through the Woods*, purchased

Cavalleri, Ferdinando 1794–1865, *Sir Thomas Gery Cullum, 8th Bt*, bequest

Closterman, John 1660–1711, *Portrait of a Gentleman Wearing Red*

Dahl, Michael I 1656/1659–1743, *Jane, Wife of Sir John Cullum*, bequest

Dance-Holland, Nathaniel 1735–1811, *Sir John Cullum, 5th Bt*, bequest

De Suet, A. *Lackford Quarry*

Des Roches, Michel *Windmill*, gift

Durrant, Roy Turner 1925–1998, *View of the River, Winter Morning*, gift

Durrant, Roy Turner 1925–1998, *Blossoms in a Landscape*, gift

Durrant, Roy Turner 1925–1998, *Red Landscape*, gift

Durrant, Roy Turner 1925–1998, *Female Nude in Grey*, gift

Durrant, Roy Turner 1925–1998, *Geometric Landscape in Black, Brown, Blue and Pink*, gift

Durrant, Roy Turner 1925–1998, *Field Woman, Groton Wood*, gift

Durrant, Roy Turner 1925–1998, *Female Nude*, gift

Durrant, Roy Turner 1925–1998, *Composition with Head of Woman (for Lo)*, gift

Durrant, Roy Turner 1925–1998, *Geometric Landscape in Black, Brown, Blue and Purple*, gift

Durrant, Roy Turner 1925–1998, *Head, Black on Blue*, gift

Durrant, Roy Turner 1925–1998, *Snow Rhapsody*, gift

Durrant, Roy Turner 1925–1998, *The Road*, gift

Durrant, Roy Turner 1925–1998, *Urban Landscape and Moon*, gift

Durrant, Roy Turner 1925–1998, *Woman*, gift

Dyck, Anthony van (follower of) 1599–1641, *Lady Penelope Hervey*, gift

Farley, Charles William 1893–1982, *Two Tethered Horses Grazing underneath a Tent*, gift

Farley, Charles William 1893–1982, *Homage to the Unknown Mule*, gift

Fayram, John active 1713–1743, *John, 1st Earl of Bristol (after Godfrey Kneller)*, gift

Forbes, Charles Stuart 1860–1926, *George Gery Milner-Gibson Cullum*, bequest

Fox, B. *Still Life with Fruit*, bequest

Fox, B. *Still Life with Fruit*, bequest

Fox, R. E. *Lord Arthur Hervey and His Daughter Mrs Sanford, Riding*, gift

Gambardella, Spiridione c.1815–1886, *Susanna Arethusa Cullum*, bequest

Graham, Kenneth *St Mary's, Woolpit*, gift

Graves, Henry Richard 1818–1882, *Lord Arthur Hervey*, gift

Harding, J. *A Cock Fight*, gift

Harraden, William *Norman Tower from the Churchyard*, purchased

Harrap, Phyllis *Cupola House*, gift

Hayls, John 1600–1679, *Colonel John Strode*, gift

Heasman, Vera *Gasworks, Tayfen Road*, gift

Huysum, Jan van (follower of) 1682–1749, *Flowers and Nest with Eggs*, gift

Hysing, Hans (circle of) 1678–1753, *John Rix of Thrandeston*, gift

Johnson, William active 1780–1810, *The Soldier Returning*, gift

Kauffmann, Angelica 1741–1807, *Reverend Sir John Cullum, 6th Bt*, bequest

Kauffmann, Angelica 1741–1807, *Susanna, Lady Cullum*, bequest

Kettle, Tilly (circle of) 1735–1786, *Sir Levett Hanson*, gift

Kettle, Tilly (circle of) 1735–1786, *Sir Levett Hanson, Kt*, bequest

Kneller, Godfrey 1646–1723, *Anne, Lady Cullum*, bequest

Ladbrooke, Frederick 1812–1865, *Frederick William, 1st Marquis of Bristol*, gift

Ladbrooke, Frederick 1812–1865, *Frederick William 1st Marquis of Bristol (after Francis Grant)*, gift

Lawrence, Thomas (follower of) 1769–1830, *Right Reverend C. J. Blomfield, DD*, gift

Lely, Peter 1618–1680, *Dudley, Lady Cullum*, bequest

Lely, Peter (attributed to) 1618–1680, *Sir Thomas Cullum, 2nd Bt*, bequest

Lely, Peter (follower of) 1618–1680, *Sir Dudley Cullum, 3rd Bt*, bequest

Lloyd, Katherine Constance active 1920–1974, *Edward Lancelot Dewe Lake*, gift

Matteis, Paolo de' (attributed to) 1662–1728, *Nymphs and Satyrs*, gift

Matteis, Paolo de' (attributed to) 1662–1728, *Pan and Nymphs*, gift

Mead, Rose 1867–1946, *Archdeacon Hodges*, gift

Mead, Rose 1867–1946, *Arthur Mead, Reading*, purchased

Mead, Rose 1867–1946, *Frank Mead*, purchased

Mead, Rose 1867–1946, *Mrs Mead Darning Socks*, purchased

Mead, Rose 1867–1946, *Reginald Mead*, purchased

Mead, Rose 1867–1946, *Self Portrait*, purchased

Mead, Rose 1867–1946, *A Jug of Summer Flowers*, purchased

Mead, Rose 1867–1946, *Anemones in a Flowered Vase*, gift

Mead, Rose 1867–1946, *Asters in a Green Vase*, gift

Mead, Rose 1867–1946, *Autumn Flowers in Flowered China Jug*, gift

Mead, Rose 1867–1946, *Cart with Barns*, gift

Mead, Rose 1867–1946, *Garden Path with Urns and Statues*, gift

Mead, Rose 1867–1946, *Garden with Hollyhocks*, gift

Mead, Rose 1867–1946, *Hollyhocks in a Brown Jug*, gift

Mead, Rose 1867–1946, *Mountainous Landscape and Stone Buildings*, gift

Mead, Rose 1867–1946, *Mrs John Greene, Mayor*, gift

Mead, Rose 1867–1946, *Nasturtiums*, gift

Mead, Rose 1867–1946, *Path and Trees*, gift

Mead, Rose 1867–1946, *Red Geraniums in a Pewter Mug*, gift

Mead, Rose 1867–1946, *River Scene with Trees*, gift

Mead, Rose 1867–1946, *Sea View from a Hill, South of France*, gift

Mead, Rose 1867–1946, *Summer Chrysanthemums in a Blue-Flowered Jug*, gift

Mead, Rose 1867–1946, *The Buttermarket, Bury St Edmunds*, gift

Mead, Rose 1867–1946, *Tulips*

Mead, Rose 1867–1946, *White Roses in a Pewter Mug*, gift

Mead, Rose 1867–1946, *Interior of Athenaeum Kitchen*, purchased

Mead, Rose 1867–1946, *The Outdoor Girl*, purchased

Mead, Rose 1867–1946, *Barbara Stone*, gift

Mead, Rose 1867–1946, *Molly Reading a Book*, purchased

Mead, Rose 1867–1946, *Self Portrait*, purchased

Mendham, Robert 1792–1875, *Boy with Fish*, gift

Moore, John of Ipswich 1820–1902, *Sailing Boats at Sea*

Moore, John of Ipswich 1820–1902, *Sailing Boats at Sea*

Munro, Olive *Anne, Lady Cullum (after Godfrey Kneller)*, bequest

Parker, William active 1730–1735, *James Reynolds, Lord Chief Baron of the Exchequer*

Patania, G. *Reverend Sir Thomas Gery Cullum*, bequest

Payne, Ernest 1903–1994, *Lord John Sanger's Circus on Holywell Meadow*, purchased

Payne, Ernest 1903–1994, *Vase of Spring Flowers*, gift

Pickersgill, Henry William 1782–1875, *Portrait of a Gentleman*, gift

Ralph, George Keith 1752–c.1811, *Alderman John Spink*

Ralph, George Keith 1752–c.1811, *Sir Thomas Gery Cullum*, bequest

Ralph, George Keith 1752–c.1811, *Orbell Ray Oakes*, gift

Ralph, George Keith (follower of) 1752–c.1811, *Portrait of a Seated Gentleman*

Ramos, Theodore b.1928, *Lord Moyne (after Fülöp László)*, anonymous loan, © the artist

Reynolds, Joshua 1723–1792, *Augustus John Hervey, 3rd Earl of Bristol*, gift

Reynolds, Joshua (after) 1723–1792, *The Age of Innocence*, gift

Rushbrooke, Barham active 1750, *Jankyn Smith*

H. M. S. *Portrait, Seated Gentleman*

Simington, Nicholas A. b.1930, *Lighthouse I*, purchased, © the artist

Simington, Nicholas A. b.1930, *Still Life with Flowers*, purchased, © the artist

Smeyes, Jacobus *Connoisseur's Studio*, gift

Smith, Charles b.1913, *Stubble Burning*, purchased

Smith, Herbert Luther *Sir Robert Rokewood of Coldham Hall*, gift

Smythe, Edward Robert 1810–1899, *Pastoral Scene with Cottage, Pond and Horse*

Smythe, Edward Robert 1810–1899, *Pastoral Scene with Cottages and Windmill*, gift

Smythe, Thomas 1825–1907, *Pony and Dead Game*, gift

Soest, Gerard (attributed to) c.1600–1681, *Sir Thomas Cullum, Bt*, bequest

Soest, Gerard (circle of) c.1600–1681, *Sir Thomas Cullum, 1st Bt*, bequest

Spanton, William Silas 1845–1930, *Alderman George Thompson*, gift

Spanton, William Silas 1845–1930, *Self Portrait*

Szego, Gilly *Tercentenary of Suffolk Regiment*

Tingle, Michael b.1954, *Thurlow Mill*, gift, © the artist

Tingle, Michael b.1954 with the assistance of Emily and Louise Tingle, and Doris and Ted Pearce, aged five to ten *Bacchanal in Bury*, purchased, © the artist

Tissot, James 1836–1902, *Sydney Isabella Milner-Gibson*, bequest

Tovey, Samuel Griffiths 1808–1873, *Sarah Maddy*, purchased

unknown artist 16th C, *The Cellarer's Window*

unknown artist *Henry James Oakes*, gift

unknown artist *George Gery Milner-Gibson Cullum*, bequest

Verelst, Simon Pietersz. (follower of) 1644–probably 1721, *Dionesse, Daughter of William Cullum*, bequest

Vivian, H. *John Gershom-Parkington*, gift

Walton, Henry 1746–1813, *Rowland Holt*, gift

Walton, Henry 1746–1813, *Charles, First Marquis Cornwallis*, gift

Walton, John Whitehead active 1830–1885, *Reverend Sir Thomas Gery Cullum*, bequest

Walton, John Whitehead active 1830–1885, *Frederick William Hervey*, bequest

Walton, John Whitehead (attributed to) active 1830–1885, *Reverend Sir Thomas Gery Cullum*, bequest

Webster, Joseph Samuel 1757–1796, *Lady Cullum, Mary*, bequest

Webster, Joseph Samuel 1757–1796, *Sir Levett Hanson, Kt*, bequest

Zinkeisen, Doris Clare 1898–1991, *Wolf Guarding the Head of St Edmund*

Dunwich Museum

Blackman, E. (attributed to) *Lily Bird Lifeboat*

Lingwood, Edward J. active 1884–1919, *All Saints' Church*, on loan from Southwold Museum

Lingwood, Edward J. active 1884–1919, *All Saints' Church*, on loan from Southwold Museum

Lingwood, Edward J. active 1884–1919, *Disappearance of All Saints'*, on loan from Southwold Museum

Lingwood, Edward J. active 1884–1919, *Dunwich Mount*, gift from Norman Scarfe

unknown artist *Dunwich*

Eye Town Council

Brooks, Frank 1854–1937, *Agnes Baroness Bateman (1831–1918)*, gift from Kerrison family to Eye Corporation

Dance-Holland, Nathaniel (attributed to) 1735–1811, *Portrait of a Man in a Red Coat*

Mendham, Robert 1792–1875, *Eye Worthies around the Market Cross*

Mendham, Robert 1792–1875, *General Sir Edward Kerrison Bt, KCB, GCH (1774–1853)*

Shee, Martin Archer (attributed to) 1769–1850, *General Sir Edward Kerrison Bt, KCB, GCH (1774–1853)*, gift from Miss M. Howell

Short, Mary active 1901–1940, *Lady Catherine Elizabeth Tacon (1846–1927)*

Short, William 1827–1921, *Charles Tacon (1833–1909), Mayor of Eye*

Short, William 1827–1921, *Samuel Peck (1812–1880), Mayor of Eye*, gift from Sir E. C. Kerrison, Bt

Felixstowe Museum

Colthorpe, Doreen *Landguard Fort, 1981*, gift from Doreen Colthorpe

Dugdale, Thomas Cantrell 1880–1952, *Caroline Amey Ruark, Matron of St Audry's Hospital (1929–1947)*, on loan from the former St Audry's Hospital, East Suffolk NHS

Gaywood, P. 20th C, *Billy Newson (1905–1988), Trinity House Pilot*

Lewis, M. *Mary and Joseph*, on loan from the former St Audry's Hospital, East Suffolk NHS

Nunn, A. L. *Walberswick, Suffolk*

Reeve, John Constable b.1929, *Lancaster Bomber B1, LM258, HA-Q of 218 Squadron*, gift from John Constable Reeve, © the artist

Smith, Harry J. d.1983, *Consolidated Catalina*

Smith, Harry J. d.1983, *Supermarine Seaplane*

Twaite, H. E. *Felixstowe Ferry*, on loan from Mr A. Rayner

unknown artist *St Audry's Hospital Chapel Entrance*, on loan from the

former St Audry's Hospital, East Suffolk NHS

unknown artist *St Audry's Hospital Garden*, on loan from the former St Audry's Hospital, East Suffolk NHS

unknown artist *Town Scene*, on loan from the former St Audry's Hospital, East Suffolk NHS

Watts, Alan *Casemated Battery, Rear of Fortress, Landguard Fort*

Felixstowe Town Council

James, David 1834–1892, *A North Cornish Breaker*

Meyer, Frederick W. active 1869–1922, *Near Milford Haven, Evening*, gift from H. B. Barkworth

Norfolk and Suffolk Aviation Museum

M. R. A. *The Whaleback*, gift

Anderson, S. G. *McDonnel F-4 Phantoms*, gift from 81st TFW USAF

Barrington, Peter b.1928, *Consolidated B-24 Liberator*, gift, © the artist

Brighton, R. *SE5 Over the Front during the First World War*, gift

Brighton, R. *Lancaster in the Far East during the Second World War*, gift

Colson, Stan *RAF Red Arrows*, gift from Ipswich Royal Air Force Association

Fairhead, Huby J. b.1944, *English Electric Lightning F1A*, gift, © the artist

Fairhead, Huby J. b.1944, *Gladiator*, gift, © the artist

Fairhead, Huby J. b.1944, *Gloster Meteors in Formation*, gift, © the artist

Fairhead, Huby J. b.1944, *Junkers Ju87 Stuka*, gift, © the artist

Fairhead, Huby J. b.1944, *Lightning Treble One*, gift, © the artist

Fairhead, Huby J. b.1944, *Provost T1*, gift, © the artist

Fairhead, Huby J. b.1944, *Swift, 56 Squadron*, gift, © the artist

Hammond, George *Anson Landing at RAF Rissington*

Lain, Arthur G. *Republic P-47 Thunderbolt*

Lee, Bert *Merlin, the Museum Cat*, gift

Lee, Bert *Vulcan B2*, gift

Parker, Geoffrey b.1930, *Allied Bristol F2b Biplane, World War One*, gift

Parker, Geoffrey b.1930, *Allied SE5 Biplanes, World War One*, gift, © the artist

Reeve, John Constable b.1929, *Handley Page HP42*, gift, © the artist

Reeve, John Constable b.1929, *North American F-100 Super Sabre*, gift, © the artist

Reeve, John Constable b.1929, *Air Battle over Ipswich*, gift, © the artist

Reeve, John Constable b.1929, *Airship R23 and Sopwith Camel at Pulham*, gift, © the artist

Reeve, John Constable b.1929, *B. C. Hucks and His Bleriot at Gorleston*, gift, © the artist

Reeve, John Constable b.1929, *Boulton and Paul Overstrand*, gift, © the artist

Reeve, John Constable b.1929, *Bristol Blenheims, Take off at Wattisham*, gift, © the artist

Reeve, John Constable b.1929, *Bristol Bulldog IIA, 19 Squadron*, gift, © the artist

Reeve, John Constable b.1929, *Bristol Scout on the Upper Wing of a Porte Baby*, © the artist

Reeve, John Constable b.1929, *De Havilland Comet Racer over Mildenhall, 1935*, © the artist

Reeve, John Constable b.1929, *First Balloon Flight over Norfolk, 1785*, gift, © the artist

Reeve, John Constable b.1929, *German Triplane over Orfordness*, © the artist

Reeve, John Constable b.1929, *Handley Page V1500, Bircham Newton, 1918*, gift, © the artist

Reeve, John Constable b.1929, *Junkers Ju188*, gift, © the artist

Reeve, John Constable b.1929, *Mr Norman Spratt's Deperdussin, Southwold 1913*, gift, © the artist

Reeve, John Constable b.1929, *NE1 with Early Rockets, 1917*, gift, © the artist

Reeve, John Constable b.1929, *Norfolk and Norwich Aero Club, Mousehold Heath*, gift, © the artist

Reeve, John Constable b.1929, *Parachute Training at Martlesham*, gift, © the artist

Reeve, John Constable b.1929, *Radio Direction Finding Station, Bawdsey 1938*, gift, © the artist

Reeve, John Constable b.1929, *Sanders Biplane, Beccles 1909*, gift, © the artist

Reeve, John Constable b.1929, *Wing Commander Ken Wallis, MBE*, gift, © the artist

Seymour, A. J. *De Havilland Mosquitos, 105 Squadron*, on loan from Mr Richard Jeeves

Spencer, Kenneth *Vickers Wellington 1a*, gift

Tyson, Ken *Shackleton Mark 2*, gift

Tyson, Ken *Messerschmitt Me109*, gift

unknown artist *Boeing B-17 Flying Fortress*, gift

unknown artist *Fairchild Republic A-10 Thunderbolt II*, gift from 81st TFW USAF

unknown artist *RAF 1918–1968*, gift from Royal Air Force Museum

unknown artist *RAF Stradishall 1938–1968*, gift from Royal Air Force Museum

unknown artist *The Museum at Play*, gift

Warren, Ron *Boeing B-17 Flying Fortress Formation*, gift

Warren, Ron *Hawker Hurricane and Supermarine Spitfire*, gift

Warren, Ron *Hawker Hurricane*, gift

Whaley, Malcolm *Supermarine Spitfire, USAAF*, gift

Wilyman, Geoffrey b.1917, *'The Sea Shall Not Have Them'*, gift

Lanman Museum

Scott, C. *Parham Old Hall*

unknown artist *A Country Scene*

unknown artist *A View up Castle Street, Framlingham*

unknown artist *St Michael's Church, Framlingham*

Halesworth and District Museum

Southgate, Anne active 1890s, *Bramfield Village*

unknown artist *Rectory Street from Fenn Farm*

Haverhill and District Local History Centre

unknown artist *Celia Gurteen (1815–1838)*, on loan from Christopher Gurteen

unknown artist *Clara Gurteen (b.1813)*, on loan from Christopher Gurteen

unknown artist *Daniel Gurteen (1809–1893)*, on loan from Christopher Gurteen

unknown artist *Sarah Gurteen (1806–1860)*, on loan from Christopher Gurteen

unknown artist *Stephen Gurteen (1808–1857)*, on loan from Christopher Gurteen

Webb, Conrade Manger 1797–1874, *Alice Alfreed Webb (1777–1838)*, gift from Grace Gurteen

Webb, Conrade Manger 1797–1874, *Barnabas Webb (1760–1846)*, gift from Grace Gurteen

Ipswich Borough Council Museums and Galleries

Adcock, Allan A. active 1915–1950, *Waldringfield on the Deben*, purchased with the assistance of the Felix Cobbold Bequest Fund

Adler, Jules 1865–1962, *Boulogne*, purchased, © ADAGP, Paris and DACS, London 2005

Ager, F. W. *House and Winter Trees*

Aikman, William 1682–1731, *Sir Charles Blois*, gift from H. Reeves

Airy, Anna 1882–1964, *Mrs Telford Simpson*, gift from M. C. Burnand

Airy, Anna 1882–1964, *The Kitchen's Queen*, puchased with the assistance of the Felix Cobbold Bequest Fund

Airy, Anna 1882–1964, *Mrs Monica Burnand*, gift from M. C. Burnand

Airy, Anna 1882–1964, *Interior with Mrs Charles Burnand*, gift from M. C. Burnand

Airy, Anna 1882–1964, *Alderman Cyril Catchpole*, gift from E. Airy

Airy, Anna 1882–1964, *Greta*, purchased with the assistance of the Felix Cobbold Bequest Fund

Alken, Henry 1785–1851, *Ipswich to London Coach*, purchased

Angillis, Pieter 1685–1734, *Figures on a Bowling Green*, gift from Mussenden Leathes

Arif, Saleem b.1949, *Harbour of Intimacy (Diptych)*

Ayrton, Michael 1921–1975, *Broom Copse*, gift from Contemporary Art Society, © the artist's estate

C. D. B. *Old Handford Bridge*, purchased from Amey's Collection

Bacon, T. (attributed to) active 18th C, *Portrait of a Man*, purchased from G. Maynard

Bacon, T. (attributed to) active 18th C, *Portrait of a Woman*, purchased from G. Maynard

Barker, Benjamin II 1776–1838, *Landscape*

Barker, Thomas 1769–1847, *Landscape and Cattle at Pool*, purchased from E. McInnes

Barker, Thomas (attributed to) 1769–1847, *Shepherd Boy, Study*, gift from E. Packard

Barnicle, J. active 1821–1845, *Orwell Park, Ipswich*, purchased from the Dashwood Sale with the assistance of the Felix Cobbold Bequest Fund

Barrett, Roderic 1920–2000, *Chair in Its Place*, purchased through East Anglian Arts from R. Barrett

Batley, Walter Daniel 1850–1936, *Angel Corner, Ipswich*, purchased from Prentice with the assistance of the Felix Cobbold Bequest Fund

Batley, Walter Daniel 1850–1936, *Demolition, Back of the Town Hall*, gift from Durby

Batley, Walter Daniel 1850–1936, *Old Provision Market, Ipswich*, purchased from Batley

Batley, Walter Daniel 1850–1936, *His First Vote*, gift from Batley

Batley, Walter Daniel 1850–1936, *Wharfedale*

Batley, Walter Daniel 1850–1936, *Minsmere Cliff*, gift from F. T. Cobbold

Batley, Walter Daniel 1850–1936, *Now Comes Still Evening on*, purchased with the assistance of the Felix Cobbold Bequest Fund

Batley, Walter Daniel 1850–1936, *Snow*, purchased with the assistance of the Felix Cobbold Bequest Fund

Batley, Walter Daniel 1850–1936, *On the Road*, gift from Batley

Batley, Walter Daniel 1850–1936, *Trees and Gate*, gift from A. Farrar

Beale, Mary (attributed to) 1633–1699, *Woman of Gage or Jermyn Families*, purchased from Hengrave Hall

Becker, Harry 1865–1928, *Cutting Chaff in the Open*, gift from Mrs H. Becker

Becker, Harry 1865–1928, *Man Hedging*, gift from Mrs H. Becker

Becker, Harry 1865–1928, *Man with Scythe Mowing*, gift from Mrs H. Becker

Becker, Harry 1865–1928, *Two Men Clearing Banks*, gift from Mrs H. Becker

Becker, Harry 1865–1928, *Cattle by Dyke*, gift from H. Becker

Becker, Harry 1865–1928, *Farm Buildings in Landscape*, gift from Mrs H. Becker

Becker, Harry 1865–1928, *Landscape with Horses Ploughing*, gift from Mrs H. Becker

Becker, Harry 1865–1928, *Reclining Man in Cap*, gift from Mrs H. Becker

Beechey, William (attributed to) 1753–1839, *Admiral Horatio Nelson, 1st Viscount Nelson, KB (1758–1805)*, transferred from Ipswich Town Hall

Beelt, Cornelis active 1661–c.1702, *Skaters on Frozen River*, gift from Mussenden Leathes

Belcher, George 1875–1947, *The Musician*, purchased from G. Belcher with the assistance of the Felix Cobbold Bequest Fund

Bellingham-Smith, Elinor 1906–1988, *Suffolk Landscape*, purchased from J. Moynihan with assistance from the V&A Purchase Grant Fund, © the artist's estate

Bennett, William Mineard 1778–1858, *Captain Richard Hall Gower (1768–1833)*, purchased from G. L. Davis with the assistance of V&A Purchase Grant Fund

Bennett, William Mineard (attributed to) 1778–1858, *William Batley, Town Recorder of Ipswich (b.1758)*

Bentley, Alfred 1879–1923, *The Silent River*

Bevan, Robert Polhill 1865–1925, *A Small Southdown Farm*, purchased from R. Bevan with assistance from the V&A Purchase Grant Fund

Birley, Oswald Hornby Joseph 1880–1952, *Sir Arthur Churchman, Lord Woodbridge*, gift from executors of the sitter, © the artist's estate

Bischoff, Friedrich H. 1819–1873, *Bishop Edward Stanley (1779–1849)*, transferred to Ipswich Corporation Museum in 1881 from original private subscription museum

Bischoff, Friedrich H. 1819–1873, *Reverend William Kirby (1759–1850), President of the Ipswich Subscription Museum*, transferred to Ipswich Corporation Museum in 1881 from original private subscription museum

Boer, John active 19th C, *St Nicholas' Street and Corner of Silent Street*, gift from Symonds

Boer, John active 19th C, *St Peter's Bridge, Ipswich*, gift from Mr M. Kett

Bout, Pieter 1658-1719 & **Boudewyns, Adriaen** 1644–1711 *Seaport Scene*, gift from Mussenden Leathes

Bout, Pieter 1658–1719 &

Boudewyns, Adriaen 1644–1711 *Seaport Scene*, gift from Mussenden Leathes

Bower, Edward (attributed to) d.1666/1667, *Anglican Divine with Boy*, purchased from M. Toynbee

Boyd, Fionnuala b.1944 **& Evans, Leslie** b.1945 *Eclipse*, gift from East England Arts

Bredael, Peeter van 1629–1719, *Market Scene with Harlequin*, gift from Mussenden Leathes

Bright, Henry 1814–1873, *Coast Scene with Figures*, purchased from W. H. Booth

Bright, Henry 1814–1873, *Landscape with Windmill*, purchased with the assistance of the Felix Cobbold Bequest Fund

Bright, Henry 1814–1873, *Landscape with Windmill*, purchased from E. E. Cook with the assistance of the National Art Collections Fund

Bright, Henry 1814–1873, *Landscape with Cottage*

Bright, Henry 1814–1873, *Ruins on the Heath*, R. Allen Bequest

Bright, Henry 1814–1873, *Scene on the Coast, North Wales*, purchased with the assistance of the Felix Cobbold Bequest Fund

Bright, Henry 1814–1873, *Scene on the Coast, North Wales*, purchased at auction

Bright, Henry 1814–1873, *Tintern Abbey*, R. Allen bequest

Brill, Reginald 1902–1974, *Bell Ringers, Lavenham*, purchased from the Fine Art Society with the assistance of the V&A Purchase Grant Fund, the Museums and Galleries Commission, the Pilgrim Trust and the Friends of Ipswich Museum

British (English) School *Peter Withipoll (1549–c.1613)*, purchased with the assistance of the Felix Cobbold Bequest Fund

British (English) School *Walter Devereux (1541?–1576), 2nd Viscount Hereford, Created 1st Earl of Essex*, purchased from G. Maynard

British (English) School *Catherine Killigrew (1579–1640)*, purchased from Rushbrooke Sale

British (English) School *Francis Manners, Earl Rutland*, purchased from Hengrave Hall

British (English) School *Sir William Playters (1590–1668)*, gift from H. J. M. Turner

British (English) School *Cecily Manners, Countess Rutland*, purchased from Hengrave Hall

British (English) School *Samuel 'Watch' Ward (1577–1640)*, transferred from Town Hall

British (English) School *Possibly William Booth*, purchased from Fonnereau

British (English) School *Oliver St John, Earl of Bolingbroke*, purchased from N. H. P. Turner with the assistance of the Felix Cobbold Bequest Fund

British (English) School *Tobias*

Blosse (c.1565–c.1630), purchased from Bonham's

British (English) School *Ann Cotton (d.1638)*, gift from A. Cotton Borrett

British (English) School *Young Boy (possibly a member of the Theobald Family)*, purchased

British (English) School *Thomas Edgar (1594–1657)*, purchased from Pawsley and Payne with the assistance of the Felix Cobbold Bequest Fund

British (English) School *John Dowsing*, gift from E. H. Biden

British (English) School *Gentleman of the Gooding or Goodwin Family*, purchased from Doughtymontagu with the assistance of the Felix Cobbold Bequest Fund

British (English) School *Boy and Helmet*, purchased from G. Maynard

British (English) School *A Gentleman*, purchased from H. Finborough with the assistance of the Felix Cobbold Bequest Fund

British (English) School *Lady of the Gooding or Goodwin Family*, purchased from Doughtymontagu with the assistance of the Felix Cobbold Bequest Fund

British (English) School *Woman in Blue Dress*, gift from G. Maynard

British (English) School *Nathanial Bacon (1593–1660)*

British (English) School *Dr Ralph Cotton*, gift from A. Cotton Borrett

British (English) School *Possibly Marguerite Fonnereau*, purchased from Fonnereau

British (English) School *Thomas Killigrew as a Boy*, purchased from Henniker with the assistance of the Felix Cobbold Bequest Fund

British (English) School *Possibly Zacharie Fonnereau (b.1636)*, purchased from Fonnereau with the assistance of the V&A Purchase Grant Fund

British (English) School *Captain Allen Cotton (c.1635–1699)*, gift from A. Cotton Borrett

British (English) School *Sir George Hutchins (d.1705)*, purchased from E. McCausland with the assistance of the Felix Cobbold Bequest Fund

British (English) School *17th C, Charles II (1630–1685)*, purchased from N. H. P. Turner with the assistance of the Felix Cobbold Bequest Fund

British (English) School *Sarah, Duchess of Marlborough*, purchased

British (English) School *Ralph Meadows Theobald*, purchased from E. G. D. Donnelly

British (English) School *Ralph Cotton*, gift from A. Cotton Borrett

British (English) School *John Goodwin*, purchased from Doughtymontagu with the assistance of the Felix Cobbold Bequest Fund

British (English) School *Lady of the Fonnereau Family, in Blue*, purchased from Fonnereau with

the assistance of the V&A Purchase Grant Fund

British (English) School *Lady of Fonnereau Family, in Green*, purchased from Fonnereau with the assistance of the V&A Purchase Grant Fund

British (English) School *Mrs John Goodwin*, purchased from Doughtymontagu with the assistance of the Felix Cobbold Bequest Fund

British (English) School *Joseph Addison*, gift from W. H. Booth

British (English) School *Claude Fonnereau (1677–1740)*, purchased from Fonnereau with the assistance of the V&A Purchase Grant Fund

British (English) School *Gentleman of the Fonnereau Family*

British (English) School *Lady of the Fonnereau Family*, from Fonnereau

British (English) School *Gentleman of the Fonnereau Family*, purchased from Fonnereau

British (English) School *Lady of Fonnereau Family, in White*, purchased from Fonnereau with the assistance of the V&A Purchase Grant Fund

British (English) School *Thomas Taylor, Ipswich Merchant, Aged 40*, gift from Marriott

British (English) School *Sir Robert Harland*, purchased

British (English) School *Lady in a Blue Dress*, from Smith

British (English) School *Lady of the Fonnereau Family*, purchased from Fonnereau with the assistance of the V&A Purchase Grant Fund

British (English) School *Gentleman of the Fonnereau Family*, purchased from Fonnereau

British (English) School *18th C, Captain Hill Mussenden, MP*, gift from Mussenden Leathes

British (English) School *18th C, Mrs Hill Mussenden*, gift from Mussenden Leathes

British (English) School *The Cornhill, Ipswich*, gift from Donavan

British (English) School *Mrs Frances Power (née Mannock)*, gift from M. Power

British (English) School *Battle for the Standard*, purchased from Doughtymontagu with the assistance of the Felix Cobbold Bequest Fund

British (English) School *Officer Killed at the Battle of Waterloo*, purchased from Doughtymontagu with the assistance of the Felix Cobbold Bequest Fund

British (English) School *Princess Charlotte Ascending*, gift from B. Holford-Smith

British (English) School *Admiral Benjamin W. Page (1765–1845)*, gift from E. Jerwood

British (English) School *Mrs Benjamin W. Page*, gift from E. Jerwood

British (English) School *Reverend Charles William Fonnereau*

(1764–1840), purchased from Fonnereau

British (English) School *Gentleman in a Black Coat*, purchased from Mulley

British (English) School *Mrs John Childs*, bequeathed by C. C. Paterson

British (English) School *The Cornhill*, gift from F. T. Cobbold

British (English) School *Gentleman of the Fonnereau Family*, purchased from Fonnereau

British (English) School *The Good Samaritan*

British (English) School *John Nottidge*, gift from Ipswich Historic Churches Trust

British (English) School *Possibly Reverend Charles Fonnereau (1764–1840)*

British (English) School *Thomas Clarkson (1760–1846)*, gift from L. Gall

British (English) School *William Charles Fonnereau*, gift from F. G. Crisp

British (English) School *Professor John S. Henslow (1796–1861), President of Ipswich Subscription Museum, 1850*, transferred to Ipswich Corporation Museum in 1881 from original private Subscription Museum

British (English) School *Edgar Shreeve and John Trigg Scrivener*, gift from Scrivener

British (English) School *Captain William Raymer*, gift from Ipswich Nautical Research Society

British (English) School *Portrait of a Man, with Books*

British (English) School *Resting at the Ford*, R. Allen Bequest

British (English) School *Portrait of Man in a Blue Coat*

British (English) School *View on the Thames*, purchased from A. Brown

British (English) School *Lord Gwydyr*

British (English) School *19th C, Cows Drinking at Woodland Spring*

British (English) School *19th C, William Henry Williams*

British (English) School *Woman with Dogs*

British (English) School *Boy in 17th Century Dress*, purchased from Coleman Street Auction

British (English) School *Cardinal Wolsey*, purchased

British (English) School *Cardinal Wolsey*, bequeathed by E. Varmy

British (English) School *Colonel Alderson on a Horse*

British (English) School *Edgar Goodwin*, gift from Scrivener

British (English) School *Edward VI (1537–1553)*, purchased

British (English) School *Going to Market*, R. Allen Bequest

British (English) School *John Grubbe*, from M. I. M. Grubbe

British (English) School *John Meadows Theobald*, purchased from E. G. D. Donnelly

British (English) School *John Trigg*

Scrivener, gift from Scrivener

British (English) School *Landscape, Man and Woman in a Cart*, purchased from G. Sawyer with the assistance of the Felix Cobbold Bequest Fund

British (English) School *Martha Shreeve*, gift from Scrivener

British (English) School *Mary Ann Goodwin (née Shreeve)*, gift from Scrivener

British (English) School *Portrait of a Lady*

British (English) School *Reverend Matthew Scrivener*, gift from Levett Scrivener

British (English) School *Shepherdess with Sheep*

British (English) School *The Poet Reverend George Crabbe (1754–1832)*, purchased from C. B. Johnson with the assistance of the Felix Cobbold Bequest Fund

British (English) School *The Thatcher with a Sickle*

British (English) School *Thomas Cromwell*, purchased

British (English) School *Thomas Shreeve*, gift from Scrivener

British (English) School *Two Horses in a Field*, A. Jennings Bequest

British (English) School *White Horse in Stable*

British (English) School *Wickham Tozer*

British (English) School *Widow Devereux*, purchased from G. Maynard

British (English) School *William Smith of Laxfield*, gift from E. H. Biden

British (English) School or Dutch School *Frances Cotton*, gift from A. Cotton Borrett

British (English) School or Dutch School *Henrietta Jermyn (b.1632)*, purchased from Hengrave Hall

British (English) School or Dutch School *Lady in Lace Cap*, purchased

British (English) School or Dutch School *Lady in Lace Cap*, purchased

British (English) School or Dutch School *19th C, River Scene with Shipping*, gift from B. Ellis

British (English) School or Dutch School *Flower Piece*, purchased from M. M. Rogers

British (English) School or Dutch School *Portrait of a Queen (possibly Mary II)*

Brown, Frederick 1851–1941, *Whin Hill, the Common, Southwold*, purchased with the assistance of the V&A Purchase Grant Fund

Brown, John Alfred Arnesby 1866–1955, *Spring*, purchased with the assistance of the Felix Cobbold Bequest Fund

Browning, Amy Katherine 1882–1978, *Lime Tree Shade*, gift from the family of A. K. Browning

Buck, Lucy Margaret active 1892–1894, *Ethel Mary Turner (1883–1984)*, gift from J. Sherman

Buck, William active 1864–1899, *Gainsborough Lane, Ipswich*, gift from A. F. Brooke

Bunbury, Henry William (attributed to) 1750–1811, *Old Man, Possibly a Saint*

Bunbury, Henry William (attributed to) 1750–1811, *Old Man, Possibly a Saint*

Burrell, Semonda active 1890s, *Lord Gwydyr*

Burrows, Robert 1810–1883, *Back of Cauldwell Hall*, purchased

Burrows, Robert 1810–1883, *Gipping near Oil Mills*, gift from Messent

Burrows, Robert 1810–1883, *Old Cauldwell, Ipswich*, purchased from W. E. Kersey

Burrows, Robert 1810–1883, *Old Gippeswyck Hall*, purchased

Burrows, Robert 1810–1883, *Orwell from Bridleway, Ipswich*, gift from S. C. Grimwade

Burrows, Robert 1810–1883, *River Orwell from Gainsborough Lane*, gift from Messent

Burrows, Robert 1810–1883, *River Scene*, purchased with the assistance of the Felix Cobbold Bequest Fund

Burrows, Robert 1810–1883, *Riverside Scene*, purchased with the assistance of the Felix Cobbold Bequest Fund

Burrows, Robert 1810–1883, *Bridge, West of Stoke Bridge*, gift from Cordy Wolton

Burrows, Robert 1810–1883, *Christchurch Park, Now Park Road*, purchased

Burrows, Robert 1810–1883, *Landscape in Christchurch Park*, gift from Messent

Burrows, Robert 1810–1883, *Foxhall Road, Ipswich*, purchased from Arcade Hall

Burrows, Robert 1810–1883, *Park Road, Ipswich*, purchased from Tibbenham with the assistance of the Felix Cobbold Bequest Fund

Burwood, George Vemply c.1845–1917, *Landscape with Sheep*, from H. J. W. Legerton

Butler, George Edmund (attributed to) 1872–1936, *Harbour Scene*, gift from D. B. Teale

Calvert, Charles 1785–1852 **or Calvert, Frederick** 1811–1844 *Shipping off the Coast*, R. Allen Bequest

Calvert, Charles 1785–1852 **or Calvert, Frederick** 1811–1844 *Shipping with Riverside Buildings*, R. Allen Bequest

Camp, Jeffery b.1923, *The Grey North Sea*, purchased from A. Bailey with the assistance of the V&A Purchase Grant Fund, © the artist

Campbell, Peter 1931–1989, *Tower and Churchyard*, from Peter Campbell

Carpenter, Margaret Sarah 1793–1872, *Eleonora Long, née Montagu (c.1811–1900)*, gift from A. H. V. Aldous

Castro, Lorenzo de active 1678–c.1700, *Men O'War and Shipping*

off a Jetty, gift from Mussenden Leathes

Churchyard, Thomas 1798–1865, *Clump of Trees*

Churchyard, Thomas 1798–1865, *Landscape with Cart Track*, purchased from R. J. Southgate

Churchyard, Thomas 1798–1865, *Landscape with Sheep*, purchased from W. Marshall

Churchyard, Thomas 1798–1865, *Landscape with Sheep and Trees*, gift

Churchyard, Thomas 1798–1865, *River Deben below Kyson Point*, purchased

Churchyard, Thomas 1798–1865, *Woodbridge*, purchased

Churchyard, Thomas 1798–1865, *Wooded Landscape*, purchased from A. Cubitt with the assistance of the Felix Cobbold Bequest Fund

Churchyard, Thomas 1798–1865, *Fifteen Scenes of Melton and Woodbridge*, purchased from H. M. Cautley

Churchyard, Thomas 1798–1865, *Melton Quay*, gift from E. G. Redstone

Churchyard, Thomas 1798–1865, *Ploughing*, purchased from J. H. Wrinch

Churchyard, Thomas 1798–1865, *Pond with Trees*, R. Allen Bequest

Churchyard, Thomas 1798–1865, *Ufford Stocks*

Churchyard, Thomas 1798–1865, *Watermill at Campsea Ashe*, purchased from G. Smith with the assistance of the Felix Cobbold Bequest Fund

Churchyard, Thomas 1798–1865, *Woodland Ride*

Cleveley, John c.1712–1777, *Bombardment of Castillo de San Lorenzo by Admiral Vernon*, purchased from Marshall Spring with the assistance of the Felix Cobbold Bequest Fund

Cleveley, John c.1712–1777, *View of Ipswich*, gift from W. Alexander

Clough, Prunella 1919–1999, *Sweetpea*, from Contemporary Art Society distribution, © the estate of Prunella Clough 2005. All rights reserved, DACS

Cobbold, Richard 1797–1877, *Margaret Catchpole*, gift from S. Cobbold

Coe, Alfred *Chantry Drawing Room*

Coker, Peter 1926–2004, *Portrait of an Old Man*, purchased from P. Coker with the assistance of the Friends of Ipswich Museum, © Peter Coker, RA

Coker, Peter 1926–2004, *Epping Forest III*, purchased with the assistance of the V&A Purchase Grant Fund, © Peter Coker, RA

Coker, Peter 1926–2004, *Horse Island from Acheniver*, purchased from P. Coker with the assistance of the Friends of Ipswich Museum, © Peter Coker, RA

Cole, Charles *Robert Harland*, purchased from Dashwood Sale

Collier, John 1850–1934, *A Glass*

of Wine with Caesar Borgia, purchased with the assistance of the Felix Cobbold Bequest Fund

Collier, John 1850–1934, *Felix Thornley Cobbold (1841–1909)*, gift from the Friends of Ipswich Museum

Collins, Cecil 1908–1989, *Fool (Head)*, bequeathed by Mrs Elizabeth Collins through the National Art Collections Fund © Tate, London 2005

Constable, John 1776–1837, *The Ladies of the Family of Mr William Mason of Colchester*, purchased with the assistance of the Heritage Lottery Fund and the Friends of Ipswich Museum grant aid

Constable, John 1776–1837, *Abram Constable, the Artist's Brother*, purchased with the assistance of the Felix Cobbold Bequest Fund

Constable, John 1776–1837, *The Mill Stream, Willy Lott's House*, purchased from T. Yates with the assistance of the National Art Collections Fund

Constable, John 1776–1837, *Farm Cart, Horse in Harness*, gift via Museum and Galleries Commission from the estate of Miss Constance Waller

Constable, John 1776–1837, *Golding Constable's Flower Garden*, bequeathed to the nation by E. E. Cook via the National Art Collections Fund

Constable, John 1776–1837, *Golding Constable's Kitchen Garden*, bequeathed to the nation by E. E. Cook via the National Art Collections Fund

Constable, John 1776–1837, *Willy Lott's House*, purchased from B. W. Leader with the assistance of the Felix Cobbold Bequest Fund

Constable, John 1776–1837, *Avenue of Trees*, purchased from the Barratt Collection

Constable, John (after) 1776–1837, *The Cornfield*, gift from C. Cooper

Constable, John (after) 1776–1837, *Hampstead Heath*, gift from A. M. Amschel

Constable, John (after) 1776–1837, *West End Fields Looking to Harrow*, gift from A. M. Amschel

Constable, John (attributed to) 1776–1837, *Thomas Gosnall*, purchased

Constable, Lionel Bicknell (attributed to) 1828–1887, *Meadow Scene with Trees*, purchased with the assistance of the Felix Cobbold Bequest Fund

Cooper, Daniel 1749–1882, *The Courtship*, bequeathed by Miss A. E. Clutten

Copley, John Singleton 1738–1815, *Major George Leathes, Royal Dragoons*, gift from Mussenden Leathes

Corbould, Alfred active 1831–1875; *J. P. Cobbold*

Cotman, Frederick George 1850–1920, *Morning Mist on the*

Orwell, gift from C. Catchpole

Cotman, Frederick George 1850–1920, *The Widow*, purchased from W. Eade with the assistance of the Felix Cobbold Bequest Fund

Cotman, Frederick George 1850–1920, *The Dame School*, bequeathed by P. Bruff

Cotman, Frederick George 1850–1920, *Sir Edward Packard*, gift from F. G. Cotman

Cotman, Frederick George 1850–1920, *Nathaniel Catchpole*

Cotman, Frederick George 1850–1920, *Alderman Walton Turner*

Cotman, Frederick George 1850–1920, *Frank Woolnough, Ipswich Museum Curator (1893–1920)*, gift from K. G. Erith

Cotman, Frederick George 1850–1920, *Landscape, Sunset*, gift from executors of M. Slater

Cotman, Frederick George 1850–1920, *Farmyard and Dovecote, Nettlestead*, purchased from F. E. Parkington

Cotman, Frederick George 1850–1920, *Harwich Harbour*, purchased with the assistance of the Felix Cobbold Bequest Fund

Cotman, Frederick George 1850–1920, *Valley of the Gipping*, purchased from F. E. Parkington

Cotman, John Sell (attributed to) 1782–1842, *Mountain Landscape*, bequeathed by R. Allen

Courtois, Jacques (circle of) 1621–1676, *Battle Piece*, purchased from Van du Burgh

Critz, John de the elder (attributed to) 1551/1552–1642, *Anne of Denmark (1574–1619), Queen of James I*, purchased from H. Finborough with the assistance of the Felix Cobbold Bequest Fund

Crofts, Ernest 1847–1911, *Prince Rupert and Staff*, Mrs R. Allen Bequest

Crome, John (after) 1768–1821, *The Tanning Mills, Norwich*, purchased from Sir Edward Marsh with the assistance of the National Art Collections Fund

Crome, John Bernay 1794–1842, *Moonlight on the River at Norwich*, bequeathed by Baker

Crome, John Bernay (after) 1794–1842, *Moonlight Landscape with Windmill*

Crowley, Graham b.1950, *Curt, November 1976*, purchased from G. Crowley with assistance from the V&A Purchase Grant Fund and the Felix Cobbold Bequest Fund

Cufaude, Francis active 1745–1749, *The Gosnall Twins*, gift from Gosnall

Cutler, David *Lock and Stagg Corner, Wolsey Street*, gift from D. J. Pitcher

Cutler, David *Lock and Stagg, Ipswich*, gift from D. J. Pitcher

Dahl, Michael I (circle of) 1656/1659–1743, *Mrs Charles Long (née Mary North)*, gift from A. H. V. Aldous

Daniell, Edward Thomas 1804–1842, *Mountain Landscape, Castle*

Ruins, Mrs R. Allen Bequest

Daniell, Frank 1868–1932, *George Ronald Lane (1894–1916)*, gift from R. Lane, Trustees

Davy, Frederick 1833–1890, *Landscape, Suffolk View*, gift from Davy Family

Davy, Frederick 1833–1890, *Manor House in Landscape*, gift from Davy Family

Davy, Frederick 1833–1890, *Ipswich from Willoughby Road*, gift from J. Batchelor

Davy, Frederick 1833–1890, *Man in Lane Approaching House*, gift from Davy Family

Davy, Frederick 1833–1890, *Landscape with Sheep and a Bridge*, gift from Davy Family

Davy, Frederick 1833–1890, *Rural Lane with Figure*, gift from Davy Family

Davy, Henry 1793–1865, *17th Century Barn*, gift from Davy Family

Davy, Henry (attributed to) 1793–1865, *St Stephen's Church, Ipswich*

Dedham, Jacob (attributed to) *Stoke Bridge, Ipswich*

Delamotte, William Alfred (circle of) 1775–1863, *Cattle and Windmill*, Mrs R. Allen Bequest

Denner, Balthasar (circle of) 1685–1749, *Possibly Marguerite Fonnereau as an Elderly Lady*, purchased from Fonnereau

Dodgson, John Arthur 1890–1969, *Crusader's Moon*, gift from Stephen Dodgson via the National Art Collections Fund, © the artist's estate

Droochsloot, Joost Cornelisz. 1586–1666, *A Dutch Canal Scene*, purchased with the assistance of the Felix Cobbold Bequest Fund

Dunthorne, John IV 1798–1832, *Self Portrait*, from H. Day via the National Art Collections Fund

Dunthorne, John IV (attributed to) 1798–1832, *Landscape, Cornfield*, gift from C. Cruttwell

Durose, Anthea b.1933, *Peonies*, purchased from A. Durose with the assistance of the Felix Cobbold Bequest Fund, © courtesy of the artist/www.bridgeman.co.uk

Dutch School *Portrait of a Lady*, gift from D. Montagu

Dutch School *Portrait of a Man*, gift from D. Montagu

Dutch School *Old Woman Eating*

Duval, John 1816–1892, *Frederick Worts (b.1806)*, purchased from G. Maynard

Duval, John 1816–1892, *Mrs Frederick Worts (née Elizabeth Blomfield)*, purchased from Mr G. Maynard

Duval, John 1816–1892, *Suffolk Show in Christchurch Park*, gift from Colonel F. Barlow

Duval, John 1816–1892, *A Common Lot with a Pony, Donkeys and Sheep*, gift from Mrs Smith

Duval, John 1816–1892, *Horses in Stoke Park*, purchased from W. E. Kersey

Duval, John 1816–1892, *Orwell and Woolverstone Estate*, from Colonel F. Barlow

Duval, John 1816–1892, *The Kentish Plough*, gift from E. Packard

Duval, John (attributed to) 1816–1892, *Ipswich Racecourse*

Duyster, Willem Cornelisz. c.1598–1635, *Interior Guardroom, Soldiers off Duty*, gift from Mussenden Leathes

Dyck, Anthony van (after) 1599–1641, *Charles I (1600–1649)*, purchased from Rushbrooke Sale

Dyck, Anthony van (after) 1599–1641, *Henrietta Maria*, purchased with the assistance of the Felix Cobbold Bequest Fund

Edwards, John active 1880–1909, *Ballast Quay, Ipswich Dock*, purchased with the assistance of the Felix Cobbold Bequest Fund

Ellison, R. *Oak Trees*, gift from F. Smith

Esmond, Jane *An Etcher Biting (Edwin Edwards)*, gift from M. Escombe

Eves, Reginald Grenville 1876–1941, *Lord Woodbridge, Arthur Churchman*

Fancourt *The Hon. Mrs E. Mills*, purchased from D. Upton

Fantin-Latour, Henri 1836–1904, *Winter Blossoms*, gift from W. Burrell

Farley, William 1895–1963, *Girl Reading*, purchased from the Simon Carter Gallery with the assistance of the Felix Cobbold Bequest Fund

Farley, William 1895–1963, *Railway near Paris*, purchased from the Simon Carter Gallery with the assistance of the Felix Cobbold Bequest Fund

Fiske, George 1847–1932, *Willy Lott's House, Flatford*, purchased at Arcade Auction Hall

Fletcher, William Teulon Blandford 1858–1936, *The Anthem*, gift from Blandford Fletcher

Folkard, Julia B. 1849–1933, *Mary Anne Keeley (1805–1899)*, purchased with the assistance of the Felix Cobbold Bequest Fund

Fonnereau *Brook and Trees, Study*, purchased with the assistance of the Felix Cobbold Bequest Fund

Fonnereau, Kate Georgina *William Charles Fonnereau (1804–1855)*, purchased from Fonnereau with the assistance of the V&A Purchase Grant Fund

Fonnereau, Kate Georgina *Pony and Donkey*

Forbes, Stanhope Alexander 1857–1947, *Forging the Anchor*, purchased with the assistance of the Felix Cobbold Bequest Fund, © courtesy of the artist's estate/ www.bridgeman.co.uk

Forestier, Amédée 1854–1930, *A Scene from Omar Khayyam*, gift from W. W. Cobbett

Foster, Judy b.1937, *Triangular Fruit*, purchased from J. Russell

Gallery

Fox, A. H. active 1840–1856, *Boy and Girl in Landscape*, purchased from G. Maynard

French School *Portrait of a Man in a Library*, gift from G. Maynard

Friswell, Harry P. Hain 1857–after 1906, *Moments of Colour Harmony*

Friswell, Harry P. Hain 1857–after 1906, *Cornfield in Constable's Country*, gift from T. Parkington

Frost, George 1754–1821, *Bramford and Ipswich Postwoman*, purchased from Tibbenham

Frost, George 1754–1821, *Self Portrait*, purchased from W. H. Booth

Frost, George 1754–1821, *The Common Quay, Ipswich*, gift from T. Parkington

Frost, George 1754–1821, *Ladies in the Mall*, purchased from D. E. Brown

Frost, George (attributed to) 1754–1821, *Mrs Elizabeth Cobbold (1765–1824)*, gift from R. H. Cobbold

Frost, George (attributed to) 1754–1821, *John Cobbold (1746–1835)*, gift from R. H. Cobbold

Frost, George (attributed to) 1754–1821, *Westgate, St Matthew's, Ipswich*, gift from J. S. Corder

Gainsborough, Thomas 1727–1788, *Holywells Park, Ipswich*, purchased from Agnews with assistance from the National Art Collections Fund, the V&A Purchase Grant Fund, the Pilgrim Trust, the National Heritage Memorial Fund and the Friends of Ipswich Museum

Gainsborough, Thomas 1727–1788, *Reverend Robert Hingeston (1699–1776)*, purchased with the assistance of the Friends of Ipswich Museum, the National Art Collections Fund, the Heritage Lottery Fund and the Felix Cobbold Bequest Fund

Gainsborough, Thomas 1727–1788, *Pool in the Woods*, purchased with the assistance of the Felix Cobbold Bequest Fund

Gainsborough, Thomas 1727–1788, *View near the Coast*, purchased with the assistance of the Felix Cobbold Bequest Fund and the National Art Collections Fund

Gainsborough, Thomas 1727–1788, *Samuel Kilderbee (1725–1813)*, purchased with the assistance of the Felix Cobbold Bequest Fund and the National Art Collections Fund

Gainsborough, Thomas 1727–1788, *Tom Pear Tree*, gift from W. H. Booth

Gainsborough, Thomas 1727–1788, *John Sparrowe, Bailiff of Ipswich*, purchased from G. Sabin with the assistance of the V&A Purchase Grant Fund and the Felix Cobbold Bequest Fund

Gainsborough, Thomas 1727–1788, *Miss Edgar*, purchased with the assistance of the Felix Cobbold

Bequest Fund

Gainsborough, Thomas 1727–1788, *Mrs Kilderbee, née Mary Wayth (1723–1811)*, purchased from Oliver and Sons with the assistance of the National Art Collections Fund

Gainsborough, Thomas 1727–1788, *Reverend Canning (1708–1775)*, purchased with the assistance of the National Art Collections Fund

Gainsborough, Thomas 1727–1788, *William Wollaston (1730–1797)*, purchased from Gooden and Fox with the assistance of the Felix Cobbold Bequest Fund

Gainsborough, Thomas 1727–1788, *Mrs Bedingfield and Her Daughter*, purchased from Mrs R. Goode with the assistance of the National Art Collections Fund and the V&A Purchase Grant Fund

Gainsborough, Thomas 1727–1788, *Duchess of Montagu (1711–1775)*, purchased from Marsh with the assistance of the National Art Collections Fund

Gainsborough, Thomas 1727–1788, *Cottage Door with Girl and Pigs*, purchased from Scudamore with the assistance of the National Art Collections Fund, the V&A Purchase Grant Fund and the National Heritage Memorial Fund

Gainsborough, Thomas 1727–1788, *Country Cart Crossing a Ford*, purchased from Scudamore with the assistance of the National Art Collections Fund, the V&A Purchase Grant Fund and the National Heritage Memorial Fund

Gainsborough, Thomas (after) 1727–1788, *A Country Cart*, purchased from Leicester Gallery with the assistance of the Felix Cobbold Bequest Fund

Gainsborough, Thomas (after) 1727–1788, *Rustic Courtship*

Gainsborough, Thomas (attributed to) 1727–1788, *George Dashwood of Peyton Hall*, gift from J. Agnew

Gardner, Daniel c.1750–1805, *Golding Constable, the Artist's Father*, purchased with the assistance of the Felix Cobbold Bequest Fund

Gardner, Daniel c.1750–1805, *Lord Henniker (1724–1803) (after Joshua Reynolds)*, purchased from Henniker Sale with the assistance of the Felix Cobbold Bequest Fund

Geeraerts, Marcus the younger (attributed to) 1561–1635, *Robert Devereux (1566–1601), 2nd Earl of Essex*, purchased

George, Patrick b.1923, *Francis Hoyland (b.1930)*, purchased from Chappel Galleries, © the artist

German (Bavarian) School *Horseman and Hounds*, purchased from Whitbread

German (Bavarian) School *Legend of St Hubert*, purchased from Whitbread

German School 18th C, *Colonel Moses Leathes, Governor of Ghent*,

gift from Mussenden Leathes

Gilbert, John 1817–1897, *Cardinal Wolsey at Leicester Abbey*, purchased from R. W. Gleadow

Gilman, Harold 1876–1919, *Seated Girl in Blue*, purchased with the assistance of the Felix Cobbold Bequest Fund, the V&A Purchase Grant Fund and the National Art Collections Fund

Ginner, Charles 1878–1952, *The Old Paper Mill*, purchased from Spink with the assistance of the V&A Purchase Grant Fund and the National Art Collections Fund

Goddard, J. Bedloe b.c.1850, *Landscape with Thatched Cottage*, purchased from Miss Gladys Chinery

Goddard, J. Bedloe b.c.1850, *View of a Lane with a House through Trees*, purchased from Miss Gladys Chinery

Godfrey *Lady of the Fonnereau Family*, purchased from Fonnereau

Gore, Spencer 1878–1914, *Interior, Mornington Crescent*, purchased from the Fine Art Society with the assistance of the V&A Purchase Grant Fund

Govier, James 1910–1974, *Putting on the Slipper*, purchased from S. Govier with the assistance of the Felix Cobbold Bequest Fund

Goyen, Jan van (attributed to) 1596–1656, *River Scene*, purchased from Kingsley with the assistance of the National Art Collections Fund

Grant, Francis 1803–1878, *William Long (1802–1875)*, gift from A. H. V. Aldous

Gray, Kate active 1870–1897, *Girl in Landscape with Flowers*, purchased

Grayson, Stanley b.1898, *Sunflower*, gift from D. Chanter

Grayson, Stanley b.1898, *Interior with Girl Reading*, gift from D. Chanter

Grayson, Stanley b.1898, *Seated Girl*, gift from D. Chanter

Greaves, Derrick b.1927, *Listening to Music*, gift from East England Arts, © the artist

Green, Anthony b.1939, *Trimming, October*, purchased from the Piccadilly Gallery with assistance from the V&A Purchase Grant Fund

Griffiths, W. T. active 1878–1880, *White Horse Corner*, gift from J. S. Fisher

Gritten, A. *Yacht Race and Britannia*

Grone, Ferdinand E. c.1845–1920, *Evening at Lexden*, gift from Mr R. Allen

Gysbrechts, Franciscus active c.1674, *Still Life*, purchased from Batchelors

Hall, Harry 1814–1882, *Fille de l'air*, bequeathed by A. Jennings

Hall, Harry 1814–1882, *Ventre Saint Gris*, bequeathed by A. Jennings

Hambling, Harry 1902–1998, *Ray Watts*, gift from Maggi Hambling

Hambling, Maggi b.1945, *Teddy Wolfe and Blackie*, Contemporary Art Society, from Hambling © the artist

Hambling, Maggi b.1945, *Champagne Laugh*, purchased from M. Hambling with the assistance of the V&A Purchase Grant Fund, the Felix Cobbold Bequest Fund and Eastern Arts, © the artist

Hannah, Robert 1812–1909, *Admiral Benjamin William Page*, gift from B. W. Page

Hansen, E. B. *Alarm of Ipswich*, purchased from Silburn

Hare, Jabez active 1820–1837, *St Catherine's Quay, Ipswich*, purchased from Tibbenham

Hare, Jabez active 1820–1837, *Alderman G. Sampson*

Harlow, George Henry 1787–1819, *Duchess of Kent (1786–1861)*, gift from Cory Trustees

Harris, Tomás 1908–1964, *Landscape, Palm Trees and Cacti*, gift from E. Frankfort © the artist's estate

Harwood, Lucy 1893–1972, *Furrowed Fields*, purchased from Thompson's Antiques

Harwood, Lucy 1893–1972, *Landscape with Gulls*, purchased from Thompson's Antiques

Harwood, Lucy 1893–1972, *Still Life with Fish*, purchased from Sally Hunter Gallery with the assistance of the V&A Purchase Grant Fund

Harwood, Lucy 1893–1972, *Glyn Morgan*, purchased from Sally Hunter Gallery

Hazlitt, John 1767–1837, *Thomas Clarkson (1760–1814)*, purchased from Biddell with the assistance of the Felix Cobbold Bequest Fund

Heemskerck, Egbert van the elder 1634/1635–1704, *Cavalier Seated in a Tavern*, gift from Mussenden Leathes

Heins, John Theodore Jr 1732–1771, *Phoebe Fonnereau, as a Shepherdess*, purchased from Fonnereau with the assistance of the V&A Purchase Grant Fund

Helmont, Zeger Jacob van (circle of) 1683–1726, *Duke of Marlborough*, gift from Mussenden Leathes

Herkomer, Herman 1863–1935, *Mrs Phoebe Lankester*, gift from J. W. Pain

Herman, Josef 1911–2000, *Men at Table*, gift from the Contemporary Art Society, © the artist's estate

Herring, John Frederick I 1795–1865, *Grey Horse in Stable*, bequeathed by A. Jennings

Herring, John Frederick I 1795–1865, *Drawing the Covert*, bequeathed by A. Jennings

Herring, John Frederick I 1795–1865, *Full Cry*, bequeathed by A. Jennings

Herring, John Frederick I 1795–1865, *Gone away*, bequeathed by A. Jennings

Herring, John Frederick I 1795–1865, *Hounds Leaving Covert*, bequeathed by A. Jennings

assistance of the Felix Cobbold Bequest Fund

Leggett, W. J. active 1842–1906, *Upper Orwell Street, Shops*, purchased from Oxborrows with the assistance of the Felix Cobbold Bequest Fund

Leggett, W. J. active 1842–1906, *Westgate Street*, gift from E. Day

Legros, Alphonse 1837–1911, *Thomas Woolner*, purchased from A. Woolner with the assistance of the Felix Cobbold Bequest Fund

Lely, Peter (after) 1618–1680, *Charles II (1630–1685)*, purchased with the assistance of the Felix Cobbold Bequest Fund

Lely, Peter (attributed to) 1618–1680, *Charles Vesey (d.1681–1685) of Hintlesham Hall*, purchased from W. H. Booth

Lessore, John b.1939, *St James' Church, Peckham*, gift from East England Arts, © the artist

Linnell, John 1792–1882, *Katherine Georgina Fonnereau*, purchased from Fonnereau with the assistance of V&A Purchase Grant Fund

Lithiby, Beatrice Ethel 1889–1966, *Helen D. Kiddall*, purchased from Bannister and Co.

Lucas, Seymour 1849–1923, *Yesterday (The Letter)*, purchased from A. Cubitt with the assistance of the Felix Cobbold Bequest Fund

Lucas, Sydney Seymour 1888–1954, *Courtenay Barry*, from R. Muspratt

Lucas, Sydney Seymour 1888–1954, *Mrs Ernest Crofts*, purchased from the Royal Academy with the assistance of the Felix Cobbold Bequest Fund

Lucas, Sydney Seymour 1888–1954, *Suffolk Punches, Mares and Foals*, purchased with the assistance of the Felix Cobbold Bequest Fund

Mann, John *Pride of Mistley, off Harwich*, gift from G. Maynard

Mascall, Christopher Mark 1846–1933, *Belstead Road, Ipswich*, purchased from C. Daniels

Mascall, Christopher Mark 1846–1933, *Pond Hall and River Orwell*, purchased from C. Daniels

Mascall, Christopher Mark 1846–1933, *Felix Thornley Cobbold*, purchased from Southgate

Mascall, Christopher Mark 1846–1933, *Stoke Bridge*, gift from H. E. Holland

Mascall, Christopher Mark 1846–1933, *Mr Fish*

Mead, Rose 1867–1946, *Cottage Interior*, purchased with the assistance of the Felix Cobbold Bequest Fund

Mellis, Margaret b.1914, *Scarlet Green Square*, gift from East England Arts © Margaret Mellis

Mendham, Robert 1792–1875, *Self Portrait*, gift from W. Mendham

Mendham, Robert 1792–1875, *The Miser of Eye*, gift from E. F. Whant

Mendham, Robert 1792–1875, *Bernard Barton*, bequeathed by C.

Partridge

Mendham, Robert 1792–1875, *Portrait of a Man (after Correggio)*, gift from G. Maynard

Mendham, Robert 1792–1875, *Reverend Richard Cobbold*, purchased from F. Fish with the assistance of the Felix Cobbold Bequest Fund

Mendham, Robert 1792–1875, *Ice House, Back of Broome Hall*, purchased from Southgate

Mendham, Robert 1792–1875, *Susanna Hewitt, née Garnham (1807–1891)*, bequeathed by C. Partridge

Mendham, Robert 1792–1875, *William Robert Hewitt (1806–1887)*, bequeathed by C. Partridge

Mendham, Robert 1792–1875, *Christ with Thorns*, gift from G. Maynard

Mendham, Robert 1792–1875, *Portrait of a Man*, gift from G. Maynard

Mendham, Robert 1792–1875, *Still Life*, gift from G. Maynard

Mendham, Robert 1792–1875, *Virgin Mary*, gift from G. Maynard

Mendham, Robert (attributed to) 1792–1875, *Joseph Welham (1785–1842)*, purchased from C. Partridge

Mengs, Anton Raphael 1728–1779, *Self Portrait*, gift from J. Loder

Meredith, Francis V. *St Francis Blessing Assisi*, gift from Mrs Mary Pedler

Metz, Conrad Martin 1749–1827, *Mrs Elizabeth Mary Ivory (née Fonnereau) and Her Son, John Thornay*, purchased from M. B. Maynard

Michau, Theobald 1676–1765, *Rocky Landscape with Peasants*, gift from Mussenden Leathes

Momper, Joos de 1564–1635 & **Brueghel, Jan the elder** 1568–1625 *River with Castle, Horsemen and Woodcutters*, gift from Mussenden Leathes

Monnoyer, Jean-Baptiste 1636–1699, *Summer Flowers in Bronze Urn*, gift from Mussenden Leathes

Moore, John of Ipswich 1820–1902, *Seapiece*, gift from E. Packard

Moore, John of Ipswich 1820–1902, *Shipping at Harbour Mouth*, bequeathed by R. Allen

Moore, John of Ipswich 1820–1902, *Cottage in a Wood*, bequeathed by R. Allen

Moore, John of Ipswich 1820–1902, *Distant View of an Estuary*, bequeathed by R. Allen

Moore, John of Ipswich 1820–1902, *Landscape with Cattle*, bequeathed by R. Allen

Moore, John of Ipswich 1820–1902, *Landscape with Girl at Pool*, bequeathed by R. Allen

Moore, John of Ipswich 1820–1902, *Lane and Cottage, Wherstead Road*, bequeathed by R. Allen

Moore, John of Ipswich 1820–1902, *Moonlit Landscape*,

bequeathed by R. Allen

Moore, John of Ipswich 1820–1902, *Moonlit River Landscape*, bequeathed by R. Allen

Moore, John of Ipswich 1820–1902, *Moonlit Scene and Footbridge*, bequeathed by R. Allen

Moore, John of Ipswich 1820–1902, *Off Yarmouth, Seascape*

Moore, John of Ipswich 1820–1902, *Seascape*, bequeathed by L. E. Hunt

Moore, John of Ipswich 1820–1902, *Seascape*, bequeathed by P. E. Clarke

Moore, John of Ipswich 1820–1902, *Seascape, Fishing*, gift from E. C. Singleton

Moore, John of Ipswich 1820–1902, *Shipping in a Breeze*, gift from A. H. Cade

Moore, John of Ipswich 1820–1902, *Shipping in a Breeze on a Rolling Sea*, bequeathed by R. Allen

Moore, John of Ipswich 1820–1902, *Shipping, Low Tide*, bequeathed by R. Allen

Moore, John of Ipswich 1820–1902, *Ships in Ipswich Dock*, purchased from E. Kemp

Moore, John of Ipswich 1820–1902, *Palette with Scenes, Sketches*

Moore, John of Ipswich 1820–1902, *Holy Island, Northumberland*, bequest from E. Packard

Moore, John of Ipswich 1820–1902, *Northumberland Coast*, gift from J. Josselyn

Moore, John of Ipswich 1820–1902, *Old Park Road, Ipswich*, gift from A. Churchman

Moore, John of Ipswich 1820–1902, *Ipswich Docks with Distant Conflagration*, purchased from Arnott and Calver

Moore, John of Ipswich 1820–1902, *New Cut, West Entrance to Old Dock, Ipswich*

Moore, John of Ipswich 1820–1902, *River Front, Ipswich Docks*

Moore, John of Ipswich 1820–1902, *The Promenade and River Steamers, Ipswich*, gift from J. Josselyn

Moore, John of Ipswich 1820–1902, *River Orwell from the Strand*, purchased from King with the assistance of the Felix Cobbold Bequest Fund

Moore, John of Ipswich 1820–1902, *Slaughden Quay*, purchased from A. Gerald-Smith with the assistance of the Felix Cobbold Bequest Fund

Moore, John of Ipswich 1820–1902, *Tower Ramparts, Ipswich*, purchased from Silburn

Moore, John of Ipswich 1820–1902, *Bawdsey Ferry near Felixstowe*, purchased from Bucham's Collection

Moore, John of Ipswich 1820–1902, *Boat on Beach, Sunset*, bequeathed by R. Allen

Moore, John of Ipswich 1820–1902, *Evening Landscape*, bequeathed by R. Allen

Moore, John of Ipswich 1820–1902, *Lane and Cottage*, bequeathed by R. Allen

Moore, John of Ipswich 1820–1902, *Shipping*, purchased from Kersey

Moore, John of Ipswich 1820–1902, *Village Scene with Two Figures*, gift from Mrs Smith

Moorhouse, F. N. *Heifer and Young Bull*, bequeathed by R. Allen

Mor, Antonis (after) 1512–1516–c.1576, *Philip of Spain*, purchased from Leggatt with the assistance of the Felix Cobbold Bequest Fund

Mor, Antonis (after) 1512–1516–c.1576, *Queen Mary I (1516–1558)*, purchased from Leggatt with the assistance of the Felix Cobbold Bequest Fund

Mor, Antonis (attributed to) 1512–1516–c.1576, *Lady of the Boleyn Family (possibly Mary Boleyn)*, purchased from M. Maynard

Morgan, Glyn b.1926, *Cedric Morris in His Garden*, purchased from Chappel Galleries with the assistance of the V&A Purchase Grant Fund, © courtesy of the artist/www.bridgeman.co.uk

Morland, George (attributed to) 1763–1804, *Landscape with Gypsy Figures at a Fire in a Wood*, purchased from E. Paul with the assistance of the Felix Cobbold Bequest Fund

Moroni, Giovanni Battista (attributed to) c.1525–1578, *Sir Walter Raleigh*, purchased from N. H. P. Turner with the assistance of the Felix Cobbold Bequest Fund

Morris, Cedric Lockwood 1889–1982, *The River Stour in Flood*, purchased from the Sally Hunter Gallery with the assistance of the V&A Purchase Grant Fund, © trustees of the Cedric Morris Estate/Foundation

Morris, Mali b.1945, *Athabasca Trail*, transferred from East England Arts, © the artist

Moss, Colin b.1914, *Self Portrait*, gift from C. Moss, © the artist

Moss, Colin b.1914, *Gaumont Cinema Audience*, gift from C. Moss, © the artist

Moss, Colin b.1914, *Gladioli*, gift from C. Moss, © the artist

Moss, Colin b.1914, *Man with a Drill*, purchased from C. Moss with the assistance of the Felix Cobbold Bequest Fund, © the artist

Moss, Colin b.1914, *Dustbin*, gift from C. Moss, © the artist

Moss, Colin b.1914, *Rolling Nude*, gift from C. Moss, © the artist

Moss, Colin b.1914, *Landscape*, gift from C. Moss, © the artist

Moss, Colin b.1914, *Playing Soldiers*, gift from C. Moss, © the artist

Moss, Colin b.1914, *The Japanese Model*, gift from C. Moss, © the artist

Moss, Sidney Dennant 1884–1946, *Constable's County*, gift from D. Moss

Müller, P. *Costa de Caparica, Portugal*

Müller, William James 1812–1845, *Landscape with Figures*, purchased from W. H. Booth

Munnings, Alfred James 1878–1959, *Landscape at Crostwick*, purchased from Tibbenham with the assistance of the Felix Cobbold Bequest Fund

Munnings, Alfred James 1878–1959, *Travellers*, purchased with the assistance of the Felix Cobbold Bequest Fund

Munnings, Alfred James 1878–1959, *King George V Riding His Favourite Pony 'Jock' in Sandringham Great Park*, gift from Tollemache

Murfin, Michael b.1954, *An Afternoon*, transferred from East England Arts, © the artist

Murfin, Michael b.1954, *The Farrier*, gift from Contemporary Art Society, © the artist

Musscher, Michiel van 1645–1705, *Burgomaster and His Wife*, gift from Mussenden Leathes

Myn, Frans van der (attributed to) c.1719–1783, *Charles Long III (1748–1813)*, gift from A. H. V. Aldous

Myn, Frans van der (attributed to) c.1719–1783, *Dudley Long North (1749–1829)*, gift from A. H. V. Aldous

Myn, Frans van der (attributed to) c.1719–1783, *Dudley North (1706–1764)*, gift from A. H. V. Aldous

Myn, Frans van der (attributed to) c.1719–1783, *Lady Barbara Herbert, Mrs D. North*, gift from A. H. V. Aldous

Myn, Herman van der 1684–1741, *William Leathes, Ambassador Brussels*, gift from Mussenden Leathes

Myn, Herman van der 1684–1741, *Danae*, gift from Mussenden Leathes

Myn, Herman van der 1684–1741, *Death of Sophonisba*, gift from Mussenden Leathes

Myn, Herman van der 1684–1741, *Tamar and Ammon*, gift from Mussenden Leathes

Myn, Herman van der 1684–1741, *Venus and Cupid*, gift from Mussenden Leathes

Myn, Herman van der 1684–1741, *Venus and Cupid*, gift from Mussenden Leathes

Myn, Herman van der (circle of) 1684–1741, *Carteret Mussenden Leathes*, gift from Mussenden Leathes

Mytens, Daniel I c.1590–before 1648, *John Cotton*, gift from A. Cotton Borrett

Mytens, Daniel I (attributed to) c.1590–before 1648, *Sir Henry Peyton (d.1622–1623)*, purchased from Wyndham Law

Nasmyth, Alexander 1758–1840, *Mrs Merry or Mrs Leathes*, gift from Mussenden Leathes

Netscher, Caspar (school of)

Smythe, Edward Robert 1810–1899, *Two Women, Child and Pony*, purchased from J. H. Sizer

Smythe, Edward Robert (attributed to) 1810–1899, *The Old Gardener's Arms*, bequeathed by R. Allen

Smythe, Thomas 1825–1907, *Angel Corner, Ipswich*, purchased from P. W. Cobbold

Smythe, Thomas 1825–1907, *Fountain in Old Provision Market*

Smythe, Thomas 1825–1907, *Interior with Four Dogs*, transferred from Ipswich Town Hall

Smythe, Thomas 1825–1907, *Children Snowballing*, bequeathed by R. Allen

Smythe, Thomas 1825–1907, *Study of Horses with Dog*, from M. Collins

Smythe, Thomas 1825–1907, *Carrying Home the Firewood*, bequeathed by R. Allen

Smythe, Thomas 1825–1907, *Study of Horses*, purchased from M. Collins

Smythe, Thomas 1825–1907, *The Weir, Handford Hall*, purchased with the assistance of the Felix Cobbold Bequest Fund

Someren, Edmund Lawrence van Major 1875–1963, *Aline Mary Williamson (1906–1987)*, bequeathed by Judith Elizabeth Cooper

Somerville, Peggy 1918–1975, *Country Lane, Walcheren Island, Holland*, gift from Rosemary Somerville, © reproduced by kind permission of Rosemary Somerville c/o Messum Gallery

Sorgh, Hendrik Martensz. 1609/1611–1670, *Doorway, Couple Embracing*, gift from Mussenden Leathes

Sothern, Arthur *Walberswick, Suffolk*, gift from Suffolk Records Office

Spencer, F. *Sir Robert Harland (1765–1848)*, gift from B. H. Burton

Spring-Smith, Effie 1907–1974, *Self Portrait*, purchased with the assistance of the Felix Cobbold Bequest Fund

Squirrell, Leonard 1893–1979, *Chalk Pit, Noon*, gift from T. Parkington, © the artist's estate

Squirrell, Leonard 1893–1979, *In the Big Quarry*, gift from Ipswich Art Society, © the artist's estate

Stannard, Alfred George (attributed to) 1828–1885, *Pilot Boat Going off*, bequeathed by R. Allen

Stannard, Alfred George (attributed to) 1828–1885, *Seascape or Coastal Scene*, purchased from MacEwan

Stark, James 1794–1859, *Sheep Washing, Morning*, purchased from E. E. Cook with the assistance of the National Art Collections Fund

Steer, Philip Wilson 1860–1942, *Knucklebones, Walberswick*, gift from H. West © Tate, London 2005

Steer, Philip Wilson 1860–1942, *Girl on a Sofa*, from P. Schreiber via the Museum and Galleries Commission © Tate, London 2005

Steer, Philip Wilson 1860–1942, *Mother and Daughter, Boulogne*, bequeathed by D. Hamilton through the National Art Collections Fund © Tate, London 2005

Steer, Philip Wilson 1860–1942, *Girl with a St Bernard Dog*, bequeathed by D. Hamilton through the National Art Collections Fund © Tate, London 2005

Steer, Philip Wilson 1860–1942, *Woman Reading on a Couch*, bequeathed by D. Hamilton through the National Art Collections Fund © Tate, London 2005

Steer, Philip Wilson 1860–1942, *The Black Bow*, gift from H. West © Tate, London 2005

Steer, Philip Wilson 1860–1942, *River Bend near Ludlow*, gift from H. West © Tate, London 2005

Steer, Philip Wilson 1860–1942, *The Blue Dress (Miss Montgomery)*, gift from H. West © Tate, London 2005

Stokoe, Charles John active 1907–1914, *Evening*, gift from T. Parkington

Strij, Jacob van (attributed to) 1756–1815, *Cows by River*, gift from B. Ellis

Symonds, William Robert 1851–1934, *Edward Christian, Principal of Ipswich Working Men's Club*, from D. Gibbings

Symonds, William Robert 1851–1934, *James Alan Ransome, Vice President of Ipswich Working Men's Club*, from D. Gibbings

Symonds, William Robert 1851–1934, *Robert Ransome*, gift from E. C. Ransome

Symonds, William Robert 1851–1934, *Mrs Mary Ransome*, gift from E. C. Ransome

Symonds, William Robert 1851–1934, *Study of a Man*, gift from J. Chalmers

Symonds, William Robert 1851–1934, *Study of a Man*, gift from J. Chalmers

Symonds, William Robert 1851–1934, *Portrait of an Unidentified Ipswich Mayor*, transferred from Town Hall

Symonds, William Robert 1851–1934, *Archdeacon R. H. Groome (1810–1889)*, gift from R. W. Symonds

Symonds, William Robert 1851–1934, *Edward Packard, Mayor of Ipswich*, transferred from Town Hall

Symonds, William Robert 1851–1934, *Girl and Silver Fish*, purchased with the assistance of the Felix Cobbold Bequest Fund

Symonds, William Robert 1851–1934, *Old Man with Churchwarden's Pipe*

Symonds, William Robert (attributed to) 1851–1934, *Dr E.*

Beck, MD of Ipswich, gift from E. Amey

Thompson, David b.1939, *The Cliff Collapse, Dunwich*, gift from Ipswich Art Society

Thornley, Georges William 1857–1935 **& Hurneen, F. W.** *Lifting Mists*, bequeathed by R. Allen

Thornton, Valerie 1931–1991, *Mystra, the Peribleptos*, gift from Michael Chase, © the artist's estate

Todd, Henry George 1847–1898, *Landscape with Cattle*, bequeathed by R. Allen

Todd, Henry George 1847–1898, *Gainsborough Lane*, bequeathed by R. Allen

Todd, Henry George 1847–1898, *Gainsborough Lane*, bequeathed by R. Allen

Todd, Henry George 1847–1898, *Still Life with Delft Vase*, purchased with the assistance of the Felix Cobbold Bequest Fund

Todd, Henry George 1847–1898, *Still Life*, bequeathed by R. Allen

Tollemache, Duff 1859–1936, *After the Catch*, purchased from W. Eade with the assistance of the Felix Cobbold Bequest Fund

Townshend, Arthur Louis active 1880–1912, *Butterfly*, bequeathed by A. F. Jennings

Townshend, Arthur Louis active 1880–1912, *Catmint*, bequeathed by A. F. Jennings

Townshend, Arthur Louis active 1880–1912, *Hauteur*, bequeathed by A. F. Jennings

Townshend, Arthur Louis active 1880–1912, *Ladislas*, bequeathed by A. F. Jennings

Townshend, Arthur Louis active 1880–1912, *Mamia*, bequeathed by A. F. Jennings

Townshend, Arthur Louis active 1880–1912, *Tristan*, bequeathed by A. F. Jennings

Townshend, Arthur Louis active 1880–1912, *Winfreda*, bequeathed by A. F. Jennings

Turner, George II (circle of) 1843–1910, *Landscape, Peasants and Cattle*, bequeathed by R. Allen

unknown artist *The Entombment of Christ*, purchased from J. R. Fleming with the assistance of the Felix Cobbold Bequest Fund

unknown artist *Robert Gosnold of Otley (1532–1615)*, purchased from N. H. P. Turner with the assistance of the Felix Cobbold Bequest Fund

unknown artist *Lady of the Fonnereau Family*, purchased with the assistance of the Felix Cobbold Bequest Fund

unknown artist *Mrs Anne Taylor*, gift from Marriott

unknown artist *Charles Fonnereau*, purchased with the assistance of the Felix Cobbold Bequest Fund

unknown artist *The Old Cansor, Stoke Street, Ipswich*, purchased from J. M. Leese

unknown artist *A Wood in Autumn*, gift from J. B. Richardson

unknown artist *Battle*

unknown artist *Boat at Sea*

unknown artist *C. Long, MP for Dunwich*

unknown artist *Cattle and Cottage*

unknown artist *Cottage and Trees*

unknown artist *Cottage, Arboretum, Christchurch Park*, gift from J. Mann

unknown artist *Cow in a Landscape*

unknown artist *Edward Grimwade, Mayor of Ipswich*, transferred from Town Hall

unknown artist *Elderly Man in Blue Coat Wearing a Wig*, gift from G. Maynard

unknown artist *Horses in a Landscape*

unknown artist *House Surrounded by Shrubs*

unknown artist *Ipswich Mayor*, transferred from Town Hall

unknown artist *Ipswich Mayor*, transferred from Town Hall

unknown artist *Italian Scene, Castle and Figures*, bequeathed by R. Allen

unknown artist *J. Hervey, Mayor of Ipswich*

unknown artist *Landscape*

unknown artist *Landscape with Cattle*

unknown artist *Landscape with Church and Sheep*

unknown artist *Landscape with Figures and Cattle*

unknown artist *Lanterns*

unknown artist *Oulton High House*, gift from Townsend

unknown artist *Oulton High House, Interior*, gift from Townsend

unknown artist *Peter Bartholomew Long*, transferred from Town Hall

unknown artist *Portrait of a Gentleman*

unknown artist *Portrait of a Gentleman*

unknown artist *Portrait of a Gentleman*

unknown artist *Portrait of a Gentleman*

unknown artist *Portrait of a Lady*

unknown artist *Possibly Edward VI (1537–1553)*, from Mussenden Leathes

unknown artist *Prince George of Denmark*, gift from G. Maynard

unknown artist *Queen Anne*, gift from G. Maynard

unknown artist *Seated Gentleman*

unknown artist *Seated Lady*

unknown artist *Seated Lady*

unknown artist *Shepherds and Sheep by Stream*

unknown artist *St Clement's Church, Ipswich*

unknown artist *St Stephen's Church, Ipswich*, gift from E. Amey

unknown artist *St Stephen's Lane, Ipswich*

unknown artist *Suffolk Punch Colt*, purchased from Mrs Pratt

unknown artist *Sutton Hoo, Suffolk*

unknown artist *Temple Ruins*

unknown artist *The Compass at Sea*

unknown artist *Town Scene and*

Bridge

unknown artist *Unknown Nobleman*, Mussenden Leathes

unknown artist *Unknown Nobleman*, Mussenden Leathes

unknown artist *Water Mill*

unknown artist *Waterfall and Wooded Bank*

unknown artist *Wooden Bridge and Cattle*

Verbruggen, Gaspar Peeter de the elder 1635–1681, *Flower Piece*, purchased from Chadacre Hall Sale

Verbruggen, John c.1694–1739, *George I (1660–1727)*, from Armourers/Braziers

Verbruggen, John c.1694–1739, *Jane Modyford (née Beeston, later Long)*, gift from A. H. V. Aldous

Verbruggen, John (circle of) c.1694–1739, *North Family Group, Little Glenham Hall*, gift from A. H. V. Aldous

Verdussen, Jan Peeter c.1700–1763, *The Assault on the Town of Oudenarde*, gift from Mussenden Leathes

Vincent, George 1796–1831, *The Travelling Tinker*, gift from F. J. Nettlefold

Visser, Cor 1903–1982, *Waterside Works, Ransomes and Rapier, 1875*, gift from Ransomes and Rapier

Vlieger, B. de active 18th C, *Shipwreck Scene*, purchased from H. Finborough with the assistance of the Felix Cobbold Bequest Fund

Waller, Arthur Henry Naunton 1906–1995, *Summer, Suffolk Coast*, gift from Ipswich Art Society

Walton, Allan 1891–1948, *By the Green Blind*, purchased from Sally Hunter Gallery with the assistance of the V&A Purchase Grant Fund

Walton, Henry 1746–1813, *Mrs Rogers (1736–1808)*, purchased with the assistance of the National Art Collections Fund and the Felix Cobbold Bequest Fund

Warburton, Joan 1920–1996, *Burned School*, gift from L. O. O'Malley via the National Art Collections Fund, © courtesy of the artist's estate/ www.bridgeman.co.uk

Warburton, Joan 1920–1996, *Benton End*, gift from L. O. O'Malley via the National Art Collections Fund, © courtesy of the artist's estate/ www.bridgeman.co.uk

Warnes, Robin b.1952, *Umbrellas*, purchased from R. Warnes, © the artist

Warnes, Robin b.1952, *Orwell Bridge, Study*, purchased with the assistance of the Felix Cobbold Bequest Fund, © the artist

Warsop, Mary b.1929, *Coastal Suffolk*, purchased from M. Warsop

Warsop, Mary b.1929, *Nine Suffolk Scenes*, gift from Ipswich Art Society

Watt, Millar 1895–1975, *Higham from Langham*, purchased from Ipswich Art Society

Watt, Millar 1895–1975, *Rookery Farm, Dedham*, purchased with

the assistance of the Felix Cobbold Bequest Fund

Watts, Frederick W. 1800–1862, *View of Dedham*, purchased from F. W. Cobbold

Weight, Carel Victor Morlais 1908–1997, *The Maltings, Snape*, gift from J. G. Wood, © the estate of the artist

Wells, Josiah Robert active 1872–1896, *Ashore for a Tide*

West, William (attributed to) 1801–1861, *Moonlight Scene*

Williamson, Frederick 1835–1900, *A View in North Wales*

Wilson, John H. 1774–1855, *In the Firth of Forth*, bequeathed by R. Allen

Winn, Connie 1899–1985, *Girl in a Yellow Hat*, gift from J. Winn

Winterhalter, Franz Xaver 1805–1875, *Queen Victoria (1819–1901)*, transferred from Ipswich Town Hall

Wirth-Miller, Denis b.1915, *Road in a Landscape*, gift from L. O. O'Malley via the National Art Collections Fund

Wissing, Willem (attributed to) c.1656–1687, *James Scott, 1st Duke of Monmouth and Buccleuch (1649–1685)*, purchased with the assistance of the Felix Cobbold Bequest Fund

Wissing, Willem (circle of) c.1656–1687, *Charles II (1630–1685)*

Wissing, Willem (circle of) c.1656–1687, *William III (1650–1702)*

Witte, Emanuel de c.1617–1692, *The Interior of the Oude Kerk, Amsterdam (after 1658)*, purchased from Chadacre Hall Sale

Wonnacott, John b.1940, *Shingle Laboratory No.3 with Lighthouse, Orford Ness*, purchased from Agnews with the assistance of the National Art Collections Fund and the Felix Cobbold Bequest Fund, © the artist

Wood, Christopher 1901–1930, *Girl Darning*, purchased with the assistance of the Felix Cobbold Bequest Fund

Wood, John Barlow 1862–1949, *Evening, Martlesham Creek*, bequeathed by E. McInnes

Wood, John Barlow 1862–1949, *Frost, Fir and Shine*, bequeathed by E. McInnes

Wood, John Barlow 1862–1949, *Sunshine and Shadow*, purchased with the assistance of the Felix Cobbold Bequest Fund

Wood, William Thomas 1877–1958, *June Flowers*, purchased from the Reynolds Gallery with the assistance of the V&A Purchase Grant Fund

Wyck, Jan c.1640–1700, *Hawking Party*, purchased with the assistance of the Felix Cobbold Bequest Fund

Wykes, H. J. *The Gipping, Sproughton*, purchased with the assistance of the Felix Cobbold Bequest Fund

Ipswich County Library

Cobb, Charles David b.1921, *The Barge Race*, gift from Mr E. R. Hanson

Cole, Tennyson Philip 1862–1939, *Alderman William F. Paul*

Cooper, David O. *Bleak Encounter*, gift from artist in memory of Fighter and Bomber Groups in East Anglia

Devas, Anthony 1911–1958, *George Alfred Scott*, gift from Burton Son and Sanders Ltd, © courtesy of the artist's estate/ www.bridgeman.co.uk

Ipswich Hospital NHS Trust

Alexander *David Poole (1936–1995)*

Poole, David 1936–1995, *Beaumont Creek, Essex*

Poole, David 1936–1995, *Roz, Wensum Lodge 1988*

Poole, David 1936–1995, *Man in Cap with Pipe*

Poole, David 1936–1995, *At the Seashore*

Poole, David 1936–1995, *Barge at Sunrise*

Poole, David 1936–1995, *Barge at Sunset*

Poole, David 1936–1995, *Bearded Man*

Poole, David 1936–1995, *Boy Singing (after Hendrick ter Brugghen)*

Poole, David 1936–1995, *Cattle in Field*

Poole, David 1936–1995, *Cattle in Field with Windmill*

Poole, David 1936–1995, *Clouds (after John Constable)*

Poole, David 1936–1995, *Clouds (after John Constable)*

Poole, David 1936–1995, *Clouds over Woodland*

Poole, David 1936–1995, *Dancer (after Edgar Degas)*

Poole, David 1936–1995, *Estuary Scene*

Poole, David 1936–1995, *Farm Buildings*

Poole, David 1936–1995, *Field Dyke*

Poole, David 1936–1995, *Foxglove*

Poole, David 1936–1995, *Grazing Cattle near Church*

Poole, David 1936–1995, *Grazing Cattle on Marshland*

Poole, David 1936–1995, *Heavy Horses*

Poole, David 1936–1995, *Horse and Cart*

Poole, David 1936–1995, *Landscape (after John Constable)*

Poole, David 1936–1995, *Landscape with Windmill (after John Constable)*

Poole, David 1936–1995, *Low Tide*

Poole, David 1936–1995, *Maldon, Essex*

Poole, David 1936–1995, *Margarita de Geer (after Rembrandt van Rijn)*

Poole, David 1936–1995, *Mill in*

Landscape (after Henry Bright)

Poole, David 1936–1995, *Nan*

Poole, David 1936–1995, *Pigot Lane, Poringland*

Poole, David 1936–1995, *Ploughman's Lunch*

Poole, David 1936–1995, *Portrait of a Man (after Diego Velázquez)*

Poole, David 1936–1995, *Sailing Barges in the Evening*

Poole, David 1936–1995, *Sailing Wherry on the River*

Poole, David 1936–1995, *Seafront with Ships (after John Constable)*

Poole, David 1936–1995, *Setting Sun*

Poole, David 1936–1995, *Study of Characters at Horse Sale*

Poole, David 1936–1995, *Summer River Bank*

Poole, David 1936–1995, *The Dancers (after Edgar Degas)*

Poole, David 1936–1995, *Winter Scene*

Snook, Reg b.1938, *(i) Paradise Lost and Regained, Autumn* © the artist

Snook, Reg b.1938, *(ii) Paradise Lost and Regained, Winter* © the artist

Snook, Reg b.1938, *(iii) Paradise Lost and Regained, Spring* © the artist

Ipswich Record Office

Burton, Alice Mary b.1893, *The 4th Earl of Cranbrook, Chairman of East Suffolk County Council (1950–1957)*

Cope, Arthur Stockdale 1857–1940, *John Major, 5th Lord Henniker, Chairman of East Suffolk County Council (1889–1896)*

Herkomer, Hubert von 1849–1914, *Colonel Nathaniel Barnardiston, First Chairman of West Suffolk County Council*

Sancha, Carlos Luis 1920–2001, *Colonel Sir Robert Gooch Bt, Chairman of East Suffolk County Council (1957–1967)*, gift to East Suffolk County Council

Whelan, Leo 1892–1956, *James Douglas Craig, Chairman of East Suffolk County Council (1947–1950)*

Zinkeisen, Anna Katrina 1901–1976, *The Hon. C. B. A. Bernard, Chairman of East Suffolk Council (1967–1974)*

Ipswich Transport Museum

Berridge, Richard *Priory Heath Depot in 1984*, gift from Ipswich Buses

Berridge, Richard *Trolleybus 46 at the Cornhill, Ipswich in 1935*, gift from Ipswich Buses

Irwin, Valerie b.1947, *Bristol Bus*, gift from Valerie Irwin, © Valerie Irwin

Suffolk Fire and Rescue Service Headquarters

Castle *Fire at Mason's*

Long Shop Museum

Fryer, Wilfred Moody (attributed to) 1891–1967, *The Royal Train, South Africa*

Lambert, W. *Straffed Zeppelin, 17 June 1917*

Lightfoot, Graham C. *The Long Shop, Leiston*, gift from Graham Lightfoot

Swann, Edward *Four Inch Twin Naval Gun Mounting in Garrett Works*

unknown artist *Elizabeth Garrett (1806–1884)*, purchased from Mr P. De Buisson

unknown artist *Richard Garrett (1807–1866)*

unknown artist *Betsey Maria Grimwood, née Garrett (1835–1922)*

unknown artist *Elizabeth Dunnell (b.1785)*

unknown artist *George Augustus Grimwood (1826–1883)*

unknown artist *John Dunnell (1781–1866)*

unknown artist *Richard Garrett (1779–1837)*

unknown artist *Sarah Garrett, née Balls (1776–1851)*

Williams, Edwin (attributed to) active 1843–1875, *Sarah Garrett, née Balls (1776–1851)*

Lowestoft and East Suffolk Maritime Museum

W. J. A. *Wildflower LT557*

Adams, Caroline 1792–1886, *Lowestoft Lighthouse*, gift from Mrs B. Denton

Beauchamp, J. *Peace Wave LT47*, gift from M. Huke

Beauchamp, J. *Primevere LT345*, gift from Mrs B. Barber

Beere, A. Howard *Self Portrait*, gift from D. Sheales

Bennett, G. F. K. *George Spashett*, gift from G. Bennett

Bennett, G. F. K. *Fish Market*, gift from G. Bennett

Bunce, Mary C. *Lydia Eva YH89*, gift from Mrs P. Dean

Burwood, George Vemply c.1845–1917, *St Margaret's Church*

Burwood, George Vemply c.1845–1917, *Ravine Bridge*

Burwood, George Vemply c.1845–1917, *Square Rig Sail Ship*, gift from Mrs R. Roth

Burwood, George Vemply c.1845–1917, *YH151*

Burwood, George Vemply c.1845–1917, *Wildflower LT557*

Burwood, George Vemply c.1845–1917, *Golden Oriole LT292*

Cable, L. J. *Lowestoft Fish Market Scene*, gift from L. Skitterall

Cable, L. J. *Lowestoft Fish Market Scene*, gift from L. Skitterall

Chapman, D. *Sunbeam LT9*, gift from G. Jackson

Cross, Keith *Warship*, gift from Mrs J. Henderson

Crowfoot, Joe b.1946, *Covent Garden LT1258*, © the artist

Crowfoot, Joe b.1946, *Dorothy Rose LT692*, gift from L. Skitterall, © the artist

Crowfoot, Joe b.1946, *East Briton LT447*, gift from Associated British Ports, © the artist

Crowfoot, Joe b.1946, *Fisher Queen LT679*, gift from Associated British Ports, © the artist

Crowfoot, Joe b.1946, *Paddle Tug*, gift from L. Skitterall, © the artist

Crowfoot, Joe b.1946, *Pilot Me LT353*, gift from L. Skitterall, © the artist

Crowfoot, Joe b.1946, *Running for Cover, Heather LT767*, gift from Associated British Ports, © the artist

Crowfoot, Joe b.1946, *Sincerity LT952*, gift from R. Lee, © the artist

Fisher, Rowland 1885–1969, *Granby Queen LT80, Rescuing a Trawler*

Fisher, Rowland 1885–1969, *Trinidad LT210*

Gregory, John 1841–1917, *Sweet Hope LT157*

Gregory, John 1841–1917, *H. M. C. LT741*

Gregory, John 1841–1917, *Bessie LT519*

Gregory, John 1841–1917, *Fisherman LT568*

Gregory, John 1841–1917, *Maggie May LT371*

Gregory, John 1841–1917, *Watchful LT659*

Gregory, John 1841–1917, *Watchful LT659*

Gregory, John 1841–1917, *Xantho LT41*, gift from Mr Wilmont

Gregory, John 1841–1917, *Majestic LT937*

Gregory, John 1841–1917, *Recompence LT509*

Gregory, John 1841–1917, *Sweet Hope LT157*

Gregory, John 1841–1917, *Children's Friend LT537*, gift from W. E. Killett

Gregory, John 1841–1917, *Emerald LT296*, gift from Twee Swan

Gregory, John 1841–1917, *Illustrious LT546*

Gregory, John (attributed to) 1841–1917, *Active LT237*, gift from S. Farman

Gregory, John (attributed to) 1841–1917, *Wave Crest LT744*

L. W. H. *Consolation LT718*

Harper, N. R. active 1970–1974, *Ada Kerby LT72*

Harvey, S. E. *Lord Hood LT20*

Hurr, E. J. active 1909–1912, *Doris LT890*

Hurr, E. J. active 1909–1912, *Drake LT1068*

Hurr, E. J. active 1909–1912, *Young Fred LT717*

Ives, L. G. *Jumbo Fiske, Skipper*, gift from Fiske Family

Jaarsma, Haaike Abraham

1881–1970, *Sir Lancelot LT263*, gift from Mrs J. Blowers

Jaarsma, Haaike Abraham 1881–1970, *A Trinity House Vessel*

John, C. *Boats at Sea*, gift from Mr & Mrs B. Smith

John, C. *Boats at Sea*, gift from Mr & Mrs B. Smith

Joy, William (after) 1803–1867, *Lowestoft Lifeboat Goes to the Rescue*

N. de L. *Sir Charles Bullen KCH, KCB, GCB (1768–1853)*

Love, F. *Iverna LT514*

Love, F. *Fear Not LT688*, gift from Mr B. W.

Mitchell, I. J. *Sail Smacks Leaving Lowestoft*

Morgan, I. *Ocean Breeze LT341*, gift from G. Jackson

Mowle, Claude 1871–1950 **& Luck, Kenneth** 1874–1936 *Ocean Retriever YH307*

Purling, A. *Albert, Fisherman*, gift from Mrs A. Purling

Race, George 1872–1957, *Dawn of Day LT617*, gift from H. C. Raven

Race, George 1872–1957, *Harry*

Race, George 1872–1957, *Harry YH359*

Race, George 1872–1957, *Request LT629*

Race, George 1872–1957, *Laburnum LT1051*

Race, George 1872–1957, *Vigilant LT1025*, gift from H. Raven

Race, George 1872–1957, *Carnation LT50*

Race, George 1872–1957, *Hope LT1075*

Race, George 1872–1957, *Incentive LT581*

Race, George 1872–1957, *Liberty LT1055*

Race, George 1872–1957, *Renovate LT307*

Race, George 1872–1957, *Excelsior LT698*, gift from W. Sparkes

Race, George 1872–1957, *Mary Adeline LT650*

Race, George 1872–1957, *Smilax LT594*

Race, George 1872–1957, *Silver King LT1034*

Race, George 1872–1957, *Cenwulf LT49*, gift from Mrs Doy

Race, George 1872–1957, *Incentive LT581*, gift from W. Kemp

Race, George 1872–1957, *Devon County LT526*

Race, George 1872–1957, *East Briton LT447*

Race, George 1872–1957, *Smilax LT594*

Race, George 1872–1957, *Sincere LT681*

Race, George 1872–1957, *John and Norah LT203*, gift from T. Frost

Race, George 1872–1957, *Lord Cavan LT680*

Race, George 1872–1957, *Craighall LH273*

Race, George 1872–1957, *Norford Suffling LT685*, gift from Mr Websdale

Race, George 1872–1957, *Shipmates LT1134*, gift from Mrs Bloya

Race, George 1872–1957, *Smilax LT594*, gift from Mr Websdale

Race, George 1872–1957, *Bountiful LT1151*, gift from J. Button

Race, George 1872–1957, *Boy Roy LT1167*, gift from E. Moore

Race, George 1872–1957, *Locarno LT275*

Race, George 1872–1957, *Supporter LT119*, gift from Mrs D. Smith

Race, George 1872–1957, *Renascent LT288*, gift from R. Norman

Race, George 1872–1957, *Wilmington LT1201*, gift from J. Keable

Reeve, R. *Sunniside*

Richards, Francis *Ludham Queen LT87*, gift from Mrs Chamberlain

Robertson, W. *Ted Ellis and Children*

Russell, Clifford 1919–2003, *Boston Swallow LT328*, gift from Mrs Reader

H. S. *Sutterton BN39*

I. M. S. *Brothers LT216*

Sansom, K. *HMS Northern Sky*, gift from Miss V. Hambly

Swan, G. *Fancy LT366*

Taylor, R. *The Warren House*, gift from Mrs R. Taylor

Tench, Ernest George 1885–1942, *Spring Flower LT971*, gift from J. Garwood

Tench, Ernest George 1885–1942, *Defender LT183*

Tench, Ernest George 1885–1942, *Nelson LT459*

Tench, Ernest George 1885–1942, *Sincerity LT952 and Boy Russell LT346*

Tench, Ernest George 1885–1942, *Chrysolite LT635*

Tench, Ernest George 1885–1942, *George Borrow LT956*, on loan from Mrs Hague

Tench, Ernest George 1885–1942, *Good Friend LT112*

Tench, Ernest George 1885–1942, *Herring Fisher LT45*

Tench, Ernest George 1885–1942, *Indomitable LT196*

Tench, Ernest George 1885–1942, *Internos LT987*

Tench, Ernest George 1885–1942, *Internos LT987*

Tench, Ernest George 1885–1942, *John Lincoln LT140*

Tench, Ernest George 1885–1942, *True Vine LT52*, gift from M. & A. Reeve

Tench, Ernest George 1885–1942, *Boy George LT441*

Tench, Ernest George 1885–1942, *Boy Ramah LT308*, gift from Mrs Soames

Tench, Ernest George 1885–1942, *Girl Annie LT953*, gift from J. Garwood

Tench, Ernest George 1885–1942, *Girl Hilda LT1040*

Tench, Ernest George 1885–1942, *Roma LT410*, gift from T. J. Adams

Tench, Ernest George 1885–1942, *Midas LT585*

Tench, Ernest George 1885–1942, *Osprey LT1076*

Tench, Ernest George 1885–1942, *John Alfred LT470*, gift from W. Breach

Tench, Ernest George 1885–1942, *Searcher LT290*

Tench, Ernest George 1885–1942, *E. W. B. LT1124*

Tench, Ernest George 1885–1942, *Telesia LT1155*, gift from Mrs Skitterall

Tench, Ernest George (attributed to) 1885–1942, *W. E. Brown LT223*

unknown artist *A Sailing Clipper*

unknown artist *Bill Soloman, Founder Member of Lowestoft Maritime Society*

unknown artist *Fish Market Scene*

unknown artist *John Alfred LT470*

unknown artist *Keewaydin LT1192*

unknown artist *Kyoto CF19*

unknown artist *LT226*

unknown artist *Men around a Messdeck Table*, gift from Mrs Linacre

unknown artist *Norfolk LT55*

unknown artist *Vessels Returning to Harbour*, gift from C. Cox

unknown artist *W. A. Massey LT1090*, gift from Mrs Mews

Whaley, M. J. *Frederick Edward Crick*

Yallop, A. V. *Carnation LT50*

Lowestoft Museum at Broad House

Adams, Caroline 1792–1886, *St John's Church, 1861*, from the collection of Waveney District Council

Barrett, R. M. *Lowestoft Lifeboat Launching to Vessel in Distress (after William Joy)*, from the collection of Waveney District Council

Burwood, George Vemply c.1845–1917, *Lowestoft Inner Harbour, Lake Lothing*, from the collection of Waveney District Council

Burwood, George Vemply c.1845–1917, *Belle Vue Park, 1886*, from the collection of Waveney District Council

Burwood, George Vemply c.1845–1917, *The High Light, Lowestoft Score*, acquired for Trustees by R. Sprake

Cave, Peter le 1769–1801, *Lowestoft Beach, 1803*, from the collection of Waveney District Council

Cave, Peter le 1769–1801, *Yarmouth Jetty, 1803*, from the collection of Waveney District Council

Crimp, Mildred F. *Alderman D. G. Durrant*, from the collection of Waveney District Council

Green, G. Colman 1893–1964, *Yawls Racing at Lowestoft Regatta*, from the collection of Waveney District Council

Green, G. Colman 1893–1964, *Bittern Sailing on Zuyder Zee*, from the collection of Waveney District Council

Green, G. Colman 1893–1964, *Lowestoft Yacht Basin, Regatta 1906*, from the collection of Waveney District Council

Harper, N. R. active 1970–1974, *LT55 Approaching Port*, from the collection of Waveney District Council

K. T. *Frost Alley Score, Lowestoft*, from the collection of Waveney District Council

Wouwerman, Philips (after) 1619–1668, *Gypsy Encampment*, from the collection of Waveney District Council

Waveney District Council

Burwood, George Vemply c.1845–1917, *Ravine Bridge, Lowestoft*

Burwood, George Vemply c.1845–1917, *Smack Wildflower Rescuing Survivors of SS Elbe*

Burwood, George Vemply c.1845–1917, *Acme LT651*

Burwood, George Vemply c.1845–1917, *Viola LT1026*

Capps-Jenner, B. *View from 15 Stanley Street*

Craft, Percy Robert 1856–1934, *Cornish Village*

Eaton, G. C. *John Barker (1707–1787) (copy of Joshua Reynolds)*

Gregory, John 1841–1917, *Mirand LT479*

Gregory, John 1841–1917, *Forward LT708*

Gregory, John 1841–1917, *Speranza LT431 Entering Harbour*

Gregory, John 1841–1917, *Speranza LT431 in a Storm*

Gregory, John 1841–1917, *Lowestoft Smack off Claremont Pier*

Jensen, Alfred 1859–1935, *SS Copenhagen*

Kerris *Cottage and Bridge Crossing*

Linnig, Egidius 1821–1860, *Paddle Steamer Cygnus*

Love, F. (attributed to) *Lily LT572*

Phillips, Marjorie *Diketa Entering Lowestoft*

Preston, T. *Smacks at Lowestoft Harbour Entrance*

Rees, G. J. *Belle Vue Park*

Smith, David 1920–1998, *Lowestoft Old Extension Pier Head*

unknown artist *Captain Woods, Trinity House Pilot*

unknown artist *Mrs Woods*

unknown artist *Leaving Lowestoft Harbour*

unknown artist *Study of Lowestoft Smacks*

unknown artist *Study of Lowestoft Smacks*

unknown artist *Study of Lowestoft Smacks*

unknown artist *Study of Lowestoft Smacks*

unknown artist *Study of Lowestoft Smacks*

unknown artist *Study of Lowestoft Smacks*

unknown artist *The Open Book of Scriptures*

unknown artist *William Shakespeare (copy of 'The Chandos Portrait')*

Martlesham Heath Control Tower Museum

Cooper, David O. *P51 Mustangs, 343 Fighter Squadron*

Fairbairn, Gordon R. *B-26 Marauder*, on loan from Mr Gordon R. Fairbairn

Fairbairn, Gordon R. *Air Sea Rescue Launch*, on loan from Mr Gordon R. Fairbairn

Fairbairn, Gordon R. *Boulton Paul Defiant*, on loan from Mr Gordon R. Fairbairn

Hall, Charles *Slipstream on the Heath, Hawker Fury Number 1 Squadron*

Kempster, R. *Fairey Battle, France 1940*

Newson, Barry *356th Fighter Group*

Newson, Barry *Home Alone*

Newson, Barry *Martlesham Pair, P51 Mustangs*

Smith, Harry J. d.1983, *Vickers Wellington*, donated by the Felixstowe Glass Company

unknown artist *Hawker Hurricane*

Mildenhall and District Museum

Dagley *Old Cemetery Chapel, Mildenhall*, gift

Davis, James d.1995–1996, *The Last Chapter*, donated by James Davis

Smith, Harry J. d.1983, *Lancaster Bombing Raid*

Statham, F. J. N. *The Mill at Barton Mills*

British Sporting Art Trust

Adam, Emil 1843–1924, *Mimi with Rickaby up with Her Trainer, Mr Matthew Dawson, 1891*, bequeathed by gift

Alken, Samuel Henry 1810–1894, *The 1850 Cambridgeshire Stakes: Start of the Race*, bequeathed by gift

Alken, Samuel Henry 1810–1894, *The 1850 Cambridgeshire Stakes: The Finish*, bequeathed by gift

Alken, Samuel Henry 1810–1894, *Jockey Mounting (Set of Four Racing Scenes)*, bequeathed by gift

Alken, Samuel Henry 1810–1894, *Preparing for a Race (Set of Four Racing Scenes)*, bequeathed by gift

Alken, Samuel Henry 1810–1894, *Rubbing Down (Set of Four Racing Scenes)*, bequeathed by gift

Alken, Samuel Henry 1810–1894, *Saddling (Set of Four Racing Scenes)*, bequeathed by gift

Best, John active 1750–1792, *Officer of the Royal Horse Guards With His Charger and Dog*, bequeathed by gift

Bowman, Jean b.1917, *Berkeley Springs*, bequeathed by gift

Bowman, Jean b.1917, *Silly Season*, bequeathed by gift

British (English) School *Hardolph*

Wasteaeys (1612–1673) with His Tutor at Headon Hall, anonymous loan

Cooper, Abraham 1787–1868, *Studies of Sixteen Jockeys I*, bequeathed by gift

Cooper, Abraham 1787–1868, *Studies of Sixteen Jockeys II*, bequeathed by gift

Cooper, Abraham 1787–1868, *Studies of Sixteen Jockeys III*, bequeathed by gift

Cordrey, John active 1765–1825, *The Marquess of Queensberry's Coach*, bequeathed by gift

Crawford, Susan b.1941, *Mill Reef*, bequeathed by gift

De Alarcen, Richard *Park House Stables, Kingsclere*, bequeathed by gift

Dedreux, Alfred 1810–1860, *The Trainer*, bequeathed by gift

Henderson, Charles Cooper 1803–1877, *A London Cab*, bequeathed by gift

Henderson, Charles Cooper 1803–1877, *A Paris Diligence*, bequeathed by gift

Herring, John Frederick I 1795–1865, *Sluggard with Flatman up*, bequeathed by gift

Herring, John Frederick I 1795–1865, *The Match between 'Priam' and 'Augustus', 20 October 1831*, bequeathed by gift

Herring, John Frederick I 1795–1865, *Euclid, with Jockey Connolly and Trainer Pettit*, bequeathed by gift

Herring, John Frederick I 1795–1865, *Tarrare, with George Nelson up*, bequeathed by gift

Herring, John Frederick II 1815–1907, *Barefoot, with Goodison up, 1829 (Series of Four)*, bequeathed by gift

Herring, John Frederick II 1815–1907, *Bay Middleton, with Robinson up, 1836 (Series of Four)*, bequeathed by gift

Herring, John Frederick II 1815–1907, *Matilda, with Robinson up, 1827 (Series of Four)*, bequeathed by gift

Herring, John Frederick II 1815–1907, *Preserve, with Flatman up at Newmarket, 1835*, bequeathed by gift

Herring, John Frederick II 1815–1907, *Queen of Trumps, with Lye up, 1836 (Series of Four)*, bequeathed by gift

Holiday, Gilbert Joseph 1879–1937, *Hunting Scene, Full Cry*, bequeathed by gift

Landseer, Edwin Henry 1802–1873, *Lord Henniker's Bay Mare, Brunette*, bequeathed by gift

Lyne, Michael 1912–1989, *A Pony Club Bending Race*, purchased

Morland, George 1763–1804, *Ferreting*, purchased

Munnings, Alfred James 1878–1959, *Moving up to the Start, Newmarket*, bequeathed by gift

Munnings, Alfred James 1878–1959, *Study for 'The Saddling Paddock, Cheltenham March*

Meeting'*, bequeathed by gift

Munnings, Alfred James 1878–1959, *Study for 'Under Starter's Orders, Newmarket'*, bequeathed by gift

Munnings, Alfred James 1878–1959, *The 6th Earl Winterton, MFH*, bequeathed by gift

Munnings, Alfred James 1878–1959, *The Start, October Meeting, Newmarket*, bequeathed by gift

Reeves, Richard Stone 1919–2005, *Midsummer Night*, bequeathed by gift

Sanders, Philip *Worcester Races*, bequeathed by gift

Sartorius, John Francis c.1775–1831, *Brace of English Partridge*, bequeathed by gift

Sartorius, John Nost 1759–1828, *Thomas Oldaker, Huntsman to the Berkeley, on His Hunter 'Magic' Breaking Cover, 1811*, bequeathed by gift

Schwanfelder, Charles Henry 1774–1837, *A Bay Horse in a Wooded Landscape*, bequeathed by gift

Schwanfelder, Charles Henry 1774–1837, *A Greyhound in a Landscape*, bequeathed by gift

Seymour, James (after) 1702–1752, *Flying Childers, with Jockey up*, bequeathed by gift

Slaughter, Stephen 1697–1765, *Sir George Hampson and Family*, bequeathed by gift

Spode, Samuel active 1825–1858, *The Pinckney Family Coursing at Stonehenge*, purchased

Stubbs, George 1724–1806, *Lord Clanbrassil with Hunter Mowbrary*, anonymous loan

Stubbs, George 1724–1806, *A Pointer (a pair)*, bequeathed by gift

Stubbs, George 1724–1806, *A Spaniel (a pair)*, bequeathed by gift

Stubbs, George 1724–1806, *Fighting Stallions*, bequeathed by gift

Wardle, Arthur 1864–1949, *Portrait of a Deerhound, Champion Earl II*, anonymous loan

Wilson, Thomas Fairbairn active 1806–1846, *Two Shorthorn Cattle: The White Heifer Which Travelled and Red Rose*, bequeathed by gift

Zinkeisen, Doris Clare 1898–1991, *Mill Reef*, bequeathed by gift

National Horseracing Museum

Adam, Emil 1843–1924, *Ladas*, anonymous loan

Adam, Emil 1843–1924, *Troutbeck*, anonymous loan

Adam, Emil 1843–1924, *Sceptre*, purchased by Friends of NHRM

Anscombe, R. active 1950s, *Meld, H. Carr up*, purchased

Ben, I. *Tattersalls Sales*, gift from K. Abdullah

Ben, I. *Tattersalls Sales*, gift from K. Abdullah

British (English) School *Wolverhampton Races*, on loan from Yale Center of British Art

Broadhead, W. Smithson 1888–1960, *Steve Donoghue*, purchased by Friends of NHRM

Bryan, John active 1826–1835, *Queen of Trumps, J. Lye up*, anonymous loan

Calderon, William Frank 1865–1943, *Atrato, Ivor Anthony up*, gift from Paul Mellon

Cawthorne, Neil b.1936, *Newmarket Rowley Mile Millennium Grandstand*, purchased by Friends of NHRM, © the artist

Cawthorne, Neil b.1936, *Newmarket Rowley Mile Racecourse*, purchased by Friends of NHRM, © the artist

Chalon, Henry Bernard 1770–1849, *Violante, F. Buckle up*, purchased with help of grant from Resource and V&A Purchase Grant Fund

Closterman, John Baptist active c.1690–1713, *English Racehorse, c.1690*, purchased by the Friends of the NHRM

Cooper, Alfred Egerton (attributed to) 1883–1974, *Grey Manus in Stables*, anonymous loan

Cullin, Isaac active 1875–1920, *The Paddock at Tattersalls, Newmarket*, on loan from Captain J. Macdonald-Buchanan

Curling, Peter b.1955, *Sir Peter O'Sullivan and Friends*, on loan from Sir Peter O'Sullivan

Delmé-Radcliffe, Charles 1864–1937, *Hunting Scenes*, gift from P. Delmé-Radcliffe

Dighton, Joshua 1831–1908, *Cloister*, purchased

Earl, Thomas P. active 1900–1933, *Brown Betty*, gift from Lady Boyd Rochford

Gascoyne, George 1862–1933, *Victor Wild*, gift

Haigh, Alfred G. 1870–1963, *Sunstar*, gift from D. Haigh, on loan to National Stud

Haigh, Alfred G. 1870–1963, *Manna*, gift from D. Haigh, on loan to National Stud

Haigh, Alfred G. 1870–1963, *Shaun Goilin*, gift from D. Haigh, on loan to National Stud

Haigh, Alfred G. 1870–1963, *April the Fifth*, gift from D. Haigh, on loan to National Stud

Haigh, Alfred G. 1870–1963, *Bahram*, gift from D. Haigh, on loan to National Stud

Haigh, Alfred G. 1870–1963, *Ocean Swell*, gift from D. Haigh, on loan to National Stud

Haigh, Alfred G. 1870–1963, *Airborne*, gift from D. Haigh, on loan to National Stud

Haigh, Alfred G. 1870–1963, *Cannobie*, gift from D. Haigh, on loan to National Stud

Haigh, Alfred G. 1870–1963, *Diomedes*, gift from D. Haigh, on loan to National Stud

Haigh, Alfred G. 1870–1963, *Jenkinstown*, gift from D. Haigh, on loan to National Stud

Haigh, Alfred G. 1870–1963, *Nothing Venture*, gift from D.

Haigh, on loan to National Stud

Haigh, Alfred G. 1870–1963, *Sergeant Murphy*, gift from Mr D. Haigh

Hall, Harry 1814–1882, *Old Sam Day*, gift from George Welham

Hall, Harry 1814–1882, *Bertram, T. Osborne up*, gift from Ackerman and Son

Hall, Harry 1814–1882, *John Day*, anonymous loan

Hall, Harry 1814–1882, *Nat Flatman*, purchased by the Friends of NHRM

Hall, Harry (attributed to) 1814–1882, *Jockeys Chifney, Arnull, Robinson and Boyer*, anonymous loan

Hall, Sydney Prior (attributed to) 1842–1922, *Harry Hall*, gift from Mrs P. Burnard

Havell, Alfred Charles 1855–1928, *Cicero*, anonymous loan

Havell, Alfred Charles 1855–1928, *Pretty Polly*, purchased by the Macdonald-Buchanan Charitable Trust

Hayter, George 1792–1871, *Admiral Henry John Rous (1791–1877)*, anonymous loan

Herring, Benjamin II 1830–1871, *The Start of the Cambridgeshire Stakes, 1867*, gift from Paul Mellon

Herring, John Frederick I 1795–1865, *Matilda*, gift from S. Gibson

Herring, John Frederick I 1795–1865, *Touchstone*, anonymous loan

Herring, John Frederick I 1795–1865, *Amato*, gift from Mrs Pilkington

Herring, John Frederick I 1795–1865, *The Flying Dutchman and Voltigeur at York, 1851*, anonymous loan

Herring, John Frederick I 1795–1865, *Attila*, anonymous loan

Herring, John Frederick I 1795–1865, *Don John*, anonymous loan

Herring, John Frederick I 1795–1865, *Filho da puta*, anonymous loan

Herring, John Frederick I 1795–1865, *Oxygen*, anonymous loan

Jones, Richard 1767–1840, *Frank Buckle*, purchased

Koehler, Henry b.1927, *Jockeys' Room Doorway, Newmarket*, gift from Mrs Haverstock

Lucas, Henry Frederick Lucas c.1848–1943, *Cicero*, gift from L. W. Lucas

Marshall, Benjamin 1767–1835, *Match between Eagle and Eleanor*, purchased

Marshall, Benjamin 1767–1835, *Shrapnell, W. Arnull up with Trainer Dixon Boyce*, anonymous loan

McLeod, Juliet b.1917, *Carozza*, gift from Lady Murless

Millais, Raoul 1901–1999, *Nijinsky*, gift

Miller, Roy b.1938, *Lester Piggott*, gift from Mrs D. Cracknell, © the artist

Minaham, Lydia b.1942, *Sweat Boxes of Fred Archer, Heath House*

Stables, purchased, © the artist

Minaham, Lydia b.1942, *The Blacksmith and Head Lass, Hurworth House*, purchased, © the artist

Minaham, Lydia b.1942, *The Fountain, Palace House Stables*, purchased, © the artist

Munnings, Alfred James 1878–1959, *Sun Chariot, Sir Gordon Richards up*, bequeathed by executors of E. Cooper-Bland

Palmer, James Lynwood 1865–1941, *Gainsborough*, purchased by the Friends of NHRM and V&A Purchase Grant Fund

Pollard, James 1792–1867, *The 1839 Derby, Bloomsbury Beating Deception*, purchased

Quigley, Daniel active 1750–1773, *The Godolphin Arabian (copy of David Morier)*, gift from the Friends of NHRM

Ross, James I active 1709–1738, *Meeting at Clifton and Rawcliffe Ings, York, 1709*, purchased by friends of late Major David Swannell and the MGC/V&A Purchase Grant Fund

Sartorius, John Nost 1759–1828, *Sir Thomas*, anonymous loan

Sartorius, John Nost 1759–1828, *Dungannon*, anonymous loan

Sartorius, John Nost 1759–1828, *Sir Peter Teazle*, anonymous loan

Sartorius, John Nost 1759–1828, *Eclipse*, anonymous loan

Sartorius, John Nost 1759–1828, *Flying Childers*, anonymous loan

Sartorius, John Nost 1759–1828, *Grosvenor Arabian*, anonymous loan

Sartorius, John Nost 1759–1828, *Herod*, anonymous loan

Sartorius, John Nost 1759–1828, *Pot 8 Os*, anonymous loan

Sealy, Allen Culpeper 1850–1927, *Kingwood, C. Wood up*, on loan from Hon. Lady Macdonald Buchanan

Sextie, William A. 1821–1887, *Clothworker*, bequeathed by Miss J. M. Halford

Stainforth, Martin active 1895–1931, *Golden Miller in the Grand National*, purchased

Townshend, Arthur Louis active 1880–1912, *St Simon*, gift from Mrs S. Mantell

Turner, Francis Calcraft c.1782–1846, *Windsor Grand Military Steeplechase, 1840*, purchased by Friends of NHRM

Turner, Francis Calcraft c.1782–1846, *Windsor Grand Military Steeplechase, 1840*, purchased by Friends of NHRM

Turner, Francis Calcraft c.1782–1846, *Jockeys' Weighing Room*, purchased

unknown artist *Archiestown*, gift from Mrs Ogle

unknown artist *Arctic Prince*, gift from Mrs Yates

unknown artist *The Last Fence, Jerry M. in the Grand National*, on loan from A. Tennant

Wheeler, Alfred 1851–1932, *The*

Life of a Thoroughbred, purchased
Wheeler, Alfred 1851–1932, *The Life of a Thoroughbred*, purchased
Wheeler, Alfred 1851–1932, *The Life of a Thoroughbred*, purchased
Wheeler, Alfred 1851–1932, *The Life of a Thoroughbred*, purchased
Wheeler, Alfred 1851–1932, *The Life of a Thoroughbred*, purchased
Wheeler, Alfred 1851–1932, *The Life of a Thoroughbred*, purchased
Wheeler, Alfred 1851–1932, *The Life of a Thoroughbred*, purchased
Wheeler, Alfred 1851–1932, *The Life of a Thoroughbred*, purchased
Wheeler, Alfred 1851–1932, *Florizel II*, gift from Miss J. Bush
Wheeler, Alfred 1851–1932, *Ormonde, F. Archer up*, gift from Mr E. St George
Wootton, John (attributed to) c.1682–1765, *William Tregonwell Frampton (1641–1727)*, gift from A. J. Macdonald-Buchanan

Saxmundham Museum

Talbot, William active 1890s, *Hay Wain in a Country Lane*, donated by Miss Nancy Clarke
Talbot, William active 1890s, *Self Portrait*, donated by Miss Nancy Clarke
Talbot, William active 1890s, *Suffolk River Scene*, donated by Miss Nancy Clarke

Snape Parish Council

Christie, James Elder 1847–1914, *G. Whiting*, on display at Snape Concert Hall
Christie, James Elder 1847–1914, *James Berry*, on display at Snape Concert Hall
Christie, James Elder 1847–1914, *Louisa Garrett, née Dunnell (1813–1903)*, on display at Snape Concert Hall
Christie, James Elder 1847–1914, *Newson Garrett (1812–1893)*, on display at Snape Concert Hall
Christie, James Elder 1847–1914, *R. Howell*, on display at Snape Concert Hall
Christie, James Elder 1847–1914, *R. Manning*, on display at Snape Concert Hall
Christie, James Elder 1847–1914, *R. McDowal*, on display at Snape Concert Hall
Cotman, Frederick George 1850–1920, *George Chatten*, on display at Snape Concert Hall
Cotman, Frederick George 1850–1920, *Robert Thorpe*, on display at Snape Concert Hall
Cotman, Frederick George 1850–1920, *Thomas Green*, on display at Snape Concert Hall
unknown artist *An Unknown Maltster*, on display at Snape Concert Hall
unknown artist *An Unknown Maltster*, on display at Snape Concert Hall

unknown artist *James Osborne*, on display at Snape Concert Hall

Southwold Museum

Benner, William 1884–1964, *Blyburgh Station at Time of Closing Down of Southwold Railway*, gift from Mr C. Fleetwood-Pritchard
Benner, William 1884–1964, *Southwold Station*, gift from Mr A. B. McLeod
Forward, Frank c.1901–1974, *1953 Floods at Southwold*, gift from Mr P. Forward
Gilbert, W. J. active 1835–1852, *Southwold 1851, Cattle in Foreground*, gift from Miss Fanny Foster
Gilbert, W. J. (attributed to) active 1835–1852, *Black Stallion*, on loan from Southwold Town Council
Grubbe, Lawrence Carrington active 1889–1908, *Mr Took of Southwold, Aged 86*, gift from Miss Grubbe
Grubbe, Lawrence Carrington active 1889–1908, *Basil Hubert Howard Tripp, Mayor (1906–1907)*, on loan from Southwold Town Council
Knox, B. M. *Ernest George Naunton, Town Clerk (1920–1945)*, on loan from Southwold Town Council
unknown artist *William Howard Elmy, Mayor (1894–1895)*, on loan from Southwold Town Council
Walton, Edward Arthur 1860–1922, *Number 9 Park Lane, Southwold*, gift from Mr J. B. Bury
Wilcox, Eric *Locomotive Number 1, Southwold*, gift from Eric Wilcox

Southwold Sailors' Reading Room

Davidson, Allan D. 1873–1932, *Frank Upcraft, Lifeboat Coxswain*, donated
Dopita, Frank *Fishing Boats*, gift from Mrs F. Dopita
Lowsey, Ben *Loss of the Martina Maria, January 1881*, donated
Lowsey, Ben *Loss of the Martina Maria, January 1881*, donated
Lowsey, Ben (attributed to) *Right Hon. W. E. Gladstone Passing by Southwold, 1883*, donated by Mrs Margaret Hunter
Monier-Williams, H. B. *Harbour, North Wall*, donated by Mrs H. Monier-Williams
Race, George 1872–1957, *Au-Retour LT550*, donated
Reeve, John F. C. *Battle of Sole Bay*, gift from Adnams plc
Scott, Henry *Cape Horn Highway*, donated by Henry Scott
Smith, A. B. *Jack 'Davy' Green*, donated by Mrs Wittaker
Strickland, E. *Local Fisherman*, donated
unknown artist *Wreck of the Elizabeth Kilner*
unknown artist *Ben Herrington*,

donated
unknown artist *Gunhill Cliffs and White Lodge*

Southwold Town Council

Blackett, R. *Southwold Seafront at the Sailors' Reading Room*
Currie-Bell, Thomas 1873–1946, *Grey November, Founders' Landing, Southold, Long Island, USA*, gift from Mrs T. Currie-Bell
Denny, Jack W. *Florence Norah Cohen, Mayor of Southwold*, donated by Mrs L. Knights
Denny, Jack W. *John Burlong Denny, Mayor of Southwold*
Eves, Reginald Grenville 1876–1941, *Andrew Matthews*
Eyles, Charles b.1851, *Ipswich, 1898*, presented to Southwold Town Council by Ernest A. Gray
Forward, Frank c.1901–1974, *1953 Floods from Gun Hill, Southwold*
Forward, Frank c.1901–1974, *Wangford Church*
Green, John Kenneth 1905–1986, *Andrew James Critten, Mayor of Southwold*, © the artist's estate
Grubbe, Lawrence Carrington active 1889–1908, *John Eustace Grubbe, Mayor of Southwold*
Grubbe, Lawrence Carrington active 1889–1908, *Eaton Womack Moore, Mayor of Southwold*
Grubbe, Lawrence Carrington active 1889–1908, *Edgar Pipe, Mayor of Southwold*
Grubbe, Lawrence Carrington active 1889–1908, *Edward Adolphous Holmes, Mayor of Southwold*
Lucas, Seymour 1849–1923, *Eustace Edward Grubbe, Mayor of Southwold*, gift from Andrew Mathers
Saul, Henry C. *Market Place, Proclamation of Edward VII, 1901*
Ta 'Bois, J. *Dorothy Elsa Forbes Hope, Mayor of Southwold*
unknown artist *John Sutherland (1776–1852)*
unknown artist *Mrs Thomas Nunn*
unknown artist *Thomas Nunn, Bailiff of Southwold*, donated by the Gooding Family
unknown artist *Unknown Gentleman*

Museum of East Anglian Life

Aldridge, John Arthur Malcolm 1905–1983, *Wood and Iron*, gift from Mrs A. Paterson-Wallace
Butler, Philip J. active 1941–1956, *Tithe Sale*, gift from Philip J. Butler
Butler, Philip J. active 1941–1956, *Old Shepherd Mason of Coddenham*, gift from Philip J. Butler
Butler, Philip J. active 1941–1956, *The Late Abner Pearl on His Small Holding at Barking Tye, Suffolk*, gift from Philip J. Butler
Butler, Philip J. active 1941–1956, *The Late George Andrews of Barking*

Tye, Suffolk, gift from Philip J. Butler
Cobbold, H. C. *Bradfield St George Mill*, gift from H. C. Cobbold
Hart, Colin *Alton Watermill*, gift from Colin Hart
Longe, Vera *Abbotts' Hall Tithe Barn*
unknown artist *Manning Prentice*, gift from Mr Nutman
unknown artist *Wild Flowers*, gift from Mr Nutman
Wilding, G. *Cart Lodge*

Gainsborough's House

Bridgman, Henry 1831–1909, *View of Sudbury from the South-East*, purchased with a grant from the Sudbury Freemans Trust, funds from the Dorothy Elmer Bequest and a donation from Hugh Baker Esq., August 1995
Bridgman, Henry 1831–1909, *Abbas Hall*, presented by Fiona Wheeler, Caroline Wells and Alison Tricker in memory of their parents, Jean and Cecil Wells, May 2001
Bryant, Peter b.1916, *Market Hill, Sudbury*, purchased 2001, © the artist
Bunbury, Henry William 1750–1811, *Rustics in a Landscape*, purchased with assistance of V&A Purchase Grant Fund, 1985
Dargan, John b.1961, *Sudbury Common Lands 3*, purchased December 2000
Dupont, Gainsborough 1754–1797, *Lady Mendip (1725–1803)*, purchased January 1996
Dupont, Gainsborough 1754–1797, *Landscape with Peasant Children outside a Cottage*, purchased with grant from the National Art Collections Fund (Eugene Crementi Fund), 1987
Dupont, Gainsborough 1754–1797, *Reverend Robert Heron (1724–1813)*, purchased with assistance of Museums and Galleries Commission and V&A Purchase Grant Fund, 1993
Dupont, Gainsborough 1754–1797, *John Clementson (1735–1805)*, purchased with an a grant from the V&A/MGC Purchase Grant Fund, July 1997
Dupont, Gainsborough 1754–1797, *Wooded Landscape with Milkmaid and Woodman*, purchased with a grant from the Museum and Galleries Commission and V&A Purchase Grant Fund, 1996
Dupont, Gainsborough 1754–1797, *William Townshend*, purchased with a grant from the Lady Charlotte Bonham-Carter Charitable Trust, January 1997
Dupont, Gainsborough 1754–1797, *Caroline Anne Horde*, purchased with a grant from the Museum Association (Beecroft Bequest), 1991
Dupont, Gainsborough 1754–1797, *Landscape with Cow and*

Sheep, purchased November 1992
Dupont, Gainsborough 1754–1797, *Wooded Landscape with Cows*, purchased by Suffolk County Council by private treaty and transferred to Gainsborough's House with grants from the MGC and V&A Purchase Grant Fund, 1992
Dupont, Richard Gainsborough 1789–1874, *Possibly Charles Harding*, presented by Mrs K. D. Raynor
Earee, Paul 1888–1968, *St Gregory's Church, Sudbury*, purchased December 1995, © the artist's estate
Eastcott *St Peter's Church, Sudbury*, purchased 1992
Gainsborough, Thomas 1727–1788, *Portrait of a Boy (Fragment)*, purchased with grants from the National Heritage Memorial Fund, the V&A Purchase Grant Fund, 1984
Gainsborough, Thomas 1727–1788, *Portrait of a Girl (Fragment)*, purchased April 1991
Gainsborough, Thomas 1727–1788, *Man with a Dog in a Wood*, on loan from private collection
Gainsborough, Thomas 1727–1788, *Wooded Landscape with Herdsman Seated*, purchased with grants from the National Art Collections Fund, the MGC/V&A Purchase Grant Fund, the Esmée Fairbairn Charitable Trust and the Godington Trust, 1990
Gainsborough, Thomas 1727–1788, *Mary, Mrs John Vere*, on loan from private collection
Gainsborough, Thomas 1727–1788, *Mr John Vere*, on loan from private collection
Gainsborough, Thomas 1727–1788, *Peter Darnell Muilman, Charles Crokatt and William Keable in a Landscape*, purchased jointly with Tate with grants from the National Heritage Memorial Fund, the National Art Collections Fund, July 1993
Gainsborough, Thomas 1727–1788, *Mrs Mary Cobbold with Her Daughter Anne*, accepted in lieu of inheritance tax by H. M. Government and allocated to Gainsborough's House, 1998
Gainsborough, Thomas 1727–1788, *Landscape with Peasant Reclining by a Weir*, on loan from private collection
Gainsborough, Thomas 1727–1788, *Reverend Tobias Rustat (1716–1793)*, gift from Mr W. Crowfoot, 1989
Gainsborough, Thomas 1727–1788, *Thomas Vere*, on loan from private collection
Gainsborough, Thomas 1727–1788, *Caroline, Mrs Nathaniel Acton*, on loan from private collection
Gainsborough, Thomas 1727–1788, *Nathaniel Acton*, on loan from private collection
Gainsborough, Thomas 1727–

1788, *Lambe Barry*, purchased with a grant from the National Art Collections Fund and Resource/V&A Purchase Grant Fund, 2001

Gainsborough, Thomas 1727–1788, *Lord Bernard Stuart (after Anthony van Dyck)*, purchased with a donation from an anonymous trust, November 1995

Gainsborough, Thomas 1727–1788, *Descent from the Cross (after Peter Paul Rubens)*, purchased with grants from the Heritage Lottery Fund, the bequest of Miss Dorothy Elmer, the MGC/V&A Purchase Grant Fund and the National Art Collections Fund, 1998

Gainsborough, Thomas 1727–1788, *Harriet, Viscountess Tracy*, purchased with grants from the MGC/V&A Purchase Grant Fund and the National Art Collections Fund, February 1992

Gainsborough, Thomas 1727–1788, *Portrait of an Unknown Youth (The Pitminster Boy)*, on loan from private collection

Gainsborough, Thomas 1727–1788, *Abel Moysey, MP (1743–1831)*, on loan from private collection

Gainsborough, Thomas 1727–1788, *Richard, 5th Viscount Chetwynd*, on loan from private collection

Gainsborough, Thomas 1727–1788, *Wooded Landscape with Cattle by a Pool*, purchased with grants from the National Heritage Memorial Fund, the National Art Collections Fund (the Wolfson Foundation and the Aileen and Vera Woodroffe Bequest), the MGC/V&A Purchase Grant Fund and Gainsborough's House Society Development Trust (the Scarfe Charitable Trust and the A. J. Williams Charitable Trust), the Pilgrim Trust, the Bryan Guinness Charitable Trust, the South Square Trust, the John S. Cohen Foundation and the Simon Whitbread Charitable Trust by Suffolk County Council and transferred to Gainsborough's House Society, 1987–1988

Gainsborough, Thomas 1727–1788, *Mrs Thomas Gainsborough (1728–1797)*, presented by an anonymous donor, 1998

Gainsborough, Thomas 1727–1788, *An Extensive Wooded Upland Landscape*, on loan from private collection

Gainsborough, Thomas 1727–1788, *Wooded Landscape with Figure on a Winding Track*, on loan from Tate

Gainsborough, Thomas 1727–1788, *Wooded Landscape with Peasants Resting*, on loan from Tate

Gravelot, Hubert François Bourguignon 1699–1773, *Le médecin malgre lui*, purchased with a grant from the V&A Purchase Grant Fund, 2003

Hayman, Francis c.1708–1776, *Portrait of Two Boys*, purchased with assistance of the MGC/V&A Purchase Grant Fund, April 1992

Hayman, Francis c.1708–1776, *La vue*, purchased with a grant from the MGC/V&A Purchase Grant Fund and a contribution from the National Art Collections Fund, 2000

Heins, John Theodore Sr c.1697–1756, *John Gainsborough (1711–1772)*, purchased with the aid of grants from the V&A Purchase Grant Fund, the National Art Collections Fund and Sudbury Town Council, 1984

Heins, John Theodore Sr c.1697–1756, *Thomas Gainsborough (1709–1739)*, purchased with the aid of grants from the V&A Purchase Grant Fund, the National Art Collections Fund and Sudbury Town Council, 1984

Jackson, John 1778–1831, *Richard James Lane*, purchased November 1995

Kirby, John Joshua 1716–1774, *Classical Landscape with Ruins*, purchased with a grant from the Museums Association (Beecroft Bequest), 1992

Reynolds, Joshua 1723–1792, *The Hon. Mrs John Barrington*, on loan from private collection

Suddaby, Rowland 1912–1972, *Self Portrait*, purchased November 1994, © the artist's estate

Suddaby, Rowland 1912–1972, *Near Lamarsh*, purchased June 1994, © the artist's estate

Suddaby, Rowland 1912–1972, *East Anglia Stormy Day*, purchased April 1995, © the artist's estate

Suddaby, Rowland 1912–1972, *Stone Wall in Mountain Landscape*, purchased April 1995, © the artist's estate

Suddaby, Rowland 1912–1972, *Winter River Scene*, bequeathed by Mrs M. Robb, © the artist's estate

Sudbury Town Council

British (English) School *Alderman George William Andrews*, presented by Sir George Murray Humphry to the Town of Sudbury

Brownlow, George Washington 1835–1876, *The Moorhen's Nest*

Burrows, Robert 1810–1883, *Cattle Watering*

Humphry, K. Maude active 1883–1891, *Sir George Murray Humphry (1820–1896)*, presented by Sir George Murray Humphry to the Town of Sudbury

unknown artist *Joseph Humphry, Mayor of Sudbury*

Suffolk Punch Heavy Horse Museum

Clark, W. Albert active 1917–1936, *Sudbourne Bellman*, gift from Miss Joan Woodgate

Clark, W. Albert active 1917–1936, *Sudbourne Moonlight*, gift from Mrs E. Jameson

Clark, W. Albert active 1917–1936, *Royal Mavis*, gift from Mrs Geoffrey Smith

Corbet, E. active 1850–1876, *Canterbury Pilgrim*

Corbet, E. active 1850–1876, *Cup Bearer*

D. J. D. *Team of Suffolk Punches Drawing a Miller's Wagon*

Davis, William Henry 1795–1885, *Stallion*

Davis, William Henry 1795–1885, *Fairhead Boxer 405*, on loan from Mr Murray Keer

Duval, John 1816–1892, *Canterbury Pilgrim*

Duval, John 1816–1892, *Cup Bearer III*

Duval, John 1816–1892, *Duchess*

Duval, John 1816–1892, *Leiston*

Duval, John 1816–1892, *Matchet*

Duval, John 1816–1892, *Pride*

Duval, John 1816–1892, *Scot and Vanity*

Duval, John 1816–1892, *Unnamed Horse*, private loan

Duval, John 1816–1892, *Cup Bearer II*

Farley, Charles William 1893–1982, *Joe Stearn with the Mare Rowhedge Myrtle, with Alpheton Church in the Background*, gift from Mrs B. Coulson

Grimshaw, J. *Rowhedge Myrtle*, gift from Robert Peacock Sr

Hobart, John R. 1788–1863, *Stallion*

Knight, Laura 1877–1970, *Parham Prunella and Her Foal*, gift from Mrs Brenda Brotherton, © the estate of Dame Laura Knight 2005. All rights reserved DACS

Laurie, Charlotte M. active 1960s onwards, *Ploughing Match*, gift from Charlotte M. Laurie

Laurie, Charlotte M. active 1960s onwards, *Dinner Time*, gift from Charlotte M. Laurie

Stearn of Brandeston, S. G. *A Red Poll Cow*, on loan from Red Poll Cattle Society

Thurlby, Fred active 1895–1926, *Stallion*

unknown artist *Prize Heifer, 2 Years and 8 Months*, on loan from Red Poll Cattle Society

unknown artist *Stallion*

Woodbridge Museum

Churchyard, Thomas 1798–1865, *Country Lane*, gift

Churchyard, Thomas 1798–1865, *River Scene with Barge*, gift

Moore, John of Ipswich 1820–1902, *River Landscape*, gift

Moore, John of Ipswich 1820–1902, *Flood Gates*, gift

Woodbridge Town Council

Dean *John Amos Howe (1840–1923), Parish Clerk of St Mary's*

Pike, W. *The Sylph at Sea*

unknown artist *The Bernard Barton of Woodbridge*

Woolpit and District Museum

Arnold, C. W. *Woolpit*, gift from C. W. Arnold

Arnold, C. W. *Woolpit Pump*, gift from C. W. Arnold

Collection Addresses

Aldeburgh

The Aldeburgh Museum
The Moot Hall, Market Cross Place, Aldeburgh IP15 5DS
Telephone 01728 454666

Beccles

Beccles and District Museum
Leman House, Ballygate, Beccles NR34 9ND
Telephone 01502 715722

Bungay

Bungay Museum
Council Offices, Bungay NR35 1EE
Telephone 01986 894463

Bury St Edmunds

Bury St Edmunds Record Office (Suffolk County Council)
77 Raingate Street, Bury St Edmunds IP33 2AR
Telephone 01284 352352

St Edmundsbury Museums:

> Manor House Museum
> Honey Hill, Bury St Edmunds IP33 1HF
> Telephone 01284 757076

> Moyse's Hall Museum
> Cornhill, Bury St Edmunds IP33 1DX
> Telephone 01284 706183

> The Guildhall
> Guildhall Street, Bury St Edmunds

> West Stow Country Park and Anglo-Saxon Village
> Visitor Centre,
> Icklingham Road, West Stow
> Bury St Edmunds IP28 6HG
> Telephone 01284 728718

Dunwich

Dunwich Museum
St James's Street, Dunwich, Near Saxmundham IP17 3EA
Telephone 01728 648796

Eye

Eye Town Council
The Laurels, Braiseworth Road, Eye IP23 7DR
Telephone 01379 870061

Felixstowe

Felixstowe Museum
PO Box 50, Hamilton Road, Felixstowe IP11 7JG
Telephone 01394 674355

Felixstowe Town Council
Town Hall, Felixstowe IP11 8AG
Telephone 01394 282086

Flixton

Norfolk and Suffolk Aviation Museum
Buckeroo Way, The Street, Flixton, Bungay NR35 1NZ
Telephone 01986 896644

Framlingham

Lanman Museum
Framlingham Castle, Framlingham
Woodbridge IP13 9BP
Telephone 01728 724189

Halesworth

Halesworth and District Museum
The Railway Station, Station Road, Halesworth IP19 8BZ
Telephone 01986 873030

Haverhill

Haverhill and District Local History Centre
Haverhill Arts Centre, High Street, Haverhill CB9 8AR
Telephone 01440 714962

Ipswich

Ipswich Borough Council Museums and Galleries:

> Christchurch Mansion
> Christchurch Park, Ipswich IP4 2BE
> Telephone 01473 433554

> Ipswich Museum
> High Street, Ipswich IP1 3QH
> Telephone 01473 433550

> Ipswich Town Hall
> The Cornhill, Ipswich IP1 1DA

Ipswich County Library (Suffolk County Council)
Northgate Street, Ipswich IP1 3DE
Telephone 01473 583705

Ipswich Hospital NHS Trust
Heath Road, Ipswich IP4 5PD
Telephone 01473 712233

Ipswich Record Office (Suffolk County Council)
Gatacre Road, Ipswich IP1 2LQ
Telephone 01473 584541

Ipswich Transport Museum
Old Trolleybus Depot, Cobham Road, Ipswich IP3 9JD
Telephone 01473 715666

Suffolk Fire and Rescue Service Headquarters (Suffolk County Council)
Colchester Road, Ipswich IP4 4SS
Telephone 01473 588888

Leiston

Long Shop Museum
Main Street, Leiston IP16 4ES
Telephone 01728 832189

Lowestoft

Lowestoft and East Suffolk Maritime Museum
Sparrow's Nest Gardens, Whapload Road
Lowestoft NR32 1XG
Telephone 01502 561963

Lowestoft Museum at Broad House
Broad House, Nicholas Everitt Park, Oulton Broad
Lowestoft NR33 9JR
Telephone 01502 511457

Waveney District Council
Town Hall, Lowestoft NR32 1HS
Telephone 01502 562111

Martlesham Heath

Martlesham Heath Control Tower Museum
Off Parker's Place, Martlesham Heath IP5 2QU

Mildenhall

Mildenhall and District Museum
6 King Street, Mildenhall
Bury St Edmunds IP28 7EX
Telephone 01638 716970

Newmarket

British Sporting Art Trust
99 High Street, Newmarket CB8 8LU
Telephone 01264 710344

National Horseracing Museum
99 High Street, Newmarket CB8 8JH
Telephone 01638 667333

Saxmundham

Saxmundham Museum
27 High Street, Saxmundaham IP17 1AJ

Snape

Snape Parish Council
19 Stanhope Close, Snape, Saxmundham IP17 1RH

Southwold

Southwold Museum
9–11 Victoria Street, Southwold IP18 6HZ
Telephone 01502 726097

Southwold Sailors' Reading Room
East Cliff, Southwold IP18 6EL

Southwold Town Council
Town Hall, Southwold IP18 6EF
Telephone 01502 722576

Stowmarket

Museum of East Anglian Life
Stowmarket IP14 1DL
Telephone 01449 612229

Sudbury

Gainsborough's House
46 Gainsborough Street, Sudbury CO10 2EU
Telephone 01787 372958

Sudbury Town Council
Town Hall, Sudbury CO10 1TL
Telephone 01787 372331

Woodbridge

Suffolk Punch Heavy Horse Museum
The Market Hill, Woodbridge IP12 4LU
Telephone 01394 380643

Woodbridge Museum
5A Market Hill, Woodbridge IP12 4LP
Telephone 01394 380502

Woodbridge Town Council
The Shire Hall, Market Hill, Woodbridge IP12 4LU
Telephone 01394 383599

Woolpit

Woolpit and District Museum
The Institute, Woolpit IP30 9TU
Telephone 01359 240822

Index of Artists

In this catalogue, artists' names and the spelling of their names follow the preferred presentation of the name in the Getty Union List of Artist Names (ULAN) as of February 2004, if the artist is listed in ULAN.

The page numbers next to each artist's name below direct readers to paintings that are by the artist; are attributed to the artist; or, in a few cases, are more loosely related to the artist being, for example, 'after', 'the circle of' or copies of a painting by the artist. The precise relationship between the artist and the painting is listed in the catalogue.